MORE PRAISE FOR *CAVE PAINTINGS*

"The origin of spirituality is an age-old problem without a solution. David Whitley, with caution, great expertise, and sound arguments, examines possibilities, not to say probabilities. He does so with talent, humor, and feeling in a hugely enjoyable book, thus bringing a new and valuable contribution to this everlasting quest."
 —**Jean Clottes, PhD**, prehistoric art specialist and
 former conservator general of heritage,
 French ministry of culture

"New finds, new insights, new ideas, therefore new disputes are enlivening study of the famous painted images in the ice age caves. David Whitley, himself active in the field, gives an enticing personal account—informed, smart, and sharp."
 —**Christopher Chippindale**, Museum of Archaeology
 & Anthropology, University of Cambridge, UK

"Cave paintings fascinate many of us and ancient rock art can be found across the world. But what do the images mean and how did they first come about? In this enthralling account, David Whitely provides a refreshing new perspective by taking us on a personally informed journey. This book is compelling reading that gives a new perspective on both past and present human creativity. Anyone interested in the origin of art, religion, or what makes us human would be mad not to come along for the ride."
 —**Paul S. C. Taçon, PhD**, anthropologist and archaeologist,
 Griffith University, Queensland, Australia

"David Whitley has written an inspired and provocative book. Everyone who has ever wanted to visit or actually has visited rock art sites and/or the European Paleolithic caves will enjoy his engaging discussion of certain sites, and the vignettes surrounding his own visits. But he has a wider goal and a contro-

versial thesis to articulate. Drawing on aspects of evolutionary psychology and on ethnographic accounts about shamanic practices, and on his own revelations about madness, aberrant behaviors, and religiosity, Whitley reworks some of the extant notions of shamanism and creative process in ways that both intervene into and yet reframe how we might think about not just the makers of the image of the Paleolithic and elsewhere but about our own selves, belief systems, and the powers of the human mind. A good read that will often make you 'talk back' to and with the author!"
　　—**Meg Conkey, PhD**, professor of anthropology,
　　　University of California, Berkeley

"David Whitley, the leading American scientist in cave paintings and rock art, has attempted nothing less than to explain the origins of art and religion. Drawing from his decades of archaeological research, and pulling from literature as diverse as neuropsychology, anthropology, geochemistry, religion, and art history, Whitley helps us understand the　basic human drives behind—and meanings of—the breathtaking paintings left deep in caves by our ancestors 25,000 years ago. Audacious? Of course. But he might just be right."
　　—**Mitch Allen, PhD**, archaeologist and professor at
　　　Mills College, Oakland, CA, and founder of
　　　archaeological publication house, Left Coast Press,

"*Cave Paintings and the Human Spirit* furthers the scientific investigation initiated by David Lewis-Williams, which proposes that the expression of art and visual aesthetics are a recognition of what is already resident in the human mind."
　　—**Don Hill**, "thought leader" at the Banff Centre
　　　and former national radio program host in Canada

CAVE PAINTINGS
AND THE HUMAN SPIRIT

CAVE PAINTINGS
AND THE HUMAN SPIRIT
THE ORIGIN OF
CREATIVITY AND BELIEF

DAVID S. WHITLEY

Prometheus Books

59 John Glenn Drive
Amherst, New York 14228-2119

Published 2009 by Prometheus Books

Inquiries should be addressed to
Prometheus Books
59 John Glenn Drive
Amherst, New York 14228–2119
VOICE: 716–691–0133, ext. 210
FAX: 716–691–0137
WWW.PROMETHEUSBOOKS.COM

13 12 11 10 09 5 4 3 2 1

Library of Congress Cataloging-in-Publication Data

Whitley, David S.
 Cave paintings and the human spirit : the origin of creativity and belief /
David S. Whitley.
 p. cm.
 Includes bibliographical references and index.
 ISBN: 978–1–59102–636–5 (hardcover)
 1. Cave paintings—Europe. 2. Petroglyphs—Europe. 3. Art, Prehistoric—
Europe. 4. Art, Shamanistic—Europe. 5. Shamanism in art.

GN803 .W495 2008
709/.01/12 22
 2008031602

Printed in the United States of America on acid-free paper

For

Jean, David, Tamy, and Carmen

CONTENTS

7

FIGURE AND
PHOTO LIST

FIGURES

ACKNOWLEDGMENTS

I have benefited from the assistance, comments, and aid of a number of colleagues and friends during the preparation and writing of this book. For my visits to Paleolithic sites, I am grateful to "Team Chauvet": Jean Clottes, Jean-Michel Geneste, Norbert Aujoulat, Valérie Feruglio, Michel-Alain Garcia, Dominique Baffier, Yanik LeGuillo, Carole Fritz, and Giles Tossello. At the Volp Caves, I am greatly indebted to Robert and Eric Bégouën and their families. My visit to Côa occurred through the kind help of Antonio Batarda Fernandes. While at Chauvet, I also benefited from the comments of my American colleagues and traveling companions, Jim Keyser and Larry Loendorf. Jean and Ray Auel have for many years, in many ways, been supportive of my research and writing, and I am indebted to them both.

I also benefited from conversations about the archaeolog-

ical and other issues developed here with a series of individuals, especially Chris Carr, Jean Clottes, Ron Dorn, Jo Ann Harris, Kelley Hays-Gilpin, Knut Helskog, Don Hill, Jannie Loubser, Peter Nabokov, Neil Price, Joe Simon, and Andy Rozwadowski. Jean Clottes, Valérie Feruglio, Jean-Michel Geneste, Michel-Alain Garcia, and Antonio Fernandes allowed me to interview them at length about a series of topics, and my narrative has benefited from their openness and interest. My understanding of the mental health of shamans has profited from discussions with Ron Pollack and Heather Davis; Matthias Jakobson provided important genetic information at a critical point while I was finishing the book. I am very grateful to Jean Clottes, Norbert Aujoulat, Robert Bégouën and the Association Louis Bégouën, and Tamy Whitley, each of whom contributed key illustrations for the book. I also thank Linda Regan, my able editor at Prometheus Books, and Andree Abecassis, of the Ann Elmo Agency, for undertaking this project and seeing it to completion.

Tamy and Carmen Whitley are owed special thanks for their many contributions. They are part of the story told in this book, but they have also been especially supportive during the frenzied period when it was all written down. As they know, this is a book about Paleolithic art, and horses are involved—in this case on both sides of the narrative. (I think best on horseback.) I'd like to thank Randy Kendall for giving me his best horse, Twelve, when our roping horse, RockAway Romeo ("Henry" for short), had to be euthanized in the middle of this project. I couldn't have completed this book without those two faithful horses.

PREFACE

There is a story. It lies somewhere between human history and human evolution; somewhere between large events and prominent people played against biological processes and changes that, jointly, make us who we are. Although we can no longer fully hear that story, we can be certain that it exists. Archaeology finds its traces in the small things that mark a culture's passing. But the story tends to get lost in the tales of tools and the details of diet that are the necessary but mind-blind fodder of most archaeological work.

The story is an account of the human spirit. It is a narrative of victory and defeat, knowledge and ignorance, and survival and death matched, often, by elation or fear. I have listened to the remnants of that story for all of my adult life. But, at best, all I've caught are occasional words, like furtive glances, that can mislead as easily as reveal. I am not certain that we can

ever get all of it, or especially get it all right. But it is there, and it challenges us by its presence, whenever we look to the archaeological record in an effort to gaze somehow knowingly at our prehistoric past.

I've written this book with that story in mind. I don't pretend that it captures that story entirely, for how could it do so when many of the actors and events are still uncertain? I have aimed instead to catch at least some of its essence with my own account of what prehistorically matters most. This is the origin of religion and art, to be sure, but also the beginnings of the modern human mind.

As a working archaeologist, I have attempted to make what follows a scientific account (perhaps despite first appearances). This requires explanation because, too often, appearance and substance are confused. Science is to me a wholly personal endeavor for the simple fact that it is a mental voyage, and we can only occupy one mind at a time. It is easy to depersonalize science, as if these mental voyages never occurred. Most scientific writing seems to promote that goal, as if depersonalization somehow also makes intellectual results more factual. I have spent too much time, for better or for worse, learning from poets to accept that argument. My narrative in this sense is wholly personal (or at least mostly so) and, though it waivers at times from the usual scientific approach, this is not because it lacks science's intent or merit.

The result is a series of accounts—stories in their own right, if you will—of archaeological work. They are unified by a concern with the first visible evidence of religious beliefs and the oldest known creations of art. New discoveries always can alter our understanding of matters such as these, but Western Europe currently contains the best evidence for these early expressions of the human spirit. I have focused my attention on that region, admittedly to the exclusion of other contenders for the earliest art (such as

southern Africa). But Europe remains where the earliest known examples lie.

Like a number of recent explorations of these topics, much of my discussion concerns shamanism. This was (and is) a complex of religious beliefs that partly emphasized individual interactions with the supernatural world, achieved through visions. My point of departure is the long-held idea that shamanism was the earliest religion, and that shamanic practices motivated the first art. Good evidence supports these interpretations, but I also suggest that we historically have misunderstood shamanism on some important points. One of these is the nature of the shaman's trance. The second, an implication of the first, concerns the broader issue of how shamanism can then be linked to a credible explanation of the origin of belief. And the third concerns a long discussed topic in the anthropological literature—the shaman's mental health. As you will see, I believe that this is a key to the origins of art.

My understanding of shamanism is primarily based on years of research with Native American cultures, especially the tribes that occupied the far western United States, where I live and work. This requires a preliminary caution. My interpretations are potentially biased by this knowledge, and this can be a danger for an archaeologist. (Prehistory should be understood in its own right, not explained by imposing the ways of life of recent peoples onto ancient cultures.) But to know the past requires a frame of reference that is different from our contemporary Western perception. An understanding of Native American (and other traditional non-Western) cultures provides a kind of prism by which the ancient past can be examined and explored, beyond the heavy intellectual weight imposed by our Western worldview. This is not a final model for how things must have worked but instead a framework that helps us overcome our contemporary—and usually unarticulated—biases. I admittedly see the archaeological past through

a Native American lens. I have attempted to use this fact to focus and clarify my perception rather than to create some kind of simplistic final snapshot.

The human mind certainly played a critical role in the origin of art and belief. To this point, most investigations of the evolution of cognition have followed the standard Western intellectual model—the Enlightenment agenda, first articulated by René Descartes—that has emphasized rationality over emotion. Their goal has been to identify how reason and intellect developed, and when they first appeared. Yet this has been problematic partly because Descartes' goal was to create a science that was an alternative to religion, and that could thus compete with it. At best, this makes the (scientific) study of religion, following his approach, difficult. Although reason is of the greatest importance, more is certainly involved than it alone, especially in religion (as Descartes seemed to know). And also especially with art.

I have turned to an investigation of emotion, and in particular emotional/mental health, in order to explain the origin of the remarkable aesthetic mastery that is the hallmark of the earliest cave paintings. In doing so, I have moved the problem beyond the simple appearance of religious art alone. The question is not why this art appeared, but why the first art represents an outbreak of creative genius and, perhaps, a full flowering of the human spirit.

The result, as I mentioned above, is a personal account of science; perhaps a very personal account. But I think most scientific narratives, honestly recounted, are personal.

FOREWORD

D avid Whitley is an archaeologist who artfully combines the rigor of the scientific approach with a passion for cave art. His mission in this book is to tackle the serious and fundamental human questions of the origins of creativity and belief, and he does so in an eminently readable fashion.

Whitley sets about this task by examining the ancient Paleolithic painted caves of Europe and by also analyzing the nature of shamanism. In the process, he raises and delineates some large and important issues along with the fierce controversies that surround these isses, such as when the Americas were first peopled. These issues are illuminated in terms of his arguments about the relationship between the first religion and art. I cannot say that I agree with all of his statements—particularly some of what he says about me—but his argu-

ments are forceful, and they are eloquently woven together with personal accounts of his visits to some of the earth's most magnificent painted caves.

Like Whitley (both of us are following in the footsteps of South African archaeologist David Lewis-Williams), I realized years ago that the best explanation for the origin of Paleolithic art was in shamanism. This does not mean that the fabulous cave paintings were made by people in a trance, or that they were solely the result of the shaman's visions when experiencing an altered state of consciousness. Shamanism is far more complex than these simplistic views imply, even if repeated contacts with the world of the spirits are fundamental to them.

Whatever the exact dates when the Americas were first peopled, there is widespread agreement that this happened toward the end of the Ice Age (or Pleistocene), during what archaeologists call the Upper Paleolithic. By approximately twelve thousand years ago, the so-called Clovis people had spread over most of the American continent. Whitley's inference that the continent must have first been colonized prior to the appearance of this Clovis culture is obviously right, even if this hypothesis was long considered heretical by many American archaeologists. The prevalence of shamanic elements in Native American religions and the high probability that Paleolithic peoples in Europe also practiced shamanism poses the question of their relationship. There must have been many waves (or dribbles) of immigrants over the millennia, coming to the Americas from different starting points, perhaps from the Bering Strait on foot, perhaps from the west European shores by boats, and these migrants inevitably brought their religious beliefs with them. Chances are that those beliefs were shamanistic.

Whitley argues that a few millennia ago the influences could have been reversed and that Siberian shamanism, a relatively recent phenomenon as we know it historically, might

have resulted from contacts with Native Americans. This hypothesis reverses a century of Western thinking, and it will no doubt be controversial. But why should it be? Cultural influences have always worked both ways, as innumerable ethnographic examples have shown.

Ethnography—anthropological accounts of hunting and gathering peoples—is one of the mainstays of the book and rightly so. When we look at the past, trying to decipher what lies behind the artifacts and the drawings left by prehistoric people, we cannot do so in the abstract. The concept that the "facts speak for themselves" is at best naive, and at worst deceitful, because it implies that we can objectively interpret the facts from our own standpoint, with our own values. It is a safer bet to wager that Paleolithic hunter-gatherers' ways of thinking were closer to those of early Native Americans or Australian Aborigines rather than to ours today.

It is ethnography and the accounts collected for several centuries about the behavior of shamans worldwide that led Whitley to his contention that their mental unbalance or downright mental disorders are crucial to understanding their religion: "The characteristics of shamans and their rituals are perhaps only fully understandable in terms of the symptomology of their diseases." He thus argues that "shamans were masters of the spirits because they harnessed these diseases to channel their creative impulse into what we see as magnificent art." This, too, will be widely discussed.

Shamans played a particularly important role because they organized human spirituality, which the author defines as "our biologically ingrained tendency to believe in spirits." This spirituality is ingrained, Whitley suggests, because it ultimately is derived from the dangerous lives of our early ancestors, always on the alert for predators, for lurking shadows, and for odd noises that would portend danger both from the material and the supernatural worlds.

The origin of spirituality is an age-old problem without a solution. Many complex processes probably account for it, and the one that Whitley outlines may well be one of them. As for me, I would follow in Edward Tylor's ancient footsteps and favor the emergence of spirituality from dreams—both the ordinary night dreams we all experience and the daydreams of altered states of consciousness. With the evolution of language, and the ability of people to talk about and rationalize their dreams, humans could have attributed their dream experiences to voyages to a different realm of reality, where all sorts of strange things could happen.

Be that as it may, the fact that we shall never know for sure must not deter us from trying to know more. There is still plenty to do, to research, and to discover about what made us what we are. David Whitley—with caution, great expertise, and sound arguments—examines possibilities, not to say probabilities. He does so with talent, humor, and feeling in a hugely enjoyable book, thus bringing a new and valuable contribution to this everlasting quest.

Jean Clottes,
former Conservator General of Heritage,
French Ministry of Culture

PART I

THREE DAYS
AT CHAUVET

CHAPTER 1

THE WORLD'S EARLIEST CAVE ART

Where do art, belief, and creativity come from? When did they first appear? Most importantly, why did they develop? These are hard questions because they concern deep issues that are at once fundamental to understanding human nature, yet are more or less peripheral to daily life. And, for many, they are matters of unquestioned faith, rather than inquisitive science. These are, in other words, the kinds of problems that animate archaeology, which often enough is practiced as a passion without immediate material reward. Nowhere are the tensions between what we can or cannot learn about these problems more obvious than in a deep cave on a steep cliff in southern France. It is here that archaeologists have discovered the earliest known cave art—art that is surprisingly sophisticated and unmasks our comic-book image of our monosyllabic, caveman progenitor, wooden club in hand.

In late December 1994, three French cave explorers ("spele-
ologists") scouted the limestone cliff containing a cave that
fronts the Ardèche Gorge, near Vallon Pont d'Arc, southeastern
France, not far from Lyon. Like many cavers, they were searching
for an opening that might lead into a major but as yet undiscov-
ered "dark zone" cavern: a cave that extends beyond the limits
of light. To a caver, such a discovery is akin to the first ascent of
a major peak for a mountain climber, and a rare chance for a bit
of immortality. As the day unfolded, the discovery made by
these cavers, and the events that it unleashed, vindicated their
efforts. Within a few short months, all archaeologists would
know of Jean-Marie Chauvet and the cave named for him;
shortly thereafter, so would the rest of the world.

The presence of the cave was first signaled to Chauvet by a
faint breeze emerging from a scree of boulders—a sign, he knew,
of air moving in and out of the cliff face, indicating an under-
ground passage hidden by the rubble.[1] He and his companions
—Éliette Brunel Deschamps and Christian Hillaire—cleared
aside the loose rocks and, one at a time, squeezed into the small
hole in the cliff that this exposed. What followed was a pro-
tracted snake crawl through a long, narrow, and sloping tunnel
—about seven yards in length and, in places, less than ten inches
wide—a traverse that was bloodying even for a thin Frenchman.
While the first seven yards were bad enough, the tunnel termi-
nated at a fifteen-yard drop-off, straight down, to the pitch-black
cavern floor. As experienced cavers, Chauvet and his team had
brought ropes allowing them to descend to this floor. Unknown
to them at the time, what they would find a few hundred yards
deeper into the cave would change their lives and, perhaps,
change our understanding of the origins of art.

Shortly after the discovery, I received a call from my French
friend and fellow archaeologist Jean Clottes. Then in his
capacity as Conservator General for the French Ministry of
Culture (he has subsequently retired) and an expert on the

Paleolithic paintings of Europe, Clottes had been called away from a family gathering on Christmas Eve to authenticate Chauvet's discovery. The site, according to Clottes, was comparable to the best-known and most highly regarded Paleolithic caves: Lascaux (in France) and Altamira (in Spain). Even more important, he said, the archaeological context of the cave was pristine. Previous discoveries of caves this significant had all occurred fifty or more years earlier and they had been disturbed to varying degrees by visitation and artifact collecting prior to archaeological investigation. Chauvet Cave, as he was already calling it, was a different matter entirely. No one but the discoverers, Clottes, and a few others had been inside the cave since it had been sealed off with the collapse of the original entryway, save for the small hole discovered by the cavers, which had been unknown for thousands of years. Precautions were already being taken to ensure that all remains left by the painters—fire pits, occasional dropped stone tools, bits of pine torches, ivory spear points, and even footprints—were kept intact for careful study and analysis. It was, Clottes suggested, the greatest thing that he had seen in his career—a career that had already been marked by a series of significant discoveries and breakthroughs.[2]

It was, I thought, a great way to start a new year. I couldn't wait for my chance to see the cave. But it would take five years and a series of legal battles before I got the chance.

DISCOVERING PALEOLITHIC ART

The cave art of northern Spain and southern France has been around since the beginning of time—if we measure time on the human scale. Archaeologists date these paintings, engravings, and low-relief carvings to the Upper Paleolithic period, roughly from thirty-five thousand to ten thousand years ago.

This was the Pleistocene, or Ice Age, a period of rapidly changing climate and environment that was quite unlike what we experience today. Moreover, the Upper Paleolithic heralded the first appearance of anatomically modern humans in western Europe: the movement of *Homo Sapiens sapiens* (Cro-Magnon man and woman) into this region, replacing the earlier Neandertal.

Almost all things Neandertal are emotionally debated by archaeologists: Are we their direct evolutionary descendants or instead an entirely different species? Did Neandertal have the capacity for speech? One point, however, seems quite certain—cave art, along with a wide array of other technological innovations, did not appear in Europe until modern humans first arrived. This resulted in a dramatic change in the archaeological record commonly called the "Upper Paleolithic Revolution," or "creative explosion"[3]: only anatomically modern humans, not Neandertals, made cave art. And although cave art probably does not represent the first example of human artistry, it is for the archaeologist a useful surrogate. It is more visible than smaller examples of art, which may be deeply buried (and hard to find) in archaeological deposits. Even in the worst cases it is certainly better preserved than ephemeral art forms such as song, dance, or body paint, which generally leave no traces whatsoever.

Partly for this reason, Paleolithic cave art has fascinated the Western world for more than a century. Although it is clear that historic peoples occasionally visited some of the decorated caves (like the earlier painters, they, too, left their traces), this art did not reach the consciousness of Western science until 1879. In that year, a young Spanish girl, Maria de Sautuola, noticed a series of paintings on the low ceiling of Altamira, a cave that her father, an early archaeologist, was excavating (fig. 1). Recognizing the stylistic similarities between these paintings and small bone carvings from excavated caves in France, Maria's father concluded that the Altamira images were Pale-

olithic in age, like the archaeological deposits that he was exca-
vating at the mouth of this Cantabrian cave.[4]

This was the first recognition of the antiquity of European
cave paintings.[5] Yet its seeming florescence—the painting of
dramatic polychrome images in the great caves as first seen at
Altamira—was traditionally thought to lie between about ten
thousand and eighteen thousand years, with an emphasis on
the younger end of the range. This reflected a presumed, some-
what gradual emergence of sophisticated art from humbler
origins millennia earlier: a slow evolution of human mental
and artistic capabilities. Recent radiocarbon dating at Altamira,
using a nuclear accelerator, places these paintings between
13,300 and 14,900 years, seemingly confirming this belief.[6]

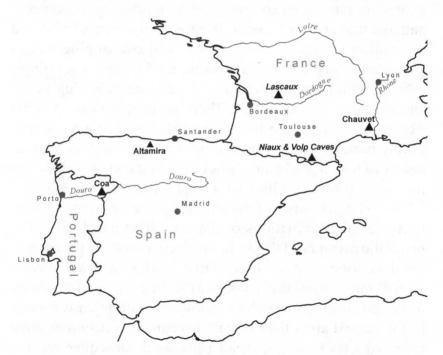

Figure 1. The painted and engraved Paleolithic sites extend from
England to Italy, but the majority are found from northern Portugal and
Spain, north into central France. Some of the major sites discussed
here are shown above. (Map courtesy of Tamara Whitley.)

What Maria de Sautuola had noticed at Altamira and brought to her father's attention was a ceiling covered with large red and black painted animals, primarily bison, but also including horse, deer, and boar. Horses and bison, especially, but also woolly mammoths and other large animals (such as ibex, oxen, and deer) are common at most Paleolithic sites; some of these species, like the woolly mammoth, went extinct at the end of the Ice Age and thus were clearly ancient in origin. While the Altamira paintings are multicolored, paintings at most sites are simply red or black, colors easily made from ground ocher, charcoal, or manganese mixed with fat or oil.[7] Engravings scraped into the cave walls and ceilings occur frequently, sometimes intermixed with the paintings. Human figures are rare; more common are handprints and geometric patterns that archaeologists call, prosaically, "signs." Size and orientation are variable; incomplete and overlapping images are found at many sites. But all sites tend toward a seemingly obvious naturalism, expressed by strong lines reflecting a clear and confident artistic talent. There is no question, in other words, that a depiction of a Paleolithic bison or a horse outwardly portrays a bison or a horse. These are not ambiguous figures of four-legged animals but instead the kind of drawings that an accomplished illustrator might make.

Two characteristics of the sites stood out even to the relatively casual examinations of the earliest archaeologists. The first is the presence of the art in the deep recesses of the caves—the dark zones that lie in perpetual blackness, in some cases long distances from the living areas at the mouths of the caves. Although ensuing research has shown that more art is present in the lighted areas than initially recognized, including some engraved sites in the open air (discussed subsequently), the undeniable association between decorated panels and the deep, dark inner sanctums of the caves continues to be both compelling and perplexing. Why create what by any measure

is fabulous art, precisely where it is hardest to draw and least likely to be seen?

INTERPRETING THE EARLIEST ART

Also immediately notable is the numerical and visual emphasis on the animal drawings at the sites. This fact played to the then developing perception of European Paleolithic prehistory: Ice Age peoples presumably eking out a living by hunting in a cold, arcticlike environment that was inhabited by large and dangerous megafauna, including woolly rhinoceros, huge cave bears, mammoths, and cave lions. It only took a few years before an interpretation conjoining these different elements was offered—paint an animal, kill an animal, or, in two words, "hunting magic." The concept here was that by making an image in the caves, the artists believed this would either increase the fecundity of the herds or enhance the hunter's luck.[8] Occasional indications of what appeared to be wound marks on the animal images seemed to prove this interpretation and it was vigorously promoted by the Abbé Henri Breuil, the leading French archaeologist for much of the first half of the twentieth century.[9]

Hunting magic was a kind of "man-against-beast" scenario (certainly, women played at best a silent part in this early view of prehistory). It reflected the prevailing "conquest-of-nature" ethos as well as the male-biased tenor of the times. Yet like most seemingly simple intellectual ideas, the subtexts of this interpretation were further roiled in the muddy waters of the then nascent science of anthropology and its views of hunting and gathering peoples. Anthropologists at that time perceived such people to be primitive, borderline irrational, and not at all like members of the Western scientific world. It was an interpretation promoting modern Enlightenment thought

against a confused religious (meaning here superstitious) past. This perspective dominated archaeological thinking until the middle of the twentieth century, while also providing an early explanation for the origin of religious beliefs and practices: early people were motivated by an anxiety over the quest for food, and religion was invented in the hopes of ensuring future security.

The hunting magic interpretation was almost certainly wrong (there is little correlation between the depicted species and excavated food remains from camp sites, for example). But there was (and continues to be) strong support for its key underlying implication—the religious origin of cave art. Support for this conclusion is primarily based on location. Mundane activities usually occur in mundane places, archaeological thinking goes, and no places are less mundane than the decorated caves. The use of the caves was clearly unusual and this implies ceremony. Generations of authors and archaeologists, as a result, have used a small set of synonyms with undeniable religious connotations—*sanctuary* and *shrine* come especially to mind—to describe these dark underground recesses. Efforts at unimpassioned and emotionless, rational scientific thinking simply succumbs to the profound and awe-inspiring feelings that a visit to the caves evokes. But the early conclusion that the paintings are religious in origin does not result from scientifically-suspect emotions alone. Not only are the paintings and engravings commonly found far removed from the living areas and refuse dumps of the prehistoric artists, but they also contain occasional images that can only be plausibly reconciled with sacral intent. Key among these are depictions that are half-human and half-animal: ritual performers, not hunters, by common consent.

The locations of the decorated galleries also dictate strongly against an alternative interpretation of Paleolithic art that has been suggested from time to time but never widely accepted—

"art for art's sake." This may seem at first glance a reasonable enough interpretation, since many of the paintings and engravings are by any definition the works of master artists. They are in fact true masterpieces, by which I mean that their aesthetic qualities are timeless and would be recognizable by any culture and at any time. But this aesthetic interpretation only works under two conditions. The first requires ignoring the location problem—if the goal is aesthetic accomplishment, why create art that almost no one can ever see? Second, it assumes on no evidence whatsoever that the recent Western concept of and desire for artistic expression for its own sake—an art devoid of religious and/or ideological intent, made solely for the purposes of aesthetic satisfaction and need (tellingly, as articulated perhaps best by Oscar Wilde)—was also maintained by people in dramatically different cultures, living ten thousand or more years ago. Certainly there may be an inherent and intrinsic human tendency to create art, and great art at that. But traversing the deep, pitch-black caves with only a pine torch for lighting, and risking an encounter with the gigantic Ice Age cave bears that denned within them, seems the least likely scenario for such kinds of expressive behavior. So does the relatively narrow emphasis of the art itself, which includes a restricted set of animals and a few other subjects, not the much wider range of Paleolithic life as it was once practiced.

Two discoveries contributed to a widespread rejection of the hunting magic hypothesis after the mid-twentieth century. One involved the animal bones excavated from the living areas at the mouths of the caves. As a number of studies began to show, there was little if any correlation between the animals painted and the animals eaten.[10] Why, if the intent was to promote the hunt, were so few of the ritualized animals found in the dietary remains at the sites? The other discovery was increasing evidence that the designs in many of the caves were purposely placed. Rather than a random accumulation of

images, there appeared to be a pattern to the way that the animal depictions were laid out, creating a seemingly coherent composition of some kind. The presumption is that, where there is a pattern, there is a symbolic structure and thus some deeper communication intended. This implied that the message lies not so much in individual paintings or engravings but in the relationships between them. All that was needed to interpret the art was the proper code or key.

The most detailed analysis of the composition of the caves was provided at midcentury by French archaeologist André Leroi-Gourhan.[11] Inspired by noted structural anthropologist Claude Lévi-Strauss, Leroi-Gourhan developed a massive synthesis predicated on the system of binary oppositions (like *Good : Bad* or *Up : Down*) that, to the structuralist, reflect the basic workings of the human mind. In Leroi-Gourhan's thesis, the sites consisted of three basic units: central versus peripheral groupings of animals, framed by a third group of paintings found in the entrance and back-cave/passageway areas. The underlying oppositional element in the caves, to Leroi-Gourhan, was expressed in the pairing of horse and bison, reflecting male and female principles, respectively. The central portions of the compositions emphasized the female element, surrounded by peripheral, male-oriented groupings. In some cases, other animals substituted for either element in this basic pair but, regardless, they were also matched by male and female signs—broad, short geometric patterns were feminine, and long, thin (and therefore presumably phallic) ones were masculine.

Any quick summary cannot do justice to the depth of Leroi-Gourhan's ideas, nor to the evidence that he marshaled in its support (not the least of which were detailed statistics on the layouts of the caves). For example, horse, ibex, and cervids (deer and elk) were equated with males because these animals are most commonly found engraved on hunting weapons made of bone that he assumed were used by males—a sugges-

tion that, while contentious from the perspective of current views of gender prehistory, is at least arguable. And, although he never published this fact, Leroi-Gourhan was known to point out that the horse, proportionally, has the largest penis among the depicted animals, thus making it a logically appropriate male symbol.[12] Some of the broad geometric signs, similarly, resemble what many archaeologists would classify as "vulva forms," suggesting a female association.

Leroi-Gourhan was fully aware that his argument potentially implied a fertility cult of some kind. This was a conclusion that he himself described as "at the same time satisfying and laughable."[13] In the end, Leroi-Gourhan argued to have found the pattern behind the layouts of motifs, but he recognized that he was still short of a true understanding of the religious beliefs that the paintings reflected. Toward the end of his career he also backed away from his initial emphasis on the cosmic duality of *Male : Female*.[14]

Like Breuil, who advocated hunting magic, Leroi-Gourhan, too, was the dominant figure of his era, and his structuralist interpretation was the reigning grand theory into the 1980s. This was due in part to Leroi-Gourhan's stature as a scientist and also perhaps to the complexity and detail of his argument, which was ultimately hard to evaluate. Like other such detailed and ponderous structuralist interpretations (notably French anthropologist Claude Levi-Strauss's analyses of Native American myths), it is easy enough to follow the arguments as they are laid out, but figuring out how to test (or contest) them is more problematic. And in the specific case of Leroi-Gourhan, who consciously stopped short of applying specific meaning to the different motifs, at some point it is hard to really know what his interpretation tells us, beyond the empirical observation that the art may be compositionally organized. Leroi-Gourhan's theory was thus never disproven; instead, it languished under the weight of its own complexity until

archaeologists, by and large, lost interest in it. It became a bit of a bicycle without wheels—one that may have seemed elegant enough in theoretical terms, but that didn't seem capable of actually taking you anywhere.

Leroi-Gourhan's real contribution, as pointed out by University of California, Berkeley, archaeologist Meg Conkey, was not what his analyses revealed about Paleolithic art as much as what they said about Paleolithic people.[15] His studies asserted that these were fully humanized, cognitively sophisticated human beings, not primitive cave people stumbling haphazardly toward the future, wooden club in hand. Whatever the art meant, it meant *something*, and this was complexly encoded in the way that the caves were painted. Only sophisticated, thinking human beings could be responsible for such achievements—a conclusion supported by the artistic merit of the paintings themselves.

THE SOUTH AFRICAN CONNECTION

A serious contender for a new grand theory appeared in the late 1980s, although, again, the theory itself was hardly new. What was different was the evidence brought to bear in its support and the manner in which it was tested. This theory holds that much Paleolithic cave art resulted from *shamanism*. This is a religious system that is commonly associated with contemporary and historical hunting and gathering peoples worldwide, hence providing a logical analog for Paleolithic religion as well. Shamans serve as the functionaries in such religions, and much of their ceremonial activities are somewhat idiosyncratic rites that, almost universally, are based on putative direct interactions with the supernatural realm. This occurs not through the carefully prescribed and formulated rites of priestly religions, but instead during the shamans' individual visionary experi-

ences of trance. Priests talk to the gods, as is explained in anthropological lore, but the gods talk to shamans.

This shamanistic interpretation of Paleolithic art was presented in a 1988 academic article by South African archaeologist David Lewis-Williams in conjunction with his student Thomas Dowson.[16] Lewis-Williams is the retired director of the Rock Art Research Centre at the University of Witwatersrand in Johannesburg, South Africa (fig. 2). He is widely known among archaeologists for his intense, focused intellect, demonstrated partly by the twin but rarely combined feats of significant theoretical and empirical breakthroughs. Less well known is his nonacademic side, including his skills as a professional magician (which David regularly used to entertain my young daughter during the many Sunday afternoon teas we enjoyed with him while I taught at the Witwatersrand in the late 1980s). Lewis-Williams also brings this talent as an entertainer—a starlike ability to entrance his audience—to his academic presentations and lectures. He is a hard act to follow (as I know from personal experience), and one can easily imagine him, in another place and time, as a Shakespearean actor of first rank. He is a personality that, in many ways, is larger than life, which is made all the more notable because of his relatively slight physical stature.

Lewis-Williams started his academic career studying the rock paintings of the San (or Bushmen) of southern Africa.[17] Like the Paleolithic artists, the San painters created magnificent polychrome images, albeit of antelope, dancers, and hunters on shallow rock shelter walls, rather than in deep caves (fig. 3). And although much of this art is relatively recent—probably less than five thousand years old, with some paintings still made into the last few hundred years—no artists are left, as in France and Spain, to explain the origin and purpose of the San art. Unlike in France or Spain, however, the problem here is not the great elapse of time, but instead the

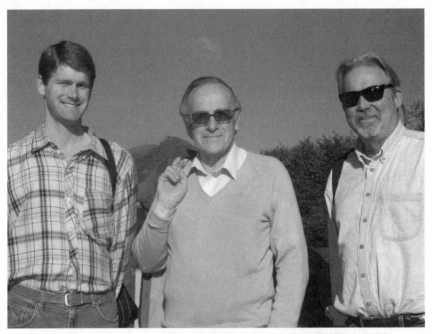

Figure 2. South African archaeologist David Lewis-Williams (center) changed our understanding of Paleolithic art and religion with the revised shamanistic interpretation that he introduced in the 1980s. South African archaeologist David Pierce on left; Whitley on right.

historical extirpation of the San people. Roughly two thousand years ago, Bantu-speaking pastoralists began migrating with their herds into southern Africa, pushing the San, perhaps inadvertently, out of the valleys and plains into the rugged mountain recesses, where their art still lingers. With the more recent appearance of European colonialists intent on claiming all of the southern African land as their own, the process of marginalizing (if not annihilating) the San continued. Licenses for "hunting" the San were issued in what is now Botswana into the beginning of the twentieth century. The London Zoo had a Bushman on display until 1911.[18]

Despite this genocide, there are still San in the remote deserts of Botswana and Namibia, made famous by the pop-

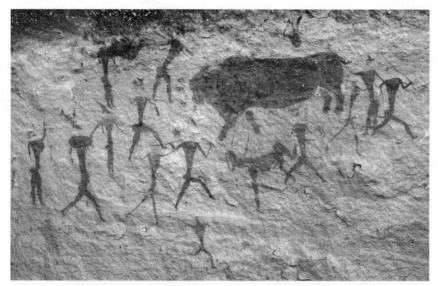

Figure 3. Finely painted southern African rock art combined with (San) Bushman ethnography provided a methodological model useful for understanding the Paleolithic art. This monochromatic example, from the Natal Drakensberg in South Africa, shows a supernatural "rain-bull" being led across the sky by shamans, in order to make rain.

ular film *The Gods Must Be Crazy* (1980)—a film that perpetuates the current Western image of these modern hunters and gatherers as childlike and whimsical, rather than as intellectually and emotionally complex as ourselves. But where these San primarily still live there are, literally, no large rocks, and hence no rock art (recall in the film the cola bottle falling out of the airplane into a land without rocks, and the chain of events that ensues). Although the living San are culturally similar to the people who painted the southern African rock shelters, they themselves do not paint, probably because they do not have the rocks that would allow them to do so.

The result for Lewis-Williams, like much archaeological research, was a detective game requiring the laborious piecing together of various strands of evidence. This included meticulously recording and tabulating the images themselves, ana-

lyzing a few short and at first very enigmatic statements about the paintings recorded from the San by early European colonists, and eliciting commentary about copies of the paintings from the living San, along with knowledge of their general beliefs and practices. Lewis-Williams also looked at texts about religion and mythology transcribed from a few San rock artists who had been incarcerated in Breakwater Prison, Cape Town, in the late nineteenth century.[19] This last source, collected by philologists in the 1870s and 1880s, is particularly poignant for rock art researchers. (Rock art includes cave paintings and engravings, as well as the art on both open-air cliff faces and boulders.) Among its roughly twelve thousand extant pages is a listing and description of the contents of the different notebooks that comprise this collection. Identified in this list is a notebook about the making and meaning of rock art, recorded from the people who made this art. Unfortunately, it has never been found among the archived materials.[20]

Lacking this lost cave art–Rosetta Stone, Lewis-Williams pieced together the disparate sources to show that the San rock paintings were made by shamans and that they portray the supernatural realm entered by these medicine men or women when under a trance. Although a trance can be induced by various means (meditation, hallucinogenic drugs, sensory deprivation, etc.), the San painters apparently achieved their ritual altered state of consciousness by repetitive dancing, singing, and clapping—the so-called trance dance. This is still practiced today by the Kalahari San for group healing, although, again, without any associated rock art in that rockless region.

The paintings are, in other words, visionary images that illustrate the spirits and events of the supernatural world (in all cases almost certainly painted after the artist's trance experience). Prominent among the paintings is the eland antelope or, perhaps more correctly, the eland spirit, into which the shaman commonly was thought to transform and which is sometimes

shown as a half-human, half-animal being—the shaman's supernatural alter ego or spirit helper. Perhaps equally important, Lewis-Williams recognized that the images are intimately tied to the rock surfaces upon which they were placed. As he has explained, this rock surface was thought to be the thin and permeable veil between the sacred and the mundane, one that the shaman penetrated on his supernatural excursions. The paintings themselves preserved the images of the spirits that were already within the rock and which only the shaman could see.[21]

There are some obvious similarities between the southern African paintings and the more ancient European cave art. Beautiful polychrome imagery and the emphasis on large animals are two of the most direct (although, for equally obvious reasons, the animals depicted are not the same). Likewise, the fact that hunting and gathering peoples created both arts seems additional cause for inferring equivalence in their origin and meaning. But these superficial similarities, even if intriguing, are far from scientifically compelling.

Comparisons such as these are *formal analogies*; formal in the sense that they concern outward appearances or similarities. The problem with them stems from the fact that the origins of appearances may be quite variable. Different historical events and circumstances and varying cultural processes can sometimes yield similar products or results—apparent comparability due to mere coincidence, in other words. To infer the origin of the Paleolithic art based on comparisons with the San paintings required a more certain kind of analogy, one based on functional relationships: physical processes that are universal to all humans and that do not change over time.

Lewis-Williams and Dowson found this in clinical studies of the neuropsychological effects of trance, one of the defining characteristics of shamanistic religions.[22] Because the nervous systems of all humans are hardwired in the same fashion, it follows that the altered states of consciousness that result in trance, regardless

of how induced, are broadly similar. Obviously, one trance experience may differ from the next, even for the same individual. Hence, LSD was, for some 1960s devotees, a consciousness-expanding experience, whereas for others it was nothing more than a "bummer trip." And how trance experiences are interpreted differs both between individuals and between cultures. Spontaneous hallucinations may be interpreted in our culture as a sign of dementia of some kind, for example, while in other places (or times) these same experiences may be construed as divine revelation. But regardless of the specifics involving individual cases and the variable cultural or personal meaning ascribed to them, trance itself results in a restricted range of reactions. By compiling the set of reactions that specifically involved the mental images (or visual hallucinations) of trance, these South African archaeologists created a kind of analytical model to test the idea that a given corpus of art depicted trance experiences, and thus was shamanistic in origin.

Archaeologists call this the neuropsychological model, partly reflecting the fact that it is the only archaeological model based on neuropsychological evidence and principles. It has three components (figs. 4 and 5). The first concerns the fact that our mental imagery during a trance commonly progresses through three stages. In the first stage, this imagery is dominated by geometric light patterns that are generated within our optical and neural systems. Lewis-Williams and Dowson used the term *entoptic* ("within the eye") *pattern* as a generic label for these light images. Next, through more or less normal mental processes of visual pattern recognition (which are themselves heavily influenced by personal and cultural expectations), an entoptic pattern is interpreted or construed as a meaningful iconic or figurative image. Finally, full-blown iconic hallucinations occur in which a sense of participation develops and an individual may imagine becoming the thing that he or she hallucinates.

Figure 4. In an influential 1988 paper, David Lewis-Williams and Thomas Dowson introduced their neuropsychological model for the mental imagery that is generated during altered states of consciousness. One aspect of their three-component model involves seven common entoptic light images that are generated by our neural and optical systems during the initial stage of trance. These seven entoptics are shown here. The left column shows the idealized geometric patterns. The middle and right column are examples of the expression of these patterns in rock art. These are from the Coso Range petroglyphs of eastern California.

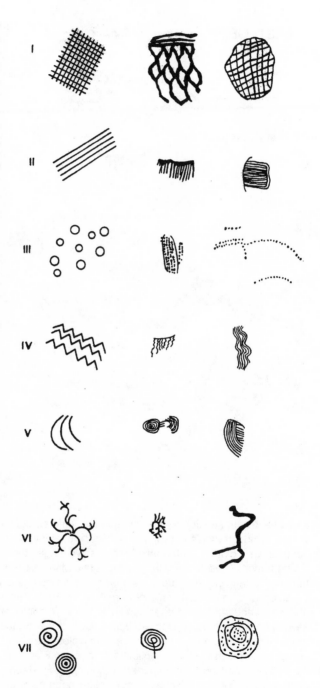

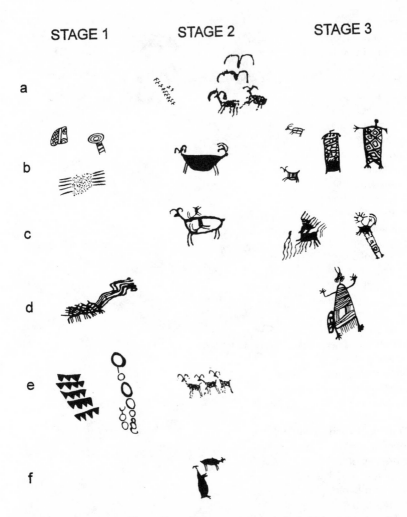

Figure 5. In addition to the perception of entoptic light images, Lewis-Williams and Dowson's neuropsychological model involves two additional components. One of these is the three progressive stages that commonly occur during trance. These start with the perception of entoptics (Stage 1). In Stage 2 these geometric patterns are construed or interpreted as culturally significant iconic images. In the last stage of trance, full-blown iconic hallucinations occur, and iconic and entoptic images combine. The third component of the model is seven principles of perception, reflecting the fact that trance imagery involves more than "normal" visual sight. These principles operate at each of the three stages. In addition to simple replication (shown in Figure 4), they are: (a) fragmentation; (b) integration; (c) superpositioning; (d) juxtapositioning; (e) reduplication; and (f) rotation. Examples are Coso Range petroglyphs.

The second component of their model concerns the entoptic light patterns themselves. A survey of the clinical literature suggested that seven patterns were most common (including zigzags, meanders, dots, spirals, etc.) as basic entoptic designs. The third component of the model pertains to the way that all of these images may be perceived in the human mind. Since hallucinations are in part generated within the brain, they are not limited to the constraints of two- or three-dimensional imagery as seen by the eyes in a normal state of consciousness. Trance images may instead invert, break apart, duplicate endlessly, pile up one atop the other, and so on.

Lewis-Williams and Dowson were not the first scientists to formalize aspects of trance imagery into a coherent model (this had been accomplished by neuropsychologists themselves).[23] Nor were they the first archaeologists to recognize the similarities between some of these hallucinatory effects and rock art motifs (Thomas Blackburn, a California archaeologist, had first made this connection a decade earlier).[24] They were, however, the first to recognize the relationship between the simple entoptic patterns, which Blackburn had identified in the geometrically patterned, shamanistic rock art of California, and the more elaborate iconic images, especially how the first was, through the progression of trance, transformed into the second. And they were the first to test, in a systematic fashion, whether the European Paleolithic art might be shamanistic. They found that all of the components of their model were illustrated in the paintings and engravings found in the Paleolithic caves, leading to the conclusion that at least some of this art, like that of the San, depicted visionary images and therefore derived from shamanistic practices. Perhaps even more importantly, they were the first archaeologists to use explicitly scientific research and methods to identify what is potentially the world's first religion.

TRANCE GOES TO FRANCE

The Anglophone archaeological reaction to Lewis-Williams and Dowson's 1988 study was in many respects predictable, given foreknowledge of the intellectual dynamics of the discipline. Those of us whose research involved known examples of shamanistic rock art were quick to see both the validity of their model and its applicability to the Paleolithic. My research at that time, which used historical accounts to demonstrate that Native Californian rock art was shamanistic in origin, served as one of the independent cases they had employed to test their model prior to applying it to the Paleolithic. Having read and commented on their work prior to its publication, I was a supporter before the fact. Others, who typically lacked personal research experience with shamanistic arts or with shamanism more generally, could not see the connection. A divide quickly developed between the proponents of their interpretation and its opponents, who in fact, had no alternative interpretation to suggest. They objected, but exactly why was not and still has not become clear, perhaps other than the fact that they seemed to disagree philosophically with the general notion that we can actually interpret this art to some degree of accuracy.

The French response was more extreme—there essentially was no response at all. This reflected the general tenor of much French archaeology and a remarkable contrast with the theoretical extremes of French semiotics and literary criticism, which have been at the heart of international postmodernist debate and the ensuing "culture wars." Since Leroi-Gourhan, and the dominating effect of his grand theory, French archaeologists have shunned interpretation of most kinds in favor of discovery, meticulous documentation, and detailed description. Lewis-Williams's shamanistic interpretation was fine, from their perspective, but it had no significant bearing on their real work, and thus warranted no comment at all.

The important exception to this French reaction was Jean Clottes, who eventually would become the director of the Chauvet Cave research. Clottes is, in certain ways, a very typical Frenchman yet, in others, somewhat atypical. He is a tall man who, in an almost clichéd French fashion, is dark, handsome, and athletic. (Now in his seventies, he is still easily enticed into a game of one-on-one basketball, even after a long day of archaeological fieldwork.) Clottes is also one of the most prolific archaeological writers alive; while most of us struggle to get out two or three articles and a book in most years, more often than not, Clottes publishes two or three books and a half dozen or more articles in the same time, meanwhile editing a journal and a book series. On top of this, in a profession where reputations, if not careers, are made by one's ability to spin yarns—a tradition that I have always attributed to our countless nights spent in field camps, with only ourselves as entertainment— Clottes is simply the best storyteller, in any language, that I know. In many ways, he is the consummate archaeologist.

Clottes is also unlike many of his French colleagues in the international scope of his interests and, especially, his connections. Having supported his family while completing his doctorate in archaeology by teaching high school English, he is fluent in spoken English and writes it better than most native speakers. These abilities have aided his de facto emergence as something of an international spokesman for French archaeology; a position of prominence of course also partly due to his research and his central involvement with a series of the most important recent French discoveries. (Indeed, I was reminded of his international prominence—and his indifference to the attention this has given him—in a UNESCO sponsored trip to France a decade back, where I was accompanied by my wife and then ten-year-old daughter. It became obvious during a series of formal banquets that a considerable amount of prefeast jostling was occurring so that various political,

bureaucratic, and archaeological dignitaries might seat them-
selves next to Clottes, or at least at his table. But unbeknownst
to them, Jean had discovered my daughter Carmen's relatively
limited capacity for pâté de foie gras and the other culinary
specialties of the Perigord. While the dignitaries were posi-
tioning themselves to get a seat next to him as, arguably, the
most famous archaeologist in the world, he was quietly posi-
tioning himself to ensure a seat next to her, so that he could
share her pâté, which she happily passed his way.)

In 1995, at my urging, Clottes and Lewis-Williams initiated
a project that combined Jean's detailed understanding of the
French caves with David's theoretical and interpretative ideas.
They spent a month jointly visiting a series of the major sites
in order to discuss and debate the shamanistic interpretation
while examining the art in question. The result, published the
following year[25] (and in English in 1998 as *The Shamans of Pre-
history: Trance and Magic in the Decorated Caves*), is an argument
that moves beyond the earlier neuropsychological model to
include a series of other features of the sites. While Clottes and
Lewis-Williams stop short of claiming that all Paleolithic cave
art is shamanistic in origin, they provide a compelling case
that some, perhaps most of it, had such an origin.

As with Lewis-Williams's earlier work, his ethnographic
and neuropsychological perspectives inform the argument that
he and Clottes formulated. From this perspective, the southern
African and western North American shamans conceptualized
rock art sites as portals into the supernatural realm. The rock
face, as the veil between the sacred and mundane, parted with
the shamans' entry into an altered state. This allowed them
access to the sacred or, similarly, permitted the spirits of the
other world to slip into ours. In verbal accounts recorded by
anthropologists, Native American shamans, for example,
sometimes describe their entry into the sacred as walking
down a tunnel that has opened up in the rock face.[26]

This cross-cultural conceptualization can be partly explained neuropsychologically in terms of certain visual and somatic effects of trance. A common reaction to an altered state, be it meditative, drug induced, or simply a result of too much alcohol, is the sense of weightlessness and spinning, with visual imagery revolving around the edges of our sight. This is the sensation of a vortex, one quickly recognizable by anyone who has ever, on occasion, drank too much, laid down in bed, and felt the room spin around. Feelings of weightlessness and movement sometimes accompany the vortex, contributing to a belief in a physical shift from the natural to the supernatural world. Anthropologists refer to this cross-cultural theme as "mystical flight." In the 1960s and 1970s, members of my generation referred to drug-induced, altered states of consciousness with the same bodily sensations, using the similar metaphor of a "trip." Certain indigenous, lowland South American groups traditionally use this same linguistic metaphor, by entirely independent invention, to describe their ritual hallucinatory experiences.[27] Today, the term "out-of-body experience" is commonly employed in our culture for the same reaction, especially by those more interested in consciousness expansion than drug-stimulated reverie. But in each case, linguistic metaphors based on bodily reactions are used to verbally describe what, otherwise, is an emotionally charged, yet largely ineffable, experience.

Clottes and Lewis-Williams argued, in essence, that the caves themselves were natural topographic models of the trance experience. As the "entrails of the underworld," they were the vortex that, through ritual trance, the shaman used to access the supernatural. And the fact that sensory deprivation, resulting from isolation in the deep caverns, can easily lead to an altered state of consciousness—a problem that archaeologists working in the caves sometimes confront,[28] and that provided the central tension in E. M. Forster's A Passage to India

(1924)—makes the direct physiological connection between the caves and trance hard to refute.

Evidence of such a Paleolithic belief and purpose could be seen not simply in the art itself, they argued, but also in the relationship between the art and the cave walls.[29] They pointed especially to the use of the undulating rock walls and ceilings, and how these were incorporated into the paintings, as suggestive of the idea that the Paleolithic artists were bringing out what was already present on the far side of the wall: "transforming the given into the created." A curved cave wall, thus, forms the back of a bison, or the velvety flowstone that coats certain areas in caves serves as the throat and chest of a megaceros (an extinct deer). In each case, careful and intentional use of soft light and shadows—as would be provided by the simple pine torch of the early artists—alternately reveals or hides the figures already contained within the supernatural.

Paleolithic art was then, in a sense, "found art." The shaman/artists combined ritual trance with the unusual environment of the caves to find and fix what normally could not be discerned, thus preserving their perceptions, for all of time, of their sacred realm. Yet in certain cases, Clottes and Lewis-Williams carefully pointed out, the art was much more than just a series of single graphic images, made by different individual artists reacting to specific spots on cave walls, during their particular trance experiences. Some sites were true and massive compositions created by groups of artists, presumably following some master shaman's design. These, too, seem to encode a shamanistic view of the supernatural, albeit on a grand scale. This suggests a kind of larger, formal, and group-based shamanistic art that is distinct from that created by the largely individualistic and idiosyncratic shamanistic cultures that we know from historical hunters and gatherers. (The best analogy perhaps is a kind of shamanistic Sistine Chapel, symbolizing a complex mythology, rather than just a single

painting of a saint.) Paleolithic art and religion then appear to have been shamanistic but, in at least some cases, this comprised a kind of shamanism that has no complete analog to the different shamanistic cultures and religions we know from recent times.

I had an opportunity to examine and discuss the shamanistic symbolism of the most dramatic of these cave compositions with Lewis-Williams in 1997, when he, Tamara Koteles Whitley (my wife and fellow archaeologist), and I visited Lascaux Cave. Lascaux is perhaps the most famous and beautiful of the Paleolithic caves. Discovered in 1940, it is renowned for its numerous large (some even life-sized) polychrome paintings of bulls, horses, and other animals.[30] Entry into the painted portion of Lascaux starts in the so-called Salon of the Bulls, a true Paleolithic bestiary. This is a medium-sized, tunnel-shaped chamber that is roughly twenty feet in diameter and about forty feet long. Its walls are covered with paintings, almost all of which are animals and most of which are headed in one direction, down-chamber toward a quickly narrowing, descending portion of the cave known as the Axial Gallery. Included on the walls of the Salon of the Bulls is the famous, if fancifully named, "Chinese horse" (illustrated in almost every historical overview of Western art), as well as more enigmatic paintings, such as the curious straight-horned "unicorn." Careful examination also shows examples of the geometric "signs" of Paleolithic art: the entoptic patterns identified as characteristic aspects of trance imagery in Lewis-Williams's neuropsychological model.

Standing in the middle of the Salon of the Bulls and looking down-chamber, it was impossible not to feel that I was in the midst of a large but strangely silent herd of prehistoric animals that rushed headlong deeper into the cave, carrying me with them into its recesses. And there, in the Axial Gallery where the cave narrows to a shoulder's width and begins to

plunge downward, David pointed to the paintings of animals that literally swirl up and across the cave roof in a constricting spiral, as if they are spinning into a maelstrom. This, he suggested, was a massive painting of the vortex of the shaman's trance, preserved graphically some eighteen thousand years ago, symbolizing that passage into the cave was itself a movement into the supernatural. Perhaps this was intended to help ritual initiates understand what they would experience when they finally parted the veil between the natural and supernatural worlds.

Like all archaeological explanations, David's interpretation of Lascaux can never be proven in the laboratory sense of this term (at least, until someone invents a time machine). But it is scientifically convincing because it accounts for the evidence in the cave and is partly based on universal human reactions to trance that have not changed over time. It is also emotionally compelling. As we turned to leave Lascaux, I looked over at Tamara, who I know to be levelheaded, practical, and not particularly emotive (important personal qualities when one spends much of her time in remote field camps under arduous conditions). Though we have worked together at and visited hundreds of sites all over the world, this was an experience of an entirely different kind. Tears were streaming down her face—an intense and personal reaction to Lascaux and especially to David's interpretation of it.

To be sure, Clottes and Lewis-Williams's shamanistic interpretation explains disparate aspects of this art that, previously, had been thought unrelated or left unexplained (the iconic and entoptic forms as logical and related components of a single artistic tradition, for example). They incorporated details about the placement of individual images on the rock surfaces that had been largely unrecognized or considered simply idiosyncratic (the use of the rock face in the composition of individual motifs). And they treated the caves themselves as large topo-

graphical compositions, thereby pointing to a kind of shamanistic art—and, by inference, religion and society—that may have no precise recent counterpart or analogue.

By all counts, a great time for the study, interpretation, and understanding of Paleolithic art seemed at hand, one made all the more timely by the discovery of Chauvet Cave. For the beauty of the Chauvet paintings certainly rivals those at Lascaux, thereby promoting an international interest in this art and what it implies. Moreover, the immediate and complete protection of Chauvet promised a wealth of archaeological information not previously obtained in the earlier-discovered caves.

But this was foiled, for a time at least, by an onslaught of legal battles. These were prompted, as in most circumstances, by an unfortunate mix of misunderstandings, greed, and sheer ego. And like a bad Hollywood divorce, they were played out in detail in the pages of French newspapers.

CHAPTER 2

INSIDE CHAUVET

The legal and political battles over Chauvet Cave began shortly after its discovery. Following his standard practice, Clottes photographed many of the paintings on his early visits, making duplicates to give to the Ministry of Culture and to keep for personal research purposes.[1] He also removed some charcoal samples for radiocarbon dating. These came back with somewhat unexpected and astonishing results. The art dated to approximately thirty thousand years ago. (Eventually the age of the site, confirmed by additional analyses, would run from about thirty-five to twenty-six thousand years and suggest two different episodes of use.)[2] This was twice as old as Altamira and more than ten thousand years older than Lascaux. Chauvet Cave had art that was not simply on par with the finest Paleolithic examples. It was, by significant margin, the oldest cave art in the world and it dramatically disproved

any contention that our human artistic capabilities had evolved, over time, from simple to complex. When art first appeared, it appeared full-blown in a technically and aesthetically sophisticated fashion.

Clottes's superiors were quick to realize the international importance of the site and what it could mean economically. Unbeknownst to him, they sold his photos to a commercial agency that placed them on the international market for about $90,000 for the set. Fellow French archaeologists soon heard part of this story and, as my daughter might say, went ballistic.[3] Not recognizing that he had nothing to do with the arrangement, nor stood to benefit from it in any way, they viewed Clottes as an opportunist who was exploiting this archaeological treasure for his own financial gain.

The two people most upset by this sale were Clottes himself and Jean-Marie Chauvet. Clottes was distraught partly due to the undeserved grief he received from other archaeologists, who he believed were quick to accuse but slow to retract their charges once the truth about the photos came out. Equally vexing was the possibility that one or more books about the site might appear, using his pictures, written by someone else who had no firsthand knowledge of the cave. The need for a detailed study of Chauvet Cave was obvious; logically, Clottes was the archaeologist who should direct it and then write the definitive book. He did not want someone else using his photos for such a purpose.

Chauvet's reaction was slightly different but equally intense. In his eyes, the cave, in a sense, belonged to him and his two friends by right of discovery. As an amateur but talented photographer, he, too, had a set of photographs from the cave. He felt that Clottes had scooped him by selling the first pictures of the cave. Chauvet thought that if anyone deserved to benefit financially from the discovery, as Clottes apparently had, surely it was he and his two fellow cavers, not

the archaeologist who they had taken into the cave. Chauvet then proceeded to sell his own set of pictures to the photo agency, to ensure that he, too, received his just reward.

Clottes eventually (and after considerable frustration) straightened out the misunderstandings over the sale of his photos with the French archaeological community and with Jean-Marie Chauvet. He also arranged for Jean-Marie's pictures to appear in the first book on the site, published in April 1995, in a French series that Clottes edited.[4] The book is a firsthand account of the discovery by the three cavers with an afterword by Jean that discusses some of the archaeological implications of the find. Though this gave the world a chance to view pictures of the majority of the paintings for the first time, it did little to quell the legal battles that were just beginning to heat up.

The first of these involved local private-property owners. By French law, the site was protected and had to be treated properly, but it belonged to the owner of the land immediately above the underground passages. In theory, at least, the owners had the right to exploit the cave commercially—for example, by charging admission for tourist visits. And with about 1.5 million visitors already coming to the Ardèche Gorge yearly, ownership of Chauvet Cave would be a bit like having a concession to King Tut's tomb located at the entrance to Disneyland. Substantial money was clearly at stake.

The problem was that no one knew who owned the cave. This was partly because it is located on marginal land (a cliff face below a wooded and unoccupied upland area) that had not been used for decades; and partly because, initially at least, no one knew exactly where the cave went underground and whose land it went under. Property and cave surveys, in the context of neighbors suing neighbors, then ensued. Chauvet Cave proved to be owned not by the resident nearest to its entrance, but by a family whose farm was a little more distant and who had brought the suit.

But then the French government moved in. Recognizing the international importance of the site along with the fact that there was no practical way to allow tourism and to keep the cave intact, the government condemned the land by eminent domain. By French law this required compensation to the land owner, but French law also specifies that compensation be based on the assessed value of the land one year prior to its condemnation, in order to avoid land speculation at the government's expense. Based on this formula, the property owners were awarded roughly $5,000 for one of the greatest archaeological discoveries of the century, destroying any dreams they may have had of obtaining a King Tut–like treasure from the find.

Naturally enough, the property owners sued again. This suit was ultimately resolved by the French Supreme Court in the property owners' favor, in light of the fact that condemnation was a result of the discovery and hence compensation could only properly be based on an assessment after the cave was known.

Meanwhile another round of lawsuits ran a parallel course. These involved the French government and Jean-Marie Chauvet and initially concerned the ownership of the pictures he had taken and then personally sold to the photo agency. Chauvet had taken these on his weekend trips into the cave, using his own personal equipment at his own expense. But he also worked for the French Ministry of Culture as a local archaeological park ranger. The ministry contended that it owned Chauvet's photos partly because he was its employee. Perhaps not surprisingly, Chauvet disagreed.

Complicating the circumstance was the fact that, shortly after the discovery, Chauvet received a small stipend—about $800—from the ministry to cover some of the expenses he had incurred in finding and opening up the cave. He had, for example, purchased and then laid down rolls of black plastic

sheeting on the path through the cave, to protect the surface evidence from harm. The government felt that this arrangement established its claim to his pictures.

Chauvet soon countersued and, in fact, brought criminal charges against the ministry officials. He alleged that he had never asked for the stipend and that, though he did receive it, the paperwork had been backdated so it appeared that it was issued prior to the cave's discovery. He charged the officials with falsifying official documents; charges that they vehemently denied.

The suit, countersuit, criminal charges, and investigation, as might be expected, were carefully covered by the French media, for here was an apparent mix of archaeological treasure and potential government corruption that guaranteed headline news. (It is refreshing to see a nation whose interest in public scandal runs more toward archaeological controversy, rather than our American obsession with the private, usually sexual, missteps of public figures.) Dénouement did not occur, however, until Jean Clottes was called to testify. Under oath, Jean stated that he was present, on the day of his first entry into the cave, when Chauvet himself requested the stipend from the ministry officials. Chauvet had in fact asked for money to cover his expenses, and, in essence, the government had paid for the photos. But the paperwork for this payment had also been backdated by the officials, Jean testified, and they were guilty of falsifying official documents. Jean's testimony pleased few people involved in the case.

Except for the newspapers. The headline the next day stated simply:

JEAN CLOTTES TELLS THE TRUTH

The battle for Chauvet Cave had been won, and, in most cases, also lost by almost everyone involved.

INTO THE CAVE

The archaeological study of Cha uvet Cave was delayed for about three years due to these legal controversies. Following an international competition conducted by the French government, Clottes was awarded direction of the project in 1998. This was due in part to his research record and professional stature. But he had also assembled a team of very talented French archaeologists to work on the project with him and had further created an international research advisory committee to consult on the work, making his research proposal unassailable. I was invited to visit the project and see the cave firsthand as a member of this committee—an opportunity of a lifetime since entry into the cave is otherwise restricted.

I arrived in May 2000, at their field headquarters. This was a recreational sports camp with dormitories, a cafeteria, and a computer lab that they lease for their biannual, two-week-long seasons of research. Along with me were two other American members of the advisory committee, Jim Keyser, then regional archaeologist for the US Forest Service who works out of Portland, and Larry Loendorf, a retired professor from New Mexico State University. The otherworldly tenor of our visit was established the moment we arrived. Unknown to us at the time, a French documentary crew was filming the project and, because they could not at that time enter the cave, they concentrated on shooting everything that occurred outside of it. One of my books had just been published that month in France, and the film crew recognized me from my cover-sleeve photo. As soon as I stepped out of our car, I came face-to-face with the Betacam version of cinema vérité. (Somewhere in France there is now a stack of video cassettes that recorded every moment of our visit, except for our time in the cave. I have strong reservations about the historical value of this material.)

The next morning, we headed to the site, a fifteen-minute

drive from the camp and a half-hour hike up a steep wooded cliff-slope, closely followed at each step by the film crew. Though the path up to it is little more than an unimproved animal trail winding through the woods, the cave entrance itself has been heavily modified. Helicopter airlifts were used to supply and support the construction of state-of-the-art entry and security systems, stainless-steel walkways, and atmospheric monitors inside the cave. Because these require electricity, a small workshop was also built in an adjacent rock shelter for equipment maintenance and, since this was wired for power, a coffeemaker and a microwave oven were brought up for crew comfort. It was a far cry from the dry and desolate desert field camps that I am accustomed to. But then so was the site itself.

Jim, Larry, and I (the three Americans) entered the cave through a kind of space-age bubble chamber (fig. 6). Its heavy, stainless-steel door only opens when one of three selected crew members place their registered palm against a sensitized plate that reads the handprint and pulse (presumably pulse is measured to ensure that one of the programmed palms isn't cut off and used, owner unattached, to gain illegal entry into the cave). James Bond–like effects aside, the irony of this security system was immediate: Chauvet Cave, like many rock art sites worldwide, contains a series of painted palm prints. We believe that this reflects a concern with touching the sacred, symbolized by the rock surface, and a common human desire to make the abstract and ineffable more concrete and tactile. Even with our most advanced computer technology, we apparently haven't lost this human impulse to touch. I couldn't help but think how this contributed to the feeling that I was entering a true shrine to prehistory.

Once inside the bubble chamber we suited up into helmets, lights, overalls, and rubber shoes and crawled on our hands and knees down the original seven-yard-long chute,

Figure 6. Larry Loendorf (left) and Whitley emerging from the modern entry to Chauvet Cave, May 2000.

now enlarged, to the vertical drop into the cave, serviced by a permanent ladder bolted onto the rock wall. This led to a landing platform and a series of metal walkways that headed off into the coal black depths of the cave. Probably better than anything else, the infrastructure illustrated the French long-term view of their actions: all of the walks and landings are made of stainless steel to avoid any kind of corrosive action that might emit gas and affect the environment of the cave and the preservation of the art. The paintings have lasted for over thirty thousand years; the French have every intention of ensuring that they last at least this much longer.

Jean led us on our first visit into the cave, walking us through the different chambers and galleries to view the known panels of art. We stayed on the walkways, which followed the original trail of Chauvet and his team into the cave in order to preserve the pristine state of as much of the groundsurface as possible. So far, all archaeological work had also been limited to the immediate edges of these walks. Once the work was completed along these verges, access would be expanded outward to other areas of the cave. In the meantime, there were many areas, including one of the most magnificent panels of paintings, that had only been studied from a distance.

And what initially impressed each of us, as archaeologists first and rock art specialists second, were the preserved remains on the floor of the cave that this meticulous approach had been safeguarding. We had, after all, seen pictures of the art itself and we were more or less prepared for it. What we saw on the ground was another matter entirely. Skeletons of gigantic, extinct cave bears were, seemingly, everywhere, as were their tracks and dens—large saucer-shaped depressions in the earth. At one point, I stopped to examine one of the bear tracks, spreading my palm and fingers above it to gauge its breadth. (I felt kinship with the Paleolithic painters immediately in my urge to place my hand directly against the print, just as the

painters had left their prints on the cave walls; an urge that, in the interest of science, I resisted.) It was roughly nine inches wide. These were huge animals (larger than Kodiak bears), or at least many of them were. Before long I began to notice substantial variations in the size of their skulls—large ones, medium ones, even a few that were obviously juvenile—contradicting my assumption that the skeletons represented bears that had died from old age during hibernation.

Apparently not so, explained Michel-Alain Garcia, who was recording and analyzing the prints in the cave—and there are hundreds of them, reflecting the pristine nature of its floor. Many of the bears suffocated during hibernation due to the buildup of carbon dioxide in the cave. Although there was some atmospheric exchange with the outside, it was slow, inefficient, and led to dangerous conditions. By the end of a two-week field season, the French crew had to be very careful in certain areas of the cave where the gas built up, working only in pairs, for example, and never lying down on the floor in those areas. Most of them still walked away with headaches by the end of the day; many of the bears clearly suffered from more than head pains as a result of their winter residence in the cave.

We had found Michel-Alain lying on the cave floor recording a wolf print near the Panel of the Horses, which was located toward the far end of the cave. His interest in animal tracks was a natural offshoot of his expertise with Pleistocene fauna. As an extremely talented illustrator (and painter), he has drawn the authoritative skeletal reference guide to these extinct mammals. (This combination of artistic and technical-scientific skills, rare in an American team, proved to be particularly characteristic of the French archaeologists.) Perhaps more interesting than the animal traces that he studied is the track of human footprints that were discovered the previous year—the oldest known footprints of an anatomically modern human (older African prints are known but they are from earlier species of hominids).[5]

Based on comparisons with modern European populations, Michel-Alain interpreted these as the tracks of a child, estimated to be about eight years old and roughly four feet three in height; judging from the length-to-width ratio of the foot, it may have been a boy. Torch marks along the ceiling followed the path of the prints and were likely a result of the child's visit; the charred wood on a pine torch must have been periodically scraped off to keep the fire burning brightly. A radiocarbon analysis dated one of these torch marks to twenty-six thousand years—roughly thirteen hundred generations back. Perhaps most intriguingly, the prints were in one direction only, and they led from the current back toward the front of the cave.

This fact has helped to crystallize a series of debates among the French crew. The cave is currently about five hundred yards long as measured in from the cliff face. It stops at a calcite barrier at the end farthest from the modern entrance; it is possible that this has blocked off what was once a more extensive cavern. But more important, the cave seemed to divide naturally into two parts: the front, which was dominated by red paintings; and the rear, which contained mostly black images along with the boy's prints. Whether these two halves were connected prehistorically is not yet clear; the current passage between the two is a low opening that may have been blocked during the Ice Age. Was there a back entrance used twenty-six thousand years ago by the boy? Some of the crew favored this interpretation, but if so, it was a largely vertical entrance that would have required a descent of about sixty yards down from the top of the plateau above.

An equally pertinent question was the reason for the child's visit. This was not the first human print, nor the first child's print, that had been found in a Paleolithic cave. Their occasional discovery in different caves has led many archaeologists to conclude that the sites may have been used for initiatory rituals and, from the shamanistic perspective, perhaps for vision

questing. But Michel-Alain, who is himself an avid recreational caver, argued otherwise. For him, it seemed more likely that the child's visit to the cave was motivated by the same emotions that brought him to caves when he was not working. This is the feeling of adventure gained by wandering through these underground wonderlands—a sense that, he suggested, is particularly strong among youngsters. Moreover, Michel-Alain felt that the tracks of children's prints were overrepresented in the preserved examples "because youths take untypical paths where their traces have less chance of being obliterated."[6]

We probably will never be able to decipher the motivations of individual prehistoric peoples, of course, and we may never know what brought this child into this cave twenty-six thousand years ago. But that some of the art (and therefore prehistoric activities) in Chauvet Cave was ritualistic in origin was undeniable to other members of the team. Notable in this regard were three large panels located near the front of the cave (roughly fifty yards in from the cliff face and the presumed original entrance) that seemingly consisted of nothing more than painted red dots. These were recorded and studied by Dominique Baffier and Valérie Feruglio, yielding, like many things at Chauvet, somewhat unexpected results.[7]

Dominique was, after Clottes, the most experienced member of the team. She started her archaeological career as an assistant to Leroi-Gourhan and knew his structuralist interpretation of the caves in detail. Still, she has not especially pursued his interpretation in her own subsequent research. When not at Chauvet, she recently has been working at the cave of Arcy-Sur-Cur, where she has been slowly grinding down thin layers of calcite to reveal a series of painted mammoths that, previously, had gone unrecognized in a cave thought to lack art. To call her work meticulous is a gross understatement. Valérie is a young woman, who, like Michel-Alain, is an artist in her own right. She divides her time working as an archaeo-

logical illustrator and a Web-page designer at her home out-
side Paris (fifty meters outside Paris, she told me), with
research at Chauvet, in Niger (where she has assisted Jean in
the recording of a series of very large and now world-famous
engravings of giraffes), and at Canyon de Chelly, Arizona, with
my fellow visitor Larry Loendorf.

Dominique and Valérie recorded two of the panels of red
dots by first photographing the images, then digitally enhancing
and enlarging them, and finally by making tracings off the dig-
ital images on clear plastic sheeting while at the panels them-
selves, in order to field check their work. What this slow process
revealed was that these were not dots at all, but instead slightly
faded palm prints. (Other panels at Chauvet had a few easily rec-
ognizable handprints, in the normal sense of this term, but not
grouped in the numbers or fashion of these three panels.) Digi-
tally enhanced examination of the "dots" revealed traces of the
finger and thumb marks that weren't immediately discernible to
even fairly careful but technologically unassisted visual exami-
nation. Moreover, the two archaeologists determined that all of
the prints on each of two of the panels were themselves created
by two separate individuals; one probably a woman or a youth
and the other by a relatively tall man, about five feet eleven,
whose little finger consistently curled inward.

I asked Valérie for her reaction to these two panels of
prints. "If the purpose is just to cover the rock surface in red,"
she told me, "it is far simpler to coat the rock with ochre. If the
purpose is to make dots, I guess it is simpler to take the paint
and apply it with the fingers or rub it on with the fist. So the
action of coloring the palm of the hand and putting the hand
on the wall is the purpose—the action is what is important
and leaving the proof of it on the wall is important too."[8]
Repetitive ritual process and behavior was the likely origin of
these "dots" in other words; certainly not art for art's sake, nor
some desire just to coat the rock surface.

We also spent part of a day with Jean-Michel Geneste, who gave us a tour directed at the archaeological finds on the cave floor that he was studying: fire hearths, dropped stone tools, even natural concentrations of floral remnants (leaves, twigs, branches) that appear to have, somehow, washed into areas of the cavern tens of thousands of years ago through some opening that has been now lost. Jean-Michel is the curator at the famous site of Lascaux and he was Jean Clottes's second in command at Chauvet (he has now taken charge following Jean's retirement). A middle-aged man, Jean-Michel has a bit of the look of a poet about him, with a bushy mustache, deep-set eyes, slightly long, wavy, and graying hair, and very softly spoken but fluent English. When not working in France, he has been excavating Paleolithic sites in the Ukraine and, recently, China. He showed us massive hearths, about five feet across, that were filled with log-sized chunks of charcoal, which were over thirty thousand years old. He believes the wood was brought in and the fires started in these hearths not for purposes of light but to make the charcoal that was used for the black paintings. Next to one of these fire pits, careful examination revealed the sharp end of an ivory spear tip that, when exposed by a brush, was roughly eight inches long. Elsewhere in the cave, as we followed along the walkways, we saw occasional small paper triangles on the floor, about an inch in length. Each of these marked a spot where Jean-Michel had identified and mapped a small flint tool or tool fragment, dropped by one of the prehistoric users of the cave.

Two areas in the cave seemed more exotic than the paintings, perhaps because I could only interpret them as some kind of shrine. (The French crew was admittedly less eager to label these features with this interpretive label.) Both were in locations where the cave floor was covered by hard layers of calcite. We took off our shoes and, carefully following Jean-Michel's footsteps on this hard rock surface, safely left the walkway for a closer look.

One of these is called the Cactus Gallery. It consisted of a small alcove dominated by a large, saguaro cactus-shaped stalagmite. (Stalagmites grow from the ground upward due to drips of calcium carbonate-rich water from the ceiling above; stalactites, their analogue, are the icicle-like growths that develop from the ceiling downward. I have always used the mnemonic "G for ground, C for ceiling" to keep the two straight.) Surrounding the unusual stalagmite was a series of large, flat stones that were positioned vertically, on edge, to essentially box it in. There was no question in my mind that this was the result of human agency; gravity alone would prevent flat, thin rocks like these from naturally accumulating in such a precarious and obviously nonrandom fashion. Small, worked flints within this "shrine" provided further evidence of human activity at this location.

A second possible shrine area was located further into the cave, near its current furthest limit. It was found in the eponymously named Cranium Salon and it was marked by an almost square, natural block of rock with an adult bear skull placed on top. Two circumstances made this particularly impressive. The altarlike natural block (which presumably fell at some point from the ceiling) was sitting in the middle of a relatively large, open chamber and was thus essentially the center of this open area. And, as if drawing attention to this fact, a series of smaller animal skulls was present on the cave floor, seemingly in four lines meeting at the central block, as if to create a kind of cruciform design. Whether human agency was responsible for the creation of this array of skulls is uncertain, but certainly possible.

Equally undeniable is the fact that we have no idea why this arrangement of natural objects was made or how it, like the Cactus Gallery, may have been used. Indeed, it is not at all certain whether these even were shrines—special areas where rituals are conducted—in our sense of this term.

AND THE CAVE INTO ME

The focus of our time spent in the cave was of course on the art; partly because the art is what makes this cave so important and partly because Larry, Jim, and I are primarily rock art specialists. Indeed, I couldn't help but feel a bit of personal serendipity as Jean Cl ottes led us through the cave. I had decided to focus my archaeological career on rock art when, as a twelve-year-old, I made my first visit to a Paleolithic site, the cave of Niaux in the French Pyrenees. (I admit to having sometimes wondered, as I've gotten older, whether twelve years of age is a good point at which to make a major career decision.) What I could not know at that time was that Jean eventually would do the primary research on Niaux and become the authority on it and that ultimately we would become close friends and colleagues.[9] My tour through Chauvet with him seemed to complete a circular path of coincidences that I had started down thirty-five years earlier.

And my first reaction to Chauvet Cave was much like my feelings in the other Paleolithic caves that I have visited—an internal struggle between my response to the art and to the geological caverns themselves. I find it difficult not to be overwhelmed by the natural splendor of these caves—they make me feel as if I've fallen, head first, into a pirate's treasure chest full of gems, jewels, gold doubloons, and silver *reales*, each piece sparkling more brilliantly than the last. This quality is the natural result of the crystalline and multihued calcite coatings that develop on their natural rock surfaces. Tellingly, the vocabulary that is used to describe these natural formations and deposits, even in the dry descriptive dialogue of scientific journals, shares little common ground with the otherwise standard, workmanlike, and earthy jargon of geology. It must turn instead to far distant crafts, like tailoring and costumery, to describe the otherworldly creations that one finds in these

subterranean chambers. Hence, a term like "drapery" is employed to describe the softly undulating sheets of calcite that sometimes develop and hang—well, like a curtain or a drape—from the ceiling. There is a visceral sensuality to these caves that I have never found aboveground that seems to defy scientific terminology.

But this emotional reaction is discomfiting; it makes me feel like a traitor to archaeology because, as a rock art researcher, I think I should always be overwhelmed by the art, not by mere geology. I struggle between what my emotions seem to tell my mind and what my mind says that I should feel. My days in Chauvet Cave were no different in this regard, as I constantly felt unbalanced by the geological versus the artistic beauties that surrounded me. And maybe, it occurred to me, this is partly what this cave is all about—a tension between the beauty in the world around us and the world that we, as humans, try to create. Maybe the lesson is that one of these doesn't have to be better, or more important, or more beautiful than the other. Maybe the lesson of Chauvet Cave is that these two types of beauty can in fact coexist perfectly—in this case for over thirty thousand years—and that each informs the other (something that painter Henrí Rousseau and his modern eco-primitivist counterparts might have trouble conceding). Maybe the lesson is that, always, we struggle between our emotions and our reason (something that philosopher René Descartes tried to set in opposition but, I think, got wrong).

Or maybe the lesson simply is that, often, my senses are confused when I am around great beauty and I struggle to make sense of it and what it means to me.

Like no other place that I have ever visited, Chauvet Cave epitomizes that murky nexus between art and belief, and emotion and rational science, a nexus that in my research I have attempted to conjoin and to understand. And though aspects of the science of Chauvet seem partly clear—at least some of

this art is shamanistic in origin—the other elements of this nexus continue to elude full explication.

That the art is at least partly shamanistic became apparent when Jean took us to a small panel located near the back of the cave where a column of natural limestone hung a few feet down from the cave ceiling. Painted in black on this pendant column was a single, clear image of a human, only it was a human partly transformed into an animal: upright and bipedal but with the head and horns of a large bison. The Chauvet crew referred to this painting, not surprisingly, as the Sorcerer (an alternative, if somewhat medieval, term for shaman). But the important point about this image is not the name it has been given, but instead its combination of human and animal features. This is a particularly common trait of shamanistic arts; a trait that some, like mythologist Joseph Campbell, attributed to universal Jungian archetypes and/or some putatively deep and unexplained ritual connection between hunters and prey.[10] Our current explanation of these human-animal conflations, in contrast, is neuropsychologically based.[11] They derive from universal attributes of the bodily effects of trance: tactile hallucinations on the skin that are frequently likened to the growth of fur, for example; wider feelings of bodily transmogrification; and the psychological sense of becoming what one is imagining—in this case a bison.

There are other aspects of the art in the cave that seemed to complement the shamanistic origin of the Sorcerer. Some of these fit specific predictions of David's neuropsychological model. A black rhinoceros was carefully drawn in anatomically correct profile, for example, but its head was superimposed against a replicated series of larger and smaller heads and horns—the kind of fragmentation and duplication of mental imagery that occurs during trance. A bison was painted with eight legs, perhaps reflecting the sensation of extra appendages that can occur as a bodily hallucination. The curve of the cave

wall was used as the back line for an ibex and, in another spot, a horse, as if the animals were really part of the rock surface and the shaman had, as Jean and David argued, "transformed the given into the created."[12] Seemingly random painted geometric designs—the entoptic light patterns experienced at the beginning of trance—were scattered in and among the recognizable animal images. And while alternative explanations could be proposed for each of these paintings and features, no interpretation but shamanism can account for all of them and other features like them found at the site.

For some, it is hard to reconcile the notion of hallucinatory imagery with the technical sophistication and aesthetic appeal of this art. Great art seems inimical to the mental confusion brought on by an altered state of consciousness. It is great art, certainly; on that point there is no debate. Valérie Feruglio, as a graphic artist herself, seemed to appreciate this fact best among the French crew, in part because her work recording the images allows her to recognize the complexities and subtleties of the artists' drafting process.[13] As she explained, "What I like most working in the cave is when I'm not far from encountering the artists; when I can feel them inside a line; when I can feel a slide of their tools or their tricks for better aesthetic results." In our discussions, she compared her favorite image in the cave, a small rhinoceros, to an original Leonardo da Vinci drawing that she had recently seen. "The emotional effects of the two are quite the same," she told me, "coming from the summary of some of the lines, and the play between the hard lines and the soft ones." And, as she further pointed out, correcting a mistake while making a cave painting is difficult to do, emphasizing even more the skilled hands of the prehistoric artists.

Valérie, in fact, finds no contradiction in the notion of shaman/artists, and is pleased with the shamanistic interpretation because she finds it more humanizing than the sterile sta-

tistical summaries that, previously, had been substituted by French archaeologists for interpretations of the art. But the idea of great art inspired by trance remains a notion that troubles critics—a fact that always reminds me of an attorney friend who is a closet "Dead Head." He collects rock and roll memorabilia and has a special interest in the psychedelic posters printed in the Haight-Ashbury district of San Francisco during the 1960s counterculture era, which he now actively trades on eBay for substantial sums of money. While I do not propose that his posters are aesthetic masterpieces on par with the paintings in Chauvet (he might disagree), they do display technical sophistication and compositional skill with marked artistic appeal. And they are undeniably inspired by hallucinatory experiences as are, potentially, the paintings of other artists who in fact are acknowledged as great (Vincent van Gogh comes first to mind). Indeed, contemporary British/California artist David Hockney is well known among neuropsychologists as a synesthete—someone who experiences spontaneous synesthesia (confusion of the senses), a characteristic of many trance experiences—and for his ability to tap his synesthesia to further his creative processes. Although I discuss this point in more detail subsequently, shamanistic trance as the origin of the Chauvet paintings is an argument concerning the source of artistic inspiration, not about drafting skill.

Moreover, there is a widely overlooked connection between shamanistic trance and contemporary art theory, and thus modern art itself. Russian artist Wassily Kandinsky, a founding figure of the abstract art movement, is well known for his paintings, of course, but also for his central involvement with the Bauhaus movement in the 1920s. His writings on art theory (especially *On the Spiritual in Art*, published in 1911) emphasized the need for artists to seek their inspiration internally rather than to look to external models, such as

nature, and he shifted in his own work toward increasingly abstract imagery—an art without subject matter save for lines and colors and their relationships. Kandinsky, like Hockney, was said to be a synesthete, with colors yielding especially strong emotional responses.[14]

Less appreciated are the influences that entoptic forms and Siberian shamanism had on Kandinsky. Prior to writing *On the Spiritual in Art,* he spent time in Siberia with Russian ethnographers working with shamans and learning about the shamans' concern with the centrality of inner visions. This clearly affected his thinking. It could be argued that Kandinsky influenced the development of contemporary abstract art largely through a rediscovery of the kind of artistic inspiration experienced by shamans in Chauvet Cave over thirty thousand years ago.

Despite the likely hallucinatory origin for the Chauvet art, an intentional structure to their layout also seemed possible, and this made me think of Leroi-Gourhan and his earlier structuralist interpretation of Paleolithic art.[15] Compositional intent at Chauvet was suggested most strongly by the two main concentrations of paintings, both located toward the rear of the cave and called, respectively, the Panel of the Horses and the Panel of the Lions. What unites them is not their overall imagery. As their names imply, the first was dominated by a series of horse heads, arranged in near-vertical echelon, with a variety of other animals (rhinos, aurochs, ibexes, etc.) nearby. The second had a large number of lions accompanied by rhinos, a mammoth, and other creatures. But each concentration was spread on either side of similar, very distinctive, and natural features in the cave walls. These were clefts or niches, naturally shaped like an inverted V, roughly six feet high and four feet deep, with undulating walls. Painted slightly off-center in each was a single horse, as if moving from right to left. And each horse, when viewed from directly in front,

seemed literally to be walking out of the cleft in the wall—emerging through the parted veil that separated the interior of the cave from the interior of the rocks themselves. It was a stunning and magical visual effect that no photograph could possibly capture.

Larry, Jim, and I experienced the power of this composition first at the Panel of the Horses where I was, upon first sight, left slack-jawed and slightly dumbfounded. Jim, a sober scientist not particularly prone to flights of fancy, unknowingly came to my rescue: "My God," I remember him exclaiming, "if this isn't sexual symbolism, I don't know what is." For there, at the base of the vaginally shaped cleft (with its undulating folds there is no other way to describe it) was a blood red deposit of clay, the existence of which reflected the fact that this spot was one of the seeps in the cave—places that, about eighteen hours after it has rained outside, start to weep water, like small springs. This is due to percolation through the limestone rocks. I had been reluctant to state the obvious; Jim was less reticent in voicing what we all thought.

And at the Panel of the Lions, which Jean took us to next, this same performance—for that is the only way that I could react to it—repeated itself. There the red clay stained the wall of a very similar cleft, rising up as if to obscure the legs of another horse. Perhaps because of this fact, this painted horse seemed to float, ethereally, as I moved back and forth in front of the cleft to gain different perspectives on the panel. To this day, my time in this part of the cave has the quality of a dream—a reaction that has prompted me to verify my visit there with my friends.

The Salon of the Bulls at Lascaux had always been my favorite rock art gallery, because it is so monumental, so over-powering, and so strong. I always have felt that it sucks you along, deeper and deeper into the cave, with the rush of the wild herd that seems to surround you. You have little choice

but to surrender to it; to become a part of it as it moves ahead and then swirls over the roof, enveloping you in a whirlwind of power and forces. But the two horses in the clefts at the Panel of the Lions and the Panel of the Horses at Chauvet are another thing entirely that, in their simple and elegant and understated way, challenge Lascaux's greatness. Instead of forcing you to become a part of the herd, at Chauvet the horses approach you, slowly, oblivious, and unmoved by the lions, rhinos, and other animals surrounding them. At Lascaux, the animals move away from you in a fury; at Chauvet, they come to you in a stately and unhurried pace. One is a Beethoven symphony that wraps you up in its power and controls your emotions, moving you by its volume and force and majesty. The other is that single, flawless woman's voice singing a simple melody that you hear inadvertently, through an open window, above the soft sounds of the birds and the crickets, accompanied only by a gentle spring day. Did you hear it for a moment? Or was it instead some phantom, a trick of your mind? Yet it sits in your memory and you cannot forget its melodic line and it haunts you, again and again and again.

Lascaux is a force of might; Chauvet is a state of grace. Which is more beautiful? I do not think that I can ever know.

And so, before we left the field camp at the end of our visit, I spent time talking with the French crew, attempting to obtain some insight into their feelings after three years of seasonal work at the cave. Like all scientists grappling with an intangible, I again fell to the comparative method and asked them to use a known phenomenon, Lascaux, to measure and calibrate and evaluate Chauvet, the new and the unknown. But Valérie, as an archaeologist and an artist, quickly saw through my scientific ruse: "Maybe it is true," she said, "that the vibration of the wing of a butterfly can cause a typhoon thousands of kilometers away, and that one ton of TNT will only make a 30 meter deep hole. But the comparison between Chauvet and

Lascaux is impossible; there is nothing to compare. They are like two different kinds of emotion, or one force coming from a butterfly wing and the other from one ton of TNT. Who can compare Leonardo and Monet? It doesn't make sense."[16] To the philosopher of science, Valérie's argument about the aesthetics of these two caves is one of incommensurability; her reaction was not far from my own.

I was saddened to leave Cha uvet Cave, but I was quite happy to lose the film crew, who had followed my every step, pointing a Betacam in my face each time I turned around.

DEEP CAVES, DEEPER MEANINGS

That the art in caves as different as Chauvet and Lascaux could reasonably be interpreted as shamanistic in origin, despite the outward aesthetic distinctions that Valérie emphasized, is no small conclusion. As Jean Clottes has repeatedly pointed out, this speaks to the fact that Paleolithic art reflects an extremely long cultural, artistic, and religious tradition—one that lasted for more than twenty thousand years.[17] Yet the observable differences between these two caves also imply that this tradition was dynamic and vibrant (as Jean understands), not simply an unchanging and monolithic one that was fully equivalent to the shamanism that we know from recent traditional cultures. Indeed, the shamanism of Paleolithic western Europe appears to have been a kind of shamanism that was in many ways unlike the individualistic practices of the Native Americans that I have studied for two decades, even if it, too, was ultimately based on individual experiences in trance.

What does this tell us about the origin of belief? To the degree that Chauvet Cave may reflect the earliest expressions of religious practice (admittedly always an uncertainty, given that earlier rituals that left no physical traces cannot be ruled out),

it was a practice that looked inward rather than outward, regardless of the seeming emphasis on the natural world in the resulting art and the realism of its imagery. This was not a religion of nature—painted on the cave walls were animals that were likely of the mind more than of the Ice Age steppe. To the degree that these Paleolithic artists sought to touch the faces of the gods, they apparently looked into themselves to find their deities, not to the world around them. I wonder if, thirty thousand years later, we are really all that much different.

But this is just a small beginning in any effort to understand this art and the beliefs and practices once associated with it, and, even more, the people responsible for creating it. With Leroi-Gourhan, I cannot help but wonder about the centrality of the horse in this apparently shamanistic art: Why? And, of course, what did the horse mean?

Perhaps surprisingly, this is a question that only occurred to me after the emotional experience of seeing the Panel of the Horses and the Panel of the Lions at Chauvet. This is probably because my wife and daughter are serious riders who spend more time at stables than stores; because our house is filled with saddles, boots, ropes and tack of every possible kind; and because, when I am not in the field, my evenings and weekends are spent riding and tending our horses. Because of this interest, Jean Clottes has, on his visits to our home, always brought my wife and daughter horse-related memorabilia from the Paleolithic caves: there is a picture of the Panel of the Horses in Carmen's room; there is a replica of an ivory horse carving that was found by Jean at the cave of Enlene—one of the Volp Caves, discussed subsequently—on our mantle. But horses had always been to me something that (as a male) you rode, used, and appreciated, much like a great camera or a favorite tool, but otherwise ignored emotionally. This is in sharp contrast to the central emotional attachment the women in my house place on these large creatures, who they view as

members of our family. Chauvet Cave changed my perception. The horses there were clearly central to Paleolithic ritual, belief, and emotion, and they simply cannot be ignored in the fashion to which I had become accustomed. I have wondered, ever since my visit, why they were so central to our ancestors' early beliefs.

A few months after my return from Chauvet, I walked across UCLA with my wife and daughter, on our way to a basketball game. We had parked at the north end of campus, partly to avoid the postgame traffic jam and partly to stroll through the Franklin D. Murphy sculpture garden on a sunny day. As we headed down to Pauley Pavilion, we happened into a sculptural installation in the sunken courtyard of Rolfe Hall; one that had been added sometime after I graduated from the Anthropology Department there three decades ago. It is *Stephanie and Spy*, by Robert Graham, a replicated series of bronze sculptures of a lithe, naked young woman, each standing upright, mounted on high pedestals, ringing the courtyard. In the middle of this concentration there is another bronze figure, again on a pedestal. And it is a horse; a horse surrounded by a field of young women.

The imagery of Chauvet Cave—the horses emerging from the vaginal-like clefts at the Panel of the Horses and the Panel of the Lions—came immediately and forcefully to my mind. "I've got to come back and take pictures of these sculptures; they remind me perfectly of Chauvet Cave," I remember saying. "But what is this thing about women and horses?" I added, still perplexed.

Carmen, twelve years old at the time, seemed to know the answer instinctively. "Dad," she said, "it should be *obvious* to you by now. Women have always been connected to horses, even during the Ice Age. You guys just don't get it."

Perhaps Carmen is right; perhaps we share more with the

shaman/artists than the neuropsychological effects of trance and a perpetual concern with touching the sacred. But Chauvet Cave alone may never give us a certain answer to these questions. Like all great archaeological sites, it is as much like a box full of questions as a cave filled with answers.

PART II

CÔA AND THE COSO CONNECTION

CHAPTER 3

THE DATING GAME

D espite the dramatic dark-zone setting of Chauvet Cave, archaeologists have long known that some Paleolithic art was created in the open-air. Cap Blanc, France, for example, includes a series of magnificent low-relief horse carvings on the back wall of a very shallow rock shelter. Visible from outside, these have been known since the early twentieth century.[1] Yet few archaeologists fully appreciated the significance of open-air Paleolithic art until the discovery of the rock engravings (or petroglyphs) in the Côa Valley, northern Portugal, in the early 1990s.[2] Certainly no archaeologist could forecast the controversies that this discovery would unleash—controversies that make the battle for Chauvet Cave seem tame in comparison. Indeed, the two ensuing controversies arguably helped change the Portuguese national government. They also derailed what was then one of the most productive areas of

ongoing rock art research: the dating of the art, especially the dating of engravings found in open-air settings.

Widespread concurrence on the Pleistocene age of the French and Spanish cave paintings developed by 1902,[3] and the evidence for this early age assignment was compelling. This started with the subject matter of the art itself: Ice Age animals, certain species of which suffered extinction at the end of the Pleistocene era. Many of the paintings also bore striking stylistic similarities to small examples of engraved art (stone plaquettes and bone and ivory carvings of various kinds) recovered from excavated archaeological layers of known antiquity. This suggested that the cave and the portable art were similar in age. Other paintings displayed soft-tissue anatomical details of Ice Age animals that were only verified after the discovery of the paintings and could not have been known by modern forgerers.[4] And still other sites—like Chauvet and Cosquer Caves—had been sealed and/or were inaccessible for the last ten thousand or more years, guaranteeing the authenticity of their art.[5]

That this art was Paleolithic in age—falling somewhere between ten and thirty-five thousand years old—was then well established. But where individual sites sat within this lengthy continuum was less certain and more subject to debate. Advances in the 1980s and 1990s in chronometrics—the age dating of materials using scientific analyses—provided a new way for archaeologists to verify and significantly refine the initial age assignments. The most important and best known of these techniques is radiocarbon dating, partly because its applicable time range covers the last fifty thousand years, the primary period of archaeological (as opposed to geological) interest, and in part because it has been developed for over a half century, making it acceptably reliable.[6] Radiocarbon dating is employed to date organic matter, especially charcoal, but also bone, shell, and similar organic remains. It potentially

can be used for paint, which was typically made by mixing a dry pigment (or colorant) with a liquid medium (or binder). A particularly common paint mixture found in rock art worldwide combines ground red ocher (a natural mineral) with water. While this produces a durable red paint, there is an absence of any organic ingredients that precludes radiocarbon dating. But if either the pigment or the binder contains organics—such as charcoal in the pigment (common in black paint) or blood or urine in the liquid binder—radiocarbon dating is, at least theoretically, possible.[7]

Radiocarbon dating (like all scientific techniques) has its limitations and, until the mid-1980s, these effectively prevented its application to cave paintings. The most important of these involved the required size of the sample to be dated, which demanded several grams of organic material, or significantly more than could possibly be extracted from a single cave painting, except by destroying it. What made radiocarbon dating useful for rock art research was an improvement in the means for calculating a sample's radiocarbon content, and thus age. This involved the use of a highly precise nuclear accelerator-mass spectrometer to determine the constituents of the ancient organics. So-called AMS (accelerator-mass spectrometer) radiocarbon dating reduced the required sample size a thousandfold, from over a gram using the traditional measuring devices to less than a milligram, and improved the statistical accuracy of the calculated date.[8] Use of this technique on very small samples of black paint at Chauvet and other Paleolithic caves has yielded our current suite of chronometric ages. These dates, among other things, establish Chauvet as the earliest known example of cave art.[9]

Dating open-air petroglyphs presented a different series of technical issues. These concern the fact that the creation of engravings was a subtractive rather than additive process. A prehistoric artist created a petroglyph by chipping away a line

or image on a rock surface, in essence leaving nothing material behind, save for an empty (patterned) space. Chronometric dating in this case had to assay the natural changes in the engraved or pecked-out rock surfaces after they were created, instead of evaluating, as is more typical for archaeology, the remnants left behind.

Initially the differences between dating paintings and engravings were not problematic, at least in terms of investigating the origins of art, because open-air art seemed to play little part in the story. All of this changed with the discovery of the Côa engravings[10]—and, with this discovery, the scandal involving petroglyph dating that ensued.

OLD ART IN *PLEIN-AIR*?

The Côa Valley is a rugged and relatively deep-cut canyon in the rolling hills of interior northern Portugal, a small tributary to the Duoro River near the Spanish border. To say that Côa was a backwater of Paleolithic research prior to the 1990s would be an understatement; up to that point it was an empty space on the research map. This began to change between 1989 and 1991 when Portuguese archaeologists Sande Lemos and Nelson Rebanda discovered rock engravings on the valley's steep canyon walls. Eventually twenty-nine separate sites would be located in a seventeen-kilometer-long stretch of the valley. These contained over six thousand images that were finely engraved, deeply pecked, or heavily scratched into the local schist. Caprids—goats, chamois, and ibex—are the most common of the identifiable images (about 23 percent of the total), but horses are also quite common (21 percent). Both classes of animals are still present in the region, and no mammoths, reindeer, or rhinos have been identified, raising an immediate question about the age of the petroglyphs. But bovids are also represented (15 per-

cent), including the extinct auroch with its lyre-shaped horns, supporting an ancient age for the sites.[11] Perhaps more importantly, Rebanda recognized the probable Paleolithic age of the petroglyphs based on their stylistic similarities with motifs at dated caves.[12] But he elected to keep the discovery secret, a decision that he no doubt lived to regret.

Why Rebanda kept his discovery confidential is complex and not fully known. It seems inexplicable in light of our contemporary obsession with fame and publicity, but there may have been legitimate archaeological reasons for his silence. Possibly he hoped to thoroughly document his find prior to presenting what was guaranteed to be a controversial claim: the existence not only of the largest open-air Paleolithic rock art site but one of the largest concentrations of this art known anywhere. (These circumstances would give a sensible person good reason for pause.) Regardless of justification, Rebanda's decision had serious implications because at about the same time as his discovery, the Portuguese Energy Company (EDP) began building a dam in the Côa River and started to flood the valley. Within just a few years, some of the sites were inundated.

Work on the dam lowered the water level during the summer of 1993, reexposing one of the flooded sites to the open air. Rebanda took two archaeologists to visit this site although, again, no announcement was made of the find. Nor, apparently, did the discovery have any impact on the dam project. Public knowledge of the engravings—and their then imminent destruction due to flooding—did not occur until over a year later, in a November 1994 newspaper article.[13] This revealed the 1993 rediscovery and alleged that the EDP (along with certain archaeologists) were covering up the presence of the art in the interest of moving ahead with energy development at the expense of a priceless Paleolithic treasure. Perhaps predictably, an international controversy resulted. This pitted the EDP and the then-in-power Portuguese political party, the

Social Democrats, against much of the archaeological world. Central to the controversy was the question of authenticity: did these open-air engravings truly date to the Paleolithic? That is, would the dam, in fact, flood Paleolithic engravings or might they instead be more recent and therefore (arguably) of lesser significance?

The answer to this question was not immediately certain. By most accounts, the engravings looked very much like the cave paintings. Their stylistic similarities were compelling to many archaeologists, as was the fact that the motifs duplicated many (though not all) of the animal species illustrated in the caves. Further, Côa was not the first open-air Paleolithic site (although it was certainly the largest), hence there was precedence for this kind of discovery. Still, substantial amounts of money had already been invested in the dam project by 1994, and Portugal needed the energy it would generate. But stylistic comparisons alone were insufficient to convince the Portuguese government and the EDP to stop their project.

In an effort to resolve the matter, the Portuguese government requested that UNESCO evaluate the sites and offer possible recommendations. Jean Clottes was asked to undertake the task.[14] Based on his 1995 visit, Clottes acknowledged the authenticity of the engravings but also appreciated the practical and political realities of the quickly intensifying controversy. One of his recommendations was to bring in outside experts to chronometrically date the art. This, he hoped, would end any debate about the age of the engravings, forcing the issue outside of the scientific arena so that a political resolution could be achieved.

In fact, a political resolution was obtained though this was entirely unrelated to the chronometric dating. Demonstrating that the law of unintended consequences operates under its own rules, the dating research at Côa did nothing to clarify the ages of the petroglyphs. But a firestorm of accusations and alle-

gations erupted in connection with this work, in part bringing a decade and a half of productive rock art research to a halt. This had implications for potential early Paleolithic engravings as well as for understanding the initial peopling of the Americas and the origins of shamanism and art.

NEW TECHNIQUES FOR OLD ART

Despite the chronometric difficulties that rock engravings pose, substantial headway had been made in petroglyph dating prior to the AMS radiocarbon analyses of the cave paintings. This was largely the result of a single individual, Ronald Dorn.[15] Dorn is a geographer whose research specialty concerns the ways that rocks weather over time, especially the natural coatings that develop on rock surfaces as they age and what this implies about the history of the natural landscape.

Dorn is an affable, practical, and down to earth scientist, qualities seemingly reinforced by his solid build and low center of gravity. Though many scientists primarily think in terms of identifying problems requiring resolution, Dorn instead seems to focus on solutions more than problems; he often finds answers to questions that have yet to be voiced. This is almost certainly the result of a particularly quick mind. Although Dorn is as friendly and easygoing as anyone I know, it is a race to keep up with his agile thoughts that sometimes seem like jump-cuts in a movie's edited storyline. As with the editing of (most) movies though, his intellectual leaps are always logical, even though it often takes time to grasp the threads that connect his ideas.

I first met Dorn when we were both graduate students: I was completing my PhD dissertation at UCLA on the petroglyphs of the Coso Range in the Mojave Desert of eastern California, while he was finishing his master's thesis at UC,

Berkeley, on a new dating technique for rock varnish. Sometimes called "desert varnish," rock varnish is a paper-thin natural coating that develops over time on desert rock surfaces, eventually giving these rocks a dark black sheen.[16] As Dorn's research has established, rock varnish is formed by dust particles that are slowly fixed to rock surfaces by bacteria that ingest the manganese contained in the dust. The creation of a petroglyph requires pecking or cutting through an existing rock varnish coating to expose the (usually lighter colored) heart of the rock below. But once engraved, the newly exposed petroglyph surface starts to slowly develop its own varnish coating. Archaeologists had long recognized that if a technique could be developed to date the onset of that new varnish coating within the engraved surface, this would provide a minimum estimate for the age of the art. Despite various efforts, the scientific community had been unsuccessful in finding a means to do so.[17] Dorn's initial insight into this problem resulted from his recognition that varnish coatings are in certain respects analogous to soil and that he could use the processes that are known to affect soils to establish the age of a specific varnish coating.

The first technique that Dorn developed was based on regular changes over time in varnish chemistry. The dust that is the building material for rock varnish is a constant in any given region since it is derived from regional soils and ultimately geological formations. But once fixed in place as varnish, the hardened dust changes chemically because some of its constituents are more soluble in water than others. Some trace elements literally leach or wash out relatively quickly, whereas others are more stable, similar to the way that the dirt underfoot undergoes pedogenic (or soil building) processes. Turning this insight into a dating technique required accurately measuring the chemical constituents of small varnish samples, and then calibrating these measurements against a timescale by using

samples from geological surfaces of an already known age. He called his technique cation-ratio (CR) dating, signaling that his measurements were ratios of cations (positively charged atoms) of trace elements in the varnish samples.[18]

When Dorn and I first talked, he had satisfied himself that he could determine the relative age of different varnish coatings (e.g., varnish sample X is older than sample Y, and sample Y is older than Z). But he lacked a location with well-dated geological surfaces that he could use to determine if these relative age relationships represented a true calendrical scale (e.g., varnish sample X is one thousand years old, whereas sample Y is only five hundred years old). A series of previously dated volcanic buttes in the Cosos provided just the kind of study area that he needed.[19] Not incidentally, this brought him into what is probably the largest concentration of petroglyphs in the Americas. Dorn established a calendrical calibration for CR dating following our first trip into the Cosos, but, equally important, he also recognized that his chronometric tool had an immediate and significant alternative application beyond geomorphology—dating petroglyphs. He has been involved in rock art research ever since.

Although the Cosos were occupied into the nineteenth century by the Western Shoshone tribe, "Coso" itself is a word from the language of their close cultural and linguistic neighbors, the Southern Paiute. Coso means "fire" and, despite its foreign origin, it is an entirely appropriate appellation. The Cosos are one valley west of Death Valley to start and thus are at one end of the hottest and driest landscape on the continent. They were also formed by volcanic activity and consist of intensely rugged terrain characterized by blue-black basalt buttes, domes, and lava flows—a landscape truly formed by fire and molten rock. Indeed, hot geothermal waters, underneath portions of the Cosos, have created a large, hot springs and active, otherworldly looking fumaroles, making it appear

in places that the land itself is on fire. In almost all respects (save perhaps the breadth of the vistas), the Cosos are the opposite of the regular, linear, and predominantly horizontal red landscapes found in Arizona and New Mexico that so many visitors find appealing, if not iconic, of the West. Still, there is a beauty in the serene ruggedness of the Cosos that I and other archaeologists find compelling—my late archaeological colleague Emma Lou Davis labeled it "the last silent place"[20]—making it the kind of terrain that will (as archaeologists like to say) eat your boots on long projects, but will also maybe help you find your soul.

Part of the archaeological appeal of the Cosos are its rock engravings (not surprisingly), which, almost literally, are present on boulders and cliff faces everywhere. There is no accurate count of them, and more sites are found as new areas are searched. But a reasonable estimate is that there are over one hundred thousand individual petroglyphs within an area measuring roughly one hundred square miles.[21] They concentrate in particular in the vertical walled canyons that sporadic storms have slowly cut through the massive basalt flows, as if (somewhat like the Paleolithic caves) the interior of the earth has been opened up to reveal its beautiful inner graphic secrets. But the Coso petroglyphs are also very unlike the cave paintings because, ultimately, there is little comparability between the intimacy of the deep caves and the expansiveness of the Mojave Desert. This difference is sensed not just in the topographic scale but also in smaller things, like the lambent light of a torch that softly highlights a cave painting versus the unblinking burning sun over the canyons—a harsh glare that creates the sharpest contrasts between dark and light. The Cosos are instead much more like the Côa engravings than the cave paintings, naturally enough, although present in numbers greater than the Portuguese art.

The leitmotif of the Cosos, reminiscent of the most

common Côa engravings, is the bighorn sheep that, based on our best estimates, comprise just over half of the petroglyphs as a whole (fig. 7). These are pecked with schematicized or stylized bodies, unlike the realism characteristic of the engraved and painted Paleolithic art, with body sizes that range from almost minute to double that of life-size. All lack any effort at more than a rudimentary portrayal of the head and snout; all graphically emphasize the bighorn rack, shown unnaturally either from the side, as two perfectly concentric curves, or as undulating curves, as if seen from the front, almost like a cursive "m." Second most common are human (or humanlike) figures, ranging from simple stick-figure motifs, to larger solid-bodied humans with sheep heads, carrying bows and arrows, to large rectangular-bodied individuals portrayed wearing ritual dresses or shirts displaying intricate designs. These last images, by widespread archaeological agreement, are shamans, shown with the ritual costumery that they wore during their ceremonies.[22] Other kinds of identifiable motifs are rare, but there are numerous geometric designs, totaling about one-third of all the engravings, which correspond to the entopic patterns that are visualized during a shaman's trance.

The Coso rock art—and rock art in the rest of eastern California and the Great Basin—has been recognized as shamanistic in origin for a half century.[23] Like the Paleolithic corpus, the iconographic unity of the North American motifs alone implies that this art is the product of intentional and purposive acts and not just an exercise in individual creativity. Unlike the Paleolithic art, however, we know that the art is shamanistic because there are Native American accounts supporting the creation of the petroglyphs, by shamans, to portray their visionary imagery.[24] Indeed (and as noted earlier), the Coso petroglyphs and ethnography were used by David Lewis-Williams as a test case, along with his southern African San

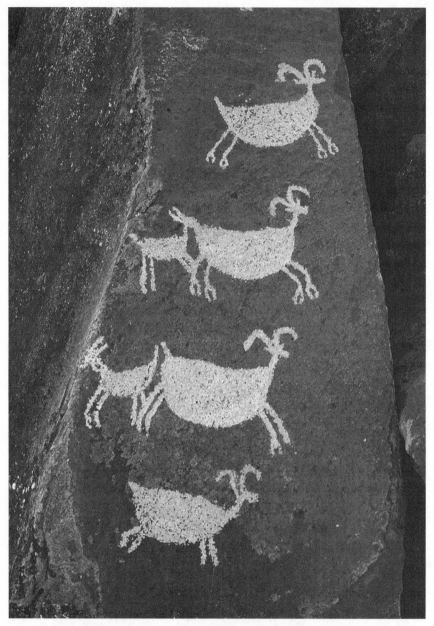

Figure 7. Bighorn sheep petroglyphs, made by Shoshone and Paiute shamans, are the hallmark of the Coso Range rock art, eastern California.

data, to demonstrate the efficacy of his neuropsychological model and, from that demonstration, to analyze the Paleolithic corpus.[25] Despite the geographical, temporal, and artistic differences between them, the Coso petroglyphs have been central to the interpretation of the Paleolithic art for the last two decades.

Dorn's first suite of CR dates was important not simply for the understanding of the Coso chronology but because it represented the first chronometric ages obtained on rock art worldwide.[26] He followed his initial results with additional dates from other parts of eastern California, ultimately also working in the Bighorn Basin of Wyoming, the easternmost extent of Shoshonean speaking tribes, and elsewhere in the western United States.[27] During this process Dorn developed two additional techniques for dating rock varnish and thus for petroglyphs. These were useful because, while CR dating worked reasonably well, it was not precise.[28]

The first of the additional techniques requires a microscopic analysis of a polished thin section of a varnish coating. Over time, varnish develops in a series of layers or lenses, much like soil that develops underfoot; or perhaps more like a tree that adds a new growth ring every year. Like the rings in a tree, the microstratigraphy of varnish is influenced by major climatic trends: wet versus dry years yield broad versus narrow tree growth bands; for rock varnish, long, wet periods result in manganese-rich layers, whereas dry period layers are manganese poor.[29] These chemical differences result in different characteristics that are visible under a microscope. This sequence of layers, or laminations, is constant across a given region (like western North America); if calibrated against the time scale (using geological surfaces that had been previously dated), a sample can be assigned to a particular time period. Dorn called the technique Varnish Microlamination (VML) dating.

Initially Dorn was able to recognize only catastrophic

paleoclimatic changes—ice ages versus temperate periods. The implications for archaeology were significant because he could determine whether a varnish sample had started to develop before or after the end of the Pleistocene, at about 11,000 YBP (Years Before Present), whether it dated between 11,000 and 14,000 years, and whether it ranged between 14,000 and 21,000 years. But these were ages that mostly then exceeded the presumed first entry of humans into the Americas. Although his identification of additional microlaminations improved as his research advanced, initially his sequence was still restricted to the Pleistocene era. This limited the archaeological use of VML dating to only the most ancient petroglyphs, associated with the earliest archaeological evidence in the hemisphere. Still, VML dating was significant because it provided a fully independent check on CR ages, or at least on the earliest CR ages that, by this fact, were the most controversial.

Dorn's final additional technique seemed to resolve all of the problems and limitations of both CR and VML dating, partly because it appeared to be accurate and precise, in part because it was based on the existing AMS radiocarbon dating technique (which had already undergone substantial development and testing), and also because it was applicable over a temporal range stretching back to 50,000 YBP. It was based on the fact that very small fragments of organic matter are trapped in and under rock varnish (and other natural rock coatings); perhaps as a result of lichen that grew on the rock surface before the varnish began to develop, perhaps just as windborn constituents of the dust that formed the varnish.[30] Regardless of the source, Dorn painstakingly isolated the very small bits of organic matter associated with rock varnish and submitted these for AMS radiocarbon analysis. This technique promised to make varnish dating more exact, certain, and reliable than previously possible, and Dorn called it Weathering Rind Organics (WRO) AMS dating. The name reflected that,

while he primarily used it for dating rock varnish, the varnish itself protected the porous natural weathering rind of the underlying rock, and the technique could be applied to these rinds more generally.

Dorn's chronometric breakthroughs were primarily directed toward dating landforms and identifying and understanding ancient climates (his main research interests), with the archaeological applications serving as sidelines. But the impact of his research was great, perhaps extraordinary, and he immediately accumulated academic awards that demonstrated this fact. These started in 1986 with a prize for the best-published professional paper in geomorphology, a paper that he had written as an undergraduate with his adviser and junior author, Theodore Oberlander.[31] (It is exceptional for any undergraduate to publish a paper in a major academic journal; for an undergraduate to receive a national award for the best professional paper of the year is likely unparalleled.) They also included a National Science Foundation Presidential Young Investigator Award, received as a freshly graduated PhD, and a Guggenheim Fellowship about a decade later, with numerous accolades and major awards in between. His career trajectory was meteoric, and he seemed destined for eventual induction into the National Academy of Sciences, the American academic equivalent of an All-Star Team, if not a sport's Hall of Fame.

PALEOLITHIC ART IN THE AMERICAS?

Despite his growing fame in the earth sciences, Dorn continued his occasional work in archaeology. The results he obtained with his archaeological collaborators (myself included) were significant, very unexpected, and controversial, far beyond rock art research alone. The previous eastern California petroglyph chronology, for example, had argued for a

short span of art running from just 1,500 BCE to 1,500 CE. The terminal date reflected the (incorrect archaeological) belief that recent Native Americans knew nothing about the art.[32] As Dorn's chronometric results accumulated, it became increasingly clear that the art was both younger and substantially older than previously thought and that the previous scheme was wrong.[33] At the recent end of the timescale, petroglyph ages into the last few hundred years were eventually obtained. Combined with Native American accounts concerning the making and meaning of the art, and occasional historical subject matter (especially horse and rider motifs), it was clear that the speculative terminal date for the sequence—pre–1,500 CE—was incorrect.

But the most surprising results involved the oldest petroglyph ages, and these had implications for the prevailing interpretation of the peopling of the Americas. In the 1980s, this was a short chronology arguing that the first migrants entered the continent only about 11,200 years ago. This was called the "Clovis-first" theory, after the spear points found at the earliest recognized site of this age, near Clovis, New Mexico. To say that this short chronology was deeply entrenched in the profession is an understatement. It may not have been *complete* career suicide to argue in favor of the alternative "pre-Clovis," or long chronology (which supported a first migration somewhere in the fifteen- to twenty-thousand-year range), but it was guaranteed to result in intellectual marginalization to the archaeological fringe—a certainty enforced by the so-called Clovis police, as the vocal proponents of the Clovis-first theory were sometimes labeled. Because our initial petroglyph sampling in eastern California focused on early (heavily revarnished) motifs, we not only began to get Clovis-age results, but we quickly obtained dates going back to about sixteen thousand years, well into pre-Clovis terrain. Professional attitudes were so strongly opposed to the pre-Clovis hypothesis that we

had to take our results outside of North America to get them published.[34] In the 1980s at least, there was simply no way to fight the Clovis-first proponents—most American journal editors and article reviewers would not consider the presentation of data that did not fit this position.

Despite this predominant view, there was, even in the late 1980s, accumulating South American evidence that the Clovis-first theory was incorrect, independent of our petroglyph dates (and aside from other possible North American evidence). As Dorn and I pointed out in a 1993 article,[35] Clovis-first advocates had themselves acknowledged the authenticity of a series of South American sites with dates going back to about eleven thousand years—that is, sites that were Clovis aged or younger. But given that a first entry across the Bering Strait was accepted as the only plausible migration route, it was a physical and biological impossibility to populate two continents in just a few hundred years, as the implications of the Clovis-first theory—in light of these accepted South American sites—required. Even using the lowest possible population densities, with migration and colonization rates that were faster than any known, we argued that the noncontroversial South American sites could only be reconciled with an initial Bering Strait migration at least fifteen hundred years before the start of the Clovis period. Clovis-first was an empirical impossibility when the implications of the theory itself were considered in terms of plausible biological reproduction and colonization rates.

Archaeology for some practitioners, however, is wholly a concrete science. This apparently was especially true for many of those whose primary interest was the peopling of the Americas—archaeologists who felt that the only allowable evidence was an artifact that you can hold in your hands. Despite the implausibility of their position, our argument was simply inadequate to change their strongly held views. This change only came, after a decade of intellectual hand wringing and debate,

with the widespread acceptance of the authenticity and age of Monte Verde, a habitation site in southern Chile dating to about 13,000 YBP.[36] This acceptance made our pre-Clovis petroglyph ages at least empirically plausible. And our dates had further implications for a series of other issues, including the origins of shamanism and its potential place as a first religion, even though these issues didn't seem to concern those fixated on the question of when humans first stepped onto the Americas.

By the mid-1990s, we had compiled sixty varnish dates on petroglyphs from the Mojave Desert, including the Coso Range.[37] Five of these appeared to be pre-Clovis in age, but we recognized that the acceptance of these early dates would require extraordinary evidence, despite the then growing accommodation of the pre-Clovis long chronology. Our best argument for pre-Clovis aged petroglyphs came from two different locations. The first was a set of engraved concentric circles at a site located on the western edge of the Coso Range. These concentrics are so deeply revarnished that there is no color contrast between them and the underlying (rock varnished) boulder, making them only visible in raking light. Dorn's WRO AMS radiocarbon age on the motif was 14,760 ± 90 YBP.[38] It was seemingly confirmed by a CR date of 16,500 ± 1,500 YBP, yielding an overlap at two standard deviations (that is, giving us a 95 percent statistical confidence that the true age of the petroglyph fell between 13,500 and 19,500 YBP—admittedly a broad period, yet clearly pre-Clovis in age). The VML age supported the first two results: the thin section indicated that the design was greater than 14,000 but younger than about 21,000 YBP. Although this seemed good enough, the setting of the site (a scree slope that was partly covering the ancient course of the Owens River) gave us an additional line of supporting evidence. The petroglyph could only have been created after this river ceased to flow and the talus boulders collapsed onto the streambed. Geological dating indicated

that the river stopped running at about 16,200 years ago,[39] and the boulder with its petroglyphs had to postdate that point. This combination of evidence placed the motif in the 16,200 to 14,700 YBP range, which was convincing support for pre-Clovis aged rock art, at least in my mind.

The first implication of these results then was obvious: there appeared to have been Ice Age rock art made in the Americas. This art may not have been as old as all of the European Paleolithic caves, like Chauvet, but it was as old as some of the sites, and—since no one yet knew when humans first arrived in the Americas—we could not immediately predict how ancient New World rock art might ultimately prove to be. Yet there was also an implied problem in this early date: if early Native Americans were creating Ice Age art, why were there no depictions of extinct Pleistocene creatures, as there are at the French and Spanish sites?

This was a more complicated problem than is immediately obvious, one with parallels to the circumstances at Côa. The Portuguese art is predominated by caprids and horses; although there are examples of extinct species in these engravings (notably the auroch), they emphasize animals that still existed in the region in more recent past. The situation in the Mojave Desert is similar: bighorn sheep are the most common motifs. Although there were a series of Pleistocene mammals that occupied the Mojave that are now extinct (like the Columbian mammoth), the bighorn is an Ice Age survivor that has lived in the far west for over twenty thousand years and was apparently hunted by Clovis peoples.[40] Some of the bighorn petroglyphs themselves might be Pleistocene in age; and, in fact, Dorn's results did include a pre-Clovis Coso bighorn. The CR age on this is 16,500 ± 1,000 YBP, an age confirmed by the VML analysis. Yet a motif depicting a clearly extinct species would provide a more convincing argument in favor of pre-Clovis art.

We found this by dating a hornless/anterless animal motif from the Rodman Mountains, in the central Mojave Desert outside of the town of Barstow.[41] This looked like a camel (an Ice Age species in California that has long been extinct) to me, but I am not a paleontologist or zoologist, nor can I admit any special knowledge about camels. As a kind of blind test, I showed a slide of this motif without prior explanation to a room of scientists, asking if anyone could identify the animal depicted. As I knew in advance, one of the individuals present was paleontologist Robert Reynolds, then curator of the San Bernardino County Museum and an expert on the Pleistocene fossils of the Mojave Desert. He responded to my question in a quick but cautious scientific fashion: "Paleontologists don't deal with soft tissue," he said immediately, meaning the skin and meat. "But that looks like a Mojave Desert llama to me," referring to a camelid species related to modern camels and the llamas of South America.

His response to my next query, concerning the age of the species, was even more cautious: "Well, it *must* be older than 7,000 years," he observed, hedging his bet and recognizing by this time that this motif had significant implications—if his identification was correct—and that he might be going out on a limb by his statements. Reynolds seemed relieved to hear the chronometric results: there were no identifiable organics in the varnish sample and no WRO AMS date was obtained, but the CR age was 13,400 ± 2,000 YBP. VML dating confirmed this, with microlaminations indicating that the motif fell between 12,500 and 16,500 YBP. A natural mineral skin or coating (calcium oxalate) had also developed within the varnish itself so Dorn was able to obtain an AMS age on this embedded layer. Although calcium oxalate radiocarbon dating is experimental, the microstratigraphic position of this sample indicated that it should be younger than the start of the revarnishing on the motif and thus its original age of creation. The oxalate date

came back as 11,860 ± 60 YBP, matching our expectations. All evidence pointed to a true pre-Clovis age for this petroglyph that seemingly depicts an extinct Pleistocene species.

As exciting as these early dates themselves seemed to be, the most interesting implications concerned their significance for the origins of shamanism. By nearly universal North American agreement, Native American shamanism has been acknowledged as originating in Siberia and then was carried into the Americas by the first migrants.[42] Supporting this interpretation are similarities between Siberian and Native American shamanism that are truly remarkable. Religious historian Karl Schlesier, for example, documented over one hundred specific shamanistic traits that were shared by the Cheyenne on the North American Plains and northern Siberia groups—far more than could ever likely be explained by chance.[43] Siberian shamanism itself was widely thought to represent a kind of archaic cultural fossil that, similarly, was our best model for the shamanism of Paleolithic hunters and gatherers of France and Spain.

Dorn's dates, in combination with an analysis of other evidence supporting continuity in the petroglyph tradition, confirmed this point: Mojave Desert shamanism had been continuously practiced for over ten thousand years, as a Siberian origin would imply.[44] Yet when I compared the time depth of Mojave shamanism to the archaeological record in Siberia,[45] I discovered something very unexpected: "classic" Siberian shamanism only appeared about four thousand years ago, among Bronze Age reindeer pastoralists. This suggested the almost unthinkable—perhaps Siberian shamanism developed initially in the Americas and then diffused westward into the Old World.

This was a radical thought that ran counter to over a century of archaeological belief. Whenever I voiced this possibility to colleagues, I always got the same reaction: "that cannot possibly

be true." But the quickness and certainty of their responses said less about empirical reality than the fact that this was a question they had never considered and that it challenged an unproven idea we had all taken on blind faith. Moreover, the issue touched on a topic of potential great significance to Native Americans: the depth and breadth of their contributions to world heritage, and the possibility that they may have been creative innovators whose ideas influenced the Old World, rather than just the recipients of influences from abroad. Although their contributions to agriculture are certainly widely appreciated, the possibility that they may have also made significant and influential philosophical and religious contributions has never much been considered. After all, the Western historical narrative insists that Europeans "discovered" Native America living in remote isolation from the rest of the world. Or perhaps, as the implications of the petroglyph dates suggested, history really wasn't that unilinear, despite the entrenched biases that are part of our Western intellectual legacy.

Still, that my colleagues *possibly* suffered from a long-standing bias does nothing to prove that a New World to Old World diffusion of religion occurred. They could be biased but still entirely correct. The petroglyph dates matched against the Siberian archaeological record at least suggested that the prehistory of shamanism was more complex than anyone had heretofore assumed. But before I could address these questions, I had to determine first whether any of Dorn's dates could be trusted.

Related to his dating work at C ôa, accusations were broadcast that Dorn's results had been fabricated. With those charges, all petroglyph dating was cast in doubt. The age of the Côa petroglyphs was uncertain, at best, as were any arguments that I might make about a pre-Clovis occupation of the Americas and the origin of Old World versus New World shamanism.

THE COSO CRISIS

The decade and a half of previous and (seemingly) successful petroglyph dating research was the context for Jean Clottes's suggestion, in 1995, that efforts be made to date the Côa petroglyphs. Clottes's goal was to end any lingering archaeological controversy over their authenticity. In order to achieve as much scientific credibility as possible, the Portuguese authorities arranged for a blind test involving Dorn and a second researcher, Alan Watchman. Watchman is a Canadian geochemist who began researching and dating rock art in the late 1980s. Watchman and Dorn were taken to Côa separately, had no contact during their petroglyph sampling and analyses, and only learned of the other's results once their studies were independently submitted. They both used AMS dating in an effort to be as accurate as possible and, presumably, to obtain the most reliable results. In this case, science worked as expected and both sets of dates were statistically the same. Unfortunately, however, they averaged about 4,000 to 5,000 YBP, only about half as old as the Paleolithic.[46] Based on the chronometric analyses, the Coâ engravings were relatively recent and, while they still had some research importance, they were far from internationally significant. From the EDP perspective, this was a green light to complete its work on the dam and flood the Côa valley.

Or, instead, was the dating all wrong?

Archaeological consensus quickly held that the chronometric results were incorrect, that the dating technique was flawed, and that the engravings must date to the Paleolithic.[47] Watchman vocally contested these ideas, insisting that the post-Paleolithic ages were right and that the technique, as he used it, worked fine.[48] Perhaps surprisingly, Dorn disagreed and sided with the opposing archaeologists. Although he had developed WRO AMS dating and had applied it to geological

and archaeological samples around the world, Dorn argued that, at Côa, for the first time, he had sufficient funding to carefully examine the organic matter that was present in his samples. These contained at least two kinds of organic carbon. When he split these two visually distinguishable types and AMS dated them separately, he got very different results—one type seemed to be younger and the other older.[49]

The implications of this circumstance were severe, as Dorn understood. The veracity of the technique rested on the assumptions that the microscopic pieces of carbon trapped under rock coatings were all the same age, that this corresponded to the onset of the coating development, and that the organics originated at the same time that the coating started to form and thus could be used to date the beginning of its growth. The original test application of the technique, comparing his results to dates previously obtained by other means on Hawai'ian lava flows, had shown a close match with the controls,[50] seemingly supporting this original assumption. But if two types of organic matter were present, and they had distinct radiocarbon ages, the organics under rock coatings (including rock varnish) must be mixed in origin. Either older bits of carbon were "inherited" when the coating began to form (perhaps relict pieces carried in by wind-borne dust), or younger organics somehow "contaminated" the sample (potentially as the result of almost microscopic rootlets that, somehow, worked their way into the coating). Or at least this was what Dorn suggested. Regardless, he argued that the dates were meaningless. Certainly they provided no clear indication of the true age of the underlying petroglyph.

Dorn announced his Côa findings in the spring and summer of 1996, and in the process retracted all of his previous WRO AMS dating results, including our Mojave Desert AMS petroglyph ages. At about the same time, a series of scientists from three separate institutions began investigating

Dorn's dating work.[51] Their position was that, in the Côa study, Dorn wasn't trying to correct a significant scientific error involving a single dating technique. Instead, he was quickly covering up a long pattern of fraud and was rushing to get his retractions into print now that they were investigating his research.[52] This was no minor matter because, they claimed, "almost all of the radiocarbon dates purported to support human occupation of the Americas prior to twelve thousand years ago are on samples which have passed through Ron's hands." The implication of this assertion was that "his sin against science ranks with the greatest frauds of all times."[53] Instead of resolving long-standing questions about the age of rock art, petroglyph dating was beginning to look like a rerun of the infamous Piltdown fake—the craftily manufactured skull that was once said to represent the "missing link."

The primary scientists raising these allegations worked at three major research facilities. The investigation was initiated and spearheaded by four scientists at the NSF-Arizona AMS Laboratory, at the University of Arizona, Tucson. This was one of only three AMS radiocarbon dating facilities in the country at that time and the primary lab used for archaeological research.[54] Although this alone was a distinguished, world-renowned group, the Arizona team was joined by two scientists from the AMS dating lab at the Swiss Federal Institute of Technology (ETH), in Zurich, and a third professor from Columbia University's Lamont-Doherty Earth Observatory.

Their initial action was to file a formal complaint to the National Science Foundation—the federal agency that had funded much of Dorn's research and hence had oversight on it.[55] This was submitted in September 2006 to the NSF's Office of the Inspector General. The OIG handles allegations of scientific misconduct, following a well-defined and rigorous set of procedures. One of these is strict confidentiality: although the accused is informed that an investigation is occurring, the

accusers themselves receive no information about its status until it is terminated. Another involves securing custody of any pertinent scientific evidence. In this case, this resulted in a subpoena for the remaining portions of Dorn's samples that were originally AMS dated at the Arizona lab, along with the notebooks related to their analysis. The Arizona scientists had analyzed the sample "remainders," as they were called, and their findings were the majority of the evidence presented in the complaint.[56]

The allegations also spread, inevitably, through gossip. Initially the rumors just involved the 1989 Hawai'ian test study, as originally explained in an internal August 1996 e-mail between the scientists raising the accusations: "All of the samples from this study appear to have been cooked up, and seem to be two component mixtures of coal and wood charcoal."[57] They soon expanded to include all of Dorn's WRO AMS work (presumably based on additional analyses of his samples). The best expression of the accusations, as they spread through the scientific community, is in an e-mail from Fred Phillips to one of the University of Arizona scientists, following a private discussion they had at a professional meeting. Phillips was the chair of the Earth and Environmental Science Department at New Mexico Tech University. He had collaborated with Dorn on various dating projects, and he had good reason to be personally concerned. Phillips sent a summary of his understanding of the scientists' allegations against Dorn, in order to fact-check it, in early 1997. In part, Phillips's summary of what he had been told stated that:

(1) Organic carbon samples submitted to several radiocarbon labs were found to consist of a bimodal distribution of materials. [That is, there were two distinct kinds of organic matter in Dorn's samples.]

(2) One component consisted of charcoal, with cell struc-

ture clearly visible under EM [Electron Microscope] and clearly identifiable as pinewood, probably bristlecone pine.

(3) The other component is dense, shiny, shows conchoidal fracture, and has been positively identified as bituminous coal.

(4) The components can be separated and individually dated. As expected, the coal component is near-dead [i.e., has little or no detectable ^{14}C] and the wood component is near-modern.

(5) This two component mixture has been indentified [*sic*] in all your archived varnish carbon samples that were examined, including those from places such as Hawaii, where neither coal nor bristlecone pine are present.

(6) This two-component mixture was present in appropriate proportions so that its bulk radiocarbon age matched independent ages on control samples (such as the Hawaiian lava flow sequence).[58]

The implications of these claims were obvious to any scientist: coal and charred pine do not naturally co-occur. They could only be present in a sample if they were intentionally mixed together. That Dorn's samples had yielded dates matching preexisting expectations, despite this mixing, demonstrated conclusively that his work was fraudulent.

This last point seemed to be the ultimate proof. Dorn had already retracted his WRO AMS results, claiming that, through his work at Côa, he had discovered that there were two different kinds of organics in his samples, with different individual ages.[59] Although this "natural explanation" might stretch scientific credulity—how could a scientist overlook a problem this severe in his or her data?—there was no way to reconcile Dorn's explanation with the lab's finding that his AMS radiocarbon dates correlated closely with preexisting ages

on the same geological features. If the two kinds of organics present in his samples were the results of natural mixing, their combined AMS ages should instead be random relative to the previously dated features.

Perhaps in an effort to constrain the rumor mill to the scientific facts as then understood, one of the Arizona scientists traveled to Australia in March 1997 and delivered a paper at a conference presenting their findings.[60] Rather than diminishing the controversy, this resulted in international press coverage, escalating the scandal even more.[61] Yet in this developing tempest, no word was heard from the NSF about its investigation that presumably had then been ongoing for some time.

By the end of 1997, the scientists were impatient over the NSF's apparent failure to resolve the controversy and they decided to move ahead on their own by submitting their empirical findings in a paper to *Science*—the flagship journal of the American Association for the Advancement of Science and widely acknowledged as the preeminent scientific magazine in the United States.[62] They submitted their manuscript in January 1998, and the editors at *Science* allowed Dorn to write a rebuttal. The paper and response were published jointly in June of that same year.[63]

Their paper was, in general terms, a tidied-up, much more detailed, fully illustrated, and scientifically precise version of the allegations that Phillips had earlier asked them to fact-check (above)—as would be expected in a publication like *Science*. They labeled the two kinds of dated material in Dorn's samples as type I and type II organics, and retreated from identifying these as bituminous coal and pinewood. Type I instead was said to "resemble coal" whereas type II "resembles pyrolized wood charcoal fragments,"[64] but the bottom line had not changed. As they stated in their conclusion, "Type I material is always older than the bulk age [of Dorn's samples], and type II material is always younger than the bulk age of the

sample."[65] They refrained from outlining the implications of their findings with respect to Dorn's honesty, but, by then, these were already obvious to the scientific community. Their results proved that Dorn's work was fraudulent.

Dorn's published response, to many people's surprise, was vigorous and aggressive and it confronted the implied accusation of fraud directly. It provided a plausible case that there was a natural explanation for the scientists' findings and corresponding evidence supporting his innocence of any wrongdoing. Perhaps the most important argument in this last regard involved his Côa project.[66] This had been a blind test where Dorn and Watchman had independently obtained effectively the same results. If Dorn had been "cooking up" his samples, how could he and Watchman possibly have gotten the same results? Perhaps more significant, however, was Dorn's description of an unpublished study recently completed by geologist Ramon Arrowsmith and archaeologist Glen Rice, at Arizona State University, Tempe (Dorn's own institution). This had two implications. In a carefully controlled experiment, Arrowsmith and Rice demonstrated that coal-like and charcoal-like carbon could naturally co-occur under rock varnish.[67] Their study also tacitly signaled that ASU was conducting an investigation into Dorn's research.

In fact, the NSF OIG's standard procedure in misconduct cases is to ask the home institution of the accused scientist to conduct a thorough investigation. The findings and conclusions are then submitted to the NSF, where an independent panel of scientists reviews and either concurs or disagrees with the outcome and issues a final ruling. Not only was the official investigation then still ongoing in 1998, but it apparently was obtaining results that exonerated Dorn. Or at least so he argued in the pages of *Science*.

Rumors of additional allegations against Dorn continued to circulate. Over a year later, on October 1, 1999, ASU dis-

missed the charges against Dorn. Less than two weeks later, NSF issued their ruling. They concurred with ASU and exonerated Dorn.[68] The reaction—quiet outrage is perhaps a better characterization—from the radiocarbon-dating community was predictable in light of this outcome. It seemed obvious from what they had heard that Dorn was guilty, and his exoneration could only have resulted from some legal technicality. As John Southon, then director of the Lawrence Livermore AMS lab, wrote to one of the Arizona scientists:

> I think the NSF has just sent us all a powerful message about scientific fraud. I hope you guys are holding up okay, and let me know if there's anything I can do—letters to the effect that . . . [you and your colleagues] . . . aren't half the assholes they appear to be, or whatever.

Southon followed this a few weeks later by noting that:

> The NSF committee report is pretty disgusting—an even more powerful message than I had imagined. Thanks for sending it all the same.[69]

Dorn's response was to sue his accusers for defamation. As with the rest of the controversy, this resulted in additional international news coverage along with disapproval from the scientific community.[70] And, of course, it did nothing to clarify the age of the Côa sites, their potential importance to world patrimony, nor our understanding of the relative antiquity of New versus Old World shamanism, let alone the origins of religion and art. Although not all of these issues are yet resolved, additional archaeological research was required to solve some of them.

CHAPTER 4

FINDING CÔA

Despite the dispute over Dorn's petroglyph dating techniques and the international scandal that resulted, the Côa controversy took on a life of its own. It pitted archaeologists against the Canadian geochemist Alan Watchman, who continued to insist that the engravings were all recent, and set a majority of the Portuguese people against the EDP and the then existing Portuguese government.[1] Dorn played a key role in the Côa debate, and his retraction of the dating technique was widely cited as justification for ignoring the chronometric results. Whereas the Anglophone academic community viewed him with great disfavor, the Portuguese archaeologists perceived him very differently, since his position supported their own. But it was a background role because the real issues were political. The archaeological community was convinced that the engravings were Paleolithic based on the stylistic similari-

ties between the Côa motifs and the paintings and engravings in the caves. The EDP had already invested between $5 and 10 million in developing the dam, however, and they had the full support of the government. This should have been a hopeless circumstance—archaeology rarely trumps major financial investments and urgent energy and development needs— except for one fact. The political party then in power was increasingly unpopular and was facing a general election in 1995. They lost this election and, with the change in government, Côa was saved. The new government quickly created the Côa Valley Archaeological Park, compensating the EDP roughly $100 million for their lost energy-development rights.[2] In 1998, the sites were placed on UNESCO's list of World Heritage Sites, giving them the highest level of international recognition.

The preservation of the Côa rock art sites was clearly a factor in Portugal's change in government, but it is impossible to say how important a part the archaeology played in the electoral outcome. Still, it is perhaps the first time that an archaeological concern has had a significant role in national electoral politics, and it likely resulted in the most money ever expended to preserve heritage resources. Yet despite this ostensible success, one fairly significant archaeological problem remained unresolved: were the engravings truly Paleolithic in age? If real, Côa was (by an order of magnitude) the largest concentration of open-air engravings dating to the Ice Age and one of the larger concentrations of truly ancient art, of any type, worldwide. If not, a major and truly embarrassing archaeological error had been made.

Stylistic comparisons between the open-air engravings and the cave art provided a plausible line of evidence supporting their Paleolithic age, but plausibility isn't proof. Worse, archaeological thinking had increasingly moved away from stylistic analyses and interpretations by the early 1990s. Taking a cue

from art historians, archaeologists traditionally had equated different artistic styles (as signaled by motifs, techniques, and artistic treatments) with distinct prehistoric cultures and time periods. By the 1990s, there was a widespread (though far from universal) rejection of this stylistic approach. Indeed, some archaeologists had labeled the 1990s as the "post-stylistic era" of research.[3]

Two of the reasons for this change in perspective involved issues that had become central to Paleolithic rock art research during this same period. The first was the shamanistic interpretation of the art. David Lewis-Williams's neuropsychological model for the kinds of imagery experienced during trance, which provided the argument for the shamanistic interpretation, implied that this imagery could vary, even during the course of a single altered state of consciousness experience.[4] The mental images potentially shifted, for example, from simple geometric light images ("entoptics"), to construals of the entoptics as figurative patterns (i.e., seeing a naturalistic image in a geometric pattern), to full-blown iconic or naturalistic visual hallucinations. These variations included some of the kinds of differences that had been cited as potentially significant in stylistic analyses. At least in some cases, the shamanistic interpretation was an alternative to stylistic analysis, suggesting that the visible variation in the art was caused by matters quite distinct from the traditional equation of a particular art style with a specific culture and time period.

The second issue involved chronometric dating again. Although this was fruitless in Côa, other techniques had proven useful elsewhere in the world (including the AMS radiocarbon dating of pigment organics in the European painted caves). In many cases, the chronometric results failed to support previous stylistic analyses. Further, the increasingly early ages obtained for some of the Paleolithic caves—eventually including Chauvet—struck a blow against the idea of an

evolutionary development of art (usually perceived as a pro-
gressive trend from simple to complex) that likewise was a
component of much stylistic thinking. (Admittedly, I was one
of those who were opposed to stylistic analyses, and for legiti-
mate reasons: everywhere I worked, from southern Africa to
western North America, the previously proposed stylistic
sequences did not stand up to empirical scrutiny.)[5] The inter-
national archaeological community had rallied around the
Côa petroglyphs and sites, on stylistic grounds, and had
gained the support of the new Portuguese government and
even UNESCO. But the question of the age of the sites was still
uncertain. Resolution of this problem was achieved not by
additional chronometric dating using new or different tech-
niques, but by diligent and systematic applications of standard
kinds of archaeological work on the part of the Portuguese
archaeologists, combined with a bit of good luck.

The work began with efforts to demonstrate that the Côa
region contained other kinds of evidence that would support
the presence of a Paleolithic population in the area. Logically,
a region with large amounts of early art should also contain
substantial evidence of human occupation of a similar age: if
prehistoric peoples left their traces in the form of art, they like-
wise should have left evidence of their use of the region in
other forms, especially habitation sites or camps. At the start of
the controversy, the Côa archaeological record was not well
known and it was uncertain whether it contained any signifi-
cant evidence of Paleolithic occupation at all—an uncertainty
that became one of the arguments against the possible early
age of the engravings. Site surveying to locate possible early
camps (identified by artifacts visible on the ground surface)
and excavations at the located sites were intended to clarify
this question. They did so relatively quickly, with thirty locales
showing good evidence for Paleolithic inhabitation of the Côa
area.[6] Prehistoric people were certainly living in Côa between

about ten and twenty-eight thousand years ago, as the excavations revealed, which increased the likelihood that the art might be similar in age. But this was still short of a scientific smoking gun.

A second approach used by the Portuguese archaeologists involved very detailed recordings of the rock art panels themselves, and then an analysis of the patterns of overlaps in the motifs, referred to as a superimpositional study by archaeologists. The concept behind such a study is simple, although the work required is not. Many of the Côa petroglyphs are finely incised, some even barely scratched, into the rock faces. Documenting the panels of art involves tracing them full-sized on overlying plastic sheets. But the motifs are relatively difficult to see and photograph—there is a reason they weren't discovered until almost the end of the twentieth century—making this an eye-straining and tedious process. (The best way to see and photograph the motifs in fact is at night, with controlled side lighting creating the best contrast and visibility.) Once completed, careful study allows for a reconstruction of the artistic sequence, showing which motifs were created first, which were placed on the panel next, and so on. The result is a kind of graphic stratigraphy, created with the hope that, in the region as a whole, there may be patterns in these superimpositions. The archaeologists discovered first that there was a long-term continuity in the use of the motifs, with the same kinds of animals at the top and bottom of the superimpositional sequence. This is exactly what is found in Paleolithic art as a whole and is a good mark in favor of the early temporal attribution of the art. Less conclusively, they also determined that pecked motifs tend to be earlier than deeply incised ones, suggesting that some artistic changes occurred over time, even within the context of a longstanding artistic tradition.[7] Again, similar patterns have been observed in the painted caves in France and Spain.

As valuable as these archaeological efforts were, the conclusive evidence for the antiquity of the sites was obtained in December 1999, through excavations at the site of Fariseu, on the bank of the Côa River. Fariseu is situated along a sharp meander in the river, on the inside bank of the curve, creating a circumstance with significant archaeological implications. Although this bank occasionally floods and is covered with alluvial (or riverine) soils, it is protected from the normal currents of the stream that run along (and cut away) the outside bend, leaving the inside bank more or less undisturbed. This is a "stable landform": one that was not only usable for prehistoric occupation (a flat terrace, immediately adjacent to a water source) but also one that has experienced only minimal natural change in the last thirty thousand years. Indeed, the only significant alterations have consisted of new alluvial soils that were deposited on top of older ones on the terrace, during the rare floods, thereby capping or sealing what lay below. This is a textbook-perfect context for archaeological site preservation. And as luck sometimes has it, the Portuguese archaeologists not only found an intact Paleolithic site on this stable terrace, but a partly buried panel of petroglyphs.

The petroglyph panel contains a confusing palimpsest of images, mostly animal motifs, including horses, deer, aurochs, and goats. This circumstance—a welter of overlapping images lacking any systematic orientation or pattern—is characteristic of some Paleolithic art; it also reflects many artists' lack of concern with composition in any standard sense. Critically, however, two and a half meters of soil had accumulated against and partly covered at least eighty-two engravings on the panel. Although the top layers of the soil were recent, soil layers containing stone tools and other artifacts, interbedded with naturally deposited river soils, covered many of the petroglyphs. Included among the mundane stone tools are a series of small pieces of the local rock that are themselves engraved with

designs that are equivalent to the petroglyphs. These examples of mobile art, as they are called, confirm what the soil stratigraphy itself indicated: the archaeological deposit developed after (but close to the same time as) the period during which the petroglyphs were made. The kinds of tools combined with chronometric dating demonstrate that this was during the Paleolithic: the Côa petroglyphs are clearly greater than about 11,000 years old. Taking the most conservative position, some of them must be older than 14,500 years; plausibly, some may be 20,000 to 25,000 years in age.[8]

Regardless of exact date, the Côa petroglyphs are very ancient art indeed and existed fully in the open air with Paleolithic peoples living in direct sight, and contact, with them. The Côa art in many respects is certainly very much like the paintings and engravings in the dark-zone caves, but it is also quite unlike them in equally important ways.

FIGURING CÔA

My own trip to Côa occurred a decade after the controversy, well after the smoke had fully cleared. I arrived in Porto, Portugal, after a week in Scotland. As a California resident I was pleased to leave the soggy, even if green and picturesque countryside of Scotland for a Mediterranean climate; though sun scorched and dry in places, it is still at least sunny and warm. The trip from Porto, on the north coast, to Côa roughly follows the Duoro River, with Côa itself situated in the Upper Duoro region, close to the Spanish border. This is the home of port wine and thus vineyards that spread across a rolling uplands region, deeply cut by the Duoro and its tributaries. This creates a kind of checkerboard of domesticated, farmed fields bounded by small but rugged gorges. Olive and almond groves are interspersed among the vineyards, giving the hills a

variegated and very textural quality, enhanced (during my fall visit) by the different colors of the fields. This, too, was a picturesque landscape, even before seeing the rock art.

I admit that I am not a fan of port wine. I much prefer dry reds. Luckily, the current generation of Duoro winemakers has developed a new "table wine" industry, as the Portuguese prosaically (and misleadingly) call it, that produces excellent wine. Regardless of preference, the Upper Duoro vineyards are themselves tied to the underlying soil (naturally enough), which is a product of the even deeper lying bedrock that, importantly, is exposed in the steep-sided canyons. This is schist—a hard metamorphic rock that is slow to weather but, when this occurs, tends to break along tabular planes. It is a perfect lithic support for rock art, partly because of its great durability and in part due to its tendency to fracture in flat surfaces that are well suited for engraving. Indeed, as subsequent research has shown, the immediate Cô a Valley area now appears to represent the densest concentration of a larger regional distribution of open-air Paleolithic petroglyphs, constrained by geology:[9] the same bedrock that preserves the ancient engravings in the river gorges is also responsible for the soil that, combined with climate, is the key to Upper Duoro wine—its *terroir*. If I were a Roman, I would likely view the region as blessed by the gods (or, at least, by Bacchus). For, as an archaeologist, I can trace the distribution of these preserved Paleolithic open-air sites by following the distribution of the regional wines. I've followed much worse trails in search of sites during my life.

I went to Côa to see Antonio Fernandes, an archaeologist and rock art conservator who works at the Côa Valley Archaeological Park, headquartered in the small town of Vila Nova de Foz Côa (fig. 8). Antonio is a handsome young man who is articulate, talkative, and engaging, apparently in at least three, if not four, languages. He is a passionate advocate of Côa rock

art, as well as many other things Portuguese, ranging from their history and film industry, to the Duoro region wine and cuisine. Our fieldtrips to rock art sites were interspersed with long lunches at restaurants in town where he (convincingly) demonstrated the quality of the local food and drink, as we talked about archaeology, philosophy, and global politics. As he explained, good meals properly eaten are a significant aspect of Portuguese social life. Social importance aside, they were certainly enjoyable and a welcome improvement over the fish and chips, and tatties and neeps (which I have yet to satis-factorily identify, though I suspect they are related to root crops) that I had eaten the previous week in Scotland.

Our site visits included Penascosa and Canado do Inferno, two of the largest and earliest discovered sites, along with a trek on foot into Ribeira de Piscos—a short distance upstream from Fariseu (the Paleolithic campsite with the partially buried petroglyph panel). In each case the routes required

Figure 8. Portuguese archaeologist and conservator Antonio Fernandes at the Penascosa site, Côa, October 2007.

four-wheel drive as soon as we left the pavement and dropped into the canyons, a function of the instant ruggedness of these small gorges. As an American accustomed to natural (or at least seemingly natural) landscapes, it was a welcome change from the groomed and manicured feel that characterizes so much of Western Europe, a landscape that has been tamed by thousands of years of intensive human occupation. Perhaps not surprisingly—because pastoralism typically occurs in areas that are too rugged or unproductive for farming—we encountered herds of sheep and goats in the canyons, animals that commonly are raised on the margins of farmlands and, unlike cattle, are well suited to grazing on small patches of otherwise unusable land. It was an appropriate introduction to the art, which itself includes a significant number of caprids—some things, apparently, are a constant on a landscape, even after ten or twenty thousand years.

Penascosa is located on the east bank of the Côa River, immediately adjacent to a large, flat river terrace, which creates a kind of broad, parklike beach. While it is possible that this terrace was occupied during Paleolithic times, it sits on a straight stretch of the river and is unprotected from alternating episodes of river erosion and deposition. These have left behind only alluvial soils without artifacts, signaling the inherent impermanence of the past, but also the great luck in finding a preserved site like Fariseu. We will likely never know whether a Paleolithic campsite was once situated adjacent to the Penascosa rock art, although this certainly seems possible. A similar uncertainty pertains to Canado do Inferno, located a few miles downstream, within close sight of the great scar left by the excavations for the now abandoned dam. But the damming and taming of the Côa and Duoro Rivers have in fact involved a long and complex sequence of events; the proposed Côa dam in the early 1990s was only one in a series of water and hydroelectric power projects and is only notable today

because it was not completed. Earlier finished dams, lower on the rivers, had already raised the water level of the Côa well before the construction of its dam began in the 1990s. Some of the engravings at Canado do Inferno were submerged by this earlier inundation and will likely never be reclaimed, and whether it had an associated occupation site cannot be determined. (It is also entirely possible that other rock art sites, including potential major localities, were lost as a result of earlier flooding in the Duoro Valley.) Ribeira de Piscos, in contrast, extends up a small, narrow, and relatively steeply sided minor tributary of the Côa, resulting in terrain mostly unsuited for a village or a camp because it is too restricted in size and/or steep. The association between the rock art and human inhabitation is a certain but not a universal pattern in Côa.

The engravings at the sites are located on a series of small to moderately sized, flat-faced, and vertical panels of the schist outcrops; a schist that stands out (in my previous experience with this kind of rock) due to its subtle but multihued coloring, which derives from almost microscopically thin mineral coatings or skins that have developed over time on the rock surfaces. (Color, and thus beauty, in fact is only skin-deep—on rocks at least.) The tan, yellow, and gold mottled rock faces matched the fall colors of the farm fields higher up on the slopes, yielding a chromatic unity to the landscape as a whole. Perhaps more importantly, they reminded me of the chimerical coats of brindle-skinned animals, sometimes found on cats, cattle, goats, horses, and dogs. Whether this coloring was present twenty thousand years ago is uncertain. Whether it was noted by or influenced the prehistoric artists is also unknown. Regardless, it provides an appropriately colored canvas for the engraved motifs. Knowing the possible skin tones of many of the depicted animal species, I couldn't help but think that the color played a role in the creation of the art and that, even though the petroglyphs were cut and pecked

into the rocks, they were intended as more than simple mono-chromatic images.

The most remarkable aspect of the Côa petroglyphs, as many archaeologists had argued all along, is their striking resemblance to the paintings and especially engravings in the dark-zone Paleolithic caves (figs. 9 and 10). To the degree that an engraved motif made by one artist can resemble another, created hundreds of miles away and potentially a few thousand years earlier or later by a second individual, the Côa motifs are essentially identical to those at the French and Spanish sites. Although the archaeological community had gone out on a limb by arguing, in the absence of any other kinds of evidence, that the Côa sites were Paleolithic, they had stood on a strong and solid branch. Once additional archaeological data were obtained, their speculation proved entirely correct.

Figure 9. Close-up of the head of an auroch, from the Penascosa site, Côa, Portugal. The sharp, seemingly unweathered engraved lines initially caused some archaeologists to doubt the age of these petroglyphs as Paleolithic.

Yet this circumstance left me, as a scientist, a bit disquieted. In truth, it was simply a gut reaction, which is to say an emotional rather than consciously analytical response to the art. Archaeologists have discussed, debated, and defined the concept of style for over a half century, including specifically the supposed stylistic sequence for Paleolithic art. The intellectual history of this concept in anthropology and art history extends back even further, at least one hundred years.[10] Despite this fact, and even though archaeologists have written at length about what style is supposed to mean, how it can be identified, and the ways it should be analyzed, little of this intellectual ammunition was (or, practically speaking, could be) brought to muster at Côa. (Decades of academic debate notwithstanding, we still lack any systematic and replicable way of defining and interpreting this aspect of artistry.) Those initially

Figure 10. A goat engraving from the Penascosa site, Côa, Portugal. This image is superimposed on an earlier, more crudely pecked motif, perhaps a small horse head toward the rear of the caprid. Superimpositions such as these are common in shamanic rock art.

in favor of the Paleolithic age of these engravings really reduced the argument to its simplest form: the engravings *looked* very much like other examples of Paleolithic art, therefore they *must be* equivalent in age. The circumstance reminded me of the old saying, "If it looks like a horse, and sounds like a horse, it is probably a horse."

And in this case, it certainly was; a fact that underscores the continued ambiguity between art and science. Art certainly is science's foil and if there is a valence between these two expressions of the human spirit (there must be), it remains elusive. It is that big fish that, once in awhile, strikes your bait, only to move on quickly before you can tease it with more line, lingering just long enough to let you know that there is still something worth catching. The elusiveness of the art and science nexus is, for me, exactly its appeal, and a large part of what makes the Côa petroglyphs so intriguing.

The other remarkable aspect of the Côa petroglyphs is their seemingly visual familiarity. There is nothing exotic, unusual, "tribal," graphically remote, or (superficially at least) mysterious about these engravings; that is, aside from their aesthetic mastery, which of course is itself exceptional. They are instead seemingly straightforward representations of horses, goats, deer, aurochs, and other species. Despite their great antiquity, they lack an obvious aesthetic distance—again, partly a reflection of that ambiguous but real concept of style—that characterizes most non-Western and/or noncontemporary arts. Indeed, the unambiguous realism that is partly their hallmark contributes a robust kind of accessibility, making them less foreign appearing than many more recent arts. (Here I immediately think of the Bronze Age petroglyphs of the French and Italian Alps or even early Western European medieval art as two obvious comparisons. Both are closer to us, culturally and chronologically, but visually much more foreign than these Paleolithic images.)

This sense of familiarity is, I believe, enhanced by their setting. I notice this familiarity at Côa, but not at Chauvet or Lascaux, because (I believe) the Portuguese engravings are open-air, where their visual realism cannot be overwhelmed by the otherworldly realm of the caves. (I recognized for the first time from my Côa experience that the French and Spanish caves dominate the art that they contain.) Yet this accessibility does not diminish their mystery and, in many ways, it seems instead to enhance it. The Côa petroglyphs are enigmatic partly because of the paradox that they present: an art that seems to contain no puzzle at all, yet in fact is almost wholly unknown. They are the long familiar but entirely mysterious next-door neighbor, the one who apparently trumps outward appearances with a hidden and secret life. What is that secret life in the Côa engravings, the life that lives behind the deceptive familiarity of these animal motifs?

This issue of course ultimately turns on the origin and meaning of the engravings: who made them, why they were created, and what they were intended to symbolize? Antonio had deftly skirted the conversation around this topic as we visited the sites, using what I suspect was a kind of diplomatic dodge. He has taken many archaeologists, with many different opinions, to these sites and likely has recognized the futility of debating his own ideas with his visiting colleagues. As a rock art conservator, primarily concerned with the care and management of the sites, he has a legitimate professional justification for shying away from interpretation.[11] Yet at the end of the day we traveled to the highest peak in the area, capped by a small but well-kept, white-walled, and red-tile roofed chapel, one of many similar Catholic shrines visible on each of the high prominences in the region. It demarcated a kind of religious organization to the contemporary countryside—a modern, sacred landscape begging a comparison with a similar, much more ancient ritual landscape created by the

engraved rock faces below. This setting, which gave a magnificent perspective of the gorges and rivers and the rolling upland fields and towns in between, begged the interpretive question about the rock art. Antonio, standing before this vista, could not help but raise it, despite, I think, his mannerly efforts to avoid archaeological debate. I drew from three sources to offer him my explanation.

The first source was the art itself. Although the engravings embody a kind of realism that seems to belie a hallucinatory origin, visionary imagery in fact takes many forms (as David Lewis-Williams's neuropsychological model illustrates so well). One compelling and common characteristic of the Côa engravings, typical of trance-derived images, was the absence of any concern with real-world composition. Many of the panels instead are covered with a bird's nestlike confusion of lines, caused by the repetitive engraving of one motif after another. They show little regard for what was already present, how it was oriented, and how the latest motif was arranged with respect to any normal ground line or horizon. The importance of this characteristic was enhanced by the fact that many of these motif welters were immediately adjacent to pristine rock faces, ostensibly perfect for engraving, yet which bore no trace of use. The artists were clearly reacting to specific rock panel faces, in a fashion that denied any overt concern with signaling to the outward world. It gave me the sense that, with their drawings, they were talking to the rocks and creating a kind of internal visual message, not communicating with the people they lived with or who might at some point pass by.

This sense was enhanced by a second characteristic of the Côa engravings, also typical of shamanistic rock art, including the Paleolithic caves. This was the incorporation of features in the rock face as parts of the motifs.[12] Here there was a kind of composition at play, but it was again an interaction with (or reaction to) the rock face rather than a composition defined by

ground lines, horizons, and perspectives. I could imagine a shaman, initiate, or supplicant in an altered state staring at a panel face and visualizing an image on the rock surface. Partly motivated by the natural form of the schist panel, he or she would not so much be drawing a design on a blank slate but drawing out what they already perceived as present. Like much shamanistic art, the Côa petroglyphs seem to be *manifestations* rather than renderings, made all the more aesthetically remarkable by the graphic realism that the artists captured in the rock faces.

These two factors, combined with occasional geometric/ entoptic designs, seemed sufficient in my mind to argue for a shamanistic origin for the Côa art. Yet I could add to these formal characteristics their larger prehistoric cultural context, which also seemed supportive, if not equally compelling, in two separate ways. To the degree that the larger archaeological record—the specifics of stone tools, habitation sites, and life-ways—signals culture (and archaeologists generally believe that it does), the creators of the Côa petroglyphs were part of the larger group of people that was responsible for painting and engraving the caves. Due to this cultural connection, it only followed that the Côa art was shamanistic, given the same interpretation for the cave art.

Yet subtle variations in the nature and location of the Côa rock art further emphasized its equivalence to the cave paintings and engravings. As archaeologists had acknowledged since their discovery, the open-air petroglyphs are very similar in style and in content to the art found in the caves, despite some differences in the Côa bestiary relative to the caves in France and Spain, which are attributable to variations in the ancient climates and resident animal species in the different regions. The two arts are also similar in less obvious but poten-tially equally important ways. One of these involves variations in the kinds and placements of the motifs. Although our atten-

tion is always captured first by the large, beautifully rendered motifs, regardless of whether painted or pecked in a dark-zone cave or on a schist-covered hillside, Paleolithic sites commonly have numerous smaller, sometimes poorly produced images, often in less visible or accessible spots. Not all of this art, after all, consists of aesthetic masterpieces. At Lascaux, these are the hastily scratched designs in the small and cramped galleries beyond the great Salon of the Bulls. In some cases, palimpsests of animals and geometric signs commingle in a seemingly frenzied and random fashion, almost a graphic splash against the cave walls. Perhaps not surprisingly, I discovered similar variation at Côa when Antonio took me to a heavily fractured exposure of schist at Ribeira de Piscos, at the confluence of this small stream and the Côa River.

The unusual weathering of the schist at this location resulted in a large series of small staggered panels, each roughly the size of an adult hand, laid flat. It is an outcrop that is markedly discordant from the regularity and size of most of the other rock exposures in the region and probably not one, given this fact, where rock art would be expected. Yet almost all of these small panels contained one or more engravings, many lightly scratched, some relatively crude, others drawn to conform to the shape of their small rock canvas, some superimposed on top of others. These motifs were created, some in more haste than others, but none apparently with much intent to be seen. (Some art, even at open-air and seemingly "public" sites, may be quite "private" in effect, if not intent.) As with the crude engravings at Lascaux,[13] these appeared to be the work of initiates or supplicants, perhaps inspired by the visions of the supernatural manifested, with much greater visibility and artistic skill, on the larger panels.

Regardless of exact origin, the small, often crude and out-of-the-way engravings are another point of similarity between Côa and the cave art, but not the final one. I found this instead

in the human figures, which were surprisingly common at Côa but very difficult to see (and impossible to photograph), because they tended to be lightly scratched into the schist. Although human figures are rare in Paleolithic art,[14] about a half dozen have been found at Côa. The dramatic human-animal conflations at sites like Chauvet, Lascaux, and Trois Frères—shaman figures, almost certainly—are well known and often illustrated. But these conflations are exceptional, with the majority of Paleolithic human images, like those at Côa, consisting of seemingly hastily drawn, sometimes incomplete, sketches. They are more like caricatures or cartoons drawn by a good artist, and their significance (unlike the conflations) is not well understood. That Côa shared this somewhat obscure and often overlooked kind of Paleolithic imagery speaks again of the cultural continuity between this open-air art and that found in the caves.

Antonio was of course aware of many of these similarities, since they were the basis for the original argument in favor of preserving the Côa sites. ("The earliest expression of the EU," he labeled the art, referring to the European Union. This was a circumstance made all the more ironic, as he explained, because the then recently enacted EU regulations required environmental assessments associated with the proposed construction of the Côa dam, which contributed to the preservation of the sites.) But it did not answer the real question, which concerned the caves themselves: how could open-air engravings on schist panels, sometimes with adjacent campsites and sometimes without, possibly have the same origin and meaning as the art found in the dark-zone recesses of limestone caverns? Context is a key to interpretation for most archaeologists and the context of these two kinds of sites—their physical settings and the kinds of archaeological remains (if any) found associated with them—were seemingly too distinct to suggest an equivalence in symbolism or purpose. Yet my long years

working with Native American ethnography and contemporary Indian consultants, my third source of information, had caused me to recognize that context is far more complex than archaeology tends to allow, and that there was no necessary contradiction in both kinds of art having similar origins.

It would of course be a mistake to blithely apply North American tribal practices and beliefs to the Paleolithic art because the temporal, geographical, and historical divide between them is so great. Yet the opposite approach—paying no attention whatsoever to the ethnographies of traditional, non-Western tribal peoples—is much worse. It results in a kind of "science" fiction (as I like to call it), undertaken with a misplaced sense of objectivity and intellectual distance, that is inculcated by unrecognized modern biases and naive assumptions about human nature. (The myth of the "economically rational man" is probably the worst of these, but at least this only brands 49 percent of the human population with this simplistic quality.) Native American and other sources of ethnography are essential to interpreting even the earliest art, not because they contain specific answers to our questions about symbolism and meaning, but because they give us a range of ideas and possibilities concerning why this art may have been made, somewhat independent of twenty-first-century Western thought. The ethnographic sources do not provide the interpretations but they do provide guides. And they are a surer source of information and inspiration about prehistory than many archaeologists have yet acknowledged.

What I know from my studies in western North America is at once simple, yet extremely complex. Shamanistic religions in these cultures were unified by a series of general tendencies and patterns, yet also divided by substantial local variations and distinctions.[15] In southern Ca lifornia, south of Los Angeles, for example, Luiseño tribal shamans painted rock art to depict their supernatural visions, often in slightly secluded

small caves or overhangs; young girls also painted their spirit helpers at the conclusion of their group puberty initiations on open boulders, usually above and visible from the villages (fig. 11). Although the color and form of the shamans' pictographs varied, the young girls' paintings were invariably red and typically consisted of either rattlesnake designs (the preferred spirit helpers, in a gender inversion, for females) or handprints. In the Chumash region north of Los Angeles, and among the Yokuts in the southern Sierra Nevada, in contrast, only shamans painted rock art. This was elaborately psychedelic, often multicolored, and commonly found in the middle of large villages. Despite this last fact, the pictograph sites (called "shamans' caches," where they were believed to store their power and ritual paraphernalia) were considered private places owned by individual shamans. Villagers were warned to avoid them and the shamans whenever possible.

Not all rock art in this region was painted, however. The petroglyphs of the Coso Range, in eastern California, provide a useful comparison to the painted caves and shelters of the Chumash and Yokuts. The Coso petroglyphs, like the Côa engravings, are found in open-air canyons and cliff faces. They were only made by shamans (as noted previously) on solitary vision quests and, like the rest of the shamanistic rock art in the far West, they were intended to depict visionary experiences. Much like Côa, some of the petroglyphs (about 25 percent) are adjacent to villages, while others are more remote. Yet any locational association (or lack thereof) had no bearing on their purpose, symbolism, or meaning. The locally resident Shoshone were mobile hunter-gatherers, probably much like the Paleolithic inhabitants of the Côa region, and their camps were occupied only seasonally. An individual shaman could easily engrave a petroglyph adjacent to a village site in complete isolation when the village's inhabitants were, seasonally, elsewhere. And multiple shamans, some coming from great distances, could use any

Figure 11. Not all shamanistic rock art was made by shamans. This example of red pictographs is from an open-air boulder near Perris, California. It was painted historically by girls during their puberty initiations and shows the spirit helpers they acquired during these rituals. Rattlesnake spirit, symbolized by zigzag and diamond chain designs, was the most common. Handprints show that they had touched the sacred—the rock face that separates the natural and supernatural realms.

site for vision questing because there was no sense of rock art site ownership. This could take place despite the fact that many of these shamans also served as band-headmen with religious and political authority perfectly conjoined.

The shamanistic egalitarianism suggested by the lack of site ownership in the Coso Range was even more pronounced on the Columbia Plateau, where all members of society made rock art at different stages of their lives. Shamans of course painted or engraved rock art during their vision quests. But so did young boys and young girls on their own individual quests at about the onset of puberty. And so did adult non-shamans subsequently, at later stages in their life, during so-called life crises (perhaps after the death of a child or spouse or after a bad string of gambling luck). Rock art is particularly common in this region, to be sure, because its creation was (and likely continues to be) a relatively commonplace occurrence.

Shamanistic rock art was created in each of these cases, in the sense that this art reflected shamanistic beliefs and practices. Central among these are the ideas of accessing the supernatural world through an altered state of consciousness, acquiring supernatural power through this experience (usually in the form of a spirit helper or guide), and (probably slightly subsequently) portraying the visionary experiences themselves. Yet the individuals responsible for making the art varied, in terms of age, sex, and social position, from local culture to culture. In far western North America, at least, the variability in shamanistic rock art is at least as great as the differences between the open-air art at Côa and the paintings and engravings in the dark-zone caves. I could see no good reason why a shamanistic interpretation should be precluded for Côa, based on context alone, whereas a variety of lines of evidence supported this explanation.

Antonio seemed persuaded by this argument (though perhaps he was simply being polite). Still, he clearly grasped the

point when he observed that, "Really, what you are saying is little different from arguing that the art is religious." And this is exactly correct, although a specific kind of religion is involved—or more correctly, a religious system, because it involves no single set of practices, rituals, or creed, nor is there a single reason why this art was made. Identifying Côa as shamanistic, despite its contextual differences with the French and Spanish caves, is similar to making an argument about Judeo-Christian art, which encompasses Jewish, Catholic, and Protestant expressions, and all of the variations (temporal, religious, and functional) that these include.

That the Côa engravings are likely shamanistic is not then a conclusion so much as a starting point for analysis and a framework for future study, especially with respect to the larger question of the origins of art and belief. And what this analysis requires is not additional study of the art but a resolution of the problems concerning rock art dating, combined with a much better understanding of shamanism itself and how it relates to art.

RESOLVING DORN

Standard archaeological techniques—excavations, artifact analyses, and dating—resolved the Côa controversy to all parties' satisfaction by 1999. Clearly, this art was Paleolithic in age and it constituted an important aspect of world heritage. Moreover, there is good reason to argue that it was shamanistic in origin, and thus a parallel to the early art—and expressions of religion—at sites like Chauvet and Lascaux Caves. But this does nothing to clarify the many lingering questions concerning petroglyph dating. Could open-air engravings be dated chronometrically, without overlying archaeological deposits, as at Fariseu? Were any of the previous petroglyph age estimates

valid? Was there legitimate evidence for Ice Age rock art in North America? C ould any varnish dating techniques be applied to the earliest engravings elsewhere in the world? And perhaps most importantly, if Dorn had not really cheated, what were the implications of the ostensibly plausible allegations made against him? At stake here were not just a series of significant scientific issues but also the personal trust that I had placed in a colleague, and a friend, for almost two decades.

Support for Dorn's honesty was of course provided by the ASU and NSF investigations. Within the carefully worded legalese of the NSF close-out memo, Dorn had been exonerated of any wrongdoing.[16] But there were lingering doubts. The resulting widespread assumption was that Dorn had been cleared on a legal technicality—a conclusion that the confidential nature of the investigations themselves helped promote.

Making matters all the worse, Dorn was derided for filing the defamation lawsuit against his accusers. One commentator stated that his litigation could "have a very serious chilling effect on the publication and debating of results."[17] The academic community's disdain over the suit was perhaps exacerbated by the legally mandated silence resulting from it and the uncertainty that resulted. But the exact purpose of a defamation lawsuit is to stop allegedly damaging statements; predictably, neither side would (or perhaps could) talk about the case.

The silence reached a kind of muted crescendo in March 2001, when it was announced that Columbia University, and then the University of Arizona, had settled with Dorn out of court, prior to the trial. The nature of these settlements has never been revealed and they apparently stipulated confidentiality on the part of all parties. Dorn has not revealed the terms of his settlement to me nor (insofar as I am aware) to anyone else. But one published report indicates that the Columbia University settlement alone involved an amount between $30,000 and $70,000, paid to Dorn; the total Dorn

received from Columbia and Arizona is rumored to exceed five figures.[18] Regardless of amount, the general outcome was clear: Dorn may have been officially exonerated, but he was still widely considered guilty—at the very least of bad scientific work, if not outright fraud.[19]

Yet Dorn had been fully exonerated after a very lengthy investigation. That I had a vested interest in all of the details of this case was also obvious: the allegations against Dorn had clear implications for rock art dating, including petroglyphs that I had argued represented the earliest art in the Americas—and I hoped to use these techniques in other parts of the world, where the ultimate origins of art might be found. What exactly was the evidence that, putatively, demonstrated Dorn's innocence and why had it been so convincing? I found this information in the basement of the Jackson Street annex of the Maricopa County Superior Court, the repository for the now public records from Dorn's defamation suit.[20]

The Jackson Street annex is a desultory example of institutional architecture: a red brick-faced office building/parking structure combo whose only notable feature is the Arizona Diamondback's baseball stadium at the end of the street, visible from the front entryway. Inside the annex, and especially at the customer service center in the basement, the oppressiveness of legal entanglements seemed to hang in the air, only partly due to the low ceilings and minimal lighting. (No home runs would ever be hit in here, I remember thinking at the time.) When I arrived, the legal documents from 2001 were being scanned. But I was handed the hard copy that was then still available, consisting of ten cardboard "volumes" of papers, and allowed to examine them at one of the many worktables in the room.

Dorn's affidavit[21]—in fact his allegations against his accusers—was the obvious starting point, once I got beyond the procedural filings and counter-filings that are the froth of litiga-

tion. Perhaps understandably, the affidavit read partly like a scientific paper. Like a journal article, it was meticulously footnoted and supported. Much of the evidence consisted of e-mail correspondences between the University of Arizona, Columbia, and Zurich scientists, and their lab notebooks, originally subpoenaed by the NSF. But the backbone of Dorn's argument was the ASU investigating committee's analyses and findings.

Dorn raised the scientific issues in his affidavit initially by confronting the veracity of the claims published in the 1998 *Science* article[22] that, some felt, demonstrated Dorn had been cheating. This started with the two distinguishable types of organic matter that were putatively present in Dorn's samples. The ASU investigating committee had previously and independently examined the University of Arizona scientists' lab notebooks, as Dorn pointed out in his document. These showed no evidence that a consistent admixture of the two organic carbon types was present in his samples. The ASU investigating scientists in their report had concluded to the contrary that:

> While most of the samples [the University of Arizona scientists] examined contained type II material (44 out of 53) only about 1/3 contained both type I and type II materials (17 out of 53). . . . This indicates adulteration could not have taken place through mixing of type I and type II materials.[23]

That there was no consistent admixture of the two carbon types alone might have been enough to demonstrate that Dorn had not fabricated his sample. But it was also claimed that the two types of organic matter were distinct in age and that the charcoal-like material was always younger than the coal-like carbon. In Dorn's affidavit, he demonstrated that the evidence did not support this related allegation. Referring to the 1998 *Science* paper, Dorn noted that:

Defendants presented eleven radiocarbon dates in Table 2 of the Article. These dates were presented to prove to the scientific world that I had falsified my radiocarbon samples. . . . Defendants purposefully omitted from the Article eleven more radiocarbon dates, nine of which they themselves had found, as documented in their own lab notebooks, or included in other publications, including earlier drafts of the Article. These eleven omitted radiocarbon dates disproved Defendants' claim about the Types I and II materials in my samples and showed I did not falsify my radiocarbon samples.[24]

Most of the radiocarbon evidence omitted from the *Science* article was annotated in the subpoenaed lab notebooks, as the ASU committee verified.

Another serious allegation against Dorn concerned the claim that there was a close correlation between his varnish dates and preexisting control ages—that is, that his dates matched those obtained by independent analyses. Evidence in support of this claim had been presented to the NSF and the ASU investigating committee but never published.[25] The implication of this allegation was clear: if the irregularities in his samples were natural rather than intentional, Dorn's chronometric results should not favorably compare to preexisting dates on the same landforms or samples. Dorn summarized the results of the ASU investigation (chaired by Professor Robert Blankenship) of this allegation, appending Blankenship's analysis to his affidavit, as follows:

The Blankenship/ASU analysis of the [presented evidence] documents that 50% of [the presented] data points represented different types of fabrications, falsifications and misrepresentation [*sic*] of the published literature. Defendants' errors ranged from simple arithmetic errors, to completely fabricated empirical dates, to non-existent control dates, to the use of inappropriate control dates, to the inclusion of

control dates that did not exist when my empirical work was conducted. . . . The Blankenship/ASU analysis further notes that all but one of [the] fabrications and falsifications skew data in one direction only: towards a tighter fit between the putative ages of my samples and the pre-existing target controls. Negligent error would go in both directions. Defendants' errors went in one direction.[26]

The allegations against Dorn clearly had been specious, as the evidence in the Jackson Street Annex made clear. He was exonerated by ASU and the NSF, and Columbia and the University of Arizona settled the defamation lawsuit before it went to trial for straightforward reasons. There were no technicalities involved, as the scientific world assumed. Yet there was one final question that came to mind, as I went through the pile of documents from the legal case. This concerned a basic issue: how could a scientist of Dorn's talent and intelligence make a mistake so grave and not realize sooner that his dating technique might not work? Why hadn't he examined his samples to see whether the organics were homogenous or mixed? How could he have overlooked this issue for so many years?

If there was any poignancy to be found in the lawsuit paperwork, it is in a single page, legally annotated as document ASU 02686. This is a cover letter, dated 1991, from the ASU Office of Research, sent to the NSF. It was the first page of a research proposal and application for a project that was never funded. The title of the project was "Assessing Distortion of Radiocarbon Ages of Rock Coatings by Non-Contemporaneous Materials." Dorn was identified as the principal investigator.

Dorn had been attempting to determine whether or not varnish organics might be heterogeneous, and whether the WRO AMS dating technique could be used with confidence, at least since 1991. The Côa project apparently was the first funding opportunity he had to resolve this question, though

not due to an earlier lack of trying. Moreover, Dorn's publica-
tions from the early 1990s contain clear statements concerning
his assumption about the contemporaneity of varnish
organics, cautioning the scientific community that confidence
in his results rested on this point. These cautions became more
pronounced as his research progressed and as he obtained
increasing numbers of microphotographs of subvarnish
carbon of different kinds.[27] Contrary to what his accusers
claimed, and what many in the scientific community chose to
believe, Dorn had not covered anything up at all.

RESOLVING COSO

Left unanswered in these debates and controversies was
another archaeological result of Côa: the uncertainty over the
other two petroglyph chronometric techniques, CR and VML
dating, and the many results that they had previously yielded.
These dates were important to regional research but they also
had significant implications for global issues. One of these,
noted above, is the relationship of Old and New World
shamanism and what this might imply about the origin of art
and belief more generally. Another concerns the fact that there
are numerous regions in the world with potentially very
ancient engravings that are still undated (Africa in particular,
but also Australia and Asia). Any hope for a detailed under-
standing of the origin of art and belief partly, maybe entirely,
depends on a reliable petroglyph dating technique.

Although CR dating has been independently replicated by
six different labs worldwide, it was invented and initially pro-
moted by Dorn and was unfairly tainted by that association.[28]
This was due to the widespread but ultimately disproved belief
that Dorn had been conducting fraudulent research; in part it
resulted from the fact that, while he was still using WRO AMS

dating, Dorn used the varnish radiocarbon dates as controls to calibrate specific C R applications. Those calibrations were obviously wrong, given the admitted problems with varnish radiocarbon dating, and the resulting dates were incorrect.

Dorn had also invented VML dating, though he had turned over research on this method to his former student, Tanzhuo Liu, who was working at Columbia University with Wallace Broecker at the time that the allegations against him were raised—a distinction and circumstance that few archaeologists appreciated. Although Liu and Broecker continued to make headway with the technique, their research emphasized paleo-climates and landforms, resulting in papers concerning topics that archaeologists never read. Further, VML dating was initially limited by the fact that it could be applied only to the Pleistocene era. This, too, kept it beyond archaeological visibility where, in North America, most of the archaeological record dates to the last eleven thousand years. A resuscitation of petroglyph varnish dating was clearly needed. This has recently occurred through a conjunction of circumstances, stemming from Liu's advances with the VML technique.

Our initial approach was to recalibrate our original Coso Range and Mojave Desert CR dates, eliminating the varnish radiocarbon ages that the earlier calibrations had included. This revised our results, downward in many cases, making the engravings younger than initially thought.[29] But varnish radiocarbon dates were only some of the calibration points and, even with these eliminated, the same temporal trend existed. Dorn and I were still left with a handful of pre-Clovis CR ages, including the twelve-thousand-year-old camelid in the Rodman Mountains and the approximately fifteen-thousand-year-old concentric circles in the Cosos (discussed in chapter 3), both of which were verified, at least provisionally, by their VML microstratigraphies. Recalibration of the CR curve changed our individual results but did not alter their implica-

tions. If varnish dating worked—and I believed that it did—there is pre-Clovis rock art in the Americas. But we needed stronger evidence demonstrating that CR and VML are reliable dating techniques.

This has recently been provided by Liu. He first completed a blind test of the technique, matching his results on geological samples against another chronometric method. The close match in the two sets of results demonstrate the accuracy of VML dating.[30] Next, following a decade of tedious lab work, he calibrated the Holocene (or last ten thousand years) portion of the VML microstratigraphic record, extending the potential applicability of the technique across the entirety of the North American archaeological record.[31] His Holocene calibration does not have a direct impact on our putative pre-Clovis ages because they predate the Holocene. But the Holocene microstratigraphy is critical because it allows us to verify our younger CR ages. These are much more numerous than the possible earliest dates, and cross-checking them against the Holocene VML calibration provided an opportunity to substantially strengthen confidence in the CR technique as a whole. The indirect impact of the Holocene calibration on our earlier dates, in this sense, is very significant.

I sent Liu sixteen varnish samples from petroglyphs that Dorn had previously CR dated. Liu received these blind, in the sense that he did not know where the samples were from or what the age estimates on any of them had been. His results all fell within one standard deviation of Dorn's previously obtained CR dates, confirming that the two techniques yielded the same ages.[32] These dates range from 12,000 ± 600 to 250 ± 100 years ago. They are strong support for a very lengthy rock art tradition that started by the end of the Pleistocene and continued into the relatively recent past. They also confirmed the utility of CR dating.

Despite the debate and contentions resulting from Côa and

the Dorn controversies, there continues to be evidence, and I believe good evidence, of great antiquity for New World shamanism. As implied previously, there is no indication of any discontinuity in rock art production in the Coso Range and Mojave Desert, in terms of the motifs created, the style of these images, or the sites where they are made (and thus where the rituals were performed). Although the relative proportions of the images change somewhat over time (with an increase in human figures), the mix of geometric/entoptic and bighorn sheep is present throughout the sequence.[33] The primary fashion of rendering the bighorn is also constant (for at least a twelve-thousand-year period, according to our dates), on a number of key features: body and head in profile, tail pronounced and upraised, and horn racks shown unnaturally, drawn as a set of concentric half circles. This last trait reflects the incorporation of a common entoptic light image (concentrics and spirals) into an iconic image: the construal of the geometric designs perceived during an altered state into a culturally and personally meaningful representational design. Since these kinds of construals are characteristic of the mental imagery of altered states, this supports the long-term shamanistic origin for the art (which is confirmed, during the historical period, by Native American accounts). Further, the horns signal that these are almost all adult male sheep: bighorns are neoteness, meaning that they retain juvenile features into adulthood. Females never grow the large and magnificent racks shown on the engravings, and males only develop these with the onset of sexual maturity.

The enlarged and raised tail posture is particularly important. Unlike deer, sheep do not "turn tail and run," and males keep their small tails flat against their rumps most of the time, except in two primary circumstances: while defecating and at death (due to rigor mortis). Combined with the fact that certain sheep are shown impaled (one even speared, bloated, and

belly up), these are depictions specifically of dead sheep. "Death" was the primary metaphor for a shaman's trance (falling into an altered state having a series of physical and physiological analogues to mortal death). Because a shaman and his spirit helper were considered indistinguishable, and because bighorns were thought important spirit helpers, these images appear to depict a shaman/bighorn spirit helper, in the supernatural world of trance.[34] A number of the bighorn motifs are also portrayed not with the natural cloven hooves of real sheep but with plantigrade feet—flat-footed, as only humans really are. These are human-bighorn conflations suggesting that, for at least twelve thousand years, Coso artists created petroglyphs of "killed" shaman/sheep; that is, in the supernatural realm.

Evidence for this long-term continuity is present in another, much more material form, resulting from the way that the petroglyphs themselves were created.[35] The same kind of stone tools (quartz hammerstones) were used to engrave the petroglyphs during this twelve-thousand-year period. Although quartz is particularly hard, almost any kind of rock can be used to create a petroglyph, even basalt on basalt. We identified the selective use of quartz implements through an analysis of the microscopic bits of foreign materials present in the engraved-out portions of the motifs, in quartz-free basalts. The use of these specific pecking tools is related to the widespread association between shamans and quartz crystals. These are frequent components of shamans' ritual paraphernalia, often called "power objects." The shamans' use of and association with quartz is based on its *triboluminescent* properties: when quartz is struck or abraded in darkness (especially by another piece of quartz) it will glow. Native California shamans broke up quartz rocks on their quests for visions so that, they said, the power released by the quartz would enter into them and enhance their own potency. (In addition to the

microscopic quartz grains left by their hammerstones in the pecked-out portions of the petroglyphs, we also sometimes find piles of broken quartz at or near rock art sites.) Ritual officials among the Puebloan farmers in the Southwest, in slight contrast, believed that rubbing quartz rocks together, which they called "thunderstones," would create rain. The ritual significance of quartz, regardless of the specific ceremonial purpose, was common if not universal throughout the Americas.

(There is a relevant story here. After we discovered the association between petroglyphs and quartz hammerstones and deciphered the significance of this quartz use, I gave a series of lectures across the country on the origins of New World shamanism. After showing microphotograph slides of the quartz grains, embedded in the petroglyph grooves, I would pull out two quartz rocks, turn off the lights, and rub them together, creating a small but dramatic glow—always a crowd pleaser—to show why quartz was significant to shamans. As a scientist, I know that what ensued was entirely coincidental: it always rained, regardless of where I was talking and what the local weather forecast and conditions had been. Surely this is pure coincidence, but after my third weather-related flight delay following one of these lectures, I decided it was time to lecture on another topic; I hate being delayed while traveling.)

The ultimate cause of triboluminescence is the effect of cosmic radiation on the quartz that knocks electrons in the quartz atoms out of orbit. The mechanical shock created by rubbing, pounding, or abrading provides force allowing these electrons to cascade back down to a ground state, releasing photons—light energy—in the process. This, to Native American shamans, was a manifestation of supernatural power, the driving force of and the ultimate causal agent in the universe. Although Native American shamans knew these properties of quartz for thousands of years, triboluminescence was only discovered for Western science by the Curie brothers in the 1880s.

Our scientific explanation for this phenomenon (also called piezoelectricity) is a change in the quartz at the atomic level.

Regardless, the selective use of quartz hammerstones for petroglyph manufacture, since the Pleistocene, is one in a series of lines of evidence arguing for very early shamanism in the Americas.[36] This conclusion has a series of implications, not the least being the general support it gives to the idea that shamanism is a very ancient religion—a long held idea, but certainly now supported in the Americas by this evidence, augmenting that found in Western Europe in the Paleolithic paintings and engravings. More intriguing is the problem mentioned earlier concerning the implications of the early American ages for shamanism with respect to the relationship of Old and New World shamanism.

OLD AND NEW WORLD SHAMANISM IN LIGHT OF THE COSOS

Shamanism has fascinated the Western world since the first reports of Siberian and North American indigenous ritual practices appeared in Europe. The late German scholar Gloria Flaherty has shown how notions about Siberian shamanism became deeply incorporated into Western art and literature in the eighteenth century as a result of these accounts, including especially in Goethe's *Faust*. At the same time, early ethnographers suggested shamanism as a link between the Old and New Worlds.[37] Substantial European research has been conducted subsequently in order to identify the origins of Siberian shamanism, much of which has been directed toward the linguistic foundation for the term "shaman," as well as possible Oriental influences in the rise and development of this northeast Asian religious complex.

Although contrasting opinions have resulted (naturally),

consensus has been achieved on two issues. The term "shaman," which entered the ethnographic literature from studies of the Tungus peoples in Siberia, is a loan word from another language, perhaps Sanskrit. The implication is that Siberian shamanism itself is a derivative phenomenon, not an intact relict of Paleolithic practices. In support of this first point, there is consensus that shamanism is relatively recent in this region. Historical accounts of it (from neighboring but literate peoples, such as the Han Chinese) extend back only about two thousand years. Archaeological evidence for northeast Asian shamanism, revealed in rock art, grave goods, and occasional other ritual artifacts, roughly doubles that antiquity, pushing it back to about four thousand years ago, toward the start of the northeast Asian Bronze Age. Although archaeologists working in the region suggest that it is probably older and may have developed during the terminal portions of the Neolithic period (perhaps around 5,000 YBP), they are certain in their conclusion that it is a later rather than primordial religion.[38] Although few American researchers have recognized this fact, "classic" Siberian shamanism, at least, could not possibly have served as the source for New World shamanism since it developed five to ten thousand years *after* the Americas were settled, as the Coso dating evidence also suggests.

The North American academic tradition concerning shamanism has emphasized slightly different issues. At the turn of the nineteenth century, substantial interest existed in the cultural relationship between the New and Old Worlds. This caused the founding father of American anthropology, Franz Boas, to initiate the Jesup North Pacific Expedition, in order to investigate the indigenous groups in Siberia and the Pacific Northwest. Boas concluded that there had been three stages of cultural and demographic change in the region. The first was an initial Beringian migration into the Americas—the first peopling of the continent. This was followed, at some

unspecified later date, by a back-migration of American cultures into northeastern Siberia. More recently, an Inuit/Eskimo cultural "wedge" moved from east to west across the North American arctic, from their original area of development in northern Canada.[39]

American anthropological interests subsequently shifted away from questions concerning the origins and diffusions of peoples and cultures, so the explicit concern with the relationship between the two regions diminished. One outcome of this earlier research, however, was the recognition that "Siberian shamanism" was a circumpolar rather than just a northeast Asian phenomenon.[40] It was recognized as stretching from the Saami (or Lapps) in arctic Norway in the west, to Greenland in the east, and southward in North America (at least into the subarctic woodlands) where it was practiced especially by Algonquian-speaking tribes.

I use the term "Siberian shamanism" here in a specific sense, setting it slightly apart from the more generic definition of shamanism that I (and many other authors) have used previously. Although Siberian shamanism shares numerous traits, beliefs, and practices with shamanism worldwide, it also has a few distinguishing traits that are not found in other manifestations of this religious complex, including, for example, in the shamanism practiced by the Native California tribes that I have studied. The two most notable of these are the "shaking tent séance" and the shaman's drum. The shaking tent séance was an initial part of the shaman's public ritual performance: he or she was secluded from the audience in an enclosure and, while hidden from view, received spirit helpers—a slightly secretive event accompanied by substantial vocalizations and bodily movements, signaling entry into the supernatural— prior to the more public healing ceremony. The drum was used in this and other ceremonies to call the spirits and to transport the shaman into the supernatural. It was a broad but shallow

tambourine-like instrument played with one stick, usually single headed and with a crossbar handhold across the back. It was often painted, like much of the shaman's ritual costumery (and like much rock art), with depictions of spirit helpers.

Shamanism, as practiced ethnographically by Siberian tribes, differed from the exact expression of shamanism on some minor points, again, with much of Native America, and with shamanism in other parts of the world, such as San or Bushman shamanism. But it is important to underscore how similar it was to the shamanic practices in the arctic and subarctic woodlands in much of North America (hence its recognition as circumpolar). Religious historian Karl Schlesier, for example, compared the ritual practices of Siberian groups with the North American Cheyenne, an Algonquian-speaking tribe.[41] Like many North American tribes, the Cheyenne moved westward (in their case from Minnesota) in the eighteenth century onto the Great Plains with the introduction of the horse and are often thought of as a Plains "horse culture." Despite this historical change, Schlesier documented 108 directly identifiable ritual features that are fully equivalent to northern Siberian practices. Neil Price, an expert on Viking archaeology and circumpolar shamanism, has commented on Schlesier's analysis. Price labels Schlesier's results "an astonishing correspondence" and emphasizes that his list of compared traits did not involve

> vague concepts, such as worshipping the sun, but specifics: the centre of the spirit lodge in which ceremonies are performed has a pole symbolizing the World Tree, on which seven divisions are marked; the vault of heaven is conceptualized as a kettle; the crane is the sacred bird of the world above, and so on.[42]

The result is a strong indication *not* of some truly ancient origin of this Native American shamanism from Siberian

roots, but instead of more recent and direct cultural connec-
tions between the two regions. Indeed, Cheyenne shamanism
is in certain respects *more like* Siberian shamanism than it is
like Native Californian shamanism. And this, I argue, is an
empirical circumstance that calls for explanation.

The cultural relationships between the Old and New
Worlds clearly were complex and the early archaeological
record in Siberia is relatively poorly known; similarly, the his-
tory of migrations into the Americas is uncertain. Historical,
linguistic, and genetic data indicate that multiple migrations
into the New World occurred, but our as-yet incomplete
understanding of these is further compounded by demo-
graphic and cultural processes that occurred within the Amer-
icas (such as the expansion of the Inuit, across the arctic
between 4,000 and 1,000 YBP).[43] Still, there are some
intriguing circumstances that highlight the possibility that
ideas and innovations did not always move just from Asia to
the Americas. This raises the possibility that Native American
shamanism is not necessarily derived from Siberia but perhaps
is partly responsible for the development of shamanism in
that region within the last four to five thousand years.

One of these circumstances involves the toggling harpoon,
a technological improvement over the simpler and older
barbed harpoon. The more complex hunting implement holds
heavier quarry, like whales and walrus, and is less easily
broken off in icy arctic waters because the point embeds itself
under the skin and blubber. It first appeared about 7,500 YBP
in Newfoundland and Labrador and reached the Bering Strait
region approximately four thousand years later.[44] This suggests
an east to west movement of technology and subsistence prac-
tices. At least some innovations appear to have moved from
the New World to the Old.

More intriguing evidence is found in both Old and New
World rock art, where depictions of technological items are

sometimes found that, counter-intuitively, are otherwise only known from the other continent. In the subarctic woodlands of North America, for example, a series of engraved and painted boats have been identified that do not resemble Algonquian or Native American vessels, but instead are very similar to boat engravings found from Siberia to Norway.[45] At Alta, Norway, four hundred kilometers north of the Arctic Circle, the petroglyphs include numerous examples of these same kinds of boats, along with bears, reindeer, moose, and at least one shaman with a drum. These date from about 7,000 to 3,000 YBP.[46] But included among the Alta engravings are a series of depictions of snowshoes, one of which is distinctively Algonquian in style, the use of which is not recorded (historically or prehistorically) in the Old World.[47]

These examples certainly are anecdotal; they are admittedly rare and may be entirely coincidental. On the other hand, perhaps Franz Boas was right about the nature of the cultural interactions between the Old and New Worlds. Perhaps one of the historical influences involved in the development of "classic" Siberian shamanism was then existing New World shamanism (regardless of whether its ultimate roots lie in some previous but long extinct Asian precursor). Certainly once we recognize that this kind of shamanism was circumpolar, not primarily nor predominantly Siberian, it promotes that possibility. And perhaps one of the historical sources of our current Western artistic imagination, stemming from the eighteenth-century accounts of shamanism that, as Flaherty has illustrated,[48] heavily influenced Goethe, Mozart, and their contemporaries, was then the North American shaman. Put another way, perhaps our Western artistic imagination is more than purely Western after all.

The belief in the Siberian origin for North American shamanism has been accepted by almost all American archaeologists as a certainty for my entire career. The Cosos petroglyph

dates do not disprove this hypothesis but, when matched against the Siberian archaeological record, they emphasize the fact that little empirical study of this theory has ever occurred. Blind faith, in science, is always a bad thing. More evidence will be required to resolve this issue, certainly, but the first step in the scientific process is to raise a question that either has never previously been asked or has been overlooked.

Moreover, this circumstance illustrates another fact with implications for understanding the origins of art and belief. This is that, despite the strong sense that the rock art at Chauvet Cave, at Côa, and at the other European Paleolithic sites is shamanistic, there are many aspects of shamanism that we do not yet understand—history (and prehistory), as in the Old versus New World origins case, simply being one of them. Perhaps shamanism was the first religion in Western Europe but not everywhere else. Perhaps—as we shall see—prehistoric shamanism was in other respects different from what we have previously believed.

PART III

MEANING AND MADNESS IN THE UPPER PALEOLITHIC

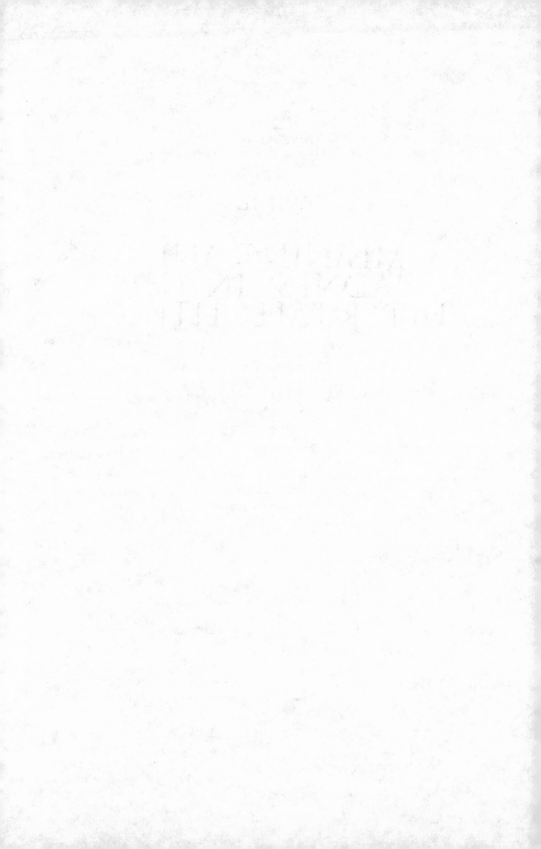

CHAPTER 5

THE MYTH OF ECSTASY AND THE ORIGINS OF RELIGION
ENTRY INTO THE VOLP CAVES

We may never know whether New World shamanism was the source for "classic" Siberian shamanism or not. The evidence involved is difficult to find and may continue to be elusive, if not inconclusive. But the data that do exist certainly should give us pause. At best, they provide no support for the long cherished idea that ethnographically described Siberian shamanism is a relict of the deep prehistoric past, nor the foundation for Native American religions. Siberian shamanism was not then an expression of the evolution of human society—one aspect of the first emergence of religion—but instead a product of relatively recent historical processes among Bronze Age hunters and herders.

What this circumstance also tells us is that the prehistory and history of shamanism are more complex than we have recognized and that there is more to know about this religious

system than we have previously thought. This fact was empha-sized to me in a particularly strong way one evening after a visit to one of the Volp caves, on a café terrace near the town of Foix, a picturesque village in the foothills of the French Pyrenees. What I realized from these experiences, confirming a decade of growing suspicion, concerned our fundamental understanding of shamanism and especially how it relates to religion. This pointed to the fact that our archaeological narra-tive for the origin of belief is incomplete. Despite how well our shamanistic interpretation of the European Paleolithic caves seems to fit the evidence (and it fits very well), it overlooks a key issue. I call this the "myth of ecstasy." Only with this myth debunked can we hope to explain the origin of belief.

THE VOLP CAVES

I had come to Foix and the Ariège region of France, south of Toulouse, for a small conference on gender and Paleolithic art. It was organized by Jim Keyser and was supported by Jean and Ray Auel. (Though Jean is well known as the author of *The Clan of the Cave Bear* and the other books in her *Earth's Chil-dren* series, less appreciated, outside of professional archaeo-logical circles, is her and Ray's long history of support for and involvement with archaeologists.) Like all small conferences in France—and most activities where Keyser is involved—the talks were interspersed with excellent meals, great wine, and lively conversation. Like all rock art conferences worldwide, it also included a series of fieldtrips to local rock art sites. In my case, I had the opportunity to visit three of the most significant Paleolithic caves—Niaux, Trois Frères, and Tuc d'Audoubert—and to relive a bit of my personal past within the larger context of the disciplinary history of Paleolithic archaeology.

I had first visited Niaux as a youngster on my initial trip to

France and the experience kindled my interest in cave art. I had been most impressed, I recall, by the graphic clarity of the images, mostly outlines of horses, bison, ibex, and other animals, mainly painted in black. That the confidence and strength of the painters' lines communicated to a twelve-year-old American, roughly fourteen thousand years after they had been created, is a testimony to the artistry involved and the cross-cultural accessibility of this art. Even as a child, I wondered to myself: Who made this art? Why did they do so? And, especially, why did they place the remarkable images in dark-zone settings where they were so difficult to see? I didn't need a college degree (or even high school diploma) to recognize, even as a preteen, the intellectual mystery the cave paintings represented.

I was able to revisit Niaux, this time with Jean Clottes as my guide, and to benefit from his many years of research on this cave.[1] What stood out for me most on this visit was not the art or the cave setting. I was fully prepared for these, having seen them previously and read about them over the years, as magnificent as they continue to be. Instead, it was the graffiti, which Jean also pointed out as we worked our way back into the painted galleries, that struck me the strongest. Based on the thousands of written names, dates, and statements (some quite ribald), the cave was periodically visited at least since 1602, and became a popular tourist attraction in the nineteenth century. It is likely that many of these early visitors saw the rock art though they had no understanding of its importance. The first known mention of the art dates from 1861, but full acknowledgment of their age and significance had to wait almost a half century more until 1906 (after Émile Cartailhac published his famous mea culpa in 1902, finally admitting the antiquity of the art).[2] The lesson here is an important one: our biggest challenge is often to see and understand the obvious; in this case, what everyone for the past three hundred years had stepped over or around, or simply ignored. The signifi-

cance of finding the obvious may seem facile, but usually it's not. Sometimes it results in our most profound insights.

My visits to the Volp caves in contrast were historically charged for another reason. The three caves here—Trois Frères, Tuc d'Audoubert, and Enlène—include some of the most renowned works of art in the Paleolithic corpus; these images have become hallmarks of the creative expression of and the resulting enigmas left by the early artists. (Trois Frères was described, along with Niaux, Lascaux, Altamira, Font de Gaume, and Les Comba relles, as one of the "six giants" of Paleolithic art by Abbe Breuil;[3] Chauvet, Cosquer, and likely Côa, all discovered long after his death, would have resulted in "nine giants.") The Volp sites are on private land and are closed to visitation. I remember buying postcard pictures of the images from these caves as a child, thinking that I would never have the opportunity to see them in person. Yet I intuitively recognized that, in many respects, the answers to our questions about this early art were likely encoded in their art. These initial impressions were reinforced due to the sites' perfect preservation since their discovery, which allowed for detailed study of the rituals associated with the art.

The three Volp caves are on property owned by the family of Count Robert Bégouën—a family that is almost as remarkable as the caverns themselves and whose own history has become completely intertwined with them.[4] Originally titled by Napoléon Bonaparte in 1808, the Bégouëns have produced an important series of prehistorians, each of whom has had a significant impact on our understanding of Paleolithic prehistory. They extend back to the late nineteenth century and Napoléon Henri Comte Bégouën (Robert's grandfather), who wrote an early book in support of Darwin's (then new and controversial) theory of evolution. Perhaps even more importantly, Henri Bégouën instilled a strong interest in prehistory in his three sons, Jacques, Louis (Robert's father), and Max—

the "trois frères" from which the eponymous cave received its name.

The Bégouën property is traversed by the Volp River (really more of a large stream) that cuts across the rolling green countryside until it intersects a series of wooded but low limestone hills. There it disappears into a cave, reemerging on the other side about a mile and a quarter away. Henri's three teenage sons decided to investigate this subterranean waterway in 1912. They built a makeshift raft and paddled roughly one hundred yards upstream into the outfall cave, known as Tuc d'Audoubert. They beached their raft on a small sandy ledge and climbed into a higher chamber that was blocked, except for a small "cat hole," by a stalagmite curtain. They returned later with the tools to enlarge this entry and explore deeper into the cave. This required inching up a forty-feet-high "chimney" (or vertical chute) to an upper series of chambers and tunnels. About a half kilometer back they discovered what was then—and continues to be—one of the most extraordinary examples of prehistoric art: two bison, masterfully modeled out of clay, in the deepest recess of the cavern. This was an electrifying discovery because it was the first evidence of three-dimensional sculpting in the Paleolithic. Cartailhac and his then young protégé, Abbé Henri Breuil, quickly rushed to the scene to appraise it.

Breuil would ultimately spend a total of ten months, spread over ten years, studying this and especially the second of the Volp caves, Trois Frères, which the brothers discovered in 1914. His recording of the engravings and paintings at this last cave is in many respects his masterwork.[5] The third Volp cave, Enlène, is connected to Trois Frères by a long and low tunnel. Except for a few small painted markings, it lacks rock art. But it does contain very important buried archaeological deposits. These were excavated by Robert Bégouën and Jean Clottes, yielding one of the largest concentrations of portable

Paleolithic art known: over a thousand small stone plaquettes finely incised with horses, bisons, other animals, and, especially, humans[6]—generally, the rarest of Paleolithic imagery. The Volp caves truly are a treasure house of prehistoric art.

We started our journey into Trois Frères, led by Robert Bégouën, at a barn on his estate that has been converted into a small museum (displaying many of the artifacts from the Enlène excavations), a library/study, and a lower workroom that housed the caving equipment and supplies. Continuing a practice initiated by his grandfather, Henri, and especially his father, Louis, Robert has dedicated himself to the preservation and care of the Volp caves. This facility is the headquarters for a nonprofit organization, the Association Louis Bégouën, chartered for that task, which (as the name suggests) is intended to promote the historical vision of his father. This, Robert explained, is relatively simple: the caves have lasted for approximately fourteen thousand years, and there is every reason to assume that they will persist for thousands of years into the future. With the exception of Breuil's recordings and the excavations in the Enlène living areas, there is no urgent need to disturb the rest of the caves in any fashion, including through additional research. (Any research that archaeologists could currently undertake will be better executed in the future, when our methods and techniques would be improved.) Extreme care and patience are the family's operating approaches. Passive preservation, as this is labeled, has become the guiding philosophy in the conservation and heritage management fields. The Bégouën family invented this principle almost a century ago.

Indeed, their intense respect for (more than just an interest in) the past was underscored by two additional circumstances, related to the major historical figures of Paleolithic archaeology. The library/study at the association headquarters was Émile Cartailhac's own library, with his desk, chairs, tables, and

books transplanted to the Ariège. And on the hidden path to Trois Frères, past the first locked metal door, there is a slightly dilapidated chair leaning against the cave wall. This had been Abbé Breuil's: the chair where he sat seven decades ago as he traced the images, aided by an assistant holding a lamp. I felt as if I had entered not only a sanctuary of Paleolithic art, but also a sanctuary for the history of Paleolithic research.

Robert Bégouën is now an older but still very active man, sure both of foot (an essential trait while traversing the slippery paths through the caves) and mind. Although he is an aristocrat, he communicates with a relaxed and unpretentious ease and he is an extremely gracious host. (His lack of pretense was notably evident in 1994, when he traveled to the United States to receive an award from the American Rock Art Research Association for his conservation efforts at the Volp caves. The award plaque had been inscribed with his name and French title, but the engraver apparently misread the instructions. "Comte Robert Bégouën" instead read "Comic Robert Bégouën." Although the error was caught and a corrected plaque was engraved, Robert insisted on keeping the original misprint, which he now proudly displays in France.) We were accompanied into Trois Frères by a small group of my fellow archaeologists, along with a Native American friend and colleague who was also attending the symposium.

LES TROIS FRÈRES

Because of the concern with preservation, little had been done to improve access to the galleries in Trois Frères, and we wore no helmets to ensure that we caused no damage to the low passages as we scrambled through. (A bruised scalp will heal; a broken chunk of a stalactite will take much longer to repair.) The walk in over uneven and, in some places, slippery ground

was difficult. Still, our route, through a new portal created in the last century, was much easier than the original access—a sixty-meter-long and low passage connected to Enlène, requiring a hands and knees crawl. Some of our group struggled as we wended our way through a series of narrow sloping tunnels, passing occasional paintings and engravings, before eventually arriving at our first destination. This was a particularly impressive but small gallery, the Chapel of the Lionness. Roughly oval and about fifteen feet in maximum dimension, it was an enclosed sanctuary that is walled by calcite, the constant mineral drip that hardens and creates the stalagmites and stalactites that adorned the inner world of the caves. The result was a room that, when lighted, literally glows warmly like a soft lamp, creating a kind of low-wattage but still incandescent shrine. Remnants of a hearth along one side made it likely that this effect was noticed during the Paleolithic.

The walls of the Chapel appeared almost pleated from the calcite (recalling the need to use tailoring terms to describe the otherworldly splendor of the caves). The prehistoric artists put these features to good use in different ways. Most noticeable was a jutting calcite ledge, called the altar, engraved and painted with a lion—or maybe more than one lion, for there were three heads and faces at its front, two in frontal and the other in three-quarters view. Whether this represented multiple views of the same lion (perhaps replicating the strobelike movements of some hallucinatory mental images, dragging across the visual field leaving after-images behind) or simply the economical depiction of a pride of lions is uncertain. (There are other lions and animals engraved on the altar and within the Chapel.) That this was no ordinary lion was however certain: a human arm and hand reached out from its rear, signaling the extraordinary nature (rather than naturalistic intent) of this depiction.

The pleated walls under and surrounding the altar were

particularly surprising because of ten offerings placed within the narrow niches that these created (and which the careful guardianship of the Bégouën family has preserved intact): an ochre-encrusted fossil sea shell, six flint tools, two splinters of animal bone, and a bear molar, all carefully placed and still sitting within the wall for roughly the last fourteen thousand years. Similar offerings had been found by Bégouën and Clottes in the walls at Enlène, and there are other examples elsewhere in the Volp caves, as well as at sites such as Chauvet Cave.[7] Uniquely, however, a single engraved plaquette—a small roughly palm-sized flat stone—was also found in the Chapel. It is a very rare association between wall and portable art in the Volp caves.

I found the offerings (and I think this is an appropriate description of them) particularly intriguing, partly because of the sense of intimacy with the past that they evoke. Despite the physical inaccessibility of the paintings and engravings in the dark-zone interiors of the caves, their creation still must have been a social act. This is because it employed codes and symbols that were widely used by Paleolithic society for over twenty thousand years. Yet, as at Côa, the artists primarily seemed to have been communicating inwardly with the rock faces. But they were using a shared graphic language to do so that, tacitly at least, it was understood by the other artists. These offerings, in contrast, were also tied to the larger beliefs and practices of the Paleolithic cultures, but they seemed to represent a much more personal interaction with the subterranean world of the spirits, each a kind of unique statement meant only for the sender and his or her otherworldly receiver. Seeing them still in place seemed a kind of trespass on a private moment, originally experienced thousands of years ago.

Admittedly, the offerings further intrigued me because I have studied offerings at Native American rock art sites for many years.[8] As I have emphasized previously, we cannot

directly apply more recent Native American practices to the Paleolithic peoples. But an understanding of these practices gives us hypotheses useful for examining apparently similar circumstances in the much more distant past.

Ritual offerings in Native California, in this regard, generally took three forms. Small stone plaquettes were incised (primarily with geometric patterns) and left at sacred places (usually caves) in a fashion equivalent to the better-known Navajo "prayer sticks," functioning as supplications to the spirits. More commonly, small and (to us) very insignificant offerings were left at the approaches to sacred places (perhaps a pass leading down to a supernaturally potent hot spring or a rock art site) and at the sacred spots themselves. In the prehistoric past these mostly consisted of items like simple waste chips of obsidian or other toolmaking stones, a few juniper berries, piñon nuts, or acorns, or just small twigs. In the historical (and contemporary) period, small coins (primarily pennies), bits of ribbon or yarn, or even broken pieces of glass might instead be left. These items were often pushed into the cracks in the rock art panels—similar to the offerings at Trois Frères and Enlène—or tied on branches of nearby bushes. (The seeming insignificance of these offerings reflects the symbolic logic of the supernatural because it is the inverse of the natural world—an insignificant offering on this side may be munificent in the sacred.) The third kind of offering, proffered primarily by shamans themselves, consisted of power objects—the items thought inherently imbued with potency. The three most important of these, in Native California, are eagle down feathers, quartz rocks and crystals, and tobacco. In its natural form (with about eight times the nicotine content of the strongest commercial cigarette), tobacco was a powerful and frequently used hallucinogen.[9]

Whether the offerings at the Trois Frères Chapel had the same meaning and intent as the much more recent Native

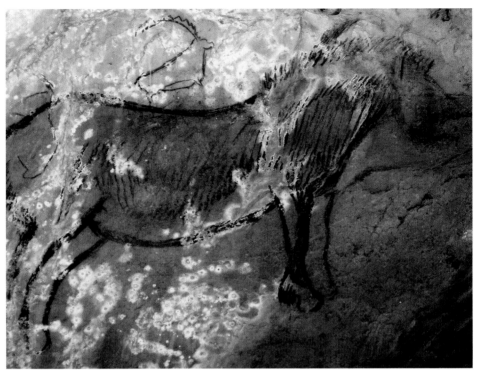

Black horse and smaller ibex *(upper)*; black bison *(lower)*; both from Niaux, France. The juxtaposition of horses and bison, along with the realism of the imagery, are characteristics of Paleolithic art. *(Both photos by and courtesy of Jean Clottes.)*

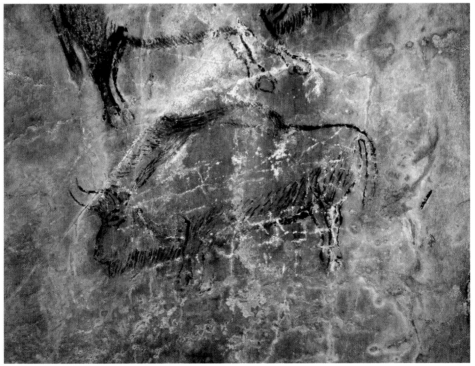

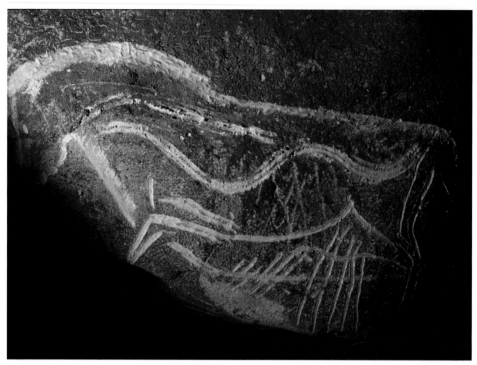

Paleolithic images were created in numerous ways. The upper horse was scraped into the soft mud wall of Chauvet Cave. The lower horse—one of two horses "emerging" from a small undulating niche at Chauvet—was painted immediately above a red clay stain created by a small seep. Note the geometric designs that are adjacent to both motifs. *(Both photos by and courtesy of Jean Clottes.)*

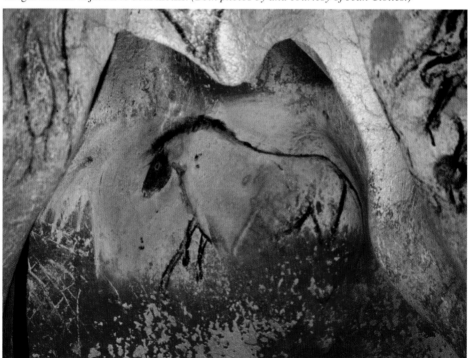

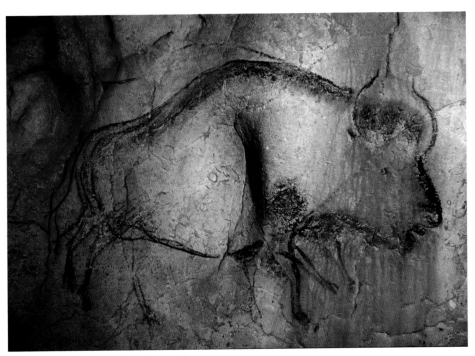

Despite the outward realism of many Paleolithic motifs, they portray aspects of Lewis-Williams and Dowson's neuropsychological model for trance imagery. The upper bison, for example, has seven front and back legs and perhaps two tails. The surface of the cave wall likewise was a fully integrated aspect of the painting (note the front shoulder). The lower rhino, similarly, is a kind of stroboscopic image, with the body, head, and horn reduplicated repeatedly. Both paintings from Chauvet Cave. *(Both photos by and courtesy of Jean Clottes.)*

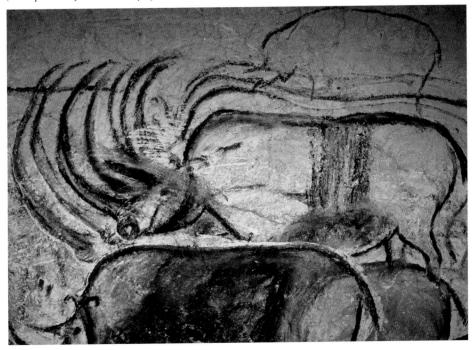

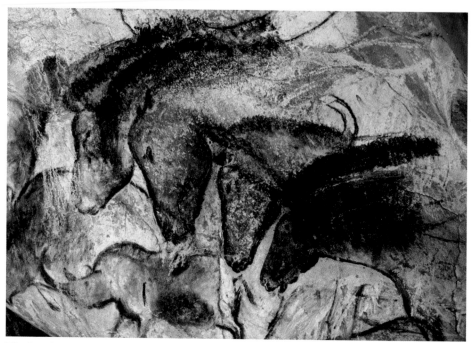

The Panel of the Horses at Chauvet Cave. Although the imagery may reflect trance experiences, the artistic craftsmanship suggests that the art was created when the artist had full use of his or her faculties. *(Photo by and courtesy of Jean Clottes.)*

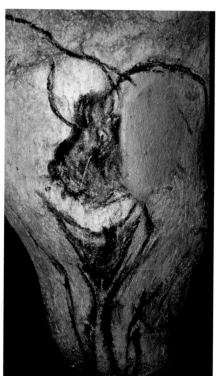

"The Sorcerer" and "vulva" at Chauvet Cave. Both are painted on a pendant stalactite, which itself is phallic-like. The leg of the Sorcerer, a human-bison conflation, creates the left leg of the female pubic region. *(Photo by and courtesy of Jean Clottes.)*

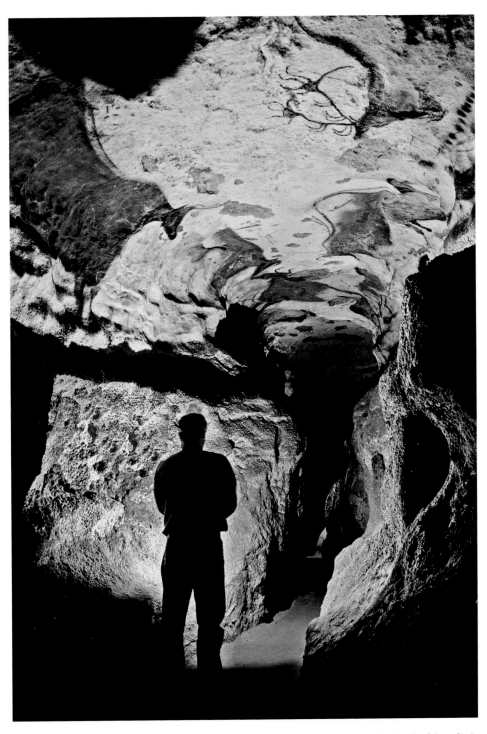

The Salon of the Bulls, Lascaux Cave, France. At the center-middle of the photo (the back of the salon), the painted animals seem to swirl over the ceiling of the cave. This creates the impression of falling into a vortex, a characteristic of a shaman's trance. *(Photo by and courtesy of Norbert Aujoulat.)*

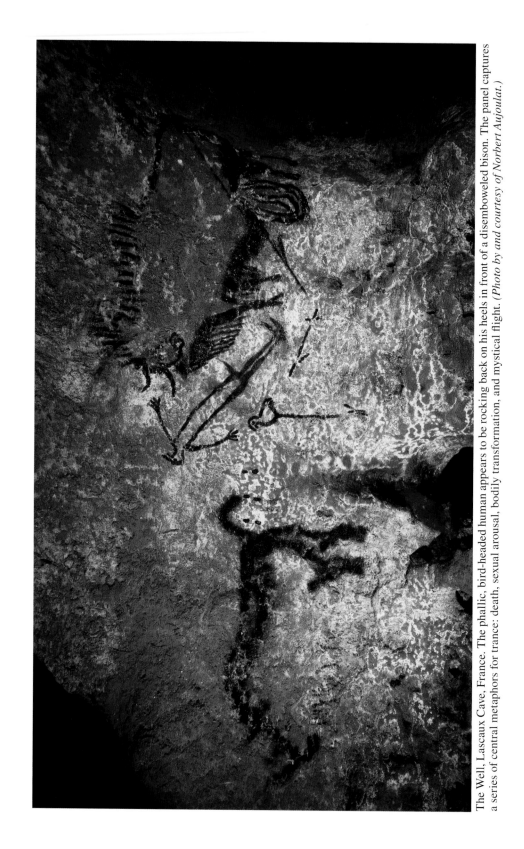

The Well, Lascaux Cave, France. The phallic, bird-headed human appears to be rocking back on his heels in front of a disemboweled bison. The panel captures a series of central metaphors for trance: death, sexual arousal, bodily transformation, and mystical flight. (*Photo by and courtesy of Norbert Aujoulat.*)

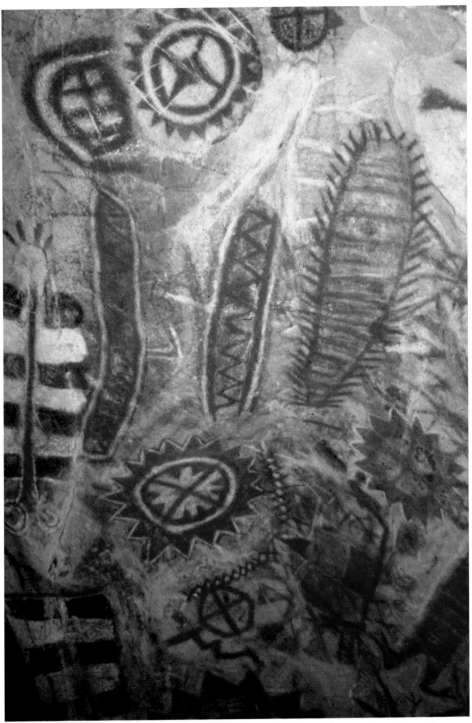

Painted Cave, a Chumash site near Santa Barbara, CA. Created by shamans to depict visionary imagery, the Chumash painted sites are outwardly dissimilar to the Coso petroglyphs, despite their similarities in origin and function. This may parallel the circumstances involving the Côa engravings and the dark-zone Paleolithic caves. *(Photo by and courtesy of the author.)*

A panel of engraved aurochs, horses, and caprids at the Penascosa site, Côa, Portugal. The confusing overlay of one image on top of another, with little regard for orientation, is characteristic of much Paleolithic art and trance imagery. *(Photo by and courtesy of the author.)*

American practices is unknown and potentially impossible to determine. Yet the similarities are striking, especially the placement of the small objects in cracks and declivities in the walls. Why not just leave them in a pile on the ground at the foot of the sacred spot? Why not leave grand objects, or massive numbers of them (although the painted and engraved art, at both kinds of sites, may be just that) instead of small found objects and minor artifacts? It is hard not to believe that the motivation behind the Trois Frères offerings was similar to the almost identical practices of more recent Native Americans, despite how speculative this suggestion remains.

The culmination of our Trois Frères visit was the Sanctuary, another chamber whose relatively small size belied the fact that it contained some of the most notable examples of Paleolithic art. The art here was almost entirely engraved like the open-air panels at Côa. Like them, too, the principle panels were a disorienting palimpsest of engraved lines, taken to another level of confusion: art seemingly gone entirely awry (fig. 12). Careful examination, aided by Breuil's meticulous copies, revealed a complex array of overlapping yet beautifully executed images: stoic, almost imperious, or alternatively fast-charging bison; short-legged, thick-bellied, and wide-necked horses (fat ponies with broached manes, to my modern eyes); curious ibex and caprids, posed as if peering intently from some high rock or crag; running reindeer and deer, chins jutted forward (lowering and streamlining their antler racks, aiding a run through wooded areas); a large bear, covered by small circular dots with lines flowing out of its mouth and nose; all mixed with a seemingly random array of geometric signs. Intermingled among the "animals" were two human-animal conflations, suggesting that all of these images were more likely spirits in animal form than animals in any normal sense.

One of these conflations stood upright on two legs with its head turned as if looking back, expectantly, over its shoulder.

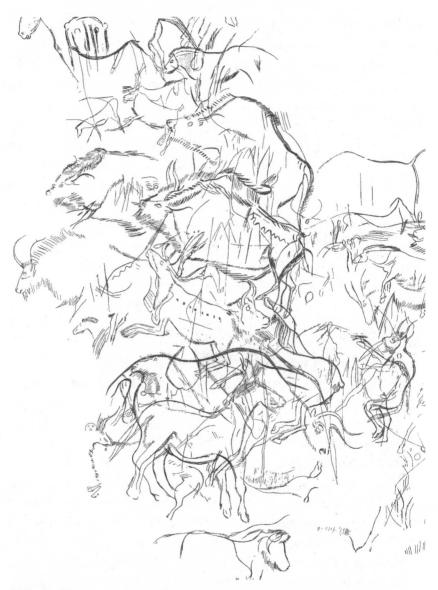

Figure 12. A palimpsest of finely engraved designs from the Sanctuary at Trois Frères, one of the Volp caves. The disregard for placement and orientation, along with the seemingly random inclusion of geometric/entoptic patterns, are characteristic of shamanic art. Note also the human-bison conflation, right-center. This upright figure seems to be pursuing a female bison, to his left. The bow-shaped line extending from his nose has generated substantial debate. (Drawing by Henri Breuil, courtesy of Robert Bégouën and the Association Louis Bégouën.)

It had a bison's upper body but it seemed human from the waist down, especially its large and erect penis, which emerged from the interior of its groin, like that of a human, rather than from a penis sheath on its belly, like that of a bovine. Another conflation, likewise an upright and noticeably phallic bison, walked forward on two distinctly human legs and feet. Two conjoined lines, creating a bowlike form, seemed to emerge from its nose. (This has created a long-lived debate as to whether this may represent a nose bow, a musical instrument otherwise unknown in the Paleolithic. Though this is possible, it seems more likely that these were just additional examples of the overlay of geometric signs that characterizes the panel as a whole or, perhaps, the visible snorting of a bull—something that, if you watch a bull in action, is quite common.) Perhaps more importantly, as Breuil first noted, this bison-human seemed to be advancing, upper bison legs out-raised, on a bison-cow, apparently in estrus.[10] Her head was turned back over her shoulder, seemingly looking at the advancing male, as she presented her exposed vagina (shown as concentric circles) for mounting.

The sexual symbolism at Chauvet Cave was to me (and Jim Keyser) obvious; the voluptuous nature of the Trois Frères imagery made the erotic intent of the artists all the clearer, pointing toward another kind of intimacy in this cave. This is the Paleolithic conceptual connection, expressed here in the most intense and biologically fundamental (sexual) form, between humans and bison. These key images signal that this art does not concern animals as food, hunted by man. Nor is it about animals as dangerous creatures, stalking the landscape. It is at least partly about the relationship of humans to animals who, in Native American terms at least, were called "nonhuman people." This conceptual linkage to humans is materialized here by the bison shaman—this is the only way that these can be reasonably interpreted—exhibiting two

common bodily hallucinations associated with altered states: bodily transformation and sexual arousal. Both were employed worldwide, as discussed below, as graphic metaphors for the otherwise ineffable feelings of trance.[11] Other aspects of the panel, especially the lack of any regular orientation in the engravings, the confusing superpositioning of the depictions, and their combination with geometric signs—each a specific characteristic of trance imagery—support this shamanistic interpretation.

Despite the significance of these motifs, the focal point of the Sanctuary was a large painted and engraved image (about two and a half feet high), placed above the lower panels, which seemed to command the room. Dubbed the "Horned God" by Breuil, this has been more commonly called the Sorcerer, and it has become one of the most famous Paleolithic images (fig. 13). It was a human, of course, or really more than a human for it conflates the features of three, maybe four, different species, poised in a half crouch falling somewhere between an upright two-legged man and a standing quadruped. The hind legs and feet were distinctly human, even to the details of the calf muscles and toes. A large pendant penis and testicles emerged from the creature's rear, making clear its sex (male) but little else: this is the position of a feline's sexual organs, not a man's. A large flowing tail (horse? canid?) also emerged from its rump, which, like the rest of the leaning body, appeared to be a cervid (most likely a stag). The ears and antlers confirmed this identification, but the face was different and distinctive, with the deep-set, night eyes and the small beak of an owl. The outward reaching front legs/arms and hands, elbows tucked against the chest, appeared half formed or, better, in a state of transformation. Rather than a sorcerer, this was a shaman transforming, standing at the balance between the natural and supernatural worlds, entering into or emerging from the spirit realm within the cave walls.

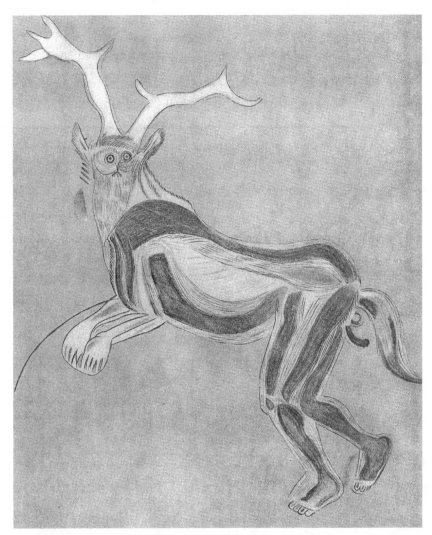

Figure 13. "The Sorcerer," the highest rock art motif in the Sanctuary at Trois Frères. This figure appears to be a conflation of at least three or four species: human, stag, owl, and perhaps canid or horse. It appears to be a shaman transformed or transforming. (Drawing by Henri Breuil, courtesy of Robert Bégouën and the Association Louis Bégouën.)

I had wanted to see this image for forty years, since I was a child. Finally viewing it was a singular event, made all the more remarkable by what ensued next. When we first entered Trois Frères, I noticed that our Native American companion (intentionally left unidentified, for his privacy's sake) was wearing an eagle-bone whistle, tied around his neck. I had never seen him wear this before and I recognized its significance on this occasion. Although (as we shall see) he and I have talked in detail about Native American shamanism, I have never directly asked about his own religious status, though it is well understood that he is a traditional practitioner in a shamanistic culture. (Raised by his grandparents, he speaks his tribal language fluently and was sent on his first vision quest as a youngster to a rock art site.) Indeed, his tribal elders politely defer religious questions to him, a man roughly half their age, thereby acknowledging his authority and knowledge. But he does not openly label himself a shaman, and I have never asked if he considers himself one. I cannot say for certain that he is, in the Western anthropological sense of this term (though I believe this to be true). If not, it is only because he may not believe he has yet reached that stage in his spiritual development.

As we sat in the Sanctuary, at the foot of transforming shaman, my friend asked if he could say a prayer in his native language. I was slightly embarrassed by the question because I was serving as the English-French translator for the group—a difficult circumstance since Spanish is my default language and my spoken French is, charitably, imprecise—and I did not know the French word for "prayer" (*prier*, as I subsequently determined). But I did the best I could, asking Robert Bégouën if our companion could "sing" (the closest I could get to "pray") in the Sanctuary. This proved entirely appropriate, as it turned out. After Robert's quick approval, my friend began a long prayer, shifting shortly into a chanting, cadenced song, and then playing his eagle bone whistle, its high pitch filling

the chamber and resonating through the connecting passageways, calling the spirits last seen by the Paleolithic shamans fourteen thousand years earlier.

I am not sure how long he sang and played; like my other companions, I was enthralled and lost track of the time. I do not know whether the original occupants of the Volp caves conducted ceremonies that resembled in any fashion what I witnessed. And I cannot say how accurate it might be to transpose contemporary Native American practices onto Paleolithic rituals and art. (Certainly there must be significant differences.) But despite these uncertainties, I am confident that our companion's ritual performance captured the spirit of the use of this cave, if only due to the outward expression of religious respect that it embodied. And that is something very much worth *feeling*, as an archaeologist trying to understand the significance of these caves.

TUC D'AUDOUBERT

Our joint visit to Tuc d'Audoubert a few days later was less eventful but equally as impressive. We were led this time by Eric Bégouën, Robert's son, who has followed the family tradition, maintaining a strong involvement with archaeology. (Eric had a good start in this regard, having worked with his father and Jean Clottes on the Enlène excavations.) Our trip began with a short boat ride in a small dingy up the Volp and into the entryway to Tuc. Docking at the sandy ledge and crossing through the first of a series of locked metal doors, we entered the so-called Wedding Chapel, a large luminescent chamber coated, top, bottom, and sides, with sparkling white calcite. Small puddles spread across the floor, flickering the light from our lamps into refracted beads and dots, filling the room with what looked like small swarms of fireflies, dancing

on a subterranean breeze. (I remember thinking that the chamber would in fact be a magical setting for a wedding, though the puddles would likely prove a problem.)

Our transit beyond this glittering entry was more adventurous—meaning energetic and difficult—than I had previously experienced in the European caves. Aside from protective metal doors and a ladder up the vertical chute, no changes had been made to improve access to the galleries. I felt as if I was caving in a series of wild underground chambers—alternately squeezing through narrow-spaced stalagmite pillars, crawling under low-hanging stalactites, or worming between narrow gaps in the walls. It was a long and slow trip, accentuated by the fact that Tuc d'Audoubert has relatively little cave art.

Most remarkable on our climb inward was again the surface traces left by Paleolithic peoples, which were carefully preserved intact by the Bégouëns. A small snake skeleton, bear canines, flints, and other objects had been carefully placed at various spots along our trail and still sat in place as if they had been dropped yesterday. It was hard to hold tenable the fact that they had rested, without disturbance, for roughly fourteen thousand years—the equivalent of seven hundred human generations. And they were occasionally intermingled with human footprints—barefooted children and adults, sometimes carefully placed, sometimes obviously playful. We saw, for example, the imprint of a small child standing on and slowly slipping down the lip of a low mud bank next to the trail, heels digging in and dragging along the slope. (He or she was apparently dexterous: I saw no evidence of a backward fall, the natural counterreaction. The child presumably leaned forward with toes flexed and feet arched to maintain his or her balance, like a good rock climber, trusting the sureness of his or her feet.) We have all seen this scenario played out thousands of times before, at airports, in grocery stores, and at bus stops: a parent urging a child on and attending to the business

at hand, while the child finds every conceivable opportunity to stop and play, using whatever distraction is available. Was the mother or father, at that ancient moment, pestering the child to stop dawdling along the path?

The prints and left objects—offerings, most likely—signaled not just the previous use of this cave but the related fact that we were following the original Paleolithic path into it. Combined with the length of the hike and the relative paucity of rock art, this helped build the anticipation for our final destination and our sense of pilgrimage to reach it. We arrived there, without warning, after crossing under a low-ceilinged passage. Crouching on our hands and knees, we crawled under the low spot and started to work our way slightly upward as the passage opened into a higher roofed, circular chamber. Eric of course knew exactly where we were in our transit and used it to great effect. Placing his lamp low on the ground, he shined his light upward to the middle of the chamber, where it dramatically side-lit the masterpieces of Tuc d'Audoubert: two clay-sculpted bison (fig. 14).

These had been found by Eric's grandfather, Louis, and his brothers, as noted above, almost a century earlier. Their discovery caused Eric's great-grandfather, Henri, to send a terse telegraph to Émile Cartailhac: "The Magdalenians also modeled in clay."[12] Cartailhac (and Abbé Breuil) fully appreciated Henri's monumental understatement. They arrived by train a few days later to examine these sculptures themselves.

Except for cracks, caused by the drying clay, the two sculptures—about a foot and a half long each—were in perfect condition. A third bison nearby suffered from dripping water and, when first found, had already eroded away to a barely recognizable lump. The front of the preserved pair was a female with sunken eyes. A male, shown with bulging eyes, larger dorsal hump and tail, followed closely behind, and is believed to be preparing to mount the female.[13] Both appeared to have

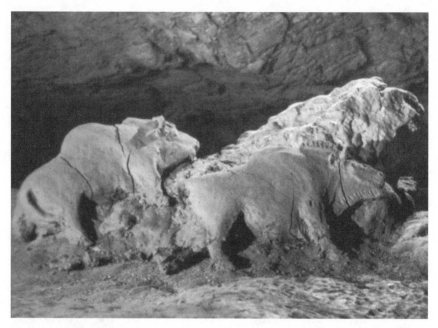

Figure 14. The two sculpted clay bison at Tuc d'Audoubert; male at left and female at right. (Photo by Robert Bégouën, courtesy of the Association Louis Bégouën.)

been relatively quickly and brusquely—even though still masterfully—sculpted. Except for the faces and snouts, which were very subtly worked, they lacked close detail, reminding me of a buffalo-head nickel that has spent some time in circulation: it is easy to recognize their artistry, but some of the fine points are missing.

Eric seemed to understand the allure of the sculptures and he was in no rush to end our visit. He stayed with us, patiently, as we sat on the cave floor surrounding them, absorbing the setting and their feel for over an hour. (I greatly appreciated his patience; my visit to these sculptures has been a high point of my career). Before we left, Eric directed us toward a small antechamber that we had overlooked as we crawled up the low-roofed incline to the bison. This smaller room was floored

with a thick deposit of soft mud. We could see where clay had been dug up from it to create the bison. Long clay "strings" (made by rolling a ball of clay back and forth between the hands, as any child knows) lay on the floor. What they were intended for (if anything) is unknown. But, most perplexingly, the floor was punctated by a series of deep heelprints. Was this the result of a ritual dance or instead just a child playing? We do not know, to be sure, though either is entirely possible.

The walk out was, like the entry, long and difficult, giving me plenty of time to ponder what I had just seen. That these sculptures were ritual in origin and intent was archaeologically certain; that they were symbolically related to the cave paintings and engravings is also difficult to dispute (if only because of the shared emphasis on bison and the dark-zone setting). And, with this admission, their place in shamanistic beliefs and practices, too, seems very likely. But what, exactly, was that place?

I cannot answer this question with any certainty, though I was most impressed by the simple materiality of this art—the physical bulk of it—given the fact that these were sculptures. Still, they contrasted with the fleeting efforts at capturing three-dimensionality, through the use of the undulating wall and ceiling surfaces and shapes, in the paintings and engravings. Yet the question of materiality in the paintings and engravings, too, may be deceptive, once we escape the graphic overemphasis that is the hallmark of our own time and place. Our perspective is inculcated in our perception by our literacy, where images placed on walls or inscribed on paper are perforce signs and symbols that stand for concepts and other things. Westerners see the world as if it were a book, a modern cultural tendency promoted by the late twentieth-century linguistic turn in social analysis. Today behavior is often interpreted in a fashion similar to words, dialogues, and texts. Especially since the rise of structuralism, semiotics, and postmodernist literary criticism, this has become an "archaeolog-

ical" approach to interpretation. This has its value, to be sure. But it also requires the imposition of a thoroughly contemporary, Western sensibility on the past. I find this overly reductive (since it imposes our perceptive worldview on past human actions and objects, as if our sense of things is culturally and temporally transcendent) and, for that reason, disquieting.

Borrowing again from Native America, despite the potential inferential hazards in doing so, I recognize that in shamanistic cultures, paintings and engravings are material objects first and foremost, before they are signs or symbols. They exist not because someone placed them there, but simply because they *are* there as physical entities in their own right. In Native American eyes, they have a life and an agency of their own, with or without human involvement.[14] Indeed, in many Native American cultures human creation of the art is consistently denied. This is not, as archaeologists for many years inferred, because the cultures have no knowledge of or cultural connection to the art. It is because the paintings and engravings are spirit objects. These by definition are believed to have an origin in the supernatural, not natural, world. Humans may play a role, but it is a minor part in the larger forces that are the genesis of the motifs.

At issue ultimately is a historical undercurrent of the West's Judeo-Christian heritage and its longstanding bias against "pagan idolatry," whereby spiritual potency is invested in material objects. This legacy contributes to our inability to see objects as more than functional implements, made by humans, or (lately) intellectualized as abstract signs and symbols representing other concepts (when our bookish mentality comes into play). Yet despite our culturally driven insistence that objects cannot have intrinsic power, we commonly invest a similar kind of extranormal potency in our words. Hence our ritual invocation of prayers and chants, intended to influence the gods, including the common belief that the Bible is "the

word of God" (why would this matter, if words weren't so potent?) and, even more to the point, certain of our civil acts. Sworn testimony, guaranteed truthful because of the power of the words we have repeated, is one example; a marriage vow is another; curses, in the old sense, not of swearing but of invoking ruin on our targeted enemy, are a third.[15] We are (self-deceptively) advantaged in our battle with idolatry not because our own thought is any more rational and scientific than the pagan's, but because our own causal irrationality is deeper beneath the surface.

This circumstance raises two questions, both of which are central to any suggested explanation for the origin of religion and belief. Were the Tuc d'Audoubert bison considered objects of Paleolithic veneration—worshipped as some kind of bovine god by family supplicants who made the exhausting pilgrimage into the dark-zone cave? Equally importantly, why would anyone rationally believe that an object like a modeled lump of clay was imbued with spirits and potency? Despite the length of our trip out of the cave, I was still pondering these questions when we boarded the small dingy and paddled out of the exit.

FIERCE POWER

Our long visit at the bison—followed by a few leisurely glasses of wine on the lawn of the Bégouën estate with Eric and his family (and dogs) and Robert and his wife—delayed our return to our conference banquet. Our belated entry was frowned upon by many of the other participants. Obviously, we had been enjoying ourselves while they had been left cooling their heels. But the two site visits and the marvels we had jointly seen gave my Native American colleague and I much to talk about over dinner. Shamanism, not surprisingly, came up as a point of discussion. More surprisingly, my Native

American friend made a couple of comments about shamanism that clarified my concerns about how the Western world has understood this religious system. And these comments, I eventually recognized, were my own key to understanding the relationship of shamanism to the origins of religion.

His comments concerned changes in the nature of Native American shamanism since Euro-American contact. Because they were partly historical, the observations were clearly informed by traditional knowledge that had been handed down to him. They centered on two points. Although he admitted difficulty finding the best description, he said that shamanism and supernatural power previously were much "fiercer" than they are today. Contemporary shamanism, he said, is almost wholly concerned with healing. This reflects the devastation that Native American tribes have suffered, at every level, following contact with Europeans. Modern tribal shamans are primarily healers because Native Americans need healers, but the emphasis previously was different.

The importance of these observations was immediately obvious to me at various levels. The first concerned the concept of supernatural power. As I understand this concept (from my ethnographic reading and Native American contacts), supernatural power was considered the ultimate causative agent in the universe. But power itself was ambivalent and, in this crucial sense, it differs markedly from potentially related Judeo-Christian concepts, such as "grace" (which we might use for comparative understanding).[16] Although we think of a state of grace as a kind of enhanced spiritual condition, there is (by that fact) a positive value judgment attached to it. A state of grace is, in our minds, an intrinsically beneficial condition. Shamanistic power has no such implications. It instead is more like nuclear energy: you can use this power to light most of the houses in France or you can use it to destroy cities in Japan. Nuclear energy does not care how it is employed.

Shamanistic power, in a similar fashion, could be used for good or evil, and shamans were at once both healers and sorcerers, white versus black shamans, responsible for curing *and* creating illness. What my Native American colleague told me was not an entirely new idea and it meshed perfectly with what I had previously understood. But his emphasis on the former fierceness of supernatural power underscored what I also understood about the shamanistic worldview and the shaman's place in it. Partly like our culture, traditional shamanistic cultures conceptualized life as a kind of struggle between good and evil. But they had no Hollywood-ending perspective on how things ultimately turned out. Perhaps to our credit, we continue to believe that good will finally triumph or, at a simpler level, that people in general can ultimately be righteous rather than bad. The Native American shaman (at least) suffered from no such Pollyannaish naïveté. Life, and especially the shaman's place in it, was always a balance between the dark and the light, death and life, hope and despair, and success and ruin. All one could reasonably hope, given this circumstance, was to stand at the balance, maintaining a kind of unstable equilibrium. Indeed, the trick was exactly to maintain that balance because, if circumstances tilt too strongly either way, order would be lost and society would spin off into disarray.

The late anthropologist Barbara Meyerhoff, who worked with Huichol shamans in northern Mexico, referred to this as a dialectical opposition. Contrasting it with our Western Aristotelian tradition, with its view of the golden mean as the highest good, she pointed out that the shamanic balance is not:

> achieved by synthesis; it is not a static condition achieved by resolving opposition. It is not a compromise. Rather it is a state of acute tension . . . when two unqualified forces encounter

each other, meeting headlong, and are not reconciled but held teetering on the verge of chaos, not in reason but in experience. ... We seek good without evil, pleasure without pain, God without the devil, and love without hate. The shaman reminds us of the impossibility of such a condition, for he stands at the juncture of opposing forces, and his dialectical task is continually to move between these opposites.[17]

The shaman's worldview was marked then by an inherent understanding of uncertainty along with an acknowledgment, perhaps a mature (maybe even a wise) resignation, that things simply are the way that they are. Moreover, it implies that the natural order of things, which all of us inherit, is one we should not, maybe cannot, change: unlike Western conceptualizations of the dialectic, one side here never dissolves the other, negating it to form a synthesis.[18] There is instead a constant and continuous state of uncertainty held partly in check, hopefully, by the shaman.

The dialectical opposition of the shaman is contrary to our contemporary vision of social and personal progress. It contradicts our sense of place, and privilege, in the world. It exists as a humbling reminder of how insignificant our individual lives may be. And it is for all of these reasons very easy for us to ignore. Yet this metaphysical view, which my colleague's comment about the fierceness of traditional shamanism helped me fully apprehend, is, I believe, the only avenue for understanding this religious system and how it may have contributed to the origin of belief.

World shamanism, especially in its most traditional expressions, certainly emphasized altered states of consciousness as the access to the sacred and thus to power. It also included a multitiered cosmological view of the universe, usually with three layers and a central axis (the "world tree") that connected them. "Soul flight," which the shaman undertook in his

visionary experiences to retrieve lost souls, find misplaced objects, encounter herds of game, or sicken his enemies, was also central. Not surprisingly, Western analyses of shamanism have emphasized these most obvious and visible universally shared features.[19] But I believe that we have missed the key points, which turn on the shaman's metaphysical position: the dialectical opposition that kept him poised *not* at the edge of grace, but between darkness and light and order and chaos.

My Native American friend's comments about shamanic fierceness struck me so strongly, not because they were novel, but because they pointed me full face at something I had seen for twenty years, knew was important, but—due to my Western biases—had not fully appreciated.[20] (Sometimes the most obvious things truly are the hardest to see.) Visionary accounts of shamans' supernatural experiences, and their relevance to the origins of religion, are the significant point here and illustrate this fact best.

I had collected published accounts of shamans' visions for over a dozen years, recognizing that they were useful for further linking the characteristics of their trances, in different cultures at different times and places, with David Lewis-Williams's neuropsychological model.[21] They also helped clarify the metaphorical nature of shamanic expressions. The issue here was a simple one: how is an essentially ineffable (hallucinationary) experience portrayed verbally or graphically? Thelonious Monk's famous jibe, "writing about music is like dancing to architecture," makes light of this same difficulty and, while Monk's exasperation with music critics likely motivated his remark, it highlights the problem posed by the description of intensely personal experiences in a socially comprehensible fashion.

My argument was that the bodily effects of trance—emotional reactions and physical and auditory hallucinations commonly occurring in altered states—served as natural

models for the description of these experiences, resulting in a series of common shamanic themes.[22] These were embodied metaphors that symbolized supernatural experiences in the starkest of terms, describing hallucinations in terms of how an individual felt. Six of these are particularly common, the most important of which is death: worldwide, a shaman's entry into trance is likened to mortal demise. This partly reflects similar physical reactions (bodily collapse, diminished vital signs, physical pain) and in part to the related emotional grief and anguish that (as we shall see) is a common attribute of shamanic trance.

Bodily transformation is another common metaphor, linked to sensations on the skin (the feeling of hair growth) and the seeming surge of energy that travels up the spine and even out of the head in some altered state experiences (hence a perception of antlers or horns emerging from the crown). Drowning or going under water is a third, resulting from the blurred vision, blocked hearing, and slowed body movements that are another set of physical reactions, which resemble immersion. (I experienced this sensation in an emergency room recently, passing out physiologically—as I could see from my attached vital sign monitors—but somehow maintaining my consciousness. I went mute and deaf and could barely move, as I urgently, but in extremely slow motion, tried to signal the nurses' station with a hand wave, in fear of falling off the high gurney in my almost inert state.) Combativeness and aggression was still another, reflecting the sense of superhuman strength and intense anger that can emerge in trance— a reaction directly tied to the fierceness of shamanic power. Sexual arousal, too, sometimes accompanies an ASC because some hallucinogens are also aphrodisiacs (jimsonweed in particular), and because REM dreaming—considered a shamanistic trance in many cultures—can result in erections in males (NPT–nocturnal penile tumescence) or an enlarged clitoris

and increased vaginal flows in women. But probably the second most common bodily reaction, after death, is a strong sense of movement, a mental dissociation from the body as a whole, along with a feeling of lightness and visual changes promoting the sense of flight. The mystical flight metaphor accounts for beliefs in both soul flight and ascension to the upper world. It provides the logic for the association of shamans and birds, and thus the widespread use of avian imagery in their ritual costumery.

Although different cultural accounts of shamans' visionary experiences emphasize certain of these metaphors more than others, the overall continuity in symbolic expression across the world is remarkable. Indeed, consider the ways that Western culture described hallucinatory experiences in the 1960s. "Going on a trip" was our analogue to mystical flight; the exact same verbal metaphor is used by lowland South American tribes to describe their shamanistic visions; our current metaphor for this same ASC experience is an "out-of-body-experience."[23] All three are based on the same sensory reactions. Drug users similarly felt the "rush," the energizing effect that sometimes occurs at the start of an ASC; whereas others were "stoned" or "wasted," which is to say immobilized, like the underwater shaman. And then others experienced "bummer trips," the unpleasant effects of trance that contribute to the death metaphor. Contemporary Western culture not only uses metaphors to describe hallucinatory states, but it uses the same metaphors as shamanistic cultures for the same reasons.

These metaphors are cross-cultural and essentially universal precisely because they are embodied—driven by our physical and emotional reactions—and therefore shared among all humans. We react in the same ways to trance that Paleolithic shamans reacted, on average. This is to say that we have the same range of variation in experiences as our ancestors, even though any given ASC may differ, even in one indi-

vidual, from event to event. All that changes, within this range of variation, is our cultural interpretation of the experience—what significance we ascribe to it and what aspects of it that we perceive as important.

We see these shamanic metaphors graphically expressed in Paleolithic art. At the Well at Lascaux, for example, a bison is disemboweled and a phallic, bird-headed man—a shaman—is rocked back on his heels, falling over: death, bodily transformation, flight (symbolized by the avian imagery), and sexual arousal, all in a single subterranean scene. We see them at Trois Frères in the three phallic human-bison conflations and at Chauvet Cave in the association of the human-bison figure and woman's vulva: transformation and sex again linked. Yet when we consider shamanic symbolism from the perspective of the origin of religion, something crucial is missing in these images. It is also missing from the verbal accounts of trance, as I had long sensed and as my Native American colleague's comments emphasized.

What is missing is any direct connection between a shaman's trance and what we understand, on a variety of levels, as an intrinsically religious experience.

THE MYTH OF ECSTASY

That shamanic experiences lack intrinsically religious characteristics is illustrated best if we consider a few descriptions of shamans' visions. An account of a prospective shaman among the Gitskan Indians, in the subarctic of northwestern North America, for example, observes that:

> He found himself repeatedly falling into deep and disturbing trances. Terrifying visions appeared to him on these occasions: visions of great, fierce animal spirits; tall, serpent-

like trees chasing him; flies crawling over his face, and a noisy crowd pursuing him.[24]

A Siberian shaman initiate described his supernatural experience in equally disturbing terms:

> In my dreams I had been taken to the ancestor shaman; cut into pieces on a black table. They chopped me up and threw me in the kettle and I was boiled.[25]

Shamanistic trance among the Kalahari !Kung, similarly:

> is very painful as well as unknown. It is greatly feared . . . [and] brings profound pain . . . healers [i.e., shamans] speak again and again of the searing pain in the [lower torso] and sometimes in the pit of the stomach. . . . Your heart stops. You're dead. Your thoughts are nothing. You breathe with difficulty. You see things, num [supernaturally potent] things; you see spirits killing people. You smell burning rotten flesh. Then you heal.[26]

Or consider the trance experience of a lowland South American Warao shaman initiate, a *wishiratu*:

> Not only must he overcome many obstacles, but his very life is threatened by the ever-present possibility that his dream will be interrupted so suddenly that his roaming soul will not have time to return to his body . . . the young *wishiratu* has to clear an abyss filled with hungry sharks, all eager to devour him. A vine hangs down over the abyss, and the novice, grasping it firmly swings himself across. But still his ordeal has not ended, for he soon reaches another obstacle. The path becomes extremely slippery, so that he can hardly keep his balance. To make matters worse, on every side there are threatening demons armed with spears, waiting to kill any novice who falls.[27]

Even an "educated" Westerner, familiar with world religions and transcendental expectations, suffered similar experiences when he trained under a Dogrib shaman in the North American subarctic:

> It was a very frightening experience. . . . I was physically ill, psychically terrified, close to death, no control, no direction. It was hell, an endless chaotic battle with no real point.[28]

Each of these accounts emphasizes terror, anguish, and sometimes even physical pain. Although there are exceptions (discussed below), these four passages are characteristic of the majority of the ethnographic descriptions that I have collected. They point to a clear fact: there was nothing intrinsically religious about the shamans' altered states experiences. Indeed, in certain respects they were anything *but* religious. This requires some explanation.

By "intrinsically religious" here I mean something specific, the significance of which is clear when the larger concept of "religion" is reduced to its component parts. Four of these are quickly recognizable. The first is *spirituality*: belief in spirits or, as they are sometimes labeled, "supernatural agents" or "actors." (Note that I use this term differently than it is sometimes employed, for reasons that will become clear momentarily.) These potentially include ghosts, devils, and demons, as well as angels and deities. People can believe in spirits without any specific commitment to religion (witness the TV show *The Ghost Hunters*), but religions always incorporate beliefs in supernatural agents.[29] *Religion* itself is a social phenomenon: the "organizing of spirituality" into a shared set of beliefs (about supernatural agents, among others), ritual practices, and behavioral precepts.[30] A third component involves an emotional experience or condition: a *transcendental, mystical*, or *ecstatic state*. This is marked by euphoria, tranquility,

and unity with the universe, passivity, enlightenment, and heightened consciousness, including self-awareness even while hallucinating. Moreover, it is transformative or life changing, sometimes resulting in a marked alteration in personality.[31] This mental-emotional state is often cited as the ultimate source or inspiration for many religions.[32] Despite this association, most people in many religions never experience visionary religious bliss. Among Americans and British, for example, only 2 to 3 percent report having had these intensely emotional mystical experiences.[33]

The transcendental condition is an intrinsically religious experience in the sense that it potently activates another component of religion, *religiosity*. This is the feeling of reverence, communion, and belief (including the individual's sense of enlightened knowledge) that is the emotional foundation of faith. Although prayer and ritual participation can contribute to a personal sense of religiosity (and hence faith), mystical states do so in an extreme—potentially inescapable—fashion; indeed, they may be said to create religiosity.

These intrinsically religious experiences involve specific neural networks in the human brain. Brain imaging studies suggest that these networks may differ, depending upon the nature of the experience (itself an important point, discussed below), but the left temporal lobe appears to be a primary locus.[34] Temporal lobe (TL) epileptics experience equivalent states during their neurochemical brainstorms: even brief TL storms can permanently alter their personality with 38 percent of TLE patients reporting mystical experiences during these events.[35] TLE, which notably differs from other forms of epilepsy, provides a neuropsychological model for an intrinsically religious experience.

The problem this circumstance raises is subtle yet fundamental because it concerns causality—a chicken or an egg problem: what first caused religion to develop? The accounts

quoted above were certainly *interpreted as* religious experiences within their respective cultures. Yet they do not match most of the characteristics of transcendental states and they are, critically, distinct in terms of their neuropsychology. Indeed, they are recognized as religious in Western thought not on their own biological or experiential merits but because of their cultural context. They were religious conditions because people treated them as such, not because hallucinations of pain and terror necessarily have any connection to intrinsic religious experience, as we understand this brain-mind state from neural imaging studies, and as we recognize it in true transcendental religious practices, such as Buddhist meditation.

This conclusion results from multiple lines of evidence, beyond the descriptive accounts alone—as compelling as these are. Among Native Americans, for example (as noted above), no distinction was made between a sleeping REM dream and a shaman's induced altered state (hallucinogenically or otherwise).[36] Both were glossed as "dreaming," both were considered equally valuable sources of supernatural experiences, and both were (culturally) labeled as religious in nature. Yet, REM dreaming is not the same brain-mind state as mystical trance. REM brain waves exhibit no dominating pattern, for example, whereas meditative states are characterized by coherence and regularity with a decrease in beta waves and an increase in theta waves. REM dreaming is also predominated by extreme and frequently unpleasant emotions, not transcendence, and an absence of volition and control, not hyperawareness. Although most people cannot remember their dreams—for good reason, as it turns out—sleep-lab studies report that over two-thirds of the emotional reactions in dreams are unpleasant, centering on fear, anxiety, and grief.[37] Clinical studies of the use of certain shamanic hallucinogens show similar results: while 5 percent of the clinical subjects in one study experienced "undescribable joy," arguably similar to the

euphoria in a mystical experience, 23 percent felt the grief of their own death.[38] If shamans were using the common lowland South American hallucinogen administered in this clinical test (yagé, *Banisteriopsis caapi*) to achieve a transcendental state—or attempting to obtain it with an REM dream—they had a high probability of failure.

Trance induction techniques, moreover, varied greatly from shamanistic culture to culture. Sometimes they differed even within a single culture or by an individual shaman from event to event. These techniques, too, have implications for the neuropsychology of the resulting experiences. In Native California, for example, tobacco was the primary shaman's hallucinogen, commonly combined with fasting, but the more potent jimsonweed was frequently used for group initiations. An altered state might also be achieved by swallowing red harvester ants in a ball of eagle down feathers (which would bite and inject poison into the stomach lining, causing hallucinations) or by self-flagellation with stinging nettles. Other New World hallucinogens included peyote, psilocybin mushrooms, Morning Glory seeds, San Pedro cactus, and a miscellany of other plants, administered as drinks, snuffs, enemas, and emetics.[39] But shamanistic trances could be induced through drumming, clapping, and dancing, or simply by sensory deprivation (a likely circumstance with respect to the Paleolithic caves). Importantly, however, different hallucinogens activate different neural receptors in the central nervous system, with varying results. The fly agaric mushroom (*Amanita muscaria*), commonly associated with Old World shamanism, for example, stimulates the Gamma aminobutyric acid-A (GABA-A) receptors and has an inhibitory effect. The various psilocybin mushrooms (*Psilocybe spp.*), common especially in Mesoamerican shamanism and (when metabolized) structurally similar to LSD, in contrast, activate the serotonin receptors 5-HT2A and 5-HT2C and are stimulants.[40] Medita-

tive trance, on the other hand, has broad-spectrum effects, increasing levels of GABA, arginine vasopressin, melatonin, and serotonin, decreasing cortisol and norepinephrine, and changing the rhythm of beta-endorphin release.[41]

I mentioned above the fact that intrinsic religious experiences, in the neuropsychological sense, may activate different substrates of the brain, depending upon specific conditions. There is brain-imaging evidence, for example, that different kinds of meditation practices (passive versus active, guided versus volitional) may have different neural implications.[42] One result is the recognition of a neuropsychological range of altered states experiences and the analytical need to treat each differently.[43] There is not one "altered state of consciousness" but many, each with potentially distinctive neural, cognitive, and emotional implications—as the neurochemical evidence implies. Although the brain-imaging studies have focused on meditation, not the shamanic trances described above, the two classes of ASCs appear to differ in significant ways. Indeed, shamanic trances vary even from mediumistic (spirit possession) states in terms of their degree of amygdala involvement; and both are distinct from TLE brain-storms,[44] our best existing model of a mystical experience.[45]

ASCs of all kinds (including REM dreaming) share a series of general similarities, including the mental imagery they help generate (hence the analytical utility of David Lewis-Williams's neuropsychological model) and the limited number of embodied metaphors that are used to describe them. But they also differ in pronounced ways. Although we do not yet fully understand all of these differences,[46] the verbal accounts alone demonstrate the markedly distinct emotional and intellectual reactions to shamanic trance versus transcendent states. One fact then is clear: shamanistic trance was religious in the sense that it was interpreted as such in its cultural context. But it was not necessarily a religious experience, such

as meditative trance, because of its neuropsychological effects. The implication of this situation is also straightforward: while shamanism may have been the first religion, its appearance (despite the importance of trance to shamanism worldwide) alone does not explain the origin of religion. This explanation must lie elsewhere: shamanism here is the chicken, and we still need to find the egg that came first.

I (and likely many other archaeologists) had long assumed otherwise. I had believed that shamanic altered states were de facto intrinsic religious experiences, and, with the development of the human mind to the point where it could experience trance, religious belief and practice were the obvious outcomes. This was not an unwitting inference on my part. It instead reflected over a century of imprecision in Western thought, the consequences of which are critical for any interest in the religious nature of shamanism and the origins of religion.

While there are at least two sources for this confusion, not all Western thinkers suffered from it.[47] It was primarily promoted by historians of religion, many of whom apparently assumed—despite the ethnographic evidence to the contrary —that shamanic visions were ecstatic in the proper sense of the word. Or, put another way, they adopted language that is so imprecise that they could equate the often-horrific experiences of shamanic trance with religious transcendence, ostensibly because some visionary experiences involved feelings of death and then rebirth—though how this necessarily related to transcendence was never clarified.[48] With the publication of Romanian scholar Mircea Eliade's influential and widely-read synthesis, *Shamanism: Archaic Techniques of Ecstasy*, the equation of shamanic trance and ecstasy became codified in our Western intellectual consciousness and they have been treated as synonymous ever since.[49] Yet this can only be true if we define ecstasy in a fashion that inverts the meaning of the word, rendering it meaningless. Shamanic experiences may

have required a conquest of visionary demons, and the eventual victory may have resulted in an emotional release, but this is still distinct from mystical transcendence.

Popular culture is also partly responsible for this muddle, however, especially the countercultural attitudes prevalent since the 1960s. Hallucinogenic drug use and oriental mystical traditions were conjoined in my generation's minds by influential figures as disparate as Allen Ginsberg, the Beatles, and Timothy Leary and his collaborator on the Harvard LSD Project, Richard Alpert (who became Baba Ram Dass, author of Be Here Now and devotee of the Maharaj-ji).[50] This has supported belief in a rough (but false) equivalence between hallucinatory states and religious experience, despite the substantial clinical (and experiential) evidence demonstrating that any such relationship is exceptional: religious experiences may involve hallucinations, but hallucinatory experiences themselves are much less frequently religious. Indeed, one motivation behind much LSD use during the 1960s was exactly the desire for enlightenment and transcendence. Though I don't doubt that many such experiences were euphoric (and certainly hallucinatory), there is little evidence that significant numbers were also mystical, and not from lack of interest on the part of the drug users. This conflation of ideas continues today, where workshops provide opportunities for self-realization through combinations of shamanic and meditative practices. Although these may be individually effective, they prove the point that shamanic trance in its various indigenous senses was alone not a religious experience as we envision this currently. As we shall see, this is not the only circumstance where 1960s countercultural beliefs have adversely influenced our understanding of shamanism.

Shamanic ecstasy, in other words, is a myth Westerners have created to understand experiences that, otherwise, make no immediate sense to us and that we could not easily equate

with our understanding of religion. By this I do not imply that shamans *never* had transcendent or mystical experiences; some of them very likely did.[51] Further, some shamanic hallucinogens appear more likely to promote mystical experiences than others. Peyote seems a particularly strong candidate, given its continued use as a sacrament in the Native American Church and the accounts I have been given from that source of its effect.[52] Psilocybin mushrooms also seem more likely to promote transcendental reactions. Hence, there certainly are *some* shamanic accounts of mystical experiences, but these are the exception, not the rule, and they are limited in their applicability and their implications. From the global perspective, the origin of religion must be sought beyond the appearance of shamanistic trance alone because religious ecstasy is the extraordinary, not typical, response.

TWO NARRATIVES FOR THE ORIGIN OF BELIEF

Shamanism, in its traditional form, was indeed then *fiercer* than it is today, as my Native American friend had explained to me on the terrace of a French café after our visit to Tuc d'Audoubert. Indeed, it was fiercer and much different than Western culture has appreciated for a century or more. The immediate implications of this fact for the Volp cave art are straightforward. The Trois Frères human-bison conflations (and the other associated engravings) were likely the product not of transcendent, ecstatic experiences, but instead of the emotionally violent and disturbing effects of shamanic trance. The engravings were not aesthetic masterpieces meant for admiration but more likely were feared, for they encoded the perilous, life-threatening nature of the supernatural. Although we will never know exactly what motivated the family of visitors in their encounter with the sculpted bison at Tuc d'Audou-

bert, my inclination is that they approached them with apprehension, caution, and respect. If they were like Native Americans in their attitudes—again, an unsupported analogy but a better starting point than the implicit assumption that they were like contemporary Westerners—they recognized the intrinsic potency of the images and the danger that this implied. I doubt that they approached the sculptures with the sense of reverence that we equate with religion today.

Despite this last supposition, a Native American would bring an offering to such a location, a possibility supported by the Paleolithic items left behind along the pathway. Native Americans, too, might use this kind of feature for a curing ritual, intending to activate and apply its power, though not necessarily with a shaman in attendance. (I have attended one such curing ritual at a California rock art site, reflecting the fact that there were—and continue to be—secondary uses of these sacred places, subsequent to their creation.) But the fierceness of shamanistic power, and the caution and knowledge that must be employed when using it, stand out as the most likely Paleolithic responses to this art.

The argument outlined above leaves us with a conundrum: the archaeological and other evidence supports the idea that this early art and the religion that produced it were shamanistic. And this evidence is good, despite the fact that shamanism varies in important ways from its common Western conceptualization. Yet this still does not explain the origin of religious belief, which apparently lies somewhere else. Where can we find a more complete explanation for this most basic aspect of the human spirit?

In fact, there currently are two competing narratives for the origin of religion, promoted by two disciplines that are equally certain of their conclusions. They have approached the problem from two entirely different perspectives (using different kinds of evidence), without talking to one another.

Archaeology is the first, and archaeologists have a long history of concern with this problem, since questions of origins—history, in other words—and the deep prehistoric past are part of our purview. Evolutionary psychology is the second. Evolutionary psychologists are strictly interested in the fundamental nature of religion and why it is a cultural universal.[53] They are concerned with evolutionary processes, not historical events, arguing that religion's development is a natural result of biological and cognitive evolution,[54] and they dismiss the origins problem as meaningless.[55] Although origins may be unknowable from the perspective of the continuum of events that comprises an evolutionary process, they are far from meaningless for an understanding of human history.

Still, the evolutionary psychologists' perspective is a significant one: the "ultimate" origin of religion lies in the earliest beginnings of earthly life, and so the question of origins is already answered. Although this is unsatisfactory for an archaeologist, it points to the crucial fact that understanding the history of religion requires apprehending the deeper roots of the human mind. One aspect of human cognition, our emotional instincts, is particularly important in this regard. These are hard-wired responses, reactions, and tendencies that originate in our lower "reptilian brain." They are an emotional package that developed early in evolution as a whole and that we have inherited from our primordial ancestors. One of these instincts has implications for the development of beliefs about spirits: the fight or flight response. It is a reaction to uncertainty and especially fear or, in its extreme form, terror—fear that is so debilitating that it is either immobilizing (causing a "freeze up") or results in mindless flight. Commonly, at least in the natural world, it is triggered when we see a predator. Or, just as important, when we *think* we may have seen a predator and are quickly deciding whether this is friend or foe.

The implication here is that religious belief is the product

of normal thought, not altered states of consciousness. Evolutionary psychologist Justin Barrett puts it this way:

> Belief in gods requires no special mystical experiences, though it may be aided by such experiences. . . . Rather, belief in gods arises because of the natural functioning of completely normal mental tools working in common natural and social contexts.[56]

Barrett is not arguing about the significance of faith or the existence of gods. These are other matters involving issues that (in my mind) science cannot easily address. What he supports instead is the fact that religious beliefs result from the kind of thinking that occurs in all of us every day. Whether a god (or gods) inspires that normal thought is another matter entirely.

Contrary to what most of us think, religious beliefs and practices worldwide are also not limitless in their variability, as a superficial view of them might suggest. Religions seen structurally express relatively few concepts, and these follow fairly predictable patterns. We might think that the differences between animism, polytheism, and monotheism are immense, for example. Certainly there are great differences between the *content* of these beliefs. When we look at their *form*, in contrast, the similarities are striking.[57]

This last fact is not surprising, given the evolutionary origin of religion. Although there are an infinite number of potential religious beliefs (how could there not be, when beliefs are unverifiable propositions?), religions are the product of a winnowing process. This selects some ideas and concepts and discards others.[58] One result is failed religions: those whose beliefs and practices are too odd or restrictive to gain widespread acceptance and permanence (despite the possibility that a charismatic leader might develop a loyal following during his or her lifetime). The "Heaven's Gate" cult that

gained notoriety in 1997 is an example. Led by Marshall Applewhite, its members committed suicide with the appearance of the Hale-Bopp comet. They believed that a rocket ship containing Jesus Christ trailed the comet and that, with their own deaths, their souls would join him inside. Even without the group suicide and their other extreme forms of behavior (including castration), this religion was unlikely to persist because its beliefs were so extreme.

The efficacy or persistence of successful religions then depends in part on the nature of their beliefs. Regardless of whether these incorporate multiple or single deities, they have two key qualities. Religious beliefs include spirits or supernatural agents who take characteristic forms.[59] And these beliefs are counterintuitive or counterfactual in nature, but only to a degree.[60]

Counterintuitive religious beliefs contradict universal expectations about the normal nature of things. The Heaven's Gate belief in a rocket ship trailing the Hale-Bopp comet is certainly counterintuitive, but massively so. Successful religious beliefs, in contrast, contradict our anticipation of how things should be, based on past experiences and knowledge, but in a limited fashion. Most religious beliefs, in fact, involve *minimally counterintuitive concepts*, or MCIs. These are memorable and particularly susceptible to recall. They are interesting and tend to be passed on to others, whereas ordinary or truly bizarre concepts or incidents, like the Hale-Bopp rocket ship, are more likely forgotten.[61] Importantly, laboratory tests have proven the relationship between religious belief and MCIs: clinical subjects consistently judge counterintuitive statements as more likely to be religious in nature than intuitive, factual statements.[62] Barrett notes then that:

> Theologians and religious leaders cannot simply teach any ideas they want and expect those ideas to be remembered, spread and believed; rather, the way human minds operate

gradually selects only those with the best fit to become wide-spread.[63]

Examples of MCIs might include a human that can fly or a dog that can talk. A tree that can both talk and fly, in contrast, is also counterintuitive, but much more so: it violates more of our preconceptions and it violates them to a greater degree. Perhaps not surprisingly, Native American religions include numerous examples of flying humans and talking dogs, but no talking and flying trees.

Although there is more to the concept of MCIs than the above suggests, two of their qualities require emphasis. The first is their intellectual richness: they activate inferential systems of vital social importance, explaining, predicting, or generating interesting stories and exciting our reasoning.[64] This is why they tend to be remembered, discussed, and, for that reason, perpetuated. Second, this occurs especially when they involve intentional agents: beings of some kind that are the subject, not just the object, of action. "The most central concepts in religions," according to Barrett, "are related to agents."[65] And the most important supernatural agents are those that are personlike beings. These may not look or act exactly like humans but they always have human minds.[66] Greek and Judeo-Christian deities and spirits are humanlike, of course. And even though the majority of the spirits in Native American religions are animal in form, they think and talk like humans.

The fundamental significance of supernatural (noncorporeal) personlike agents (spirits) in religions was first emphasized by anthropologist Stewart Guthrie.[67] He linked them to a common feature of our perception, our *agency detection device*. This is our means for identifying predators and prey in our surroundings; it is an obvious outgrowth of natural selection and the evolution of our body, instincts, and brain and it is crucial for human survival. This perception system is actu-

ally a bit overactive and, for this reason, it is sometimes referred to as our *hypersensitive agency detection device*.[68] The implication here is straightforward: evolutionary pressures have favored an overreaction to circumstances where potential threats may exist.

The importance of our resulting extreme sense of vigilance is expressed well by evolutionary psychologist Scott Atran, who observes that:

> All supernatural agent concepts trigger our naturally selected agency detection system, which is trip-wired to respond to fragmentary information, inciting perception of figures lurking in the shadows and emotions of dread or awe. Mistaking a nonagent for an agent would do little harm, but failing to detect an agent, especially a human or animal predator, could prove fatal; it's better to be safe than sorry.[69]

One result is that we "see" things in the shadows and infer patterns where none really exist (faces in the clouds, for example). Another is that people have a tendency to interpret ambiguous evidence as action by a supernatural agent.[70] Indeed, any patterned action is commonly thought supernatural in origin when it is not obviously the result of a natural agent—a "real" human being or animal. This is especially true when the pattern seems to lack any normal or commonplace function or purpose.

"Crop circles" provide a good example. These are obviously the result of patterned actions, they do not appear to have any obvious purpose or function, and they lack other associated evidence of human agency. Hence they *must have been made* by non-natural agency—extraterrestrials in this case—as the tabloids have been quick to proclaim. (Predictably, some crop circle devotees continue to insist in their extranormal origins despite the fact that pranksters have admitted creating them and

demonstrated how they did it.) There is a meaningful implica-
tion in this trivial but contemporary example: attributions of
supernatural agency may result not from putative sightings of
the supernatural beings themselves, but from their traces. The
actions of spirits are often inferred from what is left behind.[71]

An example of this common kind of thinking was provided
by Mark Twain in his classic novel *The Adventures of Huckleberry
Finn*.[72] Huck, rankling under the Widow Douglas's efforts to
"sivilize" him, slipped out of the house one night to meet Tom
Sawyer. As they were making their escape, they were almost
caught by Jim, the widow's slave. Jim had heard something
rustling in the bushes—the two boys—and investigated. He sat
down to keep watch because he knew, rightly, that something
was amiss, leaving the youngsters crouched and frozen in
apprehension. Eventually, Jim fell asleep and the boys made
their escape for a night of adventure. But before leaving, Tom
hung Jim's hat in a tree, and left a nickel on the table as pay-
ment for three candles he heisted. Jim was forever after con-
vinced by the hat and the nickel that he had been visited by
spirits (witches in this case). He wore that coin as a kind of tal-
isman from his experience and word of it spread widely, as
Huck's narration describes. Huck is also clear on the fact that
there were no witches, just Tom playing a prank. Whether
Mark Twain knew this or not, it was a successful trick because
it activated one of our most common kinds of inferential
processes, one that is a basis for religious ideas.

Supernatural agency is fundamental to religious ideas and,
perhaps not surprisingly, it is directly relevant to rock art. In
Native America, for example, more than a dozen different
tribes, stretching across North America from California to the
East Coast, attributed rock art to the actions of spirits.[73] These
spirits are identified specifically as shamans' spirit helpers,
reflecting the fact that no distinction was made between the
feats of a shaman and his spirit guide: they were indistinguish-

able.[74] Even in Australia, non-shamanistic rock art was thought created by ancestral spirits, even though it was obviously humanmade.[75] Spirituality can be understood in this sense as responsible for the origin of religious ideas and for perpetuating them through time.

Evolutionary psychological theories of the natural origin of religion cover more issues than the above examples suggest. Still, these are adequate to demonstrate that religious ideas are based not on mystical experiences but on extraordinary uses of our ordinary mental processes.[76] What then are the implications of these facts, theories, and ideas for the origins of belief?

The first and most obvious concerns spirituality (belief in spirits) and its role in shamanism. The sense of a "presence" can certainly be promoted by an altered state of consciousness. But seeing things that are not really there, interpreting sounds as more than natural background noises, and identifying patterns in random occurrences is something that we all sometimes do, and we are conditioned to do, like other (evolved) animals. (Trance heightens some of our senses and deadens others. In the case of sensing a presence, it accentuates a feeling that is natural, just as it may enhance anxiety or joy.) We scoff at accounts of the Virgin's face seen in a tortilla; many of us laugh at those who attribute slight, cool breezes and slamming doors—always at night, when our perceptions are limited—to ghosts; and we dismiss our children's fear of monsters, barely viewed under their beds. Yet these kinds of occurrences and inferences happen, and continue to happen in all cultures, not because people are ignorant or naive or deluded, but because they are human.

Belief in spirits exists with or without religious import, in other words. Indeed, specific instances of spirit belief can vary markedly, even within a single culture or faith. (I know many Roman Catholics; none of them place religious significance in the tortilla face; yet there are others that obviously do. Some of

my educated and intelligent friends believe in ghosts, even though I do not—and this fact has no direct bearing on our faith, or lack thereof.) Natural evolutionary processes have required a hyper-vigilant concern with identifying predators; spirituality is an outcome of this fact, and whether or not this always involves religion varies culturally and personally. But there is nothing mystical about spirit belief alone. Nor is there anything extraordinary about its analogue, numinosity (the notion that spirits inhabit rocks, or caves, or other objects). This follows logically from spirituality and our tendency to misinterpret ambiguous events and perceptions.

Spirit belief is then a natural outcome of evolution. It was likely a preexisting condition for *Homo Sapiens sapiens*— modern human beings. Our Neandertal predecessors (and our other earlier hominid ancestors) probably also had the capacity to believe in spirits, even though there is no certain evidence that they participated in religion as a socially organized practice. The implication is that the evolution of beliefs is distinct from the origin of these shared practices, and the appearance of religion is still a real historical problem (contrary to the contentions of the evolutionary psychologists). This is because the mental tools promoting spirit belief and (religious) social practice did not evolve simultaneously, perfectly in tandem. Nor, apparently, did they both develop in progressive steps, evolving slowly and steadily toward "religion" as we know it today. Religion (in the larger sense of the term) did not appear at one single instance, fully formed. The most likely picture instead is the unfolding of different aspects of religion—spirituality, social practice, mystical experience, and religiosity—at distinct paces; some steady, others involving leaps and bounds, and some at different times and places. This suggests that there was not one first appearance of religion but many, involving different populations residing in varying regions, each potentially with slightly different manifestations.

That said, the importance of MCIs (minimally counterintuitive concepts) in the appearance of Paleolithic shamanism requires emphasis. Shamanism was more than just a subterranean phenomenon, limited in its distribution to dark-zone caves, as Côa demonstrates. Still, the caves represent environments that promote ambiguous perceptions that are easily mistaken for spirits. It is certain that the early artists were keying on and utilizing this ambiguity in their paintings and engravings. This is evident especially in the way that natural aspects of the walls and ceilings were incorporated in the motifs: the undulating edge of a wall serving as the back of a horse, or the protruding bulge of a ceiling providing a sense of corporeal volume to a bison. As anthropologist Weston La Barre described this:

> The cave artist at Lascaux perceives an unevenness in the rock wall, and on this he paints the animal into existence deep in the womb of the earth. He literally only creates what he "conceives"—out of a half-reality he has perceived.[77]

The shaman-artists were actualizing, in other words, the counterintuitive fact that there are spirits inside the cave walls. They had seen these spirits in features in the cave walls. Their paintings and engravings ensured that others could see them too.

The significance of MCIs is also evident in another aspect of this art, the conflations of human and animals, especially bison, seen at Chauvet, Trois Frères, and other sites. Transformations such as these are perceptual products of hallucinations, of course, and we understand their origin and form, partly by this fact. But they are religious images not simply because they are the product of trance. Religious concepts confound our normal expectations (as these images certainly do), violating the categories that we use to mentally organize our

natural world. The shaman's trance, put another way, was interpreted as religious not because it generated a mystical or transcendent experience. It was religious because it activated counterintuitive concepts and beliefs that, when socially shared and perpetuated, are known as religion.

Religion is a social practice based on commonly held beliefs, feelings, and experiences. Spirituality is a key component of religion and it is innate, even though not all individuals believe in religion. Intrinsic religious experiences (transcendence) promote and can create religion, but are not needed for it. Indeed, globally and historically they are likely rare. Shamanism needs be understood in terms of this last fact. Half a century ago, there was debate (or at least discussion) over the definition and meaning of shamanism. The historians of religion, exemplified by Mircea Eliade and his synthesis, *Shamanism: Archaic Techniques of Ecstasy*,[78] have seen their preferred emphasis (shamanic trance) become the dominant paradigm for what shamanism is and, by implication, what is central to its study.[79] But forgotten in current research is a slightly alternative view, best expressed by anthropologist Raymond Firth. He defined the shaman not as an expert in ecstasy but as the master of the spirits.[80]

Certainly, a shaman entered the supernatural world through an altered state of consciousness. But he did so to encounter the spirits that, due to evolutionary processes and normal thought, haunt us every day. He did this to master them and, by that fact, the human mind, in all its grandeur and imperfections—whether he understood this fact or not. It is this definition, the master of the spirits, and by this comprehension of the shaman, that we can identify and understand the origin of religion.

I expand on this point later. But it is enough here to note that religion—a shared social practice involving spirit belief and religiosity, but not always transcendence—developed first

(insofar as we currently can tell) in western Europe, at least thirty-five thousand years ago. This occurred when certain individuals, with (I believe) specific emotional characteristics, "captured" the spirit world. By this act, they gained social mastery over what previously had been uncontrolled and unpredictable. Through this act they "created minimally impossible worlds that solve existential problems"—an evolutionary psychologist's definition of religion.[81] And with that creation, *Homo Sapiens sapiens* achieved "modernity"—despite their continued use of stone tools and lack of agriculture (let alone computers)—in the archaeological sense of the term.

The origin of religion, in this sense, did not involve the development of a series of codified beliefs and the establishment of set ritual practices. Instead it resulted from the organization of beliefs, the cognitive bases for which were already long present. Shamanism persisted (and persists in certain forms to this day) because the mental tools supporting its core concern, spirit belief, are innate—we are all born with these, whether we are individually religious or not. Spirit belief is as much a part of our modern condition as it was the prehistoric condition, thirty-five thousand or more years ago.

CHAPTER 6

CREATIVITY AND THE EMOTIONAL LIFE OF THE SHAMANS

E volutionary psychologists suggest that there is no date for the origin of religious beliefs since they are a product of our biological and mental evolution.[1] What we distinguish as religious in this case is a kind of thought that is hardwired in us and has no clear first occurrence. It has emerged over the eons as we have evolved from our hominid (and earlier) forebears. (As any scientist will tell you, there is no "missing link.") Religious thought is part of what makes us human. But it is also part of what made Neandertals Neandertals, and it is also related to what makes apes apes.

Despite this last fact, we can identify an origin of religion (a social practice) as the point when humans systematically and repeatedly exerted their control over these innate beliefs. Shamans used altered states of consciousness to do so, establishing a means for contacting what previously had been

unseen but frequently sensed. Trance was critical to the emergence of religious practice not because it necessarily resulted in transcendence or promoted religiosity (reverence for the divine) but because it activated, and explained, the ethereal half reality created by our perception. Shamans used trance to call the primordial spirits from this half reality, spirits whose existence was perceived by all humans in daily experience.

Shamans likely used multiple means for demonstrating their mastery over these spirits, including tales, songs, and dances, but they used art to permanently materialize their spirit contacts, leaving us a remarkable record of these events. Indeed, although we likely never will be certain, they may have created the first art to do so, inventing something in the real world to illustrate what was in fact unreal.

Regardless of primacy, art presents a problem because it is not something that is easily understood, at least from the perspective of Western science. It exists almost as anti-science and it is intellectually intransigent for this fact. Paleolithic art illustrates this point perhaps best. Archaeologists have spent a century counting, measuring, and dating this art. This has allowed us to compile detailed records of sites and their motifs and how they fit chronologically into changing prehistoric lifeways. It has also allowed us to consider the origin of the imagery and what this likely symbolized—and this is no small feat. But largely overlooked is the question of "art" itself: the creativity that is inherent to these images. We have worked our way intellectually around the edges of the paintings and the engravings, but, I fear, we haven't gotten to a core issue that concerns their fundamental essence.

This is the self-evident fact that much of this art represents supreme aesthetic expression. The panels at Chauvet, Lascaux, and many other sites are true masterpieces that stand among the most significant achievements of all time. Yet they present us with a rarely considered problem. If the purpose of this art

was to portray the spirit world, less skillful drawings would have easily sufficed. If a goal was to deliver an ideological message (the supremacy of the shaman in Paleolithic society, perhaps), less brilliant images could do so perfectly well. "Bad" shamanic art, in the sense of motifs less aesthetically rendered, could fulfill every possible function that great art can perform, yet these panels unquestionably are great art. (Indeed, despite many renowned, mostly old, masterpieces of religious art, our modern churches are filled with mediocrity. Yet this has no apparent impact on their religious or social effectiveness.) These circumstances of great art require explanation.

Archaeologists, to be fair, have not entirely ignored the aesthetic side of Paleolithic art. Abbé Breuil viewed art as innately human and saw these early sites as a demonstration of that fact.[2] My French colleagues, aware of the greatness of their sites, like to joke that they prove what everyone has always known: the French are artistically gifted. Jokes aside, periodically the modern concept of "art for art's sake" is revived as a possible explanation for the painted and engraved caves.[3] But this just begs the question. Many humans apparently are innately artistic, and art has many social (and individual) purposes and functions. We need art in our lives and for many different reasons. But true creative genius is a slightly different matter, and the apparent concentration of it in the Paleolithic sites is an issue that warrants understanding.

I believe there is an explanation for this question. It lies not solely from a deeper comprehension of art and aesthetics, but partly in a better understanding of the artists, the shamans who painted and engraved their visions on the rocks, and in part from a consideration of the roots of creative genius. Both issues turn on the problem of mental health.

MIND AND THE MOHAVE

Few topics involving shamans have received more discussion than their mental health.[4] This resulted from a simple fact: the early anthropological accounts of shamans were essentially unanimous in their contention that shamans were (to put it colloquially) crazy. Most commonly, shamans were labeled as schizophrenic.[5] Despite the documentation provided by the early reports, a consensus now maintains that ethnographic shamans were mentally normal.[6]

There are a number of good arguments in favor of the revisionist perspective. One of these concerns the social roles that shamans fulfilled. Modern medication has greatly improved the lives of many schizophrenics, allowing them to become productive members of society. But prior to medication, the disease was often progressive, debilitating, and dementing, and its sufferers were commonly unable to adequately perform in social settings. In addition to a series of psychotic symptoms, schizophrenia is "associated with marked social or occupational dysfunction,"[7] and it is difficult, if not impossible, to reconcile a schizophrenic diagnosis with shamanism in any general sense. This is especially true given the fact that shamans provided both the religious and the political leadership in many cultures.[8]

A related reason for the rejection of the notion of the shaman as schizophrenic is the implicit recognition that many early ethnographers misinterpreted the hallucinations of shamans' trances as medical psychosis. The anthropologists did not fully appreciate that many of these were intentionally induced altered states, not signs of mental illness, hence they confused ritual with symptom. Further, the academic and recreational interests in altered states of consciousness that developed in the 1960s demonstrated that there was nothing extraordinary about shamanic experiences: anyone could have

these with the proper hallucinogen.[9] Perhaps most importantly, however, psychological testing on contemporary shamans failed to support the schizophrenic diagnosis.[10] As one author put it:

> The world of . . . a mentally dysfunctional individual is disintegrated. On the other hand, just the opposite may be said about the shaman.[11]

The mental health of shamans, in other words, is now a resolved issue.

Unless, that is, one reads the primary ethnographic accounts. These demonstrate repeatedly, and in great detail, that shamans were mentally ill and, in many instances, borderline antisocial (despite their social roles). Consider, for example, this account recorded from the wife of a Sagay shaman in Siberia:

> How did he become a shaman? Sickness seized him when he was twenty-three and he became a shaman at the age of thirty. That was how he became a shaman, after the sickness, after the torture. He had been ill for seven years. While he was ailing, he had dreams: he was beaten up several times, sometimes he was taken to strange places.[12]

Or these statements concerning Mohave shamans from eastern California:

> The Mohave themselves seem to sense that the shaman is really insane since, when a new sexual outrage perpetrated by a shaman becomes known, people tend to exclaim: "All shamans are crazy."[13]

> Shamans cannot control themselves. They will do anything. Their power makes them act that way. It makes them crazy.

. . . When they begin to cure, they quiet down. They become almost human.[14]

Or this slightly different but important example from the Arctic Inuit:

There I soon became melancholy. I would sometimes fall to weeping and felt unhappy without knowing why. Then for no reason all would suddenly be changed, and I felt a great, inexplicable joy, a joy so powerful that I could not restrain it, but had to break into song, a mighty song, with room only for one word: joy, joy! And I had to use the full strength of my voice. And then in the midst of such a fit of mysterious and overwhelming delight I became a shaman.[15]

It would be easy to continue this recitation, but similar summaries have been provided before—despite the current consensus that shamans were mentally stable. Yet these summaries (and the evidence they draw from) are unequivocal and certain. Indeed, as English anthropologist Ioan Lewis appropriately noted, following his own lengthy review of the literature: "It would be pointless to cite further evidence of this widely held view that, by and large, shamans are mad."[16] It would be pointless because, as his synthesis demonstrated, the evidence is clear in the primary ethnographic accounts that shamans were, "by and large . . . mad." At issue then is not whether shamans were mentally healthy. They obviously were not, as the primary accounts illustrated repeatedly, even though they do not appear to have been schizophrenic. The issues instead are why they were misdiagnosed, what their symptoms actually were, and what their proper mental diagnosis should have been—schizophrenia hardly being the only mental disorder that has been identified by Western medicine. As we shall see, a look at the Mohave Indians, who live in the

Colorado River Valley between California and Arizona, helps resolve these questions.

There are multiple reasons for the confusion over shamans' mental health. They start with the fact that (with a salient exception involving the Mohave, discussed below) many of the early anthropologists who compiled the primary ethnographies had little expertise in psychiatry. Complicating this first fact is the history of Western psychiatry itself. With the ascendancy of Freudian psychoanalysis, earlier interest in the classification of mental illness diminished because it was thought that all mental diseases (putatively) could be treated in the same fashion, the "talking cure." The result was "no practical reason to make diagnostic distinctions."[17] One outcome of this circumstance involved schizophrenia. Due to diagnostic imprecision, a number of what are now recognized as distinct mental health conditions were sometimes labeled as schizophrenia (or "hysteria"), especially in the older literature. These included specifically the affective diseases or mood disorders: bipolar illness (manic-depression) and major (clinical) depression.[18] Indeed, standardized diagnostic criteria for mental illnesses were not developed until the 1970s. These were codified in 1980, due to the then growing rejection of Freudian psychoanalysis, with the third edition of the American Psychiatric Association's *Diagnostic and Statistical Manual of Mental Disorders (DSM-III)*.[19]

The implications of this last fact are straightforward. Anthropological debate over shamanism and schizophrenia, Don Quixote-like, has tilted at windmills. The original schizophrenic label was diagnostically vacuous. Subsequent evaluations of shamanism and schizophrenia, using the *DSM-III* and other criteria, demonstrated this fact. But, contrary to what many anthropologists have assumed, these studies tell us relatively little about the mental health of shamans.

One exception to the lack of psychiatric expertise was the

Hungarian-born researcher, George Devereux (1908–1985). Trained at the University of California, Berkeley, Devereux was a medical doctor, licensed psychiatrist, and anthropologist. The primary focus of his research was "ethnopsychiatry," the study of psychiatric theories and practices in traditional, non-Western cultures. His lifelong emphasis was the Mohave (sometimes "Mojave") tribe who live in the Colorado Desert bordering the Colorado River where it divides California from Arizona. His diagnoses, made in the late 1950s, provide the best clues concerning the mental health of shamans.

The Colorado Desert is a bone-dry furnace of a landscape that makes the rugged Coso Range, to the northwest, seem almost hospitable. (Early traveler John Ross Browne described the heat in 1871, stating that "butter must stand an hour in the sun before the flies become dry enough for use."[20]) The black rock ruggedness of the terrain is cut by the verdant strip of the river, pumping massive quantities of water south to the agricultural fields in the Coachella Valley. This creates a contrast that is a main theme in the gun and gallop mythos (as screenwriter A. B. Guthrie Jr. described it) of the West: livable though isolated outposts—the fort, homestead, or river edge—surrounded by hostile terrain. But there are other contrasts here as well. One, a regular theme for author Wallace Stegner, is the fragility of the desert away from the river. Despite its ruggedness, and due to its extreme aridity, this is a thin-skinned landscape whose wounds rarely heal.

But the most significant contrast for an archaeologist involves another quality of the West that Stegner emphasized. This starts with its restlessness, as a place that people pass through but rarely settle—a trait that seems particularly appropriate, given the fast-paced east-west interstates that bisect this part of the desert. The contrast is created by the Mohave, who have lived here seemingly forever, and whose traces I see everywhere along the river. Their permanence on the landscape sits

as a kind of silent reprobation of our Euro-American culture's inability to stand still.

Nowhere is the Mohave presence and permanence more strongly expressed than in their rock art. This provides a model of the potential variability in the origin and meaning of this art, even within a single shamanistic culture. Most visible are massive earth figures (geoglyphs or intaglios), scraped into the desert pavements on the terraces above the river. These depict the Mohave's mythic actors, especially the creator god, Mastamho, and his evil twin, Kaatar (emphasizing again the shamanic dialectical opposition, where good cannot exist without evil). These sites trace the primordial path of Mastamho as he moved between the creation mountain, Newberry Peak (near Laughlin, Nevada), and the Land of the Dead (at the southern end of the river). They memorialize his actions and events and were used in periodic ritual pilgrimages, led by shamans, where the mythic past was reenacted and thereby recreated.[21]

Off the river, in more isolated spots, are small concentrations of petroglyphs. These sites, at remote locations, were created by boys during the nasal septum piercing ceremony—their formal initiation into adulthood. This involved long runs through the desert with minimal food or drink. The motifs portray the spirit helpers they received during this experience, but the resulting imagery, unlike much of the Paleolithic art, is primarily geometric. The spirit helpers they received appeared as entoptic designs, the light images generated in the initial stage of a hallucination.

Geometric imagery also predominates in the third kind of Mohave rock art—engravings again, though these are found in large sites that surround their creation mountain, Newberry Peak (*Avikwa'ame*, "Spirit Mountain"), Mastamho's home (fig. 15). Though made by shamans, they do not portray spirit helpers, because all Mohave shamans receive their supernatural power directly from Mastamho. Instead, they depict the

creation event itself, which the shamans were said to first experience during prenatal dreams. Unlike the earth figures, which are narrative in form, the shaman's depictions of the creation are abstractions. Based on entoptic forms rather than illustrations of actors and a sequence of events, they are conceptually similar to an artist's portrayal of what our own theory of creation (the big bang) might have looked like. They are the most metaphysically sophisticated form of rock art that I have ever seen. The Mohave have always fascinated me (along with a number of anthropologists) partly for this fact.

George Devereux, however, was not interested in Mohave rock art. But he was concerned with Mohave shamans. In part, this was the product of a longstanding idea promoted by Carl Jung,[22] among others, that the shaman was a kind of "primi-

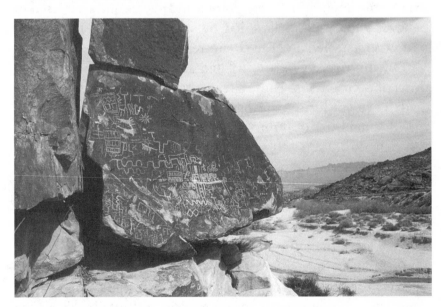

Figure 15. The Mohave Indians created rock art in three contexts. This example, from Grapevine Canyon near Laughlin, NV, is at the foot of Newberry Peak ("Spirit Mountain"), the Mohave creation spot and home of their deity, Mastamho. Shamans came to this location to re-experience the mythic creation of the world. They portrayed the pattern or essence of this event in their petroglyphs.

tive psychiatrist" and that, in their roles as healers, shamans treated mental more than physical illness. Devereux's goal was to identify Mohave theories of mental health and approaches to therapy. Any investigation of these topics necessarily required studying and interviewing the mentally ill and their indigenous healers. Shamans were part of his target research population even though their mental health was not his direct concern. Still, he fully recognized that shamans were "mentally deranged."[23]

Devereux was a product of his time, and his work (including his psychiatric evaluations) suffers from its share of Freudian psychobabble. But he nonetheless recorded information on the mental health of shamans in three forms. He cited clinical diagnoses from the records of the Arizona State Hospital for the Insane; he suggested his own psychiatric diagnoses, sometimes beyond the bounds of Freudian theory; and he provided pertinent behavioral, emotional, and cognitive observations. He was also aware of the need to distinguish schizophrenia from other forms of mental illness, recognizing that occasional hallucinations were not necessarily a sign of this more debilitating illness.[24] Devereux's study of shamans' mental states, further, was not systematic in a methodological sense, and his sample was necessarily small (because shamans are commonly a small segment of an indigenous population). Still, the information it contained is useful and particularly instructive.

Of the seven shamans/families of shamans that he discusses, Devereux mentions the mental health of three. Each apparently suffered from bipolar disease (manic-depressive illness).[25] Cross-cultural studies indicate that the prevalence of this disease varies, but it generally only afflicts from <1–2 percent of almost all populations.[26] Even with Devereux's small sample size, bipolarity in three out of seven cases (43 percent) is remarkable, and this is a conservative estimate since he did not discuss the mental health of the other four shamans.

Devereux also recorded substantial information about the characteristics of shamans, such as the behaviors and tendencies attributed to them by the population at large, including opinions about their mental states. As the quotes cited above indicate, the Mohave equated insane behavior with shamans. They took signs of insanity as a de facto demonstration of supernatural power. Shamanic healing as a vocation, in fact, was considered the only way to cure insanity.[27] Shamanism and mental illness, further, ran in family lines.[28] Shamans themselves were considered guilty of "highly obnoxious" behavior, especially during the troubled times when their shamanic power was first manifest.[29] Included among their antisocial behaviors were, especially, sexual misadventures and promiscuity: shamans were known for "perpetrating sexual outrages."[30] Perhaps most importantly, suicide was associated with shamans, especially with shamans "who drift[ed] from healing to witchcraft."[31]

The Mohave perception that their shamans were insane and that some were suicidal strongly suggests that the shamans were mentally ill. The combination of these circumstances with their other described characteristics supports this conclusion. But the questions are whether the Mohave shamans were unusual or typical of shamans more widely, and whether Devereux's specific diagnosis of bipolarity itself has any general significance.

THE SHAMANS' DISEASE

That the start of a shaman's career began with a medical crisis of some kind is well established in the anthropological accounts. The difficulty is that, beyond this fact, the specific symptoms of shaman initiates are rarely described in any detail, making any interpretation of them difficult. Mircea

Eliade, for example, characterized the circumstance as a "total crisis of the future shamans, sometimes leading to complete disintegration of the personality and to madness"[32]—a summary that is long on implications but short on specifics. But there are occasionally more useful accounts. Combined with information about shamans' general behavioral patterns, these provide a reasonable picture of their mental health.

A number of these descriptions were compiled by Finnish religious historian, Anna-Lena Siikala. Concerning a Siberian female shaman known as Savonne, Siikala, for example, wrote that:

> The most important *preliminary signs* of a *potential initiate* in a normal member of the community were, however, a nervous tendency appearing as a shaman's sickness and a capacity for visions and auditions interpreted as supranormal. . . . [The shaman Savonne was] in torment for a long time, and acted as one demented [until treated]. . . . However, her marked nervous condition did not disappear in spite of the fact that Savonne began to practice shamanism. She did not want to be a shaman; she hoped to recover. But then she became reconciled with her fate and accepted the hereditary shamanistic calling of her mother (her mother was also a shaman)[33] [emphasis in original].

Summarizing more generally, Siikala noted that:

> the bulk of shamans' own personal reports state that 'the shaman's disease' was the basic stimulus [for becoming a shaman]. The symptoms are both mental and physical; there are frequent mentions of pains in the head and the limbs, states of torment, with visions and auditions, fits reminiscent of the manifestations of hysteria, and so on. The patient turns to shamanizing in order to be healed, and this means is often mentioned as being the last and only way of attaining equilibrium.[34]

Waldemar Bogoras, who participated on the Jesup expedition with Franz Boas, provided a similar description of the Siberian Chukchi shamans:

> Nervous and highly excitable temperaments are the most susceptible to the shamanistic call. The shamans among the Chukchi with whom I conversed were as a rule extremely excitable, almost hysterical, and not a few were half mad.[35]

Bogoras further described these shamans as sometimes being incapable of sitting still for any length of time, having nervous facial twitches, and making violent gestures.

These comments and accounts provide a series of crucial clues concerning the mental health of Siberian shamans. Shamanism was hereditary, first, as Siikala documented repeatedly in her review.[36] The mental illness that accompanied it then ran in family lines, signaling the important conclusion that shamans suffered from a hereditary disease. The initial "torment" lasted for a lengthy period and this was itself quite serious, resulting in "demented" behavior and fits of "hysteria." Although neither of these terms provides clear clinical insight, hysteria generally means unmanageable fear (potentially an anxiety disorder) or emotional excesses. Bogoras's account suggests that this hysteria was agitated, perhaps manic, especially his observation about difficulty with sitting still.

The acceptance of the shamanic vocation provided some relief from the illness but did not cure it entirely. Savonne's "nervous condition" continued, and her illness in a sense was in remission, but she was not entirely healed. The initial crisis, in other words, was at least in part transitory, but the illness itself was recurrent. Future shamans also had a tendency to suffer from physical pains as well as mental torment, and from visual and auditory hallucinations.

A subtext of these summaries concerns age of onset.

Although shamans were apparently born with their disease (since it was hereditary), it did not manifest until later in life. The age appears to have varied, with early adulthood appearing most common. Further, the sex of shamans differed culturally. (In some regions of Siberia and North America, shamans were predominantly male; in others female). But both male and female shamans suffered from this disease.

Another summary of shamans' symptoms was provided by Lewis. It differs slightly from Siikala's and Bogoras's accounts because it emphasizes the initial onset of the shamans' disease rather than its manifestation later in life. Lewis characterized this as:

> hiding from the light, hysterically exaggerated crying and singing, sitting passively in a withdrawn state on a bed or on the ground, racing off hysterically . . . hiding in rocks, climbing up trees, etc.[37]

This suggests extreme emotional distress/overreaction, perhaps including mania ("hysterically exaggerated . . . singing"), withdrawal from social contact, and passivity.

These symptoms substantially overlap those cited by and deduced from Devereux and his work. Descriptions of the shaman initiate's status and condition in the rest of far western North America (beyond the Mohave alone) are at best brief and provide few clinical details. Despite this limitation, the available information correlates well with the Mohave and Siberian patterns. The shamanic calling was first manifest in a lengthy illness that could only be cured by becoming a shaman. For example:

> One man, who is still living here, was sick about a year. He almost died. When he was sick he went into trances and his body was stiff as a board. He dreamed he went to the land of the dead. . . . His father was a shaman.[38]

As this account suggests, shamanism was also hereditary, in the sense that it ran in family lines: "It is said that all the children of a shaman invariably follow in his footsteps, death resulting if they refuse to accept the spirits."[39] This last admonition (acceptance of the shamanic call or pain of death) is potentially important for reasons discussed below, and was apparently widespread.[40] Unsolicited and spontaneous visions and auditory hallucinations were also associated with the shamans' disease.[41]

Three general behavioral patterns are further evident in the far Western ethnographic data. The first is that shamans, even though healers, were considered malicious, antisocial, and obnoxious; indeed, they were "dreaded" in much of Native California.[42] Linked to this characteristic is the documented fact that they were regarded as sexually promiscuous and, in fact, predatory toward women.[43] Their activities were also largely conducted at night.[44]

This last behavioral pattern can be interpreted two ways: symbolically or symptomatically. Darkness and night are certainly symbolically significant, far beyond the limits of shamanistic religions. The night is a context that promotes strong natural associations. But unusual and regular nighttime activity may also be a sign of a sleep disorder, which is a potentially important mental health symptom. Moreover, these two explanations for the significance of nocturnal activities are not mutually exclusive (e.g., the nighttime symbolism in shamanistic cultures may reflect a behavioral tendency). Alternatively, ritual tendencies may provide a complete explanation independent of any mental pathology.

Although it is impossible to confidently resolve this inferential problem, there is one account that points towards a specific kind of sleep disorder. Anthropologist Anna H. Gayton reported that: "When a supernatural helper visited [a prospective shaman] in a dream, he rose and went out into the hills,

where he 'lay down to dream some more.'"[45] The implication of this statement is an interrupted sleep pattern, following an initial episode of REM dreaming.

There are many potential causes for insomnia, ranging from jet lag, to stress, to breathing difficulties. But "middle insomnia," implied by Gayton's remark, is a specific kind of sleep pattern primarily associated with two causes: excessive alcohol consumption or a particular mental condition—depression. Though far from certain, the evidence suggests that shamans may have suffered from a specific and symptomatic sleep disorder.

The final clue to the mental health of shamans also is based on interpretive inference and needs to be qualified by this fact. Still, it pertains to a symptom that is particularly diagnostic of mental health: suicide. Suicide in any population is a rare and extreme event. The estimated lifetime rates vary cross-culturally, ranging from below one to about forty-four per one hundred thousand people[46]—that is, substantially lower than 1 percent for any population, even at the highest statistical end. Given its rarity, it is not surprising that suicide is hardly ever mentioned in the ethnographic record, with one exception: George Devereux's work again, and his studies of the Mohave.[47] As Devereux himself cautioned, the anthropological study of suicide was greatly impeded by the widespread taboo over naming the dead and the related reluctance to discuss causes of individual deaths.[48] (This prevented him from obtaining even the most basic kinds of data, such as Mohave suicide rates, and made difficult the collection of case studies. Devereux's emphasis necessarily then was on theories of cause and motivation.) When suicide is mentioned in anthropological accounts, it needs to be recognized as extraordinary and very significant, rather than dismissed as anecdotal.

Three key facts are then evident in Devereux's data. He documented the suicide of one shaman, associating it with shamanic activities.[49] Certain kinds of behaviors—witchcraft in

particular—were considered intentionally suicidal on the part of shamans because they invited murder by the offended family: "the witch is believed to be suicidal and believes himself to be suicidal."[50] Witchcraft, put another way, was practiced by those who intentionally sought death. And the Mohave classified unusual deaths as de facto evidence of shamanic suicide. One example involved stillborn children. Shamans were believed to be predestined from conception. They were thought to first receive their power—through a dream of the creation—in the womb. The failure of an infant to survive gestation and birth was then a clear sign of intentional, self-inflected death, indicating that the infant had shamanic power. For the Mohave, at least, shamanism and suicide were conceptually linked.

There are other occasional reports of shamanic suicide in the ethnographic record,[51] but these are rare (as is any discussion of this topic). More important is a belief, noted earlier, that is related to the Mohave interpretation of unusual death as shamanic suicide. This is the widespread idea that the failure to accept the shamanic calling was fatal: "death resulting if they refuse to accept the spirits."[52] The implication of this belief is that those who did not successfully become shamans died. That is, they likely killed themselves. Although the evidence is not conclusive, it is suggestive of a widespread association between the shamans' disease and suicide.

The symptoms and behavioral tendencies of shamans then can be summarized as follows:

- They suffered from a hereditary illness
- The onset of this disease varied from adolescence to middle age, but it first appeared most commonly during young adulthood (late teens and early twenties)
- It was transitory but recurrent, involving periods characterized by greatly diminished social function and ability, matched against other times of normal functioning

- The initial manifestation was lengthy, often lasting a year or more
- Visual and auditory hallucinations were common, especially during this initial episode
- Physical pain and torment also sometimes accompanied the first manifestation
- Passivity and social withdrawal could occur or, alternatively, extreme agitation and mania
- Melancholic moods and intensely elated states sometimes alternated and were independent of immediate circumstances
- Highly antisocial and obnoxious behavior was also common, during the initial outbreak especially, but also later in life
- Sexual promiscuity, including outrageous sexual misconduct and other kinds of impulsive behavior were typical
- Unusual sleep patterns, including in particular middle insomnia, may have been characteristic of their illness
- Suicide was associated with those that suffered from this disease.

Unlike schizophrenia, however, the shaman's disease does not appear to have been progressive and dementing. Despite the seriousness of the initial onset, many shamans clearly fulfilled significant social roles and were among the most important members of their cultures.

DIAGNOSING THE SHAMAN

The ethnographic literature is unequivocal on the fact that shamans suffered from mental illness, despite recent claims to the contrary. Diagnosing the mental health of shamans based on these accounts is, however, a difficult task for a variety of rea-

sons. It is highly unlikely that all shamans had the same mental problems. It is also true that mental health itself can be difficult to assess in the best of circumstances. Using the published anecdotes is far from ideal, given especially their lack of detail. Many mental illnesses fall along a spectrum of symptoms. Mental illness does not necessarily manifest in obviously discrete diseases the way physical illness does, as, for example, small pox versus malaria. This is because the symptoms for mental illnesses overlap, especially in less severe cases.[53]

Despite these difficulties, it is possible to offer a diagnosis of the shamans' disease for two reasons. First, the pattern of symptoms is widespread, specific, and characteristic. Key among these are the hereditary nature of the disease; its recurrent or periodic nature; an initial, lengthy but transitory depressive episode; hallucinations; occasional reports of mania, involving either elation or irritability; possible related reports of antisocial behavior, sexual promiscuity, and other kinds of impulse control; and a real and widely perceived association with suicide. The possibility of a characteristic sleep disorder is also significant. Second, the problem can be approached from the perspective of the most generalized, and therefore conservative, diagnosis. That is, although it is not possible (or advisable) to attempt a specific diagnosis of most shamans, or argue for a blanket diagnosis for all of them, a spectrum of related mental diseases can be suggested as their most likely illness.

Devereux's data pointed to manic-depression as the shaman's disease. This Mohave diagnosis is supported by an Arctic Inuit account, quoted earlier. This illustrates two of the classic attributes of bipolar disease: abundant emotions that are unrelated to and independent of surrounding events and circumstances, and strong mood swings starting with depression and then shifting to manic euphoria:

I would sometimes fall to weeping and felt unhappy without knowing why. Then for no reason all would suddenly be changed, and I felt a great, inexplicable joy, a joy so powerful that I could not restrain it, but had to break into song.[54]

This shaman, like the Mohave diagnosed by Devereux, appears to have been bipolar. More generally, shamans can be understood as suffering from mood disorders or affective diseases. These range from minor depression, through major depression (unipolar depression), to mixed states and cyclothemic conditions (transitions between the extremes), to manic-depression (bipolar I and II), and to schizoaffective disorders, using some of the current psychiatric terminology.[55]

These affective diseases are a spectrum of disorders that can be grossly divided into depressive and bipolar diseases, both of which have a number of variants. The key symptom of depressive disorders as a whole is one or more lengthy periods (at least two weeks in length) of depressed mood unrelated to circumstances, combined with at least four additional symptoms. The hallmark of bipolar disease is one or more manic episodes alternating (or mixed) with major depression. It is crucial to note that, in either case, the diseases are episodic, with periods of mental illness that are matched against times of normalcy. As psychologist Kay Redfield Jamison emphasized:

Lucidity . . . is not incompatible with occasional bouts of madness, just as extended periods of normal physical health are not incompatible with occasional bouts of hypertension, diabetic crisis . . . or any other acute exacerbation of underlying metabolic disease.[56]

The *DSM-IV* provides diagnostic criteria for this spectrum of related illnesses[57] that match the ethnographic descriptions of shamans; that is, despite the fact that the specific criteria

vary depending upon each disease, and even though individual manifestations of the illnesses can also differ substantially. It is useful to consider some of these criteria and attributes in general terms for two reasons. The first is to illustrate their fit to the ethnographic data. The second is because common perceptions of mental illness (outside of the mental health field) are, typically, misinformed if not substantially error ridden. Indeed, many people who suffer from mental illnesses do not recognize this fact and rarely seek professional treatment. This is partly because of lack of self-awareness, in part a reflection of the stigma still associated with mental (but not physical) illness, and also due to widespread ignorance about mental diseases. Each of these circumstances contributes to confusion about the topic. My argument that shamans suffered from mood disorders can only be understood with an accurate apprehension of these kinds of diseases.

Perhaps the most important characteristic of mood disorders is their heritability. This is partly because the genetic facts concerning these diseases counter the widespread Western perception that equates "mad" with "bad,"[58] and the related idea that the mental health symptoms are the result of faulty character, rather than true medical issues.[59] Despite these deeply entrenched attitudes, the genetic origin of mood disorders was suggested over a century ago.[60] It is now accepted as an established biological fact, with family and twin studies providing the proof. Efforts to identify the mutations responsible for mood disorders demonstrate that these are complex genetic diseases, in the sense that multiple genes (combined with environmental factors) play a role.[61] Further, although depression and manic-depression are related, the relationship is asymmetrical. Major depression alone tends to run in some family lines. But both manic-depression and major depression are present at significantly elevated levels in bipolar families. Age of onset influences the probability of offspring mani-

festing the illnesses, with early onset (adolescence or teens) increasing the odds markedly.[62]

About 1 percent of the population overall suffers from severe manic-depression; another roughly 1 percent have milder forms. Approximately 5 percent have major depression and, though the odds for bipolarity are equivalent for males and females, women are twice as likely as men to experience major depression.[63] Note that my estimate for the number of shamans in far western North American tribes is 2 to 4 percent of the population. Given the fact that shamanism was largely constrained to males among these groups, this estimate is congruent with their inferred male rates of significant mood disorders.

The statistics are particularly telling among twins (including split twins raised in different families and environments). There is a 63 percent probability that a second identical twin will be bipolar if the first is afflicted; a 34 percent chance that the second twin will have either major depression or a mixed condition; and only a 3 percent probability of being disease free. For fraternal twins, whose genetic similarity is equivalent to non-twin siblings, bipolarity is only shared in about 9 percent of the cases.[64]

The ethnographic literature is clear on a series of points related to heritability. A shamanic calling in theory could have come to anyone. Despite this possibility, shamanism was very strongly tied to family lines. (Note that there is some discussion of "inherited shamanism" in the literature that might appear misleading on this point. Inheritance in this ethnographic sense refers to whether a shaman received his spirit helper from his father or other ancestor, not whether shamanism was associated with specific families. Many groups did not have "inherited shamanism," from the perspective of their cultural beliefs. But shamanism still ran through specific family lines.) More important, it is clear that multiple family members suffered from the shamans' disease. One of these cases

involved a Mohave shaman diagnosed as bipolar. He had a grandfather who, as Devereux wrote, also: "had a spell of insanity before he began to cure; power seems hereditary in that family."[65] Another was the female Siberian shaman Savonne, quoted earlier, whose mother was also afflicted.[66]

The prominence of shamanic family lineages has been noted by many anthropologists. They have been explained as the result of culture, emphasizing the importance of training and background in shamanism. They have also been interpreted as genetic and linked to a hypothesized neuropsychological predisposition toward entering altered states of consciousness. Both of these factors may be contributory. But the shaman's disease was defined everywhere as the sign of a supernatural calling, and it was the manifestation of a mood disorder. Shamanism ran in family lines primarily because its defining characteristic is a hereditary spectrum of mental illnesses.

A second central component of mood disorders is a significant depressive episode, characteristic of both bipolar and unipolar diseases. Depression of this type is associated with a severe melancholic mood that is unrelated to events, past or present. That is, it is not the result of some childhood trauma or necessarily linked to a recent catastrophic event (although, obviously, severe unfortunate incidents, including a medical illness, can trigger depression). It is qualitatively different and quantitatively more severe than sadness, and it is marked by fixity—it does not change. It may be dysphoric, in the sense of including irritability and anger. Alternatively, it can result in passivity and social withdrawal. In either case, it may (or may not) be associated with heightened anxiety—signaling the fact that depressive symptoms do not represent abnormal traits. They instead are normal traits, behaviors, and reactions. But they are experienced to an extreme or abnormal degree.

Depression also has a series of bodily effects. The most prominent of these are associated sleep disorders. These vary

from hypersomnia (sleeping all or much of the time) to insomnia. "Middle insomnia," waking for long periods in the middle of the night, is particularly characteristic. The so-called adolescent sleep disorder may also be associated with depression. This is a continuation into adulthood of the common teenage pattern of staying up into the middle of the night and sleeping late into the day. Another bodily symptom is muscle pain, which can be severe, even incapacitating. Perhaps the most debilitating symptom however is loss of functionality. In severe episodes, a depressive cannot perform many normal activities and tasks. Bodily movements slow down and speech can become difficult. Alternatively, again, some depressives are agitated (and more at risk of suicide for this fact) and perhaps filled with rage, rather than physically retarded by extreme lethargy.[67]

Much of the original diagnostic confusion over the shamans' disease likely resulted from reports of their hallucinations. Many, perhaps most, depressives do not suffer from psychosis, which occurs as an extreme manifestation of the disease. But visual, auditory, and bodily hallucinations certainly can result from severe depression (and bipolarity). For example:

> Hallucinations can merge with somatic delusions, and the psychotic depressive may believe that parts of his body disintegrate, rot, and fall off, or change grotesquely.[68]

Compare this clinical generalization to a description of a Siberian shaman's vision, cited previously:

> In my dreams I had been taken to the ancestor shaman; cut into pieces on a black table. They chopped me up and threw me in the kettle and I was boiled.[69]

This particular shaman's lifestory is well known (and was discussed in the previous chapter). He had this vision during a

lengthy period of mental "torture," as his wife described it, from which he eventually recovered. Although it is impossible to provide a specific diagnosis for his mental condition, the most conservative interpretation is that he experienced a lengthy depressive episode. Generically speaking, he had a mood disorder.

It is normal to suffer sadness, including severe sadness, as a result of events that occur during our lifetimes. The grief experienced over the death of a loved one is an example. This can be extreme and it can potentially push an individual into a melancholic state. Depression is pathological, however, when it is not moderated by outside events, it leads to self-destructive behavior, and it is recurrent and episodic, despite circumstances. This kind of depression is an illness, not a reaction to an unfortunate circumstance.

The opposite side of mood disorders is mania. The occurrence of one or more episodes of mania, combined with depression, defines bipolarity. Bipolar disease may be relatively mild (hypomania or bipolar II) or more severe (bipolar I), including possible psychotic episodes with florid hallucinations. Mania itself is an agitated and active state. Sometimes it is euphoric. But the mood is as often irritable and, in either case, it is again not directly a result of outside circumstances. Speech is rapid and pressured, physical activity is increased, thought can be quick, and there is a (perceived) decreased need for sleep. Sexual drive can become enhanced, sometimes to the degree of promiscuity, thought can be grandiose and/or paranoid, and bodily motions can become overactive and aimless. Impulsive, risk-taking behavior is also often characteristic.[70] Another pathological tendency is "self-medication" (drug and/or alcohol abuse). Manic-depressives have a 46 percent lifetime probability of suffering from substance abuse, versus 21 percent for those with major depression, and only 13 percent in the general population.[71]

A key characteristic of bipolarity and major depression is their cyclical natures. Both diseases come and go, as noted above, with intervening periods of normal mental health. The length of time spent ill and the timing of the recurrences varies. Partly these factors depend upon age in life, age of original onset, and overall severity. The average estimates are that manic-depressives spend between 20 to 47 percent of their lives in a mentally ill condition, with the majority of that time depressed. Depressives are ill about 32 percent of their lives.[72]

Bipolarity and depression yield seasonal, and even daily, mood swings, for reasons that are not yet fully understood. Depression is usually worst in the morning; evenings bring somewhat elevated moods. Manic states typically follow depressed periods but are themselves often seasonal, occurring in the spring or fall, on an annual or biannual basis.[73] Although the seriousness of these mood disorders should not be underestimated—both are potentially life-threatening illnesses—they are nonetheless characteristically periodic rather than chronic. As Edgar Allan Poe described his own manic-depressive condition: "I became insane, with long periods of horrible sanity."

The implication of this circumstance is critical to understanding the shaman's disease. It is possible to function, more or less normally and productively, with a significant mood disorder. Shamans were, 'by and large . . . mad,' but the madness they experienced was not debilitating or dementing in a long term or progressive sense. Mood disorders are diseases that you can live with; that is, if they do not kill you first.

Major depression and bipolarity are potentially life-threatening illnesses because both are very highly correlated with suicide—which, as discussed previously, itself is associated with shamans. Current estimates for death from suicide range from 15 to 20 percent for severe bipolar patients, and 24 to 40 percent of all manic-depressives are estimated to attempt suicide

during their lifetimes.[74] The rate is slightly lower for major depression because the commonly associated lack of will and energy often prevent the effort. Still, the attempted lifetime rate among major depressives is 18 percent, and the "success" rate (if one can call it that) is about 13 percent. For the general population only about 1 percent ever attempt suicide,[75] emphasizing how truly elevated the rates are in mood disorders. Many suicides occur among people who are never diagnosed (let alone treated) for mental illness—again, the vast majority of individuals with mental illness rarely recognize their malady and do not seek professional help—but 70 to 90 percent of all suicides are believed to have resulted from mood disorders;[76] the remainder are thought to suffer from other mental illnesses (schizophrenia in particular). Jamison noted that:

> Suicide, for many who suffer from untreated manic-depressive illness, is as much "hardwired" into the disease as myocardial infarction is for those who have occluded coronary arteries. Because suicide appears more volitional, somehow more existentially caused, and more tied to external circumstances than it often actually is, the seriousness of manic-depressive illness as a potentially lethal medical condition is frequently overlooked.[77]

In Native American terms, death resulted from the shamans' disease if the recipient "refuse[d] to accept the spirits";[78] that is, if he or she did not become a shaman. But this statement is just an inversion of the underlying logic, which held that shamanism was the only cure for madness.[79] Individuals who survived their madness were shamans; those who died from it were not. Shamanism and suicide, in this sense, were inextricably linked. They were one aspect of the symbolic dynamic that served as the foundation for the shaman's view of the world, which we describe as a dialectical

opposition: an unresolved, and unresolvable, balance between opposing forces. Two of these, as the shamans knew, are life and death.

The widely described symptoms and behavioral traits and tendencies of shamans then compare favorably to the diagnostic criteria for mood disorders.[80] Shamans were mad, as the ethnographic accounts describe with reasonable certainty. But shamans were also capable of functioning in society and fulfilling important social and religious roles, despite their periodic bouts with insanity. They did this, moreover, while struggling with an illness that promotes self-destructive and antisocial behavior. Although they were religious and social leaders, the result (in Native America and Siberia at least) is that they were dreaded and feared more than loved. The shamans' power was a fierce kind of potency, indeed.

There are two reasonable objections to this argument. One, which I have heard expressed by friends and colleagues many times, doubts that someone with a serious psychiatric disease could function productively. *"Those people,"* the objection usually goes, "could not possibly operate in any normal capacity. I've known a few, and it is impossible. They are nuts." The second likely objection involves intellectual authority: how can an archaeologist, with no psychiatric or psychological training, claim to offer a credible diagnosis of mental health?

I have a single response to both questions. I have spent my adulthood demonstrating that someone with a serious mental illness can lead a productive career. I have a lifetime of knowledge on mood disorders because of that fact. I have early-onset major depression, and I have lived with it since I was sixteen. In nontechnical (but roughly accurate) terms the reservoirs of two of my neurotransmitters, serotonin and dopamine, function poorly. I use up these two mood regulators relatively quickly, and they are slow to replenish. Mood disorders, in other words, are caused by neurochemical malfunctions. These can be

extreme, and, though the problem is not caused by external factors (I was born with the genetic mutations that cause it), circumstances can aggravate the neurochemical balance.

One of these (and it is hard to know what here is cause and what is effect) involves sleep. Though many people can treat their depression with antidepressants, these same drugs cause others to cycle into a manic phase, precipitating a kind of pharmaceutical bipolarity. I avoid this by attempting to regulate my associated sleep disorder, using a sleep medication to enhance a normal REM sleep cycle—the only way to adequately refill my neurotransmitter reserves.

I am no shaman. I make no pretense of being one and have no aspirations in that regard. But, as someone who knows that you cannot trust happiness, I understand the emotional landscape that shamans traveled. As Wallace Stegner warned us about the desert, the shaman's world was very rugged but still fragile terrain, with thin skin that was slow to heal.

MADNESS AND CREATIVITY

I am not a shaman, even though I share aspects of their mental disorders. Sadly, I cannot claim to be a creative genius either, though many shamans clearly were, as the Paleolithic cave paintings demonstrate so vividly. And yet the roots of their creativity—as we all likely know but are slow to fully apprehend—lies in their madness.

The relationship between creativity and mental illness has been recognized at least since the Greeks. Aristotle associated great ability with depression, and Socrates and Plato argued that poetic genius was inseparable from madness,[81] making this one of our oldest and most persistent cultural notions.[82] The link between insanity and creativity is in fact a commonplace idea and it is widely acknowledged in the popular imag-

ination. The mad scientist and the tortured poet are two of our best-known icons. While they have firmly established the relationship between creativity and insanity in the popular mind, they have also fully trivialized it. Both icons are laughable caricatures, and the (serious) ideas they express are easily dismissed by this fact. But quickly overlooked due to this circumstance is the substantial—and now essentially certain—scientific evidence correlating mood disorders, especially bipolar disease, with extraordinary artistic creativity.

American scientific recognition of the association between mania and artistic talent occurred in 1812, with our first "modern" treatise on psychiatric disease.[83] The connection between the two phenomena has been noted repeatedly by scientists, even if only anecdotally, ever since. During the last three decades, various kinds of research have substantially improved our understanding of this relationship. It is no longer an interesting "tendency," supported by anecdotes and off-hand observations. Recent research instead has moved our understanding of the relationship of madness and creativity to the level of statistically significant positive correlations, involving carefully constructed sample populations. That is, this research has used rigorous procedures to demonstrate a definite relationship between mood disorders and creativity, thereby turning the popular caricatures into real scientific facts.

Three primary approaches have been used to study the relationship of creativity to mental illness. The first involves investigations of living groups of artists and their close relatives. Perhaps the best-known example of this research was provided by psychologist Nancy Andreasen.[84] Her study group consisted of staff and students at the University of Iowa Writers' Workshop, the oldest and most prestigious creative writing program in the country, matched against a control (nonartist) population. Andreasen's principle research interest had been schizophrenia. Her starting hypothesis (based on earlier literature) was that

artistic talent would correlate with schizophrenia. This is not what she discovered. To her surprise, none of her artists had this disease, but fully 80 percent suffered from mood disorders and 43 percent of her artists were bipolar.[85] Andreasen also examined the mental health and life histories of the artists' first-degree relatives, along with the families of her control subjects. The artists' families were both significantly more creative and more prone to mood disorders than the control group.[86] Her results point to a strong association between this spectrum of mental diseases and artistic creativity.

A second approach objectively measures the inherent creativity of bipolar patients and their close relatives (rather than previously recognized artists) in relation to a control sample. This kind of analysis uses standardized tests that identify the quantity and quality of creative efforts in day-to-day activities. One such study, conducted by psychologist Ruth Richards and her colleagues at Harvard University, started with the hypothesis that the genetic traits associated with bipolar disease may confer a general creative advantage on those family members carrying the mutations, even if not on the bipolar patient himself or herself. Those with mood disorders and their family members again had significantly higher creativity scores than the control subjects. The scores seemed to peak with those suffering from less extreme expressions of bipolarity, suggesting that an individual's creativity is not a direct function of the severity of their illness. The authors in fact concluded that: "Overall peak creativity may be enhanced, on average, in subjects showing milder and, perhaps, subclinical expressions of potential bipolar liability."[87]

A third approach has been biographical, involving detailed examinations of the life and medical histories of renowned artists and their families. Although biography can be anecdotal, and even though there are substantial methodological issues that must be overcome in such an analysis, a number of

these studies have been systematic, rigorous, and detailed.[88] Perhaps the best was provided by psychologist Kay Redfield Jamison. She analyzed the life histories of all of the major British and Irish poets born between 1705 and 1805.[89] She concluded "that a strikingly high rate of mood disorders, suicide, and institutionalization occurred within this group of poets and their families," with 55 percent of her sample of poets so affected.[90] Her findings are fully consistent with the studies of living artists, such Andreasen's, and of bipolar patients and their relatives, such as Ruth Richards's.

Regardless of the data used, the time period examined, and the approaches taken to analysis, a strong association between artistic creativity and mood disorders has consistently been identified. The statistics that result from these studies are compelling. On average, artists tend to have about ten times the incidence rate of mood disorders compared to the general population and they are thirteen times more likely to commit suicide. Poets seem to be the most troubled, with a suicide rate that is eighteen times "normal." Compared to other educated professionals, artists tend to have roughly two to three times the rates of mood disorders, suicides, psychoses, and substance abuse problems.[91]

The correlation between mood disorders and exceptional general abilities and traits, including intelligence, is more ambiguous and controversial. Although there is general acknowledgment of at least a weak but positive correlation,[92] some contend that a bipolar disorder is

> almost indispensable to genius because of the advantages it can supply, and if there have been geniuses free from manic-depression, they have been a minority.[93]

The argument behind this claim is based partly on anecdotal yet suggestive (but scientifically unverified) associations

between mood disorders, social and financial success, and education. Bipolar disorder has been labeled the "CEO's disease" in the popular press,[94] for example, and there are well-known cases of major scientific figures that were severely manic-depressive (Isaac Newton, in particular). An analysis of the life histories of Napolean, Hitler, and Stalin, further, concluded that they suffered from grandiose paranoid bipolarity, where paranoia and megalomania predominate.[95] As intriguing (and potentially significant) as these arguments and inferences may be, substantially more scientific work would be required to fully establish any general contentions concerning this tendency.

The more immediate question is why mood disorders are associated with creative genius, whether artistically expressed or otherwise. Although the nature of creativity is not yet fully understood, a series of factors appear to play a role. The traits and characteristics of mood disorders, as noted above, are not themselves abnormal. They instead involve normal behaviors that are abnormally emphasized in the diseased. Many of the symptoms of bipolarity in particular are components of any kind of success, if controlled to a tolerable degree.[96] High work productivity is an obvious example. It is difficult (perhaps impossible) to determine the boundary between a period of intense and fruitful labor, required to realize any form of genius (or success), and a hypomanic (mildly manic) state. Bipolarity can materially contribute to the energy and drive needed for remarkable creative output.

Perhaps not surprisingly (especially given the results of Richards's study[97]), the most creative individuals are typically those with the milder forms of manic-depression, not the most severe. The cognitive aspects of their hypomania include a series of traits that are themselves associated with creativity. These include fluency, rapidity, and flexibility of thought, combined with wide-ranging associational thinking.[98] The diffi-

culty of course is that, during a severe manic phase, these tendencies are undisciplined and can reduce to distraction. Mild depression, in contrast, favors concentration and dedication.[99] It is the match between the expansive thought of mild mania and the introspection and control provided by depression that appears to be a significant source of creative insight.[100] Indeed, creative genius is especially associated with mood swings and mixed states—the transitions between the two poles of the disorder. As Jamison notes:

> It is the interaction, tension and transition between changing mood states, as well as the sustenance and discipline drawn from periods of health, that is critically important . . . [and] that ultimately gives such power to the art that is born in this way.[101]

There is substantially more that still needs to be investigated concerning mental health and creativity, especially with respect to general intellectual abilities. But the relationship between mental illness and artistic creativity seems to be scientifically established. To be sure, not all artists, including not all truly exceptional artists, are or were mentally ill. Insanity is not a requirement for artistic mastery but in moderate doses (and with discipline and training), it is one path to that end. Many shamans suffered from the kinds of mental illness that are correlated with exceptional artistic creativity. If the archaeological record created by shamans tells us anything, it is that many of them were also artists.[102] In the case of the Paleolithic caves, many of the shaman-artists were creative geniuses, and this requires empirical explanation. The best interpretation that I can offer, admittedly speculatively, is that this initial outburst of creativity, starting thirty-five thousand or more years ago in the European caves, was an early expression of the shamans' disease. The painted caves are remarkable expressions of

artistic talent because they were created by unusual people: those with specific kinds of mental disorders—mood disorders—that drove them mad yet, at the same time, promoted their genius.

I have been fascinated, since I was a young child, by the archaeological debate over what makes us human. The answer has evolved, as research has progressed, from the ability to make fire, to a facility for creating tools, to the capability for "symbolic behavior" (a current but odd concept inasmuch as animals of all kinds regularly act "symbolically," as anyone with a dog should know). Tied to this last trait is the related notion that archaeologically "modern" humans appeared not with the final evolution of our skeletons (one hundred fifty thousand or more years ago), but with the full development of our mental abilities (perhaps fifty thousand years back). Yet how can we know when this occurred, since cognition does not fossilize?

Our Western approach to the problem can be traced back to the Enlightenment, René Descartes' intellectual separation of mind and emotion, and the primacy of reason that this promoted.[103] This has emphasized the importance of the full complement of our rational capabilities because, as Descartes implied, this is what makes us human. My difficulty with this view results because I suspect that the Neandertal, too, may have been rational, only rational in a slightly different way. Or, put in another fashion, because (like Michel Foucault[104]) I believe that it is partly our irrationality—our madness—that defines us as modern humans. And it is this madness, gloriously expressed, that I see in the Paleolithic caves.

Where did the first art come from? I believe it is the product of mad geniuses suffering from the mood disorders that, historically (and likely prehistorically), were the defining characteris-

tics of shamanism. These were individuals who, by their subterranean acts, invented what we know as history. By their actions they established what "modern" humans are, and what we can be. We became "modern" humans, from this perspective, not when our full rationality alone emerged, but when our full emotional range—including mental sickness—developed.

CHAPTER 7

ART BEYOND BELIEF
CREATIVITY AND RELIGION
IN PERSPECTIVE

Few things characterize humans better than the art we create and the religions we practice. These are dimensions of humanity that we must fully apprehend if we aspire to any introspective understanding of our place in the world. As an archaeologist, my view of these matters involves origins because (as Mexican writer Carlos Fuentes suggested) we know ourselves best by where we have come from. Yet the account I have drawn here is not a linear narrative, in any standard scientific sense. It has not charted a series of progressive steps supported by a theoretical structure embedded in a detailed empirical argument. It was constructed instead with a series of intellectual threads—perhaps twisted warps and multicolored wefts are a better description. It was intended to create an interpretive fabric that provides a more textural, perhaps even slightly three-dimensional, sense of antiquity. This required

looking beyond the bounds of normal archaeology, to find new ways of knowing our deepest human past.

I started with the long-held inference that art and religion first appeared together. Future discoveries may change our understanding on this point, but currently, our best evidence of this event is found in the Paleolithic painted and engraved caves—and now open-air sites—of Western Europe. I also began with the theory that this first art and religion was shamanistic. Although there are dissenters (there are always dissenters for issues that matter), the arguments in favor of this conclusion are very good, if not compelling. These partly involve the nature of the art, particularly the conflation of human and animal characteristics in some of the images. Equally important is the fact that the art's structural features correspond to the kinds of mental imagery that are generated in hallucinatory trance. The dark-zone caves, where sensory deprivation can easily lead to an altered state, provided a context within which visions, and thus shamanic art, should be expected.

Yet this earliest art is at once very much like and also distinct from the shamanistic art that I have studied among more recent peoples in western North America and southern Africa. From the neuropsychological perspective, all exhibit the kinds and forms of images that occur during visions, certainly. Even the open-air petroglyph sites, at C ôa, Portugal, share these characteristics. Moreover, the variability in context—some Paleolithic art in caves, other sites on the open landscape—is similar to the differences that occur in the shamanic rock art of more recent peoples. The petroglyphs of the Coso Range, California, are a good comparison. We know from ethnographic accounts that these were made by Shoshone and Paiute shamans to portray their supernatural experiences. Although not in dark-zone caves (there are none in the region), the Chumash cave paintings were created just a few hundred miles away. They look quite different, superficially, from the Coso

engravings, and their setting is distinct. But the ethnography tells us that they were made for very similar purposes. The contrast between the Coso and Chumash rock art is parallel to the differences between the Paleolithic dark-zone caves in France and Spain and the petroglyph-filled landscape at Côa.

Despite these similarities, there are also significant differences between these religious arts. What strikes me most immediately is Lascaux, with its massive shamanistic composition in the Salon of the Bulls. This was created not by a lone shaman, working quietly in the bowels of the earth (if not in the subterranean depths of his mind). It instead was a fully conceptualized group effort of some kind, likely involving (among other things) the construction of scaffolding to paint the art.[1] That this is a shamanistic design seems undeniable, even though it is unlike anything I have seen in more recent shamanistic rock art. It signals a different kind of shamanism than in southern Africa or western North America, and it challenges us to find a better understanding of the earliest expression of this religious system.

I have approached this problem in (perhaps) a slightly unusual way. My goal has not been to reanalyze the art, hoping that a more detailed study would reveal the answers I sought. I have looked instead at shamanism, and attempted to reassess it as a widespread and long-lived religious tradition. The answers are not in the art, I believe, but more in the ways that we can know this art. Understanding shamanism better is the key.

The question of the origin of shamanism is a multifaceted problem, partly because human history itself is so complicated. There potentially may be a single place that shamanic religion and art first developed. It is possible that they spread everywhere from that one place to eventually cover the earth (much as anatomically modern humans first evolved in Africa, and then spread outward). Or shamanism may have developed in multiple locations, more or less simultaneously, and

thus may have many origins. (This possibility is enhanced by the fact that facets of shamanism are linked to natural aspects of human cognition. These include especially our shared range of experiences with altered states of consciousness and their influence on religious symbolism.) Archaeologists have barely begun to consider this problem, partly because early evidence is so hard to find. Still, it needs examination, if only to avoid the perpetuation of longstanding biases and confusions.

One of these involves a topic that is slightly lateral to the ultimate origin of religion but is directly pertinent to the history of shamanism (and my goal of gaining a renewed sense of this religious system). It concerns the relationship of Old to New World shamanism. We have long believed that Native American religions are fully derivative of Siberian shamanism and that they date from the initial migration of humans into the Americas. The problem with this widely accepted theory is that "classic" Siberian shamanism, by all existing Siberian evidence, is only about four thousand years old. It is, in fact, a relatively recent historical development, not a fossilized kind of Ur-religion, as it has widely been characterized. Humans have been in the Americas for over twelve thousand years, on the other hand, creating an empirical problem for the history of shamanism in global terms.

The antiquity of Native American shamanism has been controversial because of debate (and scandal) involving the techniques used to date the pertinent archaeological evidence—rock art. These techniques had suggested that this art, and the religion responsible for it, date at least back to Paleoindian times, ten thousand or more years ago. A closer look at this controversy, along with some new evidence, suggests that many of the rock art dates are still correct. There are multiple lines of evidence, and good empirical reasons, to infer that New World shamanism in fact substantially predates its counterpart in northeast Asia.

This circumstance (like many in science) has implications that are ambiguous. Clearly New World shamanism is *not* an offshoot of "classic" Siberian shamanism, despite their numerous similarities. It is nonetheless likely that New World shamanism was still part of the original migrants' cultural baggage and thus ultimately derives from Asiatic roots. But that form of shamanism was distinct from the Siberian shamanism seen historically, and it is one that we can only know today from its New World expressions.

Yet there are indeed many very specific similarities between historically described Siberian shamanism and the religious beliefs and practices in the Americas, especially in the arctic and subarctic regions. This presents an intriguing problem. As the Siberian evidence demonstrates, these commonalities can have developed only in the last few thousand years. What is the cause for these remarkable similarities, such as the widespread use of the shaman's drum and the so-called shaking tent séance? Western dogma holds that innovations always flowed from the Old to the New World (that is, except when Europeans themselves took things such as new crops in the other direction). I admittedly am biased on this point because my family roots in the Americas are deep. But the archaeological evidence concerning shamanism in these two regions raises the possibility that, in this case, influence may have gone the other direction. That is, "classic" Siberian shamanism, as described by early travelers and anthropologists, potentially originated in the New World or at least was heavily influenced by Native American religions.

It is heretical to propose that Native America may have somehow influenced the Old World, without European connivance. Yet there is archaeological evidence for other kinds of east-to-west movements of innovations, at about the same time as the appearance of Siberian shamanism, making this hypothesis at least plausible. Perhaps Native American cultures

in fact markedly contributed to the religious and intellectual history of Eurasia, instead of simply existing as a kind of (derivative) world apart.

As this problem demonstrates, there is still more to learn about the global origins of shamanism and how it may have spread around the world. A more fundamental problem concerns the question of how shamanism relates to religion. This is a question a historian of religion might ask. (It was, for example, a principle concern of Mircea Eliade, in his influential synthesis *Shamanism: Archaic Techniques of Ecstasy.*[2]) But it is a problem that anthropologists take for granted—because, for the study of living peoples, religion de facto consists of the ritual practices and beliefs of their culture. The distinction between these two perspectives is subtle but critical. It plays out seriously when the problem of the origin of religion— again an issue not asked by anthropologists—is raised. Yet this is a primary problem for an archaeologist.

The standard archaeological perspective—which I am guilty of having maintained for years—stems from the imprecise labeling of shamanic trance as "ecstasy." The implication has been that the appearance of shamanism, with its emphasis on altered states experiences, explains the origin of religion because trance is an intrinsically religious experience. Like meditative trance, that is, it is a transcendent or mystical state, making the resulting appearance of religion a self-evident consequence.

The difficulty with this idea is revealed when "religion" is disaggregated into some of its component parts. One of these is religion as a shared set of beliefs and ritual practices—a social phenomenon. Another is spirituality, which I define as the belief in spirits. Third is religiosity, the sense of reverence and communion that contributes to faith. Fourth is the intrinsically religious experience—transcendence, mysticism, and enlightenment, achieved through specific kinds of altered states of consciousness. The problems in light of these distinc-

tions are two-fold. The *specific* kinds of altered states that are known to generate intrinsically religious experiences are meditative trance and temporal lobe epilepsy. These are distinct from shamanic trance. The accounts of shamans' visionary experiences alone demonstrate this point. They are filled with horrific experiences marked by terror and pain, not enlightenment or transcendence. And it appears that shamanic trance activates different parts of the brain and involves different neurochemical reactions than intrinsically religious experiences. Moreover, religions exist despite the fact that, in many cases, very few individuals ever achieve true ecstasy. Indeed, mystical experiences tend to be the exception rather than the rule. Some religions may have been inspired by transcendental states, but this neither explains religion in a larger sense, nor necessarily applies to shamanism, the most likely first religion.

That shamanic trance was considered a religious experience was then largely a cultural, not a biological, fact. But this does not mean that biology did not play its role. I have looked to an alternative (but still biologically grounded) narrative for the origin of religion, provided by evolutionary psychology, to sketch a more probable explanation for the origin of shamanism.

Evolutionary psychology maintains that religion and its concepts are a natural outgrowth of Darwinian evolution. Rather than endless in variation, evolutionary psychologists see religions as united by a limited series of structural similarities. The specific content of polytheistic and monotheistic religious beliefs varies, for example, but they both emphasize spirits. Further, the nature of these spirits is essentially the same. Belief in spirits—spirituality in my terms—in fact is a key component of religions everywhere, and it is linked to the origin of shamanism.

Spirit belief originates deep in our evolutionary past. It is an outgrowth of perception and inference: the need for vigilance given the fact that predators are a potential threat on the land-

scape, and our tendency to over interpret ambiguous circum-
stances in order to be safe rather than sorry. We "see" lions in the
shadows (or, today, muggers in the alley) when there are none.
We misinterpret breezes and rustling leaves as evidence of
agency—intentional action on the part of some unseen being.
Spirits are the result. We are hardwired to believe in them
regardless of whether we invest them with religious impor-
tance—as ghost stories everywhere prove—or, based on rational
Western thought, decide to dismiss the notion entirely.

Spirits of course were a central concern in shamanism. In
the last half century we have somewhat neglected this fact,
instead emphasizing the centrality of altered states of con-
sciousness—best seen in the influence of Eliade's confused
definition of shamanism as an "archaic technique of ecstasy."[3]
Earlier anthropologists, in contrast, defined shamans as "mas-
ters of the spirits," not of trance. Their emphasis is closer to the
mark. It provides a better perspective for understanding
shamanism, especially if our interest is the origin of religion.

The first appearance of shamanism, and by inference religion,
occurred when shamans organized human spirituality—our bio-
logically ingrained tendency to believe in spirits. Put another
way, the appearance of religion, as a shared set of beliefs and
practices, occurred when certain individuals conceptually organ-
ized the half realities of the human mind. Neandertals likely
believed in spirits and perceived them regularly. We differ from
Neandertals on this point only (insofar as we can tell) because
certain of us have claimed to control those spirits and have devel-
oped techniques supporting that contention. (Or at least tech-
niques that left archaeological traces.) Shamans were masters of
the spirits because they were masters of the human mind.

Although I return to this point below, it is useful here to
turn to the question of art and how it relates to shamanism.
There has been widespread consensus, for good reason, that
the Paleolithic cave paintings were religious in origin. Archae-

ologists have also recognized—especially with the discovery of the thirty-five-thousand-year-old paintings at Chau vet—that this art appeared more or less suddenly, in full vigor. Art did not evolve. It burst forth, fully formed, in perhaps the most remarkable expression of creative genius in human history.

As an archaeologist, I am accustomed to listening to the faint whispers of the past. My hope is to hear enough, from dim murmurs and barely perceptible echoes, to piece together some understanding of the human story. But I am overwhelmed by the sound trumpeted by this Paleolithic art. It is a shout, at full volume, that resonates and reverberates thirty-five thousand years later. It demands an explanation for something that I, at least, cannot ignore. The question is not why art appeared with the origin of shamanism. The issue instead is why this first art consists of true aesthetic masterpieces—works of art that fully rival our greatest creative achievements, of any time and place. The answer, I believe, lies again in a better understanding of shamanism, especially the problem of shamans' mental health.

The primary ethnographic accounts (recorded in the late nineteenth and early twentieth century) were consistent on the fact that shamans everywhere were mentally ill. This consensus was revised after World War II—coincident with the termination of most direct anthropological research among shamanistic cultures. There were a number of reasons for this change, but it turned on two primary facts. Freudian psychoanalysis was responsible for a widespread diagnostic muddle that lasted at least until the 1970s, hence much Western discussion of mental illness to that time was at best inconsistent. The diagnoses of shamans, especially the early claim that they were schizophrenic, suffered directly from this confusion. Perhaps more significant, many anthropologists involved in the debate themselves lacked any real understanding of mental disease, as we know it clinically, since the demise of psychoanalysis. In their defense, this confusion continues and is widespread

today to the degree that many, perhaps even most, people with mental illnesses never recognize their malady, unless it turns catastrophic. But none of this means that shamans were mentally healthy. The primary ethnographic accounts were certain of the fact that they were not.

The symptoms of the shamans' disease, as anthropologists and indigenous informants labeled it, are widely described and follow a relatively restricted pattern. The illness was hereditary in the sense that shamanism ran in family lines, and multiple members of shamanic families suffered from the affliction. Its onset usually occurred in adolescence or early adulthood. Although shamans were born with the disease, it did not normally manifest until later in life. Its first expression was an extended melancholic state—depression, simply put—sometimes lasting for years. At least some shamans also suffered from periods of intense agitation, which might include euphoria—mania, in other words. In either case visual, auditory, and bodily hallucinations often accompanied the onset of the disease, which was transitory and episodic. That is, it came and went. Although shamans were generally renowned for their antisocial behavior and impulse control problems, they were fully capable of functioning within their respective societies, partly because they were only sometimes ill. Moreover, the shamans' disease was associated with suicide. Failure to "accept the call of the spirits" was said to result in death. But this was just an inversion of the logic claiming that active shamanic work was the only cure for this disease. An individual either overcame the disease, by becoming a practicing shaman, or it killed them.

With the move beyond Freudian psychoanalysis, systematic diagnostic criteria for mental illnesses have been developed, allowing for consistent and replicable mental health evaluations. The current standard for these is the *Diagnostic and Statistical Manual of Mental Disorders, 4th Edition (DSM-IV-TR)*[4] published by the American Psychiatric Association. It is unwise

to attempt a diagnosis of any specific shaman, and it is highly likely that their individual diseases varied. But their commonly described symptoms fit the criteria in the *DSM-IV-TR* for one general category of mental diseases, allowing for a "most conservative" diagnosis. This is that shamans suffered from mood disorders. Although these affective diseases represent a spectrum of illnesses, they can be grossly categorized as major depression or bipolar disease (manic-depression). These are genetic illnesses that are potentially lethal—in the sense that their suicide risks are high. They are not progressively psychotic or dementing (like untreated schizophrenia), even though they can yield temporary hallucinatory episodes. Importantly, they do not necessarily impair social functioning, at least in more than an episodic sense. Indeed, many highly successful individuals through the ages have suffered from these illnesses. These range from Isaac Newton, to Elvis Presley, to Martin Luther, to Joseph Stalin[5]—each of whom has influenced Western civilization in significant even if very different ways.

The potential link between the mental health of shamans—the evidence that, historically at least, they suffered from mood disorders—and the early manifestations of artistic genius seen in the Paleolithic caves seems obvious. It likely reflects the well-known connection between madness and creativity, one of our oldest cultural notions—dating back at least to the Greeks. We all know the story about Vincent van Gogh's ear. Some may also know that bipolar disease was common in his family. (His own case was a particularly severe form.) What fewer perhaps appreciate are the results of substantial recent psychological research on human creativity. Numerous studies, using different analytical approaches and various kinds of data, have demonstrated that a strong and significant correlation exists between unusual artistic creativity and these kinds of mental diseases, especially bipolar disorder. This research certainly also demonstrates that not all artistic

geniuses are diseased. A mood disorder is not required for remarkable talent, nor does it guarantee this gift. Under almost every circumstance, discipline and hard work are also required to realize genius. But a disproportionate number of recognized artists do suffer from these illnesses, and the families with bipolar disorders themselves score unusually high marks on standardized creativity tests—as do shamans.

The association between artistic genius and mood disorders seems a now well-established scientific fact. The "mad genius" has long been a cultural caricature and, for that fact, it is not always taken seriously. But sometimes there is truth in folk knowledge, as the psychological research appears to demonstrate repeatedly and compellingly in this case.

The subtext of this conclusion is an important one and it can be easily misunderstood or missed, due to common misperceptions about mental illness, and the stigma that is attached to it. This concerns the nature of mood disorders and what their symptoms imply about behavior and human capabilities. The symptoms that define this group of diseases are not unusual or abnormal. They are perfectly normal behaviors and traits, but they are expressed in the diseased to an unusual and, in some cases, abnormal degree. Moreover, mood disorders represent a spectrum of illnesses, and the severity of the symptoms can range from the very mild/subclinical to the extreme—Van Gogh's unfortunate circumstance. The rapid and wide-ranging associational thought that is characteristic of mania can contribute to highly insightful thinking or it can devolve to mental distraction. The energy and drive of mania, similarly, can make an individual unusually productive or reduce to agitated and unfruitful hyperactivity. The social ebullience of the manic can be charismatic and charming or it can turn to irritation and aggression. And the melancholic mood of both major depression and manic-depression can be introspective and promote critical thinking or it can lead to suicide.

Mood disorders, in the true sense, are both strengths and weaknesses. Somewhat like the genetic disease sickle-cell anemia (which can kill, or protect against malaria), mood disorders provide an adaptive advantage.[6] This fact goes unrecognized, outside the ranks of the mental health profession and the diseased because most people are only aware of the extreme cases. Yet it is the milder forms of these diseases— Newton and Van Gogh notwithstanding—that tend to be the most creative. Although artistic creativity can correlate with mood disorders, the degree of creativity itself is not positively related to the severity of the illness.

It is a self-evident fact that the Paleolithic caves include some of the most masterful examples of artistic creativity, by any definition or measure. This is simply an empirical fact— my own bias toward the importance of the archaeological record notwithstanding. Even though science is uncomfortable with qualitative assertions of this kind, this fact requires explanation. Good archaeological evidence suggests that shamans made this art. As we understand shamans historically, they commonly suffered from mood disorders. Indeed, the symptoms of mood disorders literally defined the shamanic calling. Put another way, the characteristics of shamans and their rituals are perhaps only fully understandable in terms of the symptomology of their diseases. And as we know these mood disorders, from psychological research, they are associated with an unusual incidence of artistic creativity.

Although I cannot prove this contention, at this point, these circumstances support the inference that the first shamans, too, suffered from these kinds of diseases. That is, the first art was not simply an expression of our earliest religion. It was also the first visible manifestation of a relatively common form of human mental illness: the mood disorders that historically defined the shaman's calling.

These mood disorders are in fact caused by genetic muta-

tions.[7] Given the advances in genetics and our rapidly improving understanding of the human genome, it is now possible to estimate the timing of specific mutations in alleles—gene variants. There is a good chance, given this scientific advance, to someday determine when mood disorders first developed in humans. The hypothesis that I propose follows from this circumstance. The first religion and art appeared not simply when the rational human mind finally evolved and not simply due to an unidentified social circumstance that, at some point in our history, developed. These traits instead appeared when the mutations that cause this form of madness—and creative genius—changed our genome and forever altered the nature of the human spirit.

Shamans were masters of the spirits because they mastered the human mind—including the beliefs in spirits that are our evolutionary heritage (or baggage, depending upon an individual's personal view of religion). But our human mind is more than just a rational cognitive system, despite the long-standing contentions of René Descartes and the thought that followed from the Enlightenment. If we hope to understand the adaptive implications of our mental evolution, we must accommodate this fact. Part of what we are includes the genetic mental illnesses that many of us inherit. Shamans were masters of the spirits because they harnessed these diseases to channel their creative impulse into what we see as magnificent art. This may have been what made them great, and made so long-lasting the relevance of their painted and engraved messages that we contemplate in the dark-zone recesses of the Paleolithic caves.

The French philosopher Michel Foucault seems to have understood this last possibility when he observed that

> If folly leads each man into blindness where he is lost, the madman, on the contrary, reminds each man of his truth.[8]

ENDNOTES

CHAPTER ONE: THE WORLD'S EARLIEST CAVE ART

1. The discovery of the eponymous Chauvet Cave by Jean-Marie and his colleagues is described in Jean-Marie Chauvet, Éliette Brunel Deschamps, and Christian Hillaire, *La Grotte Chauvet a Vallon Pont D'-Arc* (Paris: Edition du Seuil, 1995).

2. For example, Clottes has also directed the archaeological research at Cosquer Cave, France, or "the cave under the sea," which is renowned because its entryway lies under the waters of the Mediterranean Sea, near Nice, France; e.g., see Jean Clottes, J. Courtin, M. Collina-Girard, M. Arnold, and H. Valladas, "News from Cosquer Cave: Climatic Studies, Recording, Sampling, Dates," *Antiquity* 71 (1997): 321–26; Jean Clottes, Jean Courtin, and Luc Vanrell, *Cosquer Redecouvert* (Paris: Editions du Seuil, 2005).

3. See John Pfeiffer, *The Creative Explosion: An Inquiry into the Origins of Art and Religion* (New York: Harper and Row, 1982). Science writer Pfeiffer first used "the Creative Explosion" as the title of

his book on Paleolithic art and religion, but the underlying concept—that the appearance of anatomically modern humans in Western Europe represented revolutionary changes relative to the earlier Neandertal—was widely accepted by archaeologists for many decades. Substantial distinctions still appear to have distinguished the first *Homo Sapiens sapiens* in Europe from the Neandertal. But more recent discoveries in Africa have pushed the first appearance of anatomically modern humans back to between 150,000 and 200,000 years BP. For a recent summary see Pamela Willoughby, *The Evolution of Modern Humans in Africa: A Comprehensive Guide* (Lanham, NJ: AltaMira Press, 2007). The African evidence suggests that behavioral "modernity"—an archaeological term implying complex tool kits and ways of life, including the creation of art—lagged behind the appearance of this anatomical modernity. Furthermore, the appearance of behavioral modernity in Africa is now thought to have been a progressive development rather than a seemingly sudden change. The first appearance of complex art in that continent has yet to be studied in any detail, however.

 4. Histories of the discovery of and research on European Paleolithic art are included in Louis-René Nougier and Romain Robert, *The Cave of Rouffignac* (London: Georges Newnes Limited, 1958); Alan H. Brodrick, *Father of Prehistory, The Abbé Henri Breuil: His Life and Times* (New York: William Morrow and Company, 1963); Peter Ucko and Andre Rosenfeld, *Palaeolithic Cave Art* (London: Weidenfeld and Nicholson, 1967); Ann Sieveking, *The Cave Artists* (London: Thames and Hudson, 1979); Margaret W. Conkey, "The Structural Analysis of Paleolithic Art," in *Archaeological Thought in America*, ed. C. C. Lamberg-Karlovsky (Cambridge, MA: University of Cambridge Press), pp. 135–54; Margaret W. Conkey, "L'Approche Structurelle de l'Art Paléolithique et l'Héritage d'André Leroi-Gourhan," *Les Nouvelles de l'Archéologie* 48/49 (1992): 41–45; Margaret W. Conkey, "Structural and Semiotic Approaches," in *Handbook of Rock Art Research*, ed. D. S. Whitley (Walnut Creek, CA: AltaMira Press, 2001), pp. 273–310; Jean Clottes, "Perspectives and Traditions in Palaeolithic Rock Art Research in France," in *Perceiving Rock Art: Social and Political Perspectives*, ed. K. Helskog and B. Olsen (Oslo: Institute for

Comparative Research in Human Culture, 1995), pp. 35–64; J. David Lewis-Williams, *The Mind in the Cave: Consciousness and the Origins of Art* (London: Thames and Hudson, 2002); and David S. Whitley and Jean Clottes, "In Steward's Shadow: History of Rock Art Research in Western North America and France," in *Discovering North American Rock Art*, ed. L. Loendorf, C. Chippindale, and D. S. Whitley (Tucson: University of Arizona Press, 2005), pp. 161–80, among others.

5. The authenticity and age of the paintings were debated for about twenty-five years, with full acceptance of their antiquity only occurring after the turn of the century. This occurred with the publication of Émile Cartailhac, "Les cavernes ornées de dessins: La grotte d'Altamira, Espagne, 'Mea culpa d'un sceptique.'" *L'Anthropologie* 13 (1902): 348–54.

6. H. Valladas, H. Cachier, M. Arnold, F. Bernaldo de Quiros, J. Clottes, and P. Uzquiano, "Direct Radiocarbon Dates for Prehistoric Paintings at the Altamira, El Castillo and Niaux Caves," *Nature* 357 (1992): 68–70.

7. E.g., Jean Clottes, "Paint Analyses from Several Magdalenian Caves in the Ariège Region of France," *Journal of Archaeological Science* 20 (1993): 223–35.

8. Reinach (1903) introduced the concept of hunting magic to interpretations of European Paleolithic art, based on comparisons with Australian aboriginal art; see S. Reinach, "L'art et la Magie: A Propos des Peintures et des Gravures de l'age du Renne," *L'Anthropologie* 14 (1903): 257–66.

9. E.g., Henri Breuil, *Four Hundred Centuries of Cave Art* (Montignac, France: Centre d'Etudes et de Documentation Préhistoriques, 1952).

10. E.g., see Jesús Altuna, *L'Art des Cavernes en Pays Basque: Les Grottes D'Ekain et D'Altxerri* (Paris: Edition du Seuil, 1997), pp. 193–98.

11. See, e.g., Claude Lévi-Strauss, *Structural Anthropology* (New York: Basic Books, 1963); Andre Leroi-Gourhan, "Repartition et Groupement des Animaux dans l'Art Pariétal Paléolithique," *Bulletin de la Société Préhistorique Française* 55 (1958): 515–27; Andre Leroi-

Gourhan, *Treasures of Prehistoric Art* (New York: Harry Abrams, 1965); Annette Laming-Emperaire, *La Signification de l'Art Rupestre* (Paris: Picard, 1962); Annette Laming-Emperaire, "Systeme de penser et organisation sociale dans l'art rupestre paléolithique," in *L'Homme de Cro-Magnon* (Paris: Arts et Metiers Graphiques, 1970), pp. 197–211; Conkey, "L'Approche Structurelle"; and Conkey, "Structural and Semiotic Approaches."

12. Jean Clottes, personal communication with author, May 2001.

13. Andre Leroi-Gourhan, quoted in William I. Thompson, *The Time Falling Bodies Take to Light: Mythology, Sexuality and the Origins of Culture* (New York: Palgrave Macmillan, 1996), p. 108.

14. Conkey, "Structural and Semiotic Approaches."

15. Ibid.

16. J. David Lewis-Williams and Thomas A. Dowson, "Signs of All Times: Entoptic Phenomena in Upper Palaeolithic Art," *Current Anthropology* 29 (1988): 201–45; see also J. David Lewis-Williams, "Wrestling with Analogy: A Methodological Dilemma in Upper Palaeolithic Art Research," *Proceedings of the Prehistoric Society* 57, no. 1 (1991): 149–62; and Lewis-Williams, *The Mind in the Cave.*

17. See, e.g., J. David Lewis-Williams, *Believing and Seeing: Symbolic Meanings in Southern San Rock Paintings* (London: Academic Press, 1981); J. David Lewis-Williams and Thomas A. Dowson, *Images of Power: Understanding Bushman Rock Art* (Johannesburg: Southern Book Publishers, 1989).

18. E.g., see Lorna Marshall, *The !Kung of Nyae Nyae* (Cambridge, MA: Harvard University Press, 1976); Richard B. Lee, *The !Kung San: Men, Women and Work in a Foraging Society.* (Cambridge, MA: Cambridge University Press, 1979); and Richard Katz, *Boiling Energy: Community Healing among the Kalahari !Kung* (Cambridge, MA: Harvard University Press, 1982).

19. E.g., Dorothea F. Bleek, "Beliefs and Customs of the /Xam Bushmen. Part VII: Sorcerers." *Bantu Studies* 9 (1935): 147.

20. Lewis-Williams, *Believing and Seeing.*

21. E.g., see J. David Lewis-Williams and Thomas A. Dowson, "Through the Veil: San Rock Paintings and the Rock Face," *South African Archaeological Bulletin* 45 (1990): 5–16.

22. Lewis-Williams and Dowson, "Signs of All Times."

23. The structure underlying the neuropsychological model was identified by Ronald K. Siegel; see Ronald K. Siegel, "Hallucinations," *Scientific American* 237 (1977): 132–40, and Ronald K. Siegel and M. E. Jarvik, "Drug-Induced Hallucinations in Animals and Man," in *Hallucinations: Behavior, Experience, and Theory,* ed. R. K. Siegel and L. J. West (New York: Wiley, 1975), pp. 81–161. Other components of it were identified by M. J. Horowitz, "The Imagery of Visual Hallucinations, *Journal of Nerv ous and Mental Disease* 138 (1964): 513–23; M. J. Horowitz, "Hallucinations: An Information-Processing Approach," in Siegel and West, *Hallucinations,* pp. 163–95; Heinrich Klüver, "Mescal Visions and Eidetic Vision," *American Journal of Psychology* 37 (1926): 502–15; Heinrich Klüver, "Mechanisms of Hallucinations," in *Studies in Personality,* ed. Q. McNemar and M. A. Merrill (New York: McGraw-Hill, 1942), pp. 175–207; Heinrich Klüver, *Mescal and Mechanisms of Hallucinations* (Chicago: University of Chicago Press, 1966); Max Knoll and J. Kugler, "Subjective Light Pattern Spectroscopy in the Electroencephelographic Frequency Range," *Nature* 184 (1959): 1823–24; and Max Knoll, J. Kugler, O. Hofer, and S. D. Lawder, "Effects of Chemical Stimulation of Electrically Induced Phosphenes on their Bandwidth, Shape, Number and Intensity," *Confinia Neurologica* 23 (1963): 201–26; among others.

24. Thomas Blackburn, "Biopsychological Aspects of Chumash Rock Art," *Journal of California Anthropology* 4 (1977): 88–94.

25. Jean Clottes and J. David Lewis-Williams, *Les Chamanes de la Préhistoire: Transe et Magie Dans les Grottes Ornées* (Paris: Editions du Seuil, 1996).

26. Lewis-Williams and Dowson, "Through the Veil"; David S. Whitley, "Bears and Baskets: Aspects of Shamanism in North American Rock Art," in *The State of the Art: Advances in World Rock Art,* ed. T. A. Dowson (Johannesburg: University of the Witwatersrand, 1988), pp. 34–45; David S. Whitley, *The Art of the Shaman: Rock Art of California* (Salt Lake City: University of Utah Press, 2000).

27. Solveig A. Turpin, "On a Wing and a Prayer: Flight Metaphors in Pecos River Pictographs," in *Shamanism and Rock Art in*

North America, ed. S. A. Turpin (San Antonio, TX : Rock Art Foundation, Inc., Special Publication 1, 1994), pp. 73–102.

28. E.g., Barbara MacLeod and Dennis E. Puleston, "Pathways into Darkness: The Search for the Road to Xibabla," *Tercera Mesa Redonda de Palenque* 4 (1978): 71–77.

29. Clottes and Lewis-Williams, *Les Chamanes de la Préhistoire;* Lewis-Williams, *The Mind in the Cave.*

30. Descriptions of and summaries of research at Lascaux are provided by Arlette Leroi-Gourhan and Jacques Allain, eds., *Lascaux Inconnu (XIIe Supplement a "Gallia-Préhistoire")* (Paris: Éditions du Centre National de la Recherche Scientifique, 1979); Andre Leroi-Gourhan, "Grotte de Lascaux," in *L'Art des caverns: Atlas des grottes ornées paleolithiques françaises* (Paris: Ministere de la culture, 1984), pp. 180–200; Norbert Aujoulat, *Lascaux: Le Geste, L'Espace, Et Le Temps* (Paris: Editions du Seuil, 2004); Jean-Michel Geneste, Tristan Hordé, and Chantal Tanet, *Lascaux: A Work of Memory,* trans. David and Nicole Ball (Perigeux: Editions Fanlac, 2004).

CHAPTER TWO: INSIDE CHAUVET

1. Details concerning the history of the fight for Chauvet Cave were obtained through Jean Clottes, Jean-Michel Geneste, Valérie Feruglio, and other members of the Chauvet research team, in interviews with the author at Chauvet Cave, May 2000.

2. E.g., J. Clottes, J. M. Chauvet, E. B. Deschamps, C. Hillaire, J. P. Daugas, M. Arnold, H. Cachier, J. Evin, P. Fortin, C. Oberlin, N. Tisnerat, and H. Valladas, "Radiocarbon Dates for the Chauvet-Pont-d'Arc Cave," *International Newsletter of Rock Art* 11 (1995): 1–2; J. Clottes, J. M. Chauvet, E. B. Deschamps, C. Hillaire, J. P. Daugas, M. Arnold, H. Cachier, J. Evin, P. Fortin, C. Oberlin, N. Tisnerat, and H. Valladas, "Les Peintures paléolithiques de la Grotte Chauvet-Pont d'Arc, à Vallon-Pont d'Arc (Ardèche, France): Datations Directes et Indirectes par la Méthode du Radiocarbone," *Comptes Rendus Academie des Science Paris* 320 (1995): 1133–40; H. Valladas, N. Tisnerat, M. Arnold, J. Evin, and C. Oberlin, "Les dates des frequentations," in

La Grotte Chauvet: L'Art des Origines, ed. J. Clottes (Paris: Edition du Seuil, 2001), pp. 32–34. I have used the slightly revised radiocarbon ages for the site suggested by Paul Mellars, "A New Radiocarbon Revolution and the Dispersal of Moderns Humans in Eurasia," *Nature* 439 (2006): 931–35.

3. The following account of the legal and other battles is based on Jean Clottes, Jean-Michel Geneste, and Valérie Feruglio, interviews with the author at Chauvet Cave, May 2000.

4. Jean-Marie Chauvet, Eliette Brunel Deschamps, and Christian Hillaire, *La Grotte Chauvet a Vallon Pont D'-Arc* (Paris: Edition du Seuil, 1995).

5. Michel-Alain Garcia, "Human Footprints in the Chauvet Cave," *International Newsletter on Rock Art* 24 (1999): 1–4; Michel-Alain Garcia, "Les Empreintes et les traces Humaines et Animals," in Clottes, *La Grotte Chauvet*, pp. 34–43.

6. Michel-Alain Garcia, in interview with author, May 2000.

7. Dominique Baffier and Valérie Feruglio, "First Observations on Two Panels of Dots in the Chauvet Cave (Vallon-Pont-d'Arc, Ardèche, France)," *International Newsletter on Rock Art* 21 (1998): 1–4; Dominique Baffier and Valérie Feruglio, "Les points et les mains," in Clottes, *La Grotte Chauvet*, pp. 164–65.

8. Valérie Feruglio, e-mail to author, June 2000.

9. E.g., Jean Clottes, *Les Cavernes de Niaux: Art Préhistorique en Ariege* (Paris: Editions du Seuil, 1995); Jean Clottes and R. Simonnet, "Le Réseau René Clastres dans la Caverne de Niaux (Ariège)," *Bulletin de la Société Préhistorique Française* 69, no. 1 (1972): 293–323.

10. E.g., see Joseph Campbell, *Historical Atlas of World Mythology, vol. 1: The Way of the Animal Powers, Part 1: Mythologies of the Primitive Hunters and Gatherers* (New York: Harper and Row, 1988).

11. J. David Lewis-Williams and Johannes H. N. Loubser, "Deceptive Appearances: A Critique of Southern African Rock Art Studies," *Advances in World Archaeology* 5 (1986): 253–89; David S. Whitley, "Shamanism, Natural Modeling, and the Rock Art of Far Western North America," in *Shamanism and Rock Art in North America*, ed. S. Turpin (San Antonio, TX: Rock Art Foundation, Inc., Special Publication 1, 1994), pp. 1–43.

12. Clo ttes and Lewis-Williams, *Les Chamanes de la Préhistoire*, p. 16.

13. Valérie Feruglio, e-mail to author, June 2000.

14. Ulrike Becks-Malorny, *Wassily Kandinsky, 1866–1944: The Journey to Abstraction* (Köln: Benedikt Taschen, 1994).

15. Andre Leroi-Gourhan, "Repartition et Groupement des Animaux dans l'Art Pariétal Paléolithique," *Bulletin de la Société Préhistorique Française* 55 (1958): 515–27; Andre Leroi-Gourhan, *Treasures of Prehistoric Art* (New York: Harry Abrams, 1965).

16. Valérie Feruglio, e-mail to author, June 2000.

17. Jean Clottes, "Who Painted What in Upper Paleolithic European Caves," in *New Light on Old Art: Recent Advances in Hunter-Gatherer Rock Art Research*, ed. D. S. Whitley and L. L. Loendorf (University of California, Los Angeles: Institute of Archaeology, Monograph 36, 1994), pp. 1–8.

CHAPTER THREE: THE DATING GAME

1. For a description of Cap Blanc, see Alain Roussot, "Abri du Cap Blanc," in *L'Art des caverns: Atlas des grottes ornées paleolithiques françaises* (Paris: Ministere de la Culture, 1984), pp. 157–63. Jean Clottes, "Art of the Light and Art of the Depths," in *Beyond Art: Pleistocene Image and Symbol*, ed. M. W. Conkety, O. Soffer, D. Stratmann, and N. G. Jablonski (San Francisco: Memoirs of the California Academy of Sciences, Number 23, 1997), pp. 203–16 discusses the difference between dark-zone and open-air sites and the possible implications of these differences.

2. The Côa engravings were first discovered between 1989 and 1991, but their presence was not widely revealed, including to the larger archaeological community, until 1994, partly for reasons discussed subsequently. The history of events concerning Côa is covered by Nelson Rebanda, *Os trabalhos arqueológicos e o complexo de arte rupestre do Côa* (Lisboa: Instituto Portugûes do Património Arquitectónico e Arqueológico, 1995); Maria E. Gonçalves, "Science, Controversy and Participation: The Case of the Côa Rock Art Engravings,"

Journal of Iberian Archaeology 0 (1998): 7–31; António M. Baptista, *No tempo sem tempo: A arte dos caçadores paleoliticos do Vale do Côa: Com uma perspectiva dos ciclos rupestres pós-glaciares* (Vila Nova de Foz-Côa: Pargque Arqueológico do Vale do Foz Côa, 1999); Jean Clottes, "The 'Three Cs': Fresh Avenues Towards European Paleolithic Art," in *The Archaeology of Rock-Art*, ed. C. Chippindale and P. S. C. Taçon (Cambridge: Cambridge University Press, 1998), pp. 112–29; and especially Joao Zilhão, "Public Archaeology and Political Dynamics in Portugal," *Public Archaeology* 3 (2004): 167–81, among others. These accounts do not agree on all of the minor historical facts, though the broader sequence of events, discussed here, is the same in each. As Zilhão, "Public Archaeology, " makes clear, the question of the fate of the engravings itself ballooned into a series of interrelated quarrels and controversies, including a defamation lawsuit successfully prosecuted by Nelson Rebanda against another Portuguese archaeologist. As we shall see, the Côa case ultimately generated two defamation lawsuits—making it perhaps the most litigated archaeological project in history. A recent summary of Iberian Paleolithic rock art is provided by N. Bicho, A. F. Carvalho, C. González-Sainz, J. L. Sanchidrían, V. Villaverde, and L. G. Straus, "The Upper Paleolithic Rock Art of Iberia," *Journal of Archaeological Method and Theory* 14, no. 1 (2007): 81–151.

3. This was provided by then preeminent French archaeologist Émile Cartailhac, who, in a famous apology ("Les cavernes ornées de dessins: La grotte d'Altamira, Espagne, 'Mea culpa d'un sceptique.'" *L'Anthropologie* 13 [1902]: 348–54) belatedly accepted the antiquity of the cave paintings.

4. The anal operculum of the woolly mammoth, evident in drawings at Rouffignac, France, is the best example. That mammoths had these soft-tissue features was only determined after the paintings had been discovered, as a result of the subsequent inspection of frozen and preserved mammoths found in Siberia. Louis-René Nougier and Romain Robert, *The Cave of Rouffignac* (London: Georges Newnes Limited, 1958).

5. Details of the dating of Chauvet and Cosquer Caves refuting some initial allegations that they were modern forgeries are provided by Clottes, "The 'Three Cs.'"

6. Radiocarbon dating is based on the fact that all living organisms absorb carbon during their lifetimes. This carbon includes two major stable (^{12}C and ^{13}C) and one unstable (radioactive or ^{14}C) isotopes—forms of an element with different atomic weights or masses. While alive, the proportion of stable to radioactive isotopes in the organism stays more or less constant and in equilibrium with the atmosphere. Once the organism dies, however, the radioactive isotope starts to decay, at a constant rate, while the amount of the stable isotope does not change. By measuring the ratio of ^{14}C to ^{12}C in an organic specimen, such as a piece of charcoal (once a living tree) or bone (once an animal skeletal part), the approximate time since the specimen died can be calculated. See Marvin Rowe, "Dating by AMS Radiocarbon Dating," in *Handbook of Rock Art Research*, ed. D. S. Whitley (Walnut Creek, CA: AltaMira Press, 2001), pp. 139–66, for a more detailed overview, and Tom P. Guilderson, Paula A. Reimer, and Tom A. Brown, "The Boon and Bane of Radiocarbon Dating," *Science* 307 (2005): 362–64, for an update on some of the technical difficulties the technique still confronts.

7. David S. Whitley, *Introduction to Rock Art Research* (Walnut Creek, CA: Left Coast Press, 2005).

8. Rowe, "Dating by AMS Radiocarbon Dating," in Whitley, *Handbook of Rock Art*.

9. H. Valladas, H. Cachier, M. Arnold, F. Bernaldo de Quiros, J. Clottes, and P. Uzquiano, "Direct Radiocarbon Dates for Prehistoric Paintings at the Altamira, El Castillo and Niaux Caves," *Nature* 357 (1992): 68–70; H. Valladas, N. Tisnerat, M. Arnold, J. Evin, and C. Oberlin, "Les dates des frequentations," in *La Grotte Chauvet: L'Art des Origines*, ed. J. Clottes (Paris: Edition du Seuil, 2001); H. Valladas, H. Cachier, and M. Arnold, "AMS C-14 Dates for the Prehistoric Cougnac Cave Paintings and Related Bone Remains," *Rock Art Research* 7 (1990): 18–19; H. Valladas, J. Clottes, J. M. Geneste, M. A. Garcia, M. Arnold, H. Cachier, and N. Tisnérat-Laborde, "Palaeolithic Paintings: Evolution of Prehistoric Cave Art," *Nature* 413 (2001): 479.

10. Rebanda, *Os trabalhos arqueológicos*; Gonçalves, "Science, Controversy and Participation"; Baptista, *No tempo sem tempo*;

Clottes, "The 'Three Cs'"; and Zilhão, "Public Archaeology and Political Dynamics" per the caveat in note 2, above.

11. Baptista, *No tempo sem tempo*, pp. 22–23.

12. See Rebanda, *Os trabalhos arqueológicos*; Gonçalves, "Science, Controversy and Participation."

13. See M. Carvalho, "Barragem de Foz Côa ameaça achado arqueológico," *O Público* (November 21, 2004), and Zilhão, "Public Archaeology and Political Dynamics."

14. Clottes, "The 'Three Cs.'"

15. See, e.g., Ronald I. Dorn, "Cation-Ratio Dating: A New Rock Varnish Age-Determination Technique," *Quaternary Research* 20 (1983): 49–73; Ronald I. Dorn, "Cation-Ratio Dating of Rock Varnish: A Geographical Perspective," *Progress in Physical Geography* 13 (1989): 559–96; Ronald I. Dorn, "Dating Petroglyphs with a 3-tier Rock Varnish Approach," in *New Light on Old Art: Advances in Hunter-Gatherer Rock Art Research*, ed. D. S. Whitley and L. L. Loendorf (Los Angeles: University of California Institute for Archaeology, Monograph Series No. 36, 1994), pp. 2–36; Ronald I. Dorn, "Chronometric Techniques: Engravings," in *Handbook of Rock Art Research*, ed. D. S. Whitley (Walnut Creek, CA: AltaMira Press, 2001), pp. 167–89; R. I. Dorn, A. J. T. Jull, D. J. Donahue, T. W. Linick, and L. J. Toolin, "Accelerator Mass Spectrometry Radiocarbon Dating of Rock Varnish," *Geological Society of America Bulletin* 101 (1989): 1363–72; Ronald I. Dorn and David S. Whitley, "Cation-Ratio Dating of Petroglyphs from the Western United States, North America," *Nature* 302 (1983): 816–18; Ronald I. Dorn and David S. Whitley, "Chronometric and Relative Age Determination of Petroglyphs in the Western United States," *Annals of the Association of American Geographers* 74 (1984): 308–22; etc.

16. Rock or desert varnish is also sometimes incorrectly called "patina." Technically speaking, patinas develop from chemical reactions on a surface (such as the green patina that develops on copper). Rock varnish is a coating that develops on top of a rock surface from wind-borne dust, but does not derive from the surface itself.

17. E.g., James Bard, *The Development of a Patination Dating Tech-*

nique for Great Basin Petroglyphs Utilizing Neutron Activation and X-Ray Florescence (PhD diss., University of California, Berkeley, Department of Anthropology, 1979); D. S. Whitley, J. Baird, J. Bennet, and R. G. Tuck, "The Use of Relative Repatination in the Chronological Ordering of Petroglyph Assemblages," *Journal of New World Archaeology* 4, no. 3 (1984): 19–25.

18. A cation is a positively charged atom; Dorn used the term *cation-ratio dating* in recognition of the similarity the chemical changes in rock varnish have to cation exchange processes in soils. Initially Dorn used Particle Induced x-ray Emissions (PIXE) to determine the chemistry of his varnish samples; as technology improved, he switched to an Electron Microprobe, a component of a Scanning Electron Microscope that likewise measures chemical constituents. The ratio he established as time-sensitive is $(Ca+K)/Ti$. See Dorn, "Cation-Ratio Dating: A New Rock Varnish," and Dorn, "Cation-Ratio Dating of Rock Varnish: A Geographical Perspective."

19. W. A. Duffield and C. R. Bacon, *Geological Map of the Coso Volcanic Field and Adjacent Areas, Inyo County, California* (US Geological Survey Miscellaneous Investigations, Series Map 1–1200, 1981).

20. Emma Lou Davis, *The Ancient Californians: Rancholabrean Hunters of the Mojave Lakes Country* (Los Angeles: Natural History Museum of Los Angeles County, Science Series 29, 1978).

21. David S. Whitley, "Meaning and Metaphor in the Coso Petroglyphs: Understanding Great Basin Rock Art," in *Coso Rock Art: A New Perspective*, ed. E. Younkin (Ridgecrest, CA: Maturango Museum, 1998), pp. 109–74.

22. E.g., see Robert F. Heizer and Martin A. Baumhoff, *Prehistoric Rock Art of Nevada and Eastern California* (Berkeley: University of California Press, 1962); Campbell Grant, *Rock Drawings of the Coso Range* (China Lake: Maturango Museum, Publication 4, 1968); Klaus Wellman, *A Survey of North American Indian Rock Art* (Graz, Austria: Akademische Druck und Verlagsanfalt, 1979); Kenneth Hedges, "The Shamanic Origins of Rock Art," in *Ancient Images on Stone: Rock Art of the Californias*, ed. J. Van Tilburg (University of California, Los Angeles, Rock Art Archive, 1983), pp. 46–59; and Whitley, "Meaning and Metaphor."

23. E.g., Heizer and Baumhoff, *Prehistoric Rock Art*; Grant, *Rock Drawings of the Coso*; Wellman, *A Survey*; Hedges, "The Shamanic Origins," and others have all agreed that the art is shamanistic, although there has been debate about the kind of shamanism that produced it—primarily whether this was shamanistic hunting magic or other kinds of shamanism. See also David S. Whitley and Jean Clottes, "In Steward's Shadow: History of Rock Art Research in Western North America and France," in *Discovering North American Rock Art*, ed. L. Loendorf and C. Chippindale; James Keyser and David S. Whitley, "Sympathetic Magic in Western North American Rock Art," *American Antiquity* 71 (2006): 3–26.

24. See summaries in David S. Whitley, "Shamanism and Rock Art in Far Western North America," *Cambridge Archaeological Journal* 2 (1992): 89–113; David S. Whitley, "By the Hunter, For the Gatherer: Art, Social Relations, and Subsistence Change in the Prehistoric Great Basin," *World Archaeology* 25 (1994): 356–77; David S. Whitley, "Shamanism, Natural Modeling, and the Rock Art of Far Western North America," in *Shamanism and Rock Art in North America*, ed. S. Turpin (San Antonio, TX: Rock Art Foundation, Inc., Special Publication 1, 1994), pp. 1–43; David S. Whitley, "Finding Rain in the Desert: Landscape, Gender, and Far Western North American Rock Art," in *The Archaeology of Rock Art*, ed. C. Chippindale and P. S. C. Taçon (Cambridge: Cambridge University Press), pp. 11–29; Whitley, "Meaning and Metaphor"; David S. Whitley, *The Art of the Shaman: Rock Art of California* (Salt Lake City: University of Utah Press, 2000).

25. J. David Lewis-Williams and Thomas A. Dowson, "Signs of All Times: Entoptic Phenomena in Upper Palaeolithic Art," *Current Anthropology* 29 (1988): 201–45.

26. Dorn and Whitley, "Cation-Ratio Dating of Petroglyphs"; Dorn and Whitley, "Chronometric and Relative Age Determination."

27. E.g., Ronald I. Dorn, "Age Determination of the Coso Rock Art," in *Coso Rock Art: A New Perspective*, ed. E. Younkin (Ridgecrest, CA: Maturango Museum, 1998), pp. 69–96; Julie E. Francis, L. L. Loendorf, and Ronald I. Dorn, "AMS Radiocarbon and Cation-Ratio

Dating of Rock Art in the Bighorn Basin of Wyoming and Montana,"
American Antiquity 58 (1993): 711–37; D. S. Whitley, R. I. Dorn, J. M.
Simon, R. Rechtman, and T. K. Whitley, "Sally's Rockshelter and the
Archaeology of the Vision Quest," *Cambridge Archaeological Journal* 9
(1999): 221–46; David S. Whitley, J. M. Simon, and Ronald I. Dorn,
"The Vision Quest in the Coso Range," *American Indian Rock Art* 25
(1999): 1–32; Julie E. Francis and Lawrence L. Loendorf, *Ancient
Visions: Petroglyphs and Pictographs from the Wind River and Bighorn
Country, Wyoming and Montana* (Salt Lake City: University of Utah
Press, 2002).

28. All chronometric results are statistical estimates that yield
not a specific date but instead a span of years for the probable age of
a dated specimen. This is normally expressed in terms of error mar-
gins or standard deviations. For example, at one standard deviation
a radiocarbon age might be given as 1000 ± 100 years BP, meaning
that there is a 68 percent chance that the true date of the specimen
falls somewhere between nine and eleven hundred years BP. (Two
standard deviations yield a 98 percent statistical confidence or, for
this example, between eight and twelve hundred years BP.) CR
dating lacks precision because it often has large error margins,
meaning that the calculated age of a specimen falls within a rela-
tively wide span of years. "Precision," in this sense, is different than
"accuracy," which concerns specifically whether the calculated age is
correct. Comparative tests suggest that CR dating is acceptably accu-
rate, but not especially precise.

29. See, e.g., Dorn, "Dating Petroglyphs with a 3-tier Rock Var-
nish Approach"; Dorn, "Chronometric Techniques: Engravings," in
Whitley, *Handbook of Rock Art Research*; Ronald I. Dorn, *Rock Coatings*
(Amsterdam: Elsevier, 1998).

30. Ronald I. Dorn et al., "Cation-Ratio and Accelerator Radio-
carbon Dating of Rock Varnish on Mojave Artifacts and Landforms,"
Science 231 (1986): 830–33; Ronald I. Dorn et al., "Accelerator Mass
Spectrometry Radiocarbon Dating"; R. I. Dorn, P. B. Clarkson, M. F.
Nobbs, L. L. Loendorf, and D. S. Whitley, "New Approach to the
Radiocarbon Dating of Rock Varnish, with Examples from Drylands,"
Annals of the Association of American Geographers 82 (1992): 136–51.

31. Ronald I. Dorn and Theodore M. Oberlander, "Rock Varnish Origin, Characteristics and Usage," *Zeitschrift fur geomorphologie* 25 (1981): 420–36.

32. Heizer and Baumhoff, *Prehistoric Rock Art.* Their logic for the claim that contemporary Native Americans had no cultural connection to the art was twisted. They had earlier decided that Great Basin rock art resulted from shamanistic hunting magic (R. F. Heizer and M. A. Baumhoff, "Great Basin Petroglyphs and Game Trails," *Science* 129 [1959]: 904–05). When they reviewed the ethnographic record they found no evidence supporting their previously published interpretation. Since they were already certain in their minds why the art was made, they dismissed the contradicting ethnographic accounts, claiming that Native Americans then had no knowledge of the art. Hence the art must be older than the ethnographic past (see Whitley and Clottes, "In Steward's Shadow").

33. See Whitley et al., "Sally's Rockshelter"; Whitley et al., "The Vision Quest in the Coso Range"; and Francis and Loendorf, *Ancient Visions* for summaries of the varnish dates.

34. David S. Whitley and Ronald I. Dorn, "Rock Art Chronology in Eastern California," *World Archaeology* 19 (1987): 150–64; David S. Whitley and Ronald I. Dorn, "Cation-Ratio Dating of Petroglyphs Using PIXE," *Nuclear Instruments and Methods in Physics Research* B35 (1988): 410–14. The petroglyph calibrations (especially for CR dating) were regularly updated during the 1980s and early 1990s, as additional calibration points were obtained. I use the latest calibrations for the dates in this discussion, rather than the initial published ages. These revisions were presented in Whitley et al., "Sally's Rockshelter"; and Whitley et al., "The Vision Quest in the Coso Range."

35. David S. Whitley and Ronald I. Dorn, "New Perspectives on the Clovis vs. Pre-Clovis Controversy," *American Antiquity* 58 (1993): 62–147. Note that this article was published in the flagship journal of the Society for American Archaeology. It was the first pre-Clovis article published in that journal in about a decade and a half. Getting it published there took unusual efforts: I waited to submit the article until the journal had a non–North American archaeologist as

editor, Michael Graves (who works in Polynesia); I argued to Graves that the Clovis police had systematically stymied intellectual discourse by preventing the appearance of research in the journal that countered their view of the past and I asked that the article be reviewed by archaeologists who had no previous involvement in the peopling of the Americas debate, in order for it to receive an objective evaluation. Perhaps most importantly, I knew that, in order to publish our pre-Clovis results in North America, I first had to show that the Clovis-first hypothesis could not be correct, on its own empirical evidence. I shifted the nature of my debate from a discussion of the reliability of pre-Clovis evidence to the empirical plausibility of the Clovis-first hypothesis—something that had not previously been much considered—simply so that I could publish our petroglyph dates.

36. Thomas Dillehay, "A Late Ice-Age Settlement in Southern Chile," *Scientific American* 251 (1984): 106–17; Thomas Dillehay, *Monte Verde, A Late Pleistocene Settlement in Chile, vol. 1: Palaeoenvironment and Site Context* (Washington, DC: Smithsonian Institution Press, 1989); Thomas Dillehay, *Monte Verde: A Late Pleistocene Settlement in Chile, vol. 2: The Archaeological Context and Interpretation* (Washington, DC: Smithsonian Institution Press, 1997).

37. Whitley et al., "Sally's Rockshelter"; Whitley et al., "The Vision Quest in the Coso Range."

38. Originally published in David S. Whitley et al., "Recent Advances in Petroglyph Dating and Their Implications for the Pre-Clovis Occupation of North America," *Proceedings of the Society for California Archaeology* 9 (1996): 92–103. The ages given here are in radiocarbon years.

39. T. E. Cerling and H. Craig, "Geomorphology and In-situ Cosmogenic Isotopes," *Annual Review of Earth and Planetary Sciences* 22 (1994): 273–317, used ^3He dating, a cosmogenic technique, to establish the age of the last flow of the Owens River.

40. Matthew E. Hill, "A Moveable Feast: Variation in Faunal Resource Use Among Central and Western North American Paleoindian Sites," *American Antiquity* 72 (2007): 417–38, found that bighorn sheep bones were present in 36 percent of the faunal collec-

tions he examined from sixty campsites dating between thirteen and a half to eight thousand years BP (calibrated). Bighorns were clearly a widespread species at the end of the Pleistocene in North America.

In fact, there have been occasional reports of mammoth petroglyphs in the western states. The best know of these is near Moab, Utah, and it is convincingly elephant-like. It also entirely lacks any evidence of revarnishing, precluding any chance to date it, and strongly implying that it is recent in origin. There is a rumor that the motif was "cleaned up" by a local scout troop, however, perhaps in the 1930s. If true—and it is unlikely that the rumor can ever be verified or discredited—this might have removed an original varnish coating. Or perhaps, as many archaeologists contend, the motif is simply a recent image.

41. David S. Whitley, "A Possible Pleistocene Camelid Petroglyph from the Mojave Desert, California," *Tracks Along the Mojave: A Field Guide from Cajon Pass to the Calico Mountains and Coyote Lake*, in eds. R. E. Reynolds and J. Reynolds, *San Bernardino County Museum Association Quarterly* 46, no. 3 (1999): 107–108. Note that Reynolds was sufficiently convinced of the plausibility of this identification and the chronometric ages that he commissioned the report on it for this journal issue, which he was editing.

42. E.g., Alfred L. Kroeber, "American Culture and the Northwest Coast," *American Anthropologist* 25 (1923): 1–20; Peter T. Furst, "The Roots and Continuities of Shamanism," in *Stones, Bones and Skin: Ritual and Shamanic Art*, ed. A. T. Brodzy, R. Daneswich, and N. Johnson (Toronto: Society for Art Publications, 1977), pp. 1–28; Weston LaBarre, *Culture in Context* (Durham, NC: Duke University, 1980); and Karl H. Schlesier, *The Wolves of Heaven: Cheyenne Shamanism, Ceremonies, and Prehistoric Origins* (Norman: University of Oklahoma, 1987); etc.

43. Schlesier, *The Wolves of Heaven*, pp. 45–49.

44. Whitley et al., "Sally's Rockshelter"; D. S. Whitley et al., "The Vision Quest in the Coso Range"; David S. Whitley, "The Archaeology of Shamanism," in *The Encyclopedia of Shamanism* (Santa Barbara, CA: ABC-Clio, 2004), pp. 15–21. Note that the publication dates on some of our cited articles (and thus the ideas that they pre-

sented) appear out-of-sync with the chronology of events concerning the Dorn controversy discussed subsequently. The publication dates in fact do not accurately reflect when they were written (or at least conceptualized), because the controversy delayed their publication until at least an initial resolution of it had been obtained.

The additional evidence for continuity in the making of Mojave petroglyphs—and thus in shamanistic practices—includes the following: continuity in the use of the same sites as ritual places for over ten thousand years; iconographic continuity in the key components of the rock art corpus over this same period, including especially the mix of bighorns with entoptic designs; continuity in the use of a series of specific iconographic details in the way that bighorn sheep were depicted, specifically an exaggerated and upraised tail posture and concentric curves for the horn rack; and continuity in the use of quartz hammerstones to make the petroglyphs.

45. Andrzej Rozwadowski, "Sun Gods or Shamans? Interpreting the 'Solar-Headed' Petroglyphs of Central Asia," in *The Archaeology of Shamanism*, ed. N. Price (London: Routledge, 2001), pp. 65–86; Andrzej Rozwadowski, *Symbols through Time: Interpreting the Rock Art of Central Asia* (Poznan, Poland: Institute of Eastern Studies, Adam Mickiewicz University, 2004); Ekaterina Devlet, "Rock Art and the Material Culture of Siberian and Central Asian Shamanism," in *The Archaeology of Shamanism*, ed. N. Price (London: Routledge, 2001), pp. 43–55. Mircea Eliade, *Shamanism: Archaic Techniques of Ecstasy* (Princeton, NJ: Princeton University Press, Bollingen Series 67, 1972), in the standard synthesis of shamanism and following a series of earlier Russian ethnographers, also acknowledged the relative historical recency of "classic" Siberian shamanism. This point apparently went unrecognized by most American readers.

46. Ronald I. Dorn, "A Change of Perception," *La Pintura* 23, no. 2 (1995): 10–11; R. I. Dorn, F. Phillips, and M. Flinsch, "Cl-36 and C-14 Dates for Portugal's Côa Engravings Are Consistent with a Paleolithic Age," paper presented at meetings of the American Rock Art Research Association, El Paso, TX, 1996; Ronald I. Dorn, "Constraining the Age of the Côa Valley (Portugal) Engravings with Radiocarbon Dating," *Antiquity* 71 (1997): 105–15; Alan Watchman,

"Historic Antiquity for the Foz C ôa Rock Engravings, Portugal," *WAC News* 3, no. 2 (1995): 3–4; Alan Watchman, "Recent Petroglyphs, Foz Coa, Portugal," *Rock Art Research* 12 (1995): 104–108; Alan Watchman, "A Review of the Theory and Assumptions in the AMS Dating of the Foz Côa Petroglyphs, Portugal," *Rock Art Research* 13, no. 1 (1996): 21–30; Peter H. Welsh and Ronald I. Dorn, "Critical Analysis of Petroglyph ^{14}C Ages from Côa, Portugal and Deer Valley, Arizona," *American Indian Rock Art* 23 (1996): 11–24. Strictly, the organics dated from the Côa petroglyphs occurred under silica glaze, not rock varnish (hence Dorn's generic use of the term Weathering Rind Organics AMS dating), but the principal was the same as with varnish dating.

47. E.g., Joao Zilhão, "The Age of the Côa Valley (Portugal) Rock Art: Validation of Archaeological Dating to the Palaeolithic and Refutation of Scientific Dating to Historic or Proto-Historic Times," *Antiquity* 69 (1995): 883–901; Jean Clottes, M. Lorblanchet, and A. Beltrán, "Are the Foz Côa Engravings Actually Holocene?" *International Newsletter on Rock Art* 12 (1995): 19–21; C. Züchner, "Some Comments on the Rock Art of Foz Côa (Portugal)," *International Newsletter on Rock Art* 12 (1995): 18–19.

48. Watchman, "A Review of the Theory and Assumptions"; Alan Watchman, "A Review of the History of Dating Rock Varnishes," *Earth-Science Reviews* 49 (2000): 261–77; Joshua Fischman, "Portuguese Rock Art Gets Younger," *Science* 269 (1995): 304.

49. Dorn, "A Change of Perception"; Dorn, "Constraining the Age of the Côa Valley (Portugal) Engravings"; Welsh and Dorn, "Critical Analysis of Petroglyph ^{14}C Ages."

50. Dorn et al., "Accelerator Mass Spectrometry Radiocarbon Dating."

51. Except for cited publications, the sources for the following discussion are in the files of Superior Court of Arizona case number CV99-11443, housed in the Jackson Street facility of the Maricopa County Courthouse, Customer Service Center (basement floor), Phoenix, Arizona. Quoted passages are identified by their numerical designation within this ten-volume case file.

52. Warren Beck to Christopher Chippendale, e-mail, 27 March

1997, Superior Court Case CV99-11443, document Arizona 10.662. Beck sent this e-mail to then editor of the English archaeology journal *Antiquity* concerning Dorn's 1997 publication on the Côa results in this journal:

> I must admit, that reading Dr. Dorns [*sic*] paper made me feel mildly sick to my stomach. Im [*sic*] my opinion, it is a very confused, self-contradictory, thinly veiled attempt to blow a smokescreen over the real implications of his previous work.

53. Wallace Broecker to Warren Beck, e-mail, 22 August 1996, Superior Court Case CV99-11443, document UA 0010.

54. The only other US AMS radiocarbon dating labs in the 1990s were at the Lawrence Livermore National Laboratory, and at Woods Hole Oceanic Institute. Although Livermore performed archaeological and geosciences radiocarbon analyses, its emphasis was (and continues to be) on AMS applications in biomedical research; Woods Hole similarly has focused on oceanographic samples and analyses. The important point here is simply that most US archaeological and geological AMS samples passed through the Arizona lab in the 1990s, making it something of the gatekeeper for chronometric research.

55. Warren Beck to Wallace Broecker, e-mail, 27 August 1996, Superior Court Case CV99-11443, document UA 0010-11; Wallace Broecker to Warren Beck, e-mail, 27 August 1996, Superior Court Case CV99-11443, document UA 0021.

56. Aaron Manka to University of Arizona attorney, Nicolas Goodman, cover letter and close-out memo, 10 January 2000, Superior Court Case CV99-11443, document UA 0147.

57. Warren Beck to Wallace Broecker, e-mail, 17 August 1996, Superior Court Case CV99-11443, document CU 00058.

58. Fred Phillips to Tim Jull, e-mail, 20 January 1997, Superior Court Case CV99-11443, document Arizona 13.799. Jull's e-mail response to Phillips that same day (document Arizona 13.798) was cautious and guarded. Jull elaborated at some length about the need

to handle the developing controversy professionally. He also briefly warned Phillips that "some of the items you noted are not totally accurate, for example reference to 'bristlecone pine,'" but did not further correct any errors in Phillips' account, urging him instead to pursue further information by telephone.

Phillips had in fact contributed to the Côa project by using a geological dating technique (cosmogenic nuclides) to date the rock panel faces (see F. M. Phillips, M. Flynch, D. Elmore, and P. Sharma, "Maximum Ages for the Côa Valley [Portugal] Engravings Measured with ^{36}Cl," *Antiquity* 71 (1997): 100–104). This was a response to the initial belief, on the part of some observers, that the rock surfaces themselves were relatively recent geological features and, for this reason, that the art could not possibly be Paleolithic in age—that their physical context was younger than ten thousand years. Phillips's study demonstrated that the rock faces were tens of thousands of years old and hence there was no geological reason why the art could not be ancient.

59. Dorn, "A Change of Perception"; Dorn, "Constraining the Age of the Côa Valley (Portugal) Engravings"; Welsh and Dorn, "Critical Analysis of Petroglyph ^{14}C Ages."

60. W. Beck, D. Donahue, G. Burr and, A. J. T. Jull, "AMS ^{14}C Dating of Early Anasazi Petroglyphs from the North American Southwest Region," (Paper presented at the Sixth Australasian Archaeometry Conference, Australian Museum, 10–13 February, 1997). Abstract in Superior Court Case CV99-11443, document Arizona 10.109.

61. Press coverage occurred on three continents and ultimately included the *Sydney Morning Herald* (14 March 1997 and 25 March 1998), *New Scientist* (22 March 1997), *New York Times Science Watch* (30 June 1998), and the *Economist* (12 July 1998), along with the *AAP Newsfeed* and various Arizona papers. The news sections of *Nature* (19 March 1998, 2 July 1998, 30 September 1999, 14 October 1999, and 6 March 2001) and *Science* (29 October 1999) also featured the controversy.

62. Nelson to Wallace Brocker, e-mail, 31 December 1997, Superior Court Case CV99-11443, document Arizona 10.152 is copy

of 31 December 1997 message from Dr. Nelson, of the NSF, to Broecker, responding to Broecker's 16 December 1999 expression of concern over the status of the OIG investigation.

63. W. Beck, D. J. Donahue, A. J. T. Jull, G. Burr, W. S. Broecker, G. Bonani, I. Hajdas, and E. Malotki, "Ambiguities in Direct Dating of Rock Surfaces using Radiocarbon Measurements," *Science* 280 (1998): 2132–35; Ronald I. Dorn, "Response," *Science* 280 (1998): 2136–39.

64. Beck et al., "Ambiguities in Direct Dating," p. 2132.

65. Ibid., p. 2135.

66. Dorn, "Response."

67. J. R. Arrowsmith, G. E. Rice, and J. C. Hower, "Documentation of Carbon-Rich Fragments in Varnish-Covered Rocks from Central Arizona using Electron Microscopy and Coal Petrography" (unpublished manuscript on file, Arizona State University, Spring 1998).

68. Superior Court Case CV99-11443, documents Arizona 10, 241, and UA147.

69. Southon to Tim Jull, e-mail, 1 November 1999 and 17 November 1999, Superior Court Case CV99-11443, document Arizona 29.25.

70. Superior Court Case CV99-11443. International news coverage included the *Associated Press State and Local Wire*, October 2, 1999; *Science* 286, no. 5441 (October 29, 1999): 883–86; and *Nature* 409 (September 1999): 419–30.

CHAPTER FOUR: FINDING CÔA

1. According to Joao Zilhão, a 1995 opinion poll reported that 55 percent of the Portuguese people were opposed to the dam following the public announcement of the discovery and the protests that ensued. He also documents a protest by a local high school teacher and students; this resulted in a petition campaign that collected about two hundred thousand signatures in support of the preservation of the rock art. Joao Zilhão, "Public Archaeology and Political Dynamics in Portugal," *Public Archaeology* 3 (2004): 178.

2. Ibid.

3. Michel Lorblanchet and Paul Bahn, eds., *Rock Art Studies: The Post-Stylistic Era or Where Do We Go From Here?* (Oxford: Oxbow Books, Monograph 35, 1993).

4. J. David Lewis-Williams and Thomas A. Dowson, "Signs of All Times: Entoptic Phenomena in Upper Palaeolithic Art," *Current Anthropology* 29 (1988): 201–45.

5. E.g., David S. Whitley and Harold J. Annegarn, "Cation-Ratio Dating of Rock Engravings from Klipfontein, Northern Cape Province, South Africa," in *Contested Images: Diversity in Southern African Rock Art Research,* ed. T. A. Dowson and J. D. Lewis-Williams (Johannesburg, South Africa: University of Witwatersrand Press, 1994), pp. 189–97; D. S. Whitley, R. I. Dorn, J. M. Simon, R. Rechtman, and T. K. Whitley, "Sally's Rockshelter and the Archaeology of the Vision Quest," *Cambridge Archaeological Journal* 9 (1999): 221–46; David S. Whitley, J. M. Simon, and Ronald I. Dorn, "The Vision Quest in the Coso Range," *American Indian Rock Art* 25 (1999): 1–32; Julie E. Francis, "Style and Classification," in *Handbook of Rock Art Research,* ed. D. S. Whitley (Walnut Creek, CA: AltaMira Press, 2001), pp. 221–46.

6. Theirry Aubry and A. M. Faustino de Carvalho, "O povoamento pré-histórico no Vale do Côa: Síntese dos trabalhos do P.A.V.C. (1995–1997)," *Côavisão: Ciência e Cultura* 0 (1998): 23–34; T. Aubry, X. Mangado Llach, J. D. Sampaio, F. Sellami, "Open-Air Rock-Art and Modes of Exploitation during the Upper Paleolithic in the Côa Valley (Portugal)," *Antiquity* 76 (2002): 62–76.

7. António M. Baptista, *No tempo sem tempo: A arte dos caçadores paleoliticos do Vale do Côa: Com uma perspectiva dos ciclos rupestres pós-glaciares* (Vila Nova de Foz-Côa: Prague Arqueológico do Vale do Foz Côa, 1999); Aubry et al., "Open-Air Rock-Art and Modes."

8. Theirry Aubry and Antonio Martinho Baptista, "Une datation objective de l'art du Côa," *La Recherche Hors-Serie* 4 (2000): 54–55; Theirry Aubry and Marcos García Diez, "Actualité Sur la Chronologie et L'Interprétation de L'Art de la Vallee du Côa (Portugal)," *Les nouvelles de l'archéologie* 82 (2000): 52–57; Aubry et al.,

"Open-Air Rock-Art and Modes"; Marcos García Diez and Theirry Aubry, "Portable Art of the Côa Valley (Vila Nova de Foz Côa, Portugal): Fariseu Archaeological Site," *Zephyrus* 55 (2002): 157–82; N. Mercier, H. Valladas, T. Aubry, J. Zilhão, J. L. Jorons, J. L. Reyss, and F. Sellami, "Fariseu: First Confirmed Open-Air Palaeolithic Parietal Art Site in the Côa Valley (Portugal)," *Antiquity* 80 (2006): 310 (http://antiquity.ac.uk/ProjGall/mercier/index.html); H. Valladas, N. Mercier, L. Froget, J. L. Joron, J. L. Reyss, and T. Aubry, "TL Dating of Upper Paleolithic Sites in the Côa Valley (Portugal)," *Quaternary Sciences Reviews* 20 (2001): 939–43.

9. Aubry et al., "Open-Air Rock-Art and Modes."

10. E.g., Franz Boas, "Decorative Designs of Alaskan Needlecases: A Study in the History of Conventional Designs, Based on Materials in the U.S. National Museum," *Proceedings of the U.S. National Museum* 34 (1908): 321–44; William Bascom, "Creativity and Style in African Art," in *Tradition and Creativity in Tribal Art*, ed. D. Biebuyck (Berkeley: University of California Press, 1969), pp. 98–119; Meyer Schapiro, "Style," in *Anthropology Today: An Encyclopedic Compendium*, ed. A. L. Kroeber (Chicago: University of Chicago Press, 1953), pp. 287–312.

11. For example, see Antonio P. B. Fernandes, "Visitor Management and the Preservation of Rock Art: Two Case Studies of Open Air Rock Art Sites in Northeastern Portugal: Côa Valley and Mazouco," *Conservation and Management of Archaeological Sites* 6, no. 2 (2003): 95–111; Antonio P. B. Fernandes and F. M. Pinto, "Changing Stakeholders and Community Attitudes in the Côa Valley, Portugal," in *Of the Past, For the Future: Integrating Archaeology and Conservation*, ed. N. Agnew and J. Bridgland (Los Angeles: Getty Conservation Institute, 2006), pp. 136–42.

12. Jean Clottes and J. David Lewis-Williams, *Les Chamanes de la Préhistoire: Transe et Magie Dans les Grottes Ornées* (Paris: Editions du Seuil, 1996).

13. J. David Lewis-Williams, *The Mind in the Cave: Consciousness and the Origins of Art* (London: Thames and Hudson, 2002).

14. The Poitou-Charentes region of France has caves (especially Grotte de La Marche) with a small but significant number of human

engravings. See Jean Airvaux, *L'Art Préhistorique du Poitou-Charentes: Sculptures et Gravures des Temps Glaciaires* (Paris: La Maison des Roches, 2001). Enlenè, one of the Volp caverns in the Ariège region of the French Pyrenees, also has a significant number of human engravings on small plaquettes. See, e.g., Robert Bégouën and Jean Clottes, "Portable and Wall Art in the Volp Caves, Montesquieu-Avantes (Ariege)," *Proceedings of the Prehistoric Society* 57, Part I (1991): 65–79, and occasional examples occur somewhat randomly at other Paleolithic sites in other areas. Human figures are however generally rare, making the resemblance between the Côa engravings and those elsewhere potentially all the more significant.

15. David S. Whitley, *The Art of the Shaman: Rock Art of California* (Salt Lake City: University of Utah Press, 2000) summarizes the rock art and ethnography of this portion of the far west.

16. Close-out memo, 10 January 2000, Superior Court Case CV99-11443, document UA 0147.

17. Howard Schachman, quoted in Superior Court Case CV99-11443, document Arizona 10.244.

18. *Nature* 401 (March 8, 2001): 135.

19. For example, Alan Watchman commented on the Dorn controversy, after his NSF exoneration, as follows: "This intriguing case is highly controversial, even though counter arguments were offered to explain the anomaly . . . because it is apparent that a natural process was not the only contributing factor by which charcoal and bituminous coal were incorporated in those varnish samples." Alan Watchman, "A Review of the History of Dating Rock Varnishes," *Earth-Science Reviews* 49 (2000): 272. Watchman continued to promote the allegations that Dorn had fabricated his samples, after he had been deemed innocent.

20. Superior Court Case files for case CV99-11443.

21. Ronald I. Dorn, affidavit, 12 January 2001, Superior Court CV99-11443.

22. W. Beck, D. J. Donahue, A. J. T. Jull, G. Burr, W. S. Broecker, G. Bonani, I. Hajdas, and E. Malotki, "Ambiguities in Direct Dating of Rock Surfaces Using Radiocarbon Measurements," *Science* 280 (1998): 2132–35.

23. "Report of [ASU] Investigation Committee," Superior Court Case CV99-11443, document UA 0162.

24. Dorn, affidavit, 12 January 2001.

25. E.g., "Radiocarbon Dating of Rock Varnish—an Unsolved Mystery," Superior Court Case CV99-11443, document CU 00235.

26. Dorn, affidavit, 12 January 2001, pp. 36–37.

27. E.g., Ronald I. Dorn, "Dating Petroglyphs with a 3-tier Rock Varnish Approach," in *New Light on Old Art: Advances in Hunter-Gatherer Rock Art Research*, ed. D. S. Whitley and L. L. Loendorf (Los Angeles: University of California Institute for Archaeology, Monograph Series No. 36, 1994), p. 21; R. I. Dorn, P. B. Clarkson, M. F. Nobbs, L. L. Loendorf, and D. S. Whitley, "New Approach to the Radiocarbon Dating of Rock Varnish, with Examples from Drylands," *Annals of the Association of American Geographers* 82 (1992): 136–51; M. F. Nobbs and R. I. Dorn, "New Surface Exposure Ages for Petroglyphs from the Olary Province, South Australia," *Archaeology in Oceania* 28 (1993): 18–39, Figure 8; J. von Werlhof, H. Casey, R. I. Dorn, and G. A. Jones, "AMS ^{14}C Age Constraints on Geoglyphs in the Lower Colorado River Region, Arizona and California," *Geoarchaeology* 10 (1995): 257–73.

28. See, e.g., W. B. Bull, *Geomorphic Responses to Climatic Change* (Oxford: Oxford University Press, 1991); D. Dragovich, "Microchemistry and Relative Chronology of Small Desert Varnish Samples, Western New South Wales, Australia," *Earth Surface Processes and Landforms* 22 (1998): 445–53; A. F. Glazovskiy, "Rock Varnish in the Glacierized Regions of the Pamirs," *Data of the Glaciological Studies* (Moscow) 54 (1985): 136–41; L. Jacobson, C. A. Pineda, and M. Peisach, "Dating Patinas with Cation Ratios: A New Tool for Archaeologists," *Digging Stick* 6, no. 2 (1989): 8; C. A. Pineda, M. Peisach, and L. Jacobson, "Ion Beam Analysis for the Determination of Cation Ratios as a Means of Dating Southern African Rock Varnishes," *Nuclear Instruments and Methods in Physics Research* B35 (1988): 463–66; C. A. Pineda, M. Peisach, and L. Jacobson, "The Time-Clock of Aged Patinas," *Nuclear Active* 41 (1989): 17–20; C. A. Pineda, M. Peisach, L. Jacobson, and C. G. Sampson, "Cation-Ratio Differences in Rock Patina on Hornfels and Chalcedony Using Thick

Target PIXE," *Nuclear Instruments and Methods in Physics Research* B49 (1990): 332–35; J. W. Whitney and C. D. Harrington, "Relict Colluvial Boulder Deposits as Paleoclimatic Indicators in the Yucca Mountain Region, Southern Nevada," *Geological Society of America Bulletin* 105 (1993): 1008–18; Y. Zhang, T. Liu, and S. Li, "Establishment of a Cation-Leaching Curve of Rock Varnish and Its Application to the Boundary Region of Gansu and Xinjiang, Western China," *Seismology and Geology* (Beijing) 12 (1990): 251–61.

29. E.g., Whitley et al., "Sally's Rockshelter"; Whitley et al., "The Vision Quest in the Coso Range."

30. Tanzhuo Liu, "Blind Testing of Rock Varnish Microstratigraphy as a Chronometric Indicator: Results on Late Quaternary Lava Flows in the Mojave Desert, California," *Geomorphology* 53 (2003): 209–34; R. A. Marston, "Editorial Note," *Geomorphology* 53 (2003): 197; F. M. Phillips, "Cosmogenic Cl-36 Ages of Quaternary Basalt Flows in the Mojave Desert, California, USA," *Geomorphology* 53 (2003): 199–208.

31. Tanzhuo Liu and Wallace S. Broecker, "Rock Varnish Evidence for Holocene Climate Variations in the Great Basin of the Western United States," *GSA Abstracts with Program* 31 (1999): 418; Tanzhuo Liu and Wallace S. Broecker, "Rock Varnish: Recorder of Desert Wetness?" *GSA Today* 11, no. 8 (2001): 4–10; Tanzhuo Liu and Wallace S. Broecker, "Holocene Rock Varnish Microstratigraphy and Its Chronometric Application in the Drylands of Western USA," *Geomorphology* 84 (2007): 1–21.

32. David S. Whitley and Ronald I. Dorn, "The Coso Petroglyph Chronology," *Pacific Coast Archaeological Society Quarterly* (in press, 2008).

33. Whitley et al., "Sally's Rockshelter"; Whitley et al., "The Vision Quest in the Coso Range."

34. David S. Whitley, "Shamanism, Natural Modeling, and the Rock Art of Far Western North America," in *Shamanism and Rock Art in North America*, ed. S. Turpin (San Antonio, TX: Rock Art Foundation, Inc., Special Publication 1, 1994), pp. 1–43; David S. Whitley, "By the Hunter, For the Gatherer: Art, Social Relations, and Subsistence Change in the Prehistoric Great Basin," *World Archaeology* 25

(1994): 356–77; David S. Whitley, "Cognitive Neuroscience, Shamanism, and the Rock Art of Native California," *Anthropology of Consciousness* 9 (1998): 22–37; Whitley, *The Art of the Shaman*; David S. Whitley, "Science and the Sacred: Interpretive Theory in US Rock Art Research," in *Theoretical Perspectives in Rock Art Research*, ed. Knut Helskog (Oslo, Norway: Novus Press, 2001), pp. 130–57.

35. Whitley et al., "Sally's Rockshelter"; Whitley et al., "The Vision Quest in the Coso Range"; Whitley, "Science and the Sacred." An electron microprobe was used to examine small samples of rock varnish from the engravings and to identify quartz grains within these samples.

36. Another line of evidence is the prehistoric use of hallucinogens because of their significance in inducing altered states. Minor plant use for medicinal or religious purposes (as opposed to food-stuffs used for subsistence) is difficult to identify in the archaeological record because plant remains are only preserved under special conditions. Still, Carolyn E. Boyd documents early archaeological evidence for three hallucinogens in the Texas region. These are the mescal bean, in use by about eight thousand years ago; peyote, by 5000 YBP; and jimsonweed, also perhaps by 5000 YBP. See Carolyn E. Boyd *Rock Art of the Lower Pecos* (College Station: Texas A&M University Press, 2003); and Carolyn E. Boyd and J. Phillip Dering, "Medicinal and Hallucinogenic Plants Identified in the Sediments and Pictographs of the Lower Pecos, Texas Archaic," *Antiquity* 70 (1996): 256–75. Similar antiquity has been documented in South America for a hallucinogenic snuff in Constantino M. Torres, "Archaeological Evidence for the Antiquity of Psychoactive Plant Use in the Central Andes," *Annali del Museo Civico di Rovereto* 11 (1996): 291–326, and tobacco in Deborah M. Pearsall, "The Origins of Plant Cultivation in South America," *The Origins of Agriculture: An International Perspective*, ed. C. W. Cowan and P. J. Watson (Washington, DC: Smithsonian Institution, 1992), pp. 173–206—in fact, an important hallucinogen in its native form and strength. These are all minimum dates: the first archaeologically-observed plant use is almost certainly later than the initial adoption of the practice.

There has been debate concerning whether early New World

shamanism was hallucinogen free, with psychotropic plant use only developing later. Compare Johannes Wilbert, *Tobacco and Shamanism in South America* (New Haven, CT: Yale University, 1987) and Alexander von Gernet, "North American Indigenous *Nicotiana* Use and Tobacco Shamanism: The Early Documentary Record, 1520–1660," in *Tobacco Use by North Americans: Sacred Smoke and Silent Killer*, ed. J. C. Winter (Norman: University of Oklahoma Press), pp. 59–81. This debate has focused on the Southern American evidence and appears to have overlooked the North American data cited in Boyd, *Rock Art of the Lower Pecos.* Her evidence further supports the argument for early hallucinogen use in the Americas put forth in Von Gernet, "North American Indigenous Nicotiana."

37. Gloria Flaherty, *Shamanism and the Eighteenth Century* (Princeton, NJ: Princeton University Press, 1992), p. 14.

38. E.g., Mircea Eliade, *Shamanism: Archaic Techniques of Ecstasy* (Princeton, NJ: Princeton University Press, Bollingen Series 67, 1972); Flaherty, *Shamanism and the Eighteenth*; Andrzej Rozwadowski, "Sun Gods or Shamans? Interpreting the 'Solar-Headed' Petroglyphs of Central Asia," in *The Archaeology of Shamanism*, ed. N. Price (London: Routledge, 2001), pp. 65–86; Andrzej Rozwadowski, *Symbols through Time: Interpreting the Rock Art of Central Asia* (Poznan, Poland: Institute of Eastern Studies, Adam Mickiewicz University, 2004); Ekaterina Devlet, "Rock Art and the Material Culture of Siberian and Central Asian Shamanism," in *The Archaeology of Shamanism*, ed. N. Price (London: Routledge, 2001), pp. 43–55; Andrzej Rozwadowski and Maria M. Kosko, eds., *Spirits and Stones: Shamanism and Rock Art in Central Asia and Siberia* (Poznan: Instytut Wschodoznawcze, Poznanskie Studia Wschodoznawcze, 4, 2002); Esther Jacobson, "Shamans, Shamanism, and Anthropomorphizing Imagery in Prehistoric Rock Art of the Mongolian Altay," in *The Concept of Shamanism: Uses and Abuses*, ed. H. P. Francfort and R. N. Hamayon (Budapest, Czech Republic: Akadémiai Kiadó, Bibliotheca Shamanistica, vol. 10, 2001), pp. 277–96.

39. See Franz Boas, "Ethnological Problems in Canada," *Journal of the Royal Anthropological Institute of Great Britain and Ireland* 40 (1910): 533–34.

40. Neil S. Price, *The Viking Way: Religion and Warfare in Late Iron Age Scandinavia* (Uppsala: Department of Archaeology and Ancient History, August 31, 2002) provides a particularly good overview of the history of circumpolar research on shamanism.

41. Karl H. Schlesier, *The Wolves of Heaven: Cheyenne Shamanism, Ceremonies, and Prehistoric Origins* (Norman: University of Oklahoma, 1987).

42. Price, *The Viking Way*, p. 292.

43. E.g., Theodore G. Schurr, "The Peopling of the Americas: Perspectives from Molecular Anthropology," *Annual Reviews of Anthropology* 33 (2004): 551–83.

44. S. A. Arutiunov and W. W. Fitzhugh, "Prehistory of Siberia and the Bering Sea," in *Crossroads of the Continents: Cultures of Siberia and Alaska*, ed. W. W. Fitzhugh and A. Crowell (Washington, DC: Smithsonian Institution, 1988), p. 123.

45. Joan M. Vastokas and Roman K. Vastokas, *Sacred Art of the Algonkians: A Study of the Peterborough Petroglyphs.* (Peterborough, Canada: Mansard, 1973), pp. 121–29. Note that the Vastokases interpret these images not as evidence for direct Old to New World contact, but instead as a reflection of widespread shamanistic beliefs—in this case the boat as the vehicle that transported the shaman to the supernatural. I concur with their symbolic interpretation, but the close resemblance in the imagery along with this inferred symbolism begs the question I raise.

46. Knut Helskog, "The Shore Connection: Cognitive Landscape and Communication with Rock Carvings in Northernmost Europe," *Norwegian Archaeological Review* 32, no. 2 (1999): 73–94.

47. Knut Helskog, personal communication with author, 2001.

48. Flaherty, *Shamanism and the Eighteenth*.

CHAPTER FIVE: THE MYTH OF ECSTASY AND THE ORIGINS OF RELIGION: ENTRY INTO THE VOLP CAVES

1. Niaux is discussed in Jean Clottes, "Grotte de Niaux," in *L'Art des cavernes: Atlas des grottes ornées paleolithiques françaises* (Paris: Min-

istere de la culture, 1984), pp. 416–23, and Jean Clottes, *Les Cavernes de Niaux: Art Préhistorique en Ariège* (Paris: Editions du Seuil, 1995).

2. Émile Cartailhac, "Les cavernes ornées de dessins: La grotte d'Altamira, Espagne, 'Mea culpa d'un sceptique.'" *L'Anthropologie* 13 (1902): 348–54.

3. Henri Breuil, *Four Hundred Centuries of Cave Art* (Montignac, France: Centre d'Etudes et de Documentation Préhistoriques, 1952). These caves are the best known and most commonly cited as examples of artistic masterpieces. It is certainly true that not all Paleolithic art has the same aesthetic appeal as the paintings and engravings of these major sites and that there are numerous examples of poorly rendered images (both within these and at other sites). But in a well-designed quantitative and qualitative analysis, Suzanne Villeneuve concluded that 27.5 percent of the corpus consists of high-quality, complex motifs, signaling that remarkable artistry is a hallmark of this art. S. Villeneuve, "Looking at the Caves from the Bottom Up: A Visual and Contextual Analysis of Four Paleolithic Painted Caves" (master's thesis, Department of Anthropology, University of Victoria, British Columbia, 2008.)

4. Alan H. Brodrick, *Father of Prehistory, The Abbé Henri Breuil: His Life and Times* (New York: William Morrow and Company, 1963) provides a Bégouën family history and an account of Henri Breuil's work at the Volp caves; the discovery of the caves is described by Brodrick and also in Breuil, *Four Hundred Centuries.*

5. Henri Bégouën and Henri Breuil, *Les Cavernes du Volp: Trois Frères-Tuc d'Audoubert, A Montequieu-Avantès (Ariegè)* (Paris: Arts et Métiers Graphiques, 1958).

6. E.g., R. Bégouën, F. Brois, J. Clottes, and C. Servelle, "Art Mobilier sur Support Lithique d'Enlène (Montesquieu-Avantés, Ariège): Collection Bégouën du Musée de l'Homme," *Ars Praehistorica* 3–4 (1984–1985): 25–80; Robert Bégouën and Jean Clottes, "Grotte des Trois-Frères," *L'art des Cavernes: Atlas des Grottes Ornées Paléolithique Françaises* (Paris: Ministère de la Culture, 1984); Robert Bégouën and Jean Clottes, "Le Grand Félin des Trois-Frères," *Antiquités Nationales* 18 (1986–1987): 109–13; Robert Bégouën and Jean Clottes, "Portable and Wall Art in the Volp Caves, Montesquieu-

Avantès (Ariège)," *Proceedings of the Prehistoric Society* 57 (1991): 65–79; R. Bégouën, J. Clottes, J. P. Giraud, F. Rouzaud, "Complé-ments à la Grande Plaquette Gravée d' Enlène," *Bulletin de la Société Françaises* 81 (1984): 1–7; R. Bégouën, J. Clottes, J. P. Giraud, and F. Rouzaud, "La Rondelle au Bison d'Enlène (Montesquieu-Avantès, Ariège)," *Zephyrus* 41–42 (1988–1989): 19–25.

7. Ibid.

8. E.g., D. S. Whitley, R. I. Dorn, J. M. Simon, R. Rechtman, and T. K. Whitley, "Sally's Rockshelter and the Archaeology of the Vision Quest," *Cambridge Archaeological Journal* 9 (1999): 221–46.

9. Johannes Wilbert, *Tobacco and Shamanism in South America* (New Haven, CT: Yale University, 1987).

10. Breuil, *Four Hundred Centuries*.

11. For the bodily metaphors of trance, see David S. Whitley, "Shamanism, Natural Modeling, and the Rock Art of Far Western North America," in *Shamanism and Rock Art in North America*, ed. S. Turpin (San Antonio, TX: Rock Art Foundation, Inc., Special Publi-cation 1, 1994), pp. 1–43; David S. Whitley, "Cognitive Neuro-science, Shamanism, and the Rock Art of Native California," *Anthro-pology of Consciousness* 9 (1998): 22–37; and David S. Whitley, *The Art of the Shaman: Rock Art of California* (Salt Lake City: University of Utah Press, 2000).

12. Quoted in Brodrick, *Father of Prehistory*, p. 121. "The Magdale-nians" refers to the specific Paleolithic period when the cave was in use, circa 10,500 to 17,000 years ago, or at the end of the Paleolithic.

13. Breuil, *Four Hundred Centuries*.

14. James D. Keyser and David S. Whitley, "Sympathetic Magic in Western North American Rock Art," *American Antiquity* 71 (2006): 3–26.

15. Weston La Barre, *Culture in Context: Selected Writings of Weston La Barre* (Durham, NC: Duke University Press, 1980).

16. E.g., Lowell John Bean, "Power and Its Application in Native California," in *Native Californians: A Theoretical Retrospective*, ed. L. J. Bean and T. C. Blackburn (Socorro, NM: Ballena Press, 1976), pp. 407–20.

17. See Barbara Meyerhoff, "Shamanic Equilibrium: Balance

and Mediation in Known and Unknown Worlds," in *American Folk Medicine*, ed. W. D. Hand (Berkeley: University of California Press, 1976), p. 102.

18. See David Joralemon and Douglas Sharon, *Sorcery and Shamanism: Curanderos and Clients in Northern Peru* (Salt Lake City: University of Utah Press, 1993), pp. 172–73.

19. E.g., Mircea Eliade, *Shamanism: Archaic Techniques of Ecstasy* (Princeton, NJ: Princeton University Press, Bollingen Series 67, 1972); Anna-Lena Siikala, *The Rite Technique of the Siberian Shaman*. (Helsinki, Finland: Academia Scientiarum Fennica, FF Communication #220, 1978).

20. Whitley, "Cognitive Neuroscience, Shamanism," was an early statement of the empirical circumstances presented here, implicitly calling for a recognition of the nonreligious side of shamanistic trance. I wrote the paper as an expression of my own growing unease with the concept of ecstasy, despite the pervasiveness of the ecstatic hypothesis in shamanic studies.

21. J. David Lewis-Williams and Thomas A. Dowson, "Signs of All Times: Entoptic Phenomena in Upper Palaeolithic Art," *Current Anthropology* 29 (1988): 201–45.

22. Whitley, "Shamanism, Natural Modeling"; Whitley, "Cognitive Neuroscience, Shamanism"; Whitley, *The Art of the Shaman*; David S. Whitley, "Science and the Sacred: Interpretive Theory in US Rock Art Research," in *Theoretical Perspectives in Rock Art Research*, ed. Knut Helskog (Oslo, Norway: Novus Press, 2001), p. 130–57; David S. Whitley, "Archaeological Evidence for Conceptual Metaphors as Enduring Knowledge Structures," *Time and Mind* 1 (2008): 7–30.

23. Michael Harner, "Hallucinogens and Shamans: The Question of a Trans-Cultural Experience," in *Hallucinogens and Shamans*, ed. M. Harner (New York: Oxford University Press, 1973), p. 151.

24. Joan Halifax, *Shamanic Voices: A Survey of Visionary Imagery* (New York: E. P. Dutton, 1979), p. 183.

25. Siikala, *The Rite Technique*, p. 286.

26. Richard Katz, *Boiling Energy: Community Healing Among the Kalahari !Kung* (Cambridge, MA: Harvard University Press, 1982), p. 45.

27. Johannes Wilbert, *Mystic Endowment: Religious Ethnography of the Warao Indians* (Cambridge, MA: Harvard University Press, 1993), p. 120.

28. Halifax, *Shamanic Voices*, p. 154.

29. Pascal Boyer, *Religion Explained: The Evolutionary Origins of Religious Thought* (New York: Basic Books, 2001).

30. See Jean Clottes, "Spirituality and Religion in Paleolithic Times," in *The Evolution of Rationality: Interdisciplinary Essays in Honor of J. Wentzel van Huyssteen*, ed. F. Leron Shults (Grand Rapids, MI: Eerdmans Publishing Company, 2006), p. 133.

31. Cf. William James, *The Varieties of Religious Experience* (New York: Touchstone, 1997); William Braud, "Brains, Science, Nonordinary, and Transcendent Experiences," in *Neurotheology: Brain, Science, Spirituality, Religious Experience*, ed. R. Joseph (San Jose, CA: University Press, 2002), pp. 123–34.

32. La Barre, *Culture in Context*, pp. 82–83.

33. Scott Atran, "The Neuropsychology of Religion," in *Neurotheology: Brain, Science, Spirituality, Religious Experience*, ed. R. Joseph (San Jose, CA: University Press, 2002), p. 165.

34. See, for example, Eugene d'Aquili and Andrew B. Newberg, *The Mystical Mind: Probing the Biology of Religious Experience* (Minneapolis, MN: Fortress Press, 1999); Vilayanur S. Ramachandran and Sandra Blakeslee, *Phantoms in the Brain: Probing the Mysteries of the Human Mind* (New York: Quill, 1999); Anthony B. Newberg and Jeremy Iversen, "On the 'Neuro' in Neurotheology," in *Neurotheology: Brain, Science, Spirituality, Religious Experience*, ed. R. Joseph (San Jose, CA: University Press, 2002), pp. 269–72; Michael A. Persinger, "The Temporal Lobe: The Biological Basis of the God Experience," in *Neurotheology: Brain, Science, Spirituality, Religious Experience*, ed. R. Joseph (San Jose, CA: University Press, 2002), pp. 273–78.

35. Ramachandran and Blakeslee, *Phantoms in the Brain*, pp.179–80 and 285.

36. Whitley, *The Art of the Shaman*.

37. J. Alan Hobson, *The Chemistry of Conscious States: Toward a Unified Model of the Brain and the Mind*. (Boston: Little, Brown, and Company, 1994).

38. Cla udio Naranjo, "Psychological Aspects of the Yagé Experience in an Experimental Setting," in *Hallucinogens and Shamans*, ed. M. Harner (New York: Oxford University Press, 1973), pp. 176–90. Note that Naranjo also reports that about half of his subjects reported visions that he classified as religious-themed images, including demons. But, as he cautions (p. 185), whether these are correctly "religious" hallucinations is partly definitional and cultural, hence their implications are unclear.

39. See La Barre, *Culture in Context*, pp. 70–82, for a discussion of New World hallucinogen use.

40. Michael McBride, "The Neuropsychology of Altered States of Consciousness and Their Agents" (paper presented at the Third D. J. Sibley Conference on World Traditions of Culture and Art, Department of Art and Art History, University of Texas, Austin, 2000).

41. Newberg and Iversen, "On the 'Neuro' in Neurotheology," pp. 269–72.

42. Ibid., p. 258.

43. Braud, "Brains, Science, Nonordinary," pp. 123–34; Eugene d'Aquili and Andrew B. Newberg, "The Neuropsychology of Aesthetic, Spiritual, and Mystical States," in *Neurotheology: Brain, Science, Spirituality, Religious Experience*, ed. R. Joseph (San Jose, CA: University Press, 2002), pp. 243–50.

44. Peggy Ann Wright, "The Nature of the Shamanic State of Consciousness: A Review," *Journal of Psychoactive Drugs* 21 (1989): 25–33.

45. Ramachandran and Blakeslee, *Phantoms in the Brain*, pp. 179–80.

46. Felicitas D. Goodman, *Where the Spirits Ride the Wind: Trance Journeys and Other Ecstatic Experiences* (Bloomington: Indiana University Press, 1990) argues that the body postures adopted during trance induction influence the nature of the resulting visionary experiences in a predictable fashion. Lowland South American shamans also intentionally and carefully mixed different hallucinogenic plants in order to achieve specific kinds of visions (cf. Wilbert, *Tobacco and Shamanism*). Both circumstances point to the range of variability in altered states of consciousness and suggest

that shamans knowingly manipulated this variability in their practices.

47. Different academic traditions played varying roles in this confusion. Historians of religion referred to shamanic visions as "ecstasy," thereby linking them to transcendental and mystical traditions based on the inferred significance of a psychic death and rebirth experience. Further, the relationship between transcendence and shamanic trance was partly tied to the view that shamanism was stimulated by Buddhism. For them, this provided an explanation for the relationship of shamanism to religion—one of their central concerns. Cf. John A. Grim, *The Shaman: Patterns of Siberian and Ojibway Healing* (Norman: University of Oklahoma, 1983).

Anthropologists tended to refer to these same experiences as "trance" (Siikala, *The Rite Technique*, p. 39). Many anthropologists—though not all—recognized that these were not transcendental states. (Certainly many were well aware of the gruesome aspects of the experiences, which they recorded.) Many anthropologists also recognized that death and rebirth are common themes in many rituals, including especially social initiations. Ritual death-rebirth in emotionally powerful gender and age-set initiations has no intrinsic religious implications; that is, even though these social rituals sometimes occur in a religious context, they do not necessarily lead to enhanced religiosity. But anthropologists typically were not interested in either the origin of religion or the relationship of shamanism to religion. For them, this last issue was already a cultural given and questions of origins are the purview of historians and archaeologists. Hence the neuropsychological nature of the trance was anthropologically irrelevant, as was the specific term used for the shaman's ASC.

48. Transcendental states are commonly transformative and life changing, especially in the sense that they promote new kinds and levels of awareness and consciousness. They may be described, *metaphorically*, as a kind of rebirth. But this is a different phenomenon than the sense of extreme emotional grief and actual physical anguish that shamans sometime experienced, including the emotional release experienced from the relaxation of this transitory condition, and that they described, again metaphorically, as a death and

rebirth. This circumstance further points to the fact that while there are broad similarities between different kinds of ASC, reducing them all to a single lowest common denominator obscures rather than clarifies matters.

49. Eliade, *Shamanism: Archaic Techniques.*

50. Baba Ram Das, *Be Here Now* (San Cristobal, NM: Lama Foundation, 1971).

51. One of the confusing aspects of the ecstasy issue is that fact that certain (possibly) visionary accounts from true mystical traditions have the experiential form of shamanistic, not transcendental, experiences (as I use the terms here). F. Freemantle and C. Trungpa, *The Tibetan Book of the Dead, Translation and Commentary* (Boston: Shambhala, 1987), for example, describes the *chonyid* state as filled with demons and one of the steps between mortal death and rebirth. It resembles the anguish of shamanistic trance. But the implications of this fact are at best uncertain given the neuropsychological differentiation between kinds of altered states and the unknown nature of the states that *The Tibetan Book of the Dead* may or may not describe.

52. La Barre, *Culture in Context*, p. 76, observes in this regard that the aboriginal use of peyote and jimsonweed in the Americas are mutually exclusive, even though they overlap in their biological ranges. Both have markedly different effects, with jimsonweed associated with frightening visions and, sometimes, aggressive behavior. Carolyn E. Boyd, *Rock Art of the Lower Pecos* (College Station: Texas A&M University Press, 2003) has identified a widespread (though not universal) association between jimsonweed use and black shamanism or sorcery, pointing to Native American perceptions of its distinctive effect relative to other means of trance induction. In Native California, jimsonweed was primarily used in controlled group initiations, because of fear that an individual might wander off under its effects and perish (Whitley, *The Art of the Shaman*). These circumstances point to the Native American awareness of the different kinds of altered states that these hallucinogens promote, and hence the variability that exists within what we call "an altered state of consciousness."

53. See, e.g., Stewart Guthrie, *Faces in the Clouds: A New Theory*

of Religion (Oxford: Oxford University Press, 1993); Boyer, *Religion Explained*; Scott Atran, *In Gods We Trust: The Evolutionary Landscapes of Religion* (Oxford, England: Oxford University Press, 2002); Justin Barrett, *Why Would Anyone Believe in God?* (Walnut Cree k, CA: AltaMira Press, 2004); Illka Pyysiänen, *Magic, Miracles, and Religion: A Scientist's Perspective* (Walnut Creek, CA: AltaMira Press, 2004).

54. Evolutionary psychologists argue whether religion is a product or byproduct of evolution and whether it has direct adaptive significance (e.g., compare Michael Winkelman, "Cross-Cultural and Biogenetic Perspectives on the Origins of Shamanism," *Belief in the Past: Theoretical Approaches to the Archaeology of Religion*, ed. D. S. Whitley and K. Hays-Gilpin [Walnut Creek, CA: Left Coast Press, 2008], pp. 43–66; with Scott Atran, *In Gods We Trust*). Although this issue is important, it is not one requiring resolution here.

55. Atran, *In Gods We Trust*, p. 15.

56 . Barrett, *Why Would Anyone Believe*, p. 21.

57. Atran, *In Gods We Trust*, p. 9.

58. Boyer, *Religion Explained*, p. 32.

59. Barrett, *Why Would Anyone Believe*, p. 26.

60. Pyysiänen, *Magic, Miracles, and Religion*, p. 39.

61. Barrett, *Why Would Anyone Believe*.

62. Pyysiänen, *Magic, Miracles, and Religion*, p. 51.

63. Barrett, *Why Would Anyone Believe*, p. 30.

64. Boyer, *Religion Explained*; Barrett, *Why Would Anyone Believe*.

65. Barrett, *Why Would Anyone Believe*, p. 26.

66. Boyer, *Religion Explained*.

67. Guthrie, *Faces in the Clouds*.

68. Barrett, *Why Would Anyone Believe*.

69. Atran, *In Gods We Trust*, p. 267.

70. Barrett, *Why Would Anyone Believe*, p. 31.

71. Boyer, *Religion Explained*, p. 145; Barrett, *Why Would Anyone Believe*, p. 36.

72. Mark Twain, *The Adventures of Huckleberry Finn* (London: Penguin Books, 1966; originally published 1884).

73. E.g., see David S. Whitley, "Ways of Seeing and Ways of Knowing: Supernatural Agents and Native American Rock Art,"

(Kimberley, South Africa: South African Conference on Rock Art III, 2006); Åke Hultkrantz, *Native Religions of North America: The Power of Visions and Fertility* (San Francisco: Harper and Row, 1987), p. 49; John E. Roth, *American Elves: An Encyclopedia of Little People from the Lore of 380 Ethnic Groups of the Western Hemisphere* (Jefferson, MI: McFarland & Company, 1997).

74. Whitley, "Shamanism and Rock Art"; Whitley, *The Art of the Shaman*.

75. Robert Layton, *Australian Rock Art: A New Synthesis* (Cambridge, MA: Cambridge University Press, 1992).

76. Atran, *In Gods We Trust*, p. 51.

77. La Barre, *Culture in Context*, pp. 53–54.

78. Eliade, *Shamanism: Archaic Techniques*.

79. E.g., Siikala, *The Rite Technique*, p. 24.

80. Raymond Firth, "Problem and Assumption in the Anthropological Study of Religion," *Journal of the Royal Anthropological Institute*, 39 (1959): 129–48; see also S. M. Shirokogoroff, *Psychomental Complex of the Tungus* (London: Kegan Paul, Trench, and Grubner, 1935), who earlier suggested a similar definition.

81. Atran, *In Gods We Trust*, p. 83.

CHAPTER SIX: CREATIVITY AND THE EMOTIONAL LIFE OF THE SHAMANS

1. Scott Atran, *In Gods We Trust: The Evolutionary Landscapes of Religion* (Oxford, England: Oxford University Press, 2002).

2. Henri Breuil, *Four Hundred Centuries of Cave Art* (Montignac, France: Centre d'Etudes et de Documentation Préhistoriques, 1952).

3. E.g., John Halverson, "Art for Art's Sake in the Paleolithic," *Current Anthropology* 28 (1987): 63–89.

4. Anna-Lena Siikala, *The Rite Technique of the Siberian Shaman*. (Helsinki, Finland: Academia Scientiarum Fennica, FF Communication #220, 1978), p. 27.

5. E.g., see Julian Silverman, "Shamans and Acute Schizophrenia," *American Anthropologist* 69 (1967): 21–31.

6. See Jane Atkinson, "Shamanisms Today," *Annual Review of Anthropology* 21 (1992): 309.

7. American Psychiatric Association, *Diagnostic and Statistical Manual of Mental Disorders*, 4th ed. (Washington, DC: American Psychiatric Association, 2000), p. 298.

8. E.g., see David S. Whitley, "By the Hunter, For the Gatherer: Art, Social Relations, and Subsistence Change in the Prehistoric Great Basin," *World Archaeology* 25 (1994): 356–77; Sarah Nelson, *Shamanism and the Origin of States: Spirit, Power, and Gender in East Asia* (Walnut Creek, CA: Left Coast Press, 2008).

9. Atkinson, "Shamanisms Today," p. 310.

10. E.g., L. B. Boyer, B. Klopfer, F. B. Brawer, and H. Kawai, "Comparisons of the Shamans and Pseudo-Shamans of the Apaches of the Mescalero Indian Reservation: A Rorschach Study," *Journal of Projective Techniques* 28 (1964): 173–80, demonstrated that shamans had a normal perception of reality. Richard Noll, "Shamanism and Schizophrenia: A State-Specific Approach to the 'Schizophrenia Metaphor' of Shamanic States," *American Ethnologist* 10 (1983): 433–59, used the diagnostic criteria in the American Psychiatric Association's *Diagnostic and Statistical Manual of Mental Disorders*, 3rd ed. (1980) to demonstrate that the schizophrenic argument was "untenable" (p. 455). Roger Walsh, "Shamanic Experiences: A Developmental Analysis," *Journal of Humanistic Psychology* 41, no. 3 (2001): 31–52, concluded that shamanism is "clearly distinct from schizophrenic states" (p. 34).

11. Michael Ripinsky-Naxon, *The Nature of Shamanism* (Albany: State University of New York Press, 1993), p. 104.

12. Siikala, *The Rite Technique*, pp. 285–86.

13. George Devereux, *Mohave Ethnopsychiatry: The Psychic Disturbances of an Indian Tribe* (Washington, DC: Smithsonian Institution, Bureau of American Ethnology, Bulletin 175, 1969), p. 72.

14. Ibid., p. 399.

15. Knut Rasmussen, *The Intellectual Culture of the Iglulik Eskimos* (Copenhagen: Gyldendals, 1929), p. 119.

16. Ioan M. Lewis, *Ecstatic Religion: A Study of Shamanism and Spirit Possession*, 3rd ed. (London: Routledge, 2003).

17. Samuel H. Barondes, *Mood Genes: Hunting for the Origins of Mania and Depression* (Oxford: Oxford University Press, 1998), p. 37.

18. E.g., Kay Redfield Jamison, *Touched with Fire: Manic-Depressive Illness and the Artistic Temperament* (New York: Free Press, 1993), pp. 3 and 59; D. Jablow Hershman and Julian Lieb, *Manic Depression and Creativity* (Amherst, NY: Prometheus Books, 1998 [originally published 1988]), p. 20.

19. Jamison, *Touched with Fire*, p. 59; Frank Jacobi, Simone Rosi, Carlo Faravelli, Renee Goodwin, Saena Arbabzadeh-Bouchez, and Jean-Pierre Lépine, "The Epidemiology of Mood Disorders," in *Mood Disorders: Clinical Management and Research Issues*, ed. E. J. L. Griez, C. Faravelli, D. J. Nutt, and J. Zohar (Chichester: John Wiley and Sons, 2005), p. 5.

20. John Ross Browne, *Adventures in the Apache Country: A Tour Through Arizona and Sonora, with Notes on the Silver Regions of Nevada.* (New York: Promontory Press, 1974 [originally published 1871]), p. 56.

21. Mohave culture and rock art are described in David S. Whitley, *The Art of the Shaman: Rock Art of California* (Salt Lake City: University of Utah Press, 2000).

22. See C. J. Groesbeck, "C. G. Jung and the Shaman's Vision," *Journal of Analytical Psychology* 34 (1989): 255–75; H. Senn, "Jungian Shamanism," *Journal of Psychoactive Drugs* 21 (1989): 113–21.

23. George Devereux, "Shamans as Neurotics," *American Anthropologist* 63 (1961): 1089. Note that "neurotic" is a term associated with psychoanalysis; it was removed from the *DSM-III* and is no longer used diagnostically in America. Generally speaking, it was specified for a mental imbalance that caused distress, including especially depression and anxiety. It is possible though not certain, in other words, that Devereux believed that Mohave shamans suffered from mood disorders, but used slightly different terms in this reference to say so.

24. See Devereux, *Mohave Ethnopsychiatry*, p. 241.

25. Ibid. The shaman Apen Ismalyk was diagnosed as bipolar and treated with electroshock therapy at the Arizona State Hospital for the Insane. Devereux initially contested this diagnosis (p. 70),

but subsequently accepted it (p. 244). Devereux also identified what the Mohave labeled as "snake disease" as bipolar disease and "hysteria" (p. 124), and suggested that another shaman, Hilyera Anyay, was bipolar (pp. 123–24) due to his self-diagnosis of "snake disease." Devereux also diagnosed a woman as bipolar, noting that she was shamanistically cured by her grandfather (p. 182). The implication is that the woman was a member of a shamanistic family. Devereux makes no direct comments about the mental health of the remaining four shamans he discusses. It is unclear whether this was because they were mentally healthy or simply because the topic never was discussed.

26. Frank Jacobi et al., "The Epidemiology of Mood Disorders," p. 13, table 1.2; see also Jamison, *Touched with Fire*, p. 17; Barondes, *Mood Genes*, p. 1.

27. Devereux, *Mohave Ethnopsychiatry*, pp. 67, 69–70, 71, and 399.

28. Ibid., p. 70.

29. Ibid., pp. 60–61 and 388.

30. Ibid., pp. 71–72.

31. Ibid., p. 397; see also pp. 324–39.

32. Mircea Eliade, *Rites and Symbols of Initiation* (New York: Harper Torchbook, 1958), p. 89.

33. Siikala, *The Rite Technique*, pp. 189–90.

34. Ibid., p. 330.

35. Waldemar Bogoras, *The Chukchee. The Jesup North Pacific Expedition 11. Memoirs of the American Museum of Natural History* (New York: AMS Press, 1975 [originally published 1907]), p. 415.

36. Siikala, *The Rite Technique*, pp. 95, 189, 190, 197, 227, 229, 262, 285, 287, 313, and 315.

37. Lewis, *Ecstatic Religion*, p. 47.

38. Willard Z. Park, *Shamanism in Western North America: A Study in Cultural Relationships* (Evanston, IL: Northwestern University Studies in the Social Sciences, no. 2, 1938), p. 25; see also Alfred L. Kroeber, *Handbook of the Indians of California* (Washington, DC: Smithsonian Institution, Bureau of American Ethnology, Bulletin 78, 1925), p. 425; Maurice Zigmond, "The Supernatural World of

the Kawaiisu," in *Flowers of the Wind: Papers on Ritual, Myth and Symbolism in California and the Southwest*, ed. T. C. Blackburn (Socorro, NM: Ballena Press, 1977), pp. 92–93; and M. Zigmond, *Kawaiisu Mythology: An Oral Tradition of South-Central California* (Socorro, NM: Ballena Press), pp. 175 and 178.

 39. Kroeber, *Handbook*, p. 425; see also, e.g., Robert H. Lowie, "Notes on Shoshonean Ethnography," *Anthropological Papers, American Museum of Natural History* 20 (1924): 294; Kroeber, *Handbook*, pp. 197, 301, 361, and 423; Anna H. Gayton, "Yokuts-Mono Chiefs and Shamans," *University of California Publications in American Archaeology and Ethnology* 24 (1930): 393; Anna H. Gayton, "Yokuts and Western Mono Ethnography," *University of California Anthropological Records* 10 (1948): 109; Isabel T. Kelly, "Ethnography of the Surprise Valley Paiutes," *University of California Publications in American Archaeology and Ethnology* 31, no. 3 (1932): 191; Isabel T. Kelly, "Southern Paiute Shamanism," *University of California Anthropological Records* 2, no. 4 (1939): 161; G. Toffelmeier and K. Luomala, "Dreams and Dream Interpretation of the Diegueño Indians of Southern California," *Psychoanalytic Quarterly* 5 (1936): 200; Harold E. Driver, "Cultural Element Distributions: VI, Southern Sierra Nevada," *University of California Anthropological Records* 1, no. 2 (1937): 102, 104, 105, and 141; Park, *Shamanism in Western*, pp. 24, 25, 27, and 29–31; Erminie Wheeler Voegelin, "Tubatulabal Ethnography," *University of California Anthropological Records* 2 (1938): 62 and 63; Jack S. Harris, "The White Knife Shoshoni of Nevada," in *Acculturation in Seven American Indian Tribes*, ed. R. Linton (New York: D. Appleton-Century, 1940), p. 70; B. W. Aginsky, "Culture Element Distributions: XXIV, Central Sierra," *University of California Anthropological Records* 8, no. 4 (1943): 444, 446, and 447; James F. Downs, "Washo Religion," *University of California Anthropological Records* 16, no. 9 (1961): 369; Carobeth Laird, *The Chemehuevis* (Banning, CA: Malki Museum, 1976), pp. 19 and 35; Frank Latta, *Handbook of the Yokuts Indians*, 2nd ed. (Santa Cruz, CA: Bear State Books, 1977), pp. 611–12; Zigmond, "The Supernatural World of the Kawaiisu," p. 85.

 40. E.g., Park, *Shamanism in Western*, p. 26.

41. E.g., see Alfred L. Kroeber, "The Religion of the Indians of California," *University of California Publications in American Archaeology and Ethnology* 4, no. 6 (1907): 328; Kroeber, *Handbook*, pp. 197, 301, 361, 422–23, and 425; Edward W. Gifford, "The Northfork Mono," *University of California Publications in American Archaeology and Ethnology* 31, no. 2 (1932): 49; W. Park, *Shamanism in Western*, pp. 22–23 and 115–16.

42. Kroeber, "The Religion of the Indians," p. 327; see also Gayton, "Yokuts-Mono Chiefs," pp. 390, 392, and 394; Raymond C. White, "Luiseño Social Organization," *University of California Publications in American Archaeology and Ethnology* 48 (1963): 146.

43. E.g., Gayton, "Yokuts-Mono Chiefs," pp. 382, 392–93; Toffelmeier and Luomala, "Dreams and Dream Interpretation," 216, 221, and 223; John Peabody Harrington, "Annotations," in G. Boscana, *Chinigchinich: A Historical Account of the Indians of the Mission of San Juan Capistrano Called the Acagchemem Tribe* (Banning, CA: Malki Museum, 1978), pp. 91–228.

44. E.g., Robert H. Lowie, "The Northern Shoshone," *Anthropological Papers, American Museum of Natural History* 2, no. 2 (1909): 223; Kroeber, *Handbook*, p. 514; Gayton, "Yokuts-Mono Chiefs," p. 393; Gayton, "Yokuts and Western Mono Ethnography," pp. 169 and 206; Kelly, "Ethnography of the Surprise Valley Paiutes," p. 190; Isabel T. Kelly, "Chemehuevi Shamanism," in *Essays in Anthropology, Presented to A. L. Kroeber in Celebration of His Sixtieth Birthday* (Berkeley: University of California Press, 1936), p. 129; Driver, "Cultural Element Distributions: VI," p. 142; Harris, "The White Knife Shoshoni," p. 58; Julian H. Steward, "Culture Element Distributions: XIII, Nevada Shoshoni," *University of California Anthropological Records* 4, no. 2 (1941): 258; Beatrice B. Whiting, *Paiute Sorcery* (New York: Viking Fund Publications in Anthropology, Number 15, 1950), pp. 29–30; Harold Olofson, "Northern Paiute Shamanism Revisited," *Anthropos* 74 (1979): 16; C. Laird 1976, *The Chemehuevis*, p. 22; Catherine S. Fowler and Sven Liljeblad, "Northern Paiute," in *Handbook of North American Indians, Volume 11, Great Basin*, ed. W. D'Azevedo (Washington, DC: Smithsonian Institution, 1986), pp. 452; Isabel T. Kelly and C. S. Fowler, "Southern Paiute," in *Handbook*

of North American Indians, vol. 11: Great Basin, ed. W. D'Azevedo (Washington, DC: Smithsonian Institution, 1986), p. 383.

45. Gayton, "Yokuts and Western Mono Ethnography," p. 169.

46. Diego De Leo and Kym Spathonis, "Suicidal Behavior," in *Mood Disorders: Clinical Management and Research Issues*, ed. E. J. L. Griez, C. Faravelli, D. J. Nutt, and J. Zohar (Chichester: John Wiley and Sons, 2005), pp. 148–49.

47. Devereux's compendium, *Mohave Ethnopsychiatry*, is a second edition with a revised title. It was originally published in 1961 and called *Mohave Ethnopsychiatry and Suicide: The Psychiatric Knowledge and Psychic Disturbances of an Indian Tribe*.

48. Devereux, *Mohave Ethnopsychiatry*, p. 314.

49. Ibid., p. 397.

50. Ibid.

51. E.g., Robert H. Lowie, *Primitive Religion* (New York: Grosset and Dunlap, 1924), p. 244; Bogoras, *The Chukchee*, pp. 448–49; Mircea Eliade, *Shamanism: Archaic Techniques of Ecstasy* (Princeton, NJ: Princeton University Press, Bollingen Series 67, 1972), p. 258. Note that specific cases of shamanic suicide were often attributed ex post facto to stress caused by culturally required gender role reversals, reflecting the mores and biases of the anthropologists at the time.

52. Kroeber, *Handbook*, p. 425; Park, *Shamanism in Western*, p. 26.

53. Alessandro Serretti, "Genetics of Mood Disorders," in *Mood Disorders: Clinical Management and Research Issues*, ed. E. J. L. Griez, C. Faravelli, D. J. Nutt, and J. Zohar (Chichester: John Wiley and Sons, 2005), pp. 35–76.

54. Rasmussen, *The Intellectual Culture*, p. 119.

55. E.g., F. Jacobi et al., "The Epidemiology of Mood Disorders"; Carlo Faracelli, Claudia Ravaldi, and Elisabetta Truglia, "Unipolar Depression," in *Mood Disorders: Clinical Management and Research Issues*, ed. E. J. L. Griez, C. Faravelli, D. J. Nutt, and J. Zohar (Chichester: John Wiley and Sons, 2005), pp. 79–102; Leonardo Tondo, "Bipolar Disorder," in *Mood Disorders: Clinical Management and Research Issues*, ed. E. J. L. Griez, C. Faravelli, D. J. Nutt, and J. Zohar (Chichester: John Wiley and Sons, 2005), pp. 103–16.

56. Jamison, *Touched with Fire*, p. 96.

57. American Psychiatric Association, *DSM-IV*, pp. 345–428.

58. Jamison, *Touched with Fire*, p. 95.

59. Hershman and Lieb, *Manic Depression and Creativity*, p. 2.

60. Barondes, *Mood Genes*, p. 2.

61. Ibid., p. 3; Serretti, "Genetics of Mood Disorders," p. 49; Tondo, "Bipolar Disorder," p. 104.

62. Barondes, *Mood Genes*, p. 46; Serretti, "Genetics of Mood Disorders," p. 41.

63. Jamison, *Touched with Fire*, p. 17; Barondes, *Mood Genes*, pp. 1, 9. The odds of a first-degree relative (parent, child, or sibling) sharing bipolarity with another family member are 8 percent; the chance of a first-degree relative of a manic-depressive having major depression are 10 percent. In contrast (and counterintuitively), the odds of someone with major depression having a first-degree bipolar family member are only about 1 percent, which is the general risk for the population at large. First-degree relatives of a family member with early onset major depression, on the other hand, have a 30 percent chance of also having this disease; see Barondes, *Mood Genes*, p. 46.

64. Barondes, *Mood Genes*, p. 46.

65. Devereux, *Mohave Ethnopsychiatry*, p. 70.

66. Siikala, *The Rite Technique*, p. 330.

67. Jamison, *Touched with Fire*, p. 26; C. Faracelli, C. Ravaldi, and E. Truglia, "Unipolar Depression"; Leonardo Tondo, "Bipolar Disorder," p. 106.

68. Hershman and Lieb, *Manic Depression and Creativity*, p. 32.

69. Siikala, *The Rite Technique*, p. 286.

70. Tondo, "Bipolar Disorder," p. 105; Jamison, *Touched with Fire*, pp. 27–29; Hershman and Lieb, *Manic Depression and Creativity*.

71. Jamison, *Touched with Fire*, p. 38; Tondo, "Bipolar Disorder," p. 106.

72. Tondo, "Bipolar Disorder," p. 108.

73. Jamison, *Touched with Fire*, p. 15.

74. Jamison, *Touched with Fire*, p. 41; Tondo, "Bipolar Disorder," p. 109; Serretti, "Genetics of Mood Disorders," p. 38; De Leo and Spathonis, "Suicidal Behavior."

75. Jamison, *Touched with Fire*, p. 43; C. Faracelli, C. Ravaldi, and E. Truglia, "Unipolar Depression," p. 82.

76. Jamison, *Touched with Fire*, p. 58.

77. Ibid., p. 42.

78. Kroeber, *Handbook*, p. 425.

79. Devereux, *Mohave Ethnopsychiatry*, pp. 67, 69–70, 71, and 399.

80. American Psychiatric Association, *DSM-IV*, pp. 345–428.

81. Hershman and Lieb, *Manic Depression and Creativity*, p. 8.

82. Jamison, *Touched with Fire*, p. 50.

83. Benjamin Rush, *Medical Inquiries and Observations Upon the Diseases of the Mind* (Philadelphia: Kimber and Richardson, 1812).

84. Nancy Andreasen, "Creativity and Mental Illness: Prevalence Rates in Writers and Their First-Degree Relatives," *American Journal of Psychiatry* 144 (1987): 1288–92.

85. Both correlations were statistically significant: for mood disorders in general, $p = .001$; for bipolar illnesses, $p = .01$. As Jamison, *Touched with Fire*, pp. 73–74, notes, the incidence rates of mood disorders in Andreasen's control group were higher than in the population as a whole, and the cause of this result is uncertain. One possibility that Jamison suggests concerns the tendency for better-educated and upper-class populations to disproportionately suffer from mood disorders. The control group may have been biased in this direction by its match against the academics.

86. Andreasen, "Creativity and Mental Illness."

87. Ruth L. Richards, D. K. Kinney, I. Lunde, and M. Benet, "Creativity in Manic-Depressives, Cyclothemes, and Their Normal First-Degree Relatives: A Preliminary Report," *Journal of Abnormal Psychology* 97 (1988): 281–88. Note that the patterns identified in the Andreasen, "Creativity and Mental Illness," and Richards, et al., studies have been substantiated by subsequent research; cf. Diana I. Simmora, Kiki D. Chang, Lonnie Strong, and Terence A. Ketter, "Creativity in Familial Bipolar Disorder," *Journal of Psychiatric Research* 39 (2005): 623–31; C. M. Santosa, C. M. Strong, C. Nowakowska, P. W. Wang, C. M. Rennicke, and T. A. Ketter, "Enhanced Creativity in Bipolar Disorder Patients: A Controlled Study," *Journal of Affective Disorders* 100 (2007): 31–39.

88. See summaries of the methodological issues and previous research in Jamison, *Touched with Fire*, pp. 59–61.

89. Ibid., pp. 61–72. Note that her study sample was largely the Romantic poets, including writers such as William Blake, Samuel Taylor Coleridge, Percy Bysshe Shelley, Lord Byron, and others. The Romantics are well known for their mental health problems (which they wrote about) and the inspiration they received from their hallucinations. A superficial reaction to this circumstance might cause a dismissal of Jamison's results—everyone already knows that Romantics were mad, so what does that prove? Although there were methodological differences in the various studies that certainly influenced the results, Jamison in fact recorded a *lower* rate of mental pathology among her study sample than some of the studies of contemporary artists. The Romantics did exhibit a disproportionate rate of mental illness, relative to the population as a whole. But so do contemporary artists, and some studies of these modern individuals show that mental illness is more prevalent among them than among the Romantics.

90. Ibid., pp. 62 and 61.

91. Ibid., p. 61.

92. E.g., Barondes, *Mood Genes*, p. 29.

93. Hershman and Lieb, *Manic Depression and Creativity*, p. 11.

94. Holman W. Jenkins Jr., "The Latest Management Craze: Crazy Management," *Wall Street Journal*, October 8, 1996, p. 1.

95. Hershman and Lieb, *A Brotherhood of Tyrants: Manic Depression and Absolute Power* (Amherst, New York: Prometheus Books, 1994).

96. Hershman and Lieb, *Manic Depression and Creativity*, p. 11.

97. Ruth L. Richards, D. K. Kinney, I. Lunde, and M. Benet, "Creativity in Manic-Depressives."

98. Jamison, *Touched with Fire*, p. 105.

99. Hershman and Lieb, *Manic Depression and Creativity*, p. 201.

100. Jamison, *Touched with Fire*, p. 118; Hershman and Lieb, *Manic Depression and Creativity*, p. 16.

101. Jamison, *Touched with Fire*, p. 6.

102. It is worth interjecting here that, on standardized tests,

shamans have proven freer and more creative in their thinking than normal (H. Fabrega Jr. and D. B. Silver, *Illness and Shamanistic Curing in Zinacantan: An Ethnomedical Aanalysis* [Stanford: Stanford University Press, 1973]). Further, they are renowned for their extensive, often poetic vocabularies. Peter Furst, for example, cites an account indicating that a Yakut Siberian shaman had a twelve-thousand-word vocabulary, compared to only about four thousand words in the community as a whole. (see Furst, "The Roots and Continuities of Shamanism," p. 26).

103. Antonio R. Damasio, *Descartes' Error: Emotion, Reason, and the Human Brain* (New York: G. P. Putnam's Sons, 1994); Mary Midgley, *The Myths We Live By* (London: Routledge, 2003).

104. Michel Foucault, *Madness and Civilization: A History of Insanity in the Age of Reason*, rev. 2nd ed. (New York: Vintage Books, 1988).

CHAPTER SEVEN: ART BEYOND BELIEF: CREATIVITY AND RELIGION IN PERSPECTIVE

1. Cf. Gigitte Delluc and Gilles Delluc, "L'Access aux Parois," in *Lascaux Inconnu* (*XIIe supplement a "Gallia Préhistoire"*), ed. A. Leroi-Gourhan and J. Allain (Paris: Éditions du Centre National de la Recherche Scientifique, 1979), pp. 175–84; Mario Ruspoli, *The Cave of Lascaux: The Final Photographs* (New York: Harry N. Abrams, 1986), pp. 126 and 142–44; Norbert Aujoulat, *Lascaux: Le Geste, L'Espace, Et Le Temps* (Paris: Editions du Seuil, 2004), pp. 234–41.

2. Mircea Eliade, *Shamanism: Archaic Techniques of Ecstacy* (Princeton, NJ: Princeton University Press, Bollingen Series 67, 1972).

3. Ibid.

4. American Psychiatric Association, *Diagnostic and Statistical Manual of Mental Disorders*, 4th ed. (Washington, DC: American Psychiatric Association, 2000).

5. Kay Redfield Jamison, *Touched with Fire: Manic-Depressive Illness and the Artistic Temperament.* (New York: Free Press, 1993); D.

Jablow Hershman and Julian Lieb, *Manic Depression and Creativity* (Amherst, NY: Prometheus Books, 1998 [originally published 1988]); Samuel H. Barondes, *Mood Genes: Hunting for the Origins of Mania and Depression* (Oxford: Oxford University Press, 1998), p. 37.

6. Barondes, *Mood Genes*, pp. 43 and 172.

7. Ibid.

8. Michel Foucault, *Madness and Civilization: A History of Insanity in the Age of Reason*, rev. 2nd ed. (New York: Vintage Books, 1988), p. 14.

INDEX

311